Graphic Design:
Now in Production

Walker Art Center
Minneapolis

Cooper-Hewitt
National Design Museum
New York

Graphic Design:
Now in Production

Walker Art Center
Minneapolis

Cooper-Hewitt
National Design Museum
New York

Edited by Andrew Blauvelt and Ellen Lupton

**Texts by Åbäke, Ian Albinson, Peter Bil'ak, Andrew Blauvelt,
Rob Giampietro, James Goggin, Peter Hall, Steven Heller,
Jeremy Leslie, Ellen Lupton, Ben Radatz, Michael Rock,
Dmitri Siegel, Daniel van der Velden, Armin Vit and Bryony
Gomez-Palacio, and Lorraine Wild**

Published on the occasion of the exhibition *Graphic Design: Now in Production*, co-organized by Andrew Blauvelt of the Walker Art Center, Minneapolis, and Ellen Lupton of the Smithsonian Institution's Cooper-Hewitt, National Design Museum, New York.

The Walker Art Center's presentation is made possible by major support from Judy Dayton. Additional support is generously provided by the Bush Foundation as part of the Walker's Expanding the Rules of Engagement with Artists and Audiences initiative, Deborah and John Christakos, Megan and James Dayton, the Mondriaan Foundation, Amsterdam, Rebecca C. and Robert Pohlad, and Harriet and Edson Spencer. Night School is made possible by generous support from the Margaret and Angus Wurtele Family Foundation.

Cooper-Hewitt's presentation on Governors Island is made possible by support from the August Heckscher Exhibition Fund and Converse. Additional support is provided by the Ehrenkranz Fund, Behance, the Esme Usdan Exhibition Endowment Fund, Mondriaan Foundation, Amsterdam, Cooper-Hewitt Master's Program Fund, public funds from the Netherlands Cultural Services, and the Netherland-America Foundation. Media sponsorship provided by *New York* magazine and AOL.

Walker Art Center, Minneapolis
October 22, 2011–January 22, 2012

Cooper-Hewitt, National Design Museum, Governors Island, New York
May 26–September 3, 2012

Hammer Museum, Los Angeles
September 30, 2012–January 6, 2013

Grand Rapids Art Museum, Michigan
February 1–April 28, 2013

Contemporary Arts Museum Houston, Texas
July 20–September 29, 2013

Museum of Art, Rhode Island School of Design, Providence
March 28–August 10, 2014

Library of Congress Cataloging-in-Publication Data

Graphic design : now in production / edited by Andrew Blauvelt and Ellen Lupton ; texts by Rob Giampietro ... [et al.].—1st ed.
 p. cm.
 Published on the occasion of an exhibition held at the Walker Art Center, Minneapolis, Minn. and four other institutions between Oct. 22. 2011 and Jan. 2014.
 ISBN 978-0-935640-98-4
1. Commercial art—History--21st century—Exhibitions. 2. Graphic arts—History—21st century—Exhibitions. 3. Art and society—History—21st century—Exhibitions. I. Blauvelt, Andrew, 1964-II. Lupton, Ellen. III. Giampietro, Rob, 1978- IV. Walker Art Center.
 NC998.4.G668 2011
 741.609'051074766579--dc23

 2011034156

Available through D.A.P./Distributed Art Publishers, 155 Sixth Avenue, New York, NY 10013
www.artbook.com

ISBN 978-0-935640-98-4

Contents

6 **Directors' Foreword**

7 **Acknowledgments**

8 **Introduction**
Andrew Blauvelt and
Ellen Lupton

12 **The Designer as Producer**
Ellen Lupton

14 **Fuck Content**
Michael Rock

16 **Research and Destroy:
Design as Investigation**
Daniel van der Velden

19 **Unraveling**
Lorraine Wild

22 **Tool (Or, Postproduction
for the Graphic Designer)**
Andrew Blauvelt

32 **Design Entrepreneur 3.0**
Steven Heller

54 **Practice from Everyday
Life: Defining Graphic
Design's Expansive Scope
by Its Quotidian Activities**
James Goggin

58 **Reading and Writing**
Ellen Lupton

76 **Magazine Culture**
Jeremy Leslie

92 **The Persistence of Posters**
Andrew Blauvelt

112 **The Making of
Typographic Man**
Ellen Lupton

130 **Experimental typography.
Whatever that means./
Conceptual Type?**
Peter Bil'ak

135 **Design in Motion**
Ben Radatz

137 **The Art of the
Title Sequence**
Ian Albinson

145 **I Am Still Alive #21**
Åbäke

170 **Bubbles, Lines, and
String: How Information
Visualization
Shapes Society**
Peter Hall

186 **Brand Matrix**
Armin Vit and Bryony
Gomez-Palacio

190 **Brand New Worlds**
Andrew Blauvelt

210 **Designing Our Own Graves**
Dmitri Siegel

212 **School Days**
Rob Giampietro

Directors' Foreword

The Smithsonian's Cooper-Hewitt, National Design Museum and the Walker Art Center are proud to present *Graphic Design: Now in Production*, an ambitious look at the broad-ranging field of graphic design. Both institutions have established themselves as major voices in the contemporary design discourse. The Walker has a long history of organizing design exhibitions, presented in the context of a larger program devoted to visual arts, film, and performance. Cooper-Hewitt is the only institution in the United States dedicated solely to historical and contemporary design and decorative arts.

Both museums have long sought to bring public recognition to the field of graphic design. In 1989, the Walker Art Center organized the first major museum survey in the United States on this subject. Called *Graphic Design in America: A Visual Language History*, this landmark show was organized by Mildred Friedman, creator of a prominent series of exhibitions and publications at the Walker devoted to design and architecture. In 1996, Cooper-Hewitt presented *Mixing Messages: Graphic Design in Contemporary Culture*, organized by Ellen Lupton. With courage and good humor, these two projects confronted a daunting task: to survey a sprawling field of expression that is more at home in supermarkets and bookstores than on the walls of a gallery.

In 1986, just two years after the Macintosh computer was introduced, legendary graphic designer April Greiman created a special foldout poster for the Walker's influential journal *Design Quarterly*. Greiman produced the piece—a life-size, pixelated nude self-portrait—on a Mac, then an exotic tool for graphic design. Her production notes chronicle the travails of making an image of this scale and complexity; Greiman dutifully noted that her files consumed 289K of computer memory, a size that nearly crippled her laser printer. Today, that much memory is a mere speck, smaller than a cell phone snapshot.

The field has changed dramatically in the fifteen years since *Mixing Messages*— let alone in the twenty-three years since *Graphic Design in America*. Design practice has broadened its reach, expanding from a specialized profession to a widely deployed tool. Social media and numerous technologies for manipulating image,

text, and data have changed the way people produce and consume information. As design tools have become more widely accessible, more designers are becoming producers—authors, publishers, instigators, and entrepreneurs.

The lead curators of *Graphic Design: Now in Production* are Andrew Blauvelt, curator of architecture and design at the Walker Art Center, and Ellen Lupton, curator of contemporary design at Cooper-Hewitt. Practicing designers as well as writers and educators, they consistently bring their working knowledge of design processes to bear on their curatorial endeavors by exploring the behavior of words and things in physical space. Blauvelt and Lupton are producers in every sense, realizing their projects in a hands-on way as authors, designers, and publishers. We are grateful to Andrew and Ellen for partnering to create this bold, prescient, and ambitious survey of the landscape of contemporary graphic design. To create this exhibition, they invited a team of guest curators with specialties in various fields to join them: Ian Albinson (film and television titles), Jeremy Leslie (magazines), and Armin Vit and Bryony Gomez-Palacio (branding). Together, this remarkable team has assembled an original and surprising overview of progressive design practice today and worked closely with more than two hundred designers to create a singular installation conceived collaboratively.

We have been fortunate to have a variety of institutional partners across the country hosting the exhibition. We are grateful to Ann Philbin, director, and Douglas Fogle, chief curator and deputy director, exhibitions and programs, at the Hammer Museum, Los Angeles, and to Mark Leach, executive director, and Steven Matijcio, curator of contemporary art, at the Southeastern Center for Contemporary Art (SECCA), Winston-Salem, North Carolina.

For the Walker's presentation of *Graphic Design: Now in Production*, we would like to extend our heartfelt thanks to Judy Dayton, honorary trustee and patron of the museum, without whose support this exhibition would not be possible. On behalf of the Walker, we acknowledge the Bush Foundation, which has supported the Walker's organizational experimentation as

its staff reached out to explore new ways of curating and displaying art and interacting with its community.

We are grateful for additional support from trustee John Christakos and his wife, Deborah; trustee James Dayton and his wife, Megan; trustee Rebecca Pohlad and her husband, Robert; and honorary trustee Harriet Spencer and her husband, Edson. We would also like to thank the Mondriaan Foundation for its support of projects undertaken by several of the Dutch designers represented in the exhibition. A leading cultural force in contemporary design, the Netherlands is indeed a special place for the support of design and visual culture.

For this exhibition we have developed not only a new model of shared curatorial development with our outside experts, but at the Walker we have also created a new educational project called Night School, with support from the Margaret and Angus Wurtele Family Foundation. Meeting during Target Free Thursday Nights, this project brings together more than thirty graphic design students from the College of Visual Arts (CVA) in St. Paul, the Minneapolis College of Art and Design (MCAD), and the University of Minnesota College of Design to take part in a semester-long course that uses the exhibition as its textbook to explore important issues and themes for the field. In order to create this endeavor, we are thankful for the support shown by the leadership at these institutions: Ann Ledy, president of CVA; Jay Coogan, president of MCAD; and Tom Fisher, dean of the College of Design at the University of Minnesota.

Producing this exhibition collaboratively required intensive cooperation and planning from the staffs of both museums. We are grateful to everyone for their efforts to marry the diverse cultures, locales, and requirements of our two institutions in order to generate a meaningful outcome for the public. Twenty-three years from now, visual communication will look vastly different once again. This book, and the exhibition it documents, serves as a record of one way of viewing present conditions, which are already changing faster than we can observe them. ⊠

—Bill Moggridge, Cooper-Hewitt, National Design Museum
—Olga Viso, Walker Art Center

Acknowledgments

We would like to extend our utmost appreciation to all the people who helped us realize this ambitious exhibition and complex publication.

First and foremost, we would like to thank the more than two hundred designers, artists, and publishers for their participation and contributions to the show and book. Without their assistance and generosity in sharing their work, none of this would have been possible.

We are deeply grateful to all of our curatorial colleagues who helped us conceive and organize the title design, magazine, and branding sections of the exhibition: Ian Albinson of *Art of the Title* (artofthetitle.com); Jeremy Leslie of *magCulture* (magCulture.com); Armin Vit and Bryony Gomez-Palacio of Under Consideration, LLC. We salute their passion, commitment, and deep knowledge.

We are grateful to our respective directors, Olga Viso at the Walker and Bill Moggridge at Cooper-Hewitt, for their unwavering support and enthusiasm to realize this first joint venture between the museums.

Thanks to the many lenders to the exhibition for allowing both permission to show the works, particularly the film and television directors and the entertainment studios, and for the generous loan of materials.

A special thank you to our tour partners for this exhibition—the Hammer Museum in Los Angeles and the Southeastern Center for Contemporary Art (SECCA) in Winston-Salem, who helped bring the work of so many designers to audiences across the United States.

Many colleagues at Cooper-Hewitt, National Design Museum helped originate the exhibition and oversee its transformation at Governors Island in New York City. Our thanks go to: Caroline Baumann (museum administration); Cara McCarty, Jackie Killian, and Amanda Kesner (curatorial); Jocelyn Groom, Matthew O'Connor, and Mathew Weaver (exhibitions); Greg Krum and Jocelyn Crapo (shop); Debbie Ahn, Julie Barnes, Elyse Buxbaum, and Kelly Mullaney (development and membership); Caroline Payson, Mei Mah, and Shamus Adams (education); Wendy Rogers (registrar); Perry Choe (conservation); Chul R. Kim (publications); Jimpson Pell (IT); and Jennifer Northrop, Laurie Olivieri, and Micah Walter (communications and marketing).

We are also grateful to the design team that created the installation at Governors Island. Our thanks go to: Prem Krishnamurthy, Adam Michaels, Rob Giampietro, Chris Wu, and Jeffrey Waldman (Project Projects); and Dan Wood, Amale Andraos, Sam Dufaux, and Marcel Sonntag (WORKac).

At Governors Island, we thank Leslie Koch, Jonathan Meyers, and Claire Kelly for hosting our exhibition at one of New York City's most spectacular locations.

At the Walker, we are profoundly grateful for patrons' generous support of this exhibition and their commitment to presenting the most engaging arts of our time: Walker honorary trustee Judy Dayton; honorary trustee Angus Wurtel and his wife, Margaret; honorary trustee Harriet Spencer and her husband, Edson; trustee John Christakos and his wife, Deborah; trustee James Dayton and his wife, Megan; trustee Rebecca Pohlad and her husband, Robert; the Bush Foundation; and the Mondriaan Foundation, Amsterdam.

Our sincere appreciation goes to the following Walker staff: Darsie Alexander (chief curator); Mary Polta (finance); Lynn Dierks, DeAnn Thyse, and Camille Washington (visual arts); Christopher Stevens, Marla Stack, and Annie Schmidt (development); Kerstin Beyer, Masami Kawazato, and Kate Tucker (membership); Cameron Zebrun, David Dick, Peter Murphy, Scott Lewis, Kirk McCall, and Jeffrey Sherman (program services); Robin Dowden, Eric Price, Tyler Stefanich, and Nate Solas (new media); Joe King and Pamela Caserta (registration); Kathleen McLean and Pamela Johnson (editorial); Emmet Byrne, Lisa Middag, Dylan Cole, Greg Beckel, Michael Aberman, Dante Carlos, Andrea Hyde, Anton Pearson, and Brian Walbergh (design); Cameron Wittig and Gene Pittman (photography); Andy Underwood (video); Ryan French, Christopher James, and Adrienne Wiseman (marketing and public relations); Michele Tobin and Paul Schumacher (shop); and Sarah Schultz, Susy Bielak, and Ashley Duffalo (education).

Special thanks to Matthew Rezac, and to the faculty, students, and leadership of the College of Visual Arts, the Minneapolis College of Art and Design, and the College of Design at the University of Minnesota for being enthusiastic partners in our pedagogical experiment called Night School. ⊠

—**Andrew Blauvelt and Ellen Lupton**

2011
Introduction
Andrew Blauvelt and Ellen Lupton

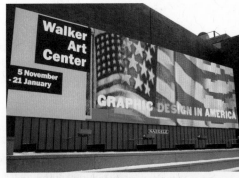

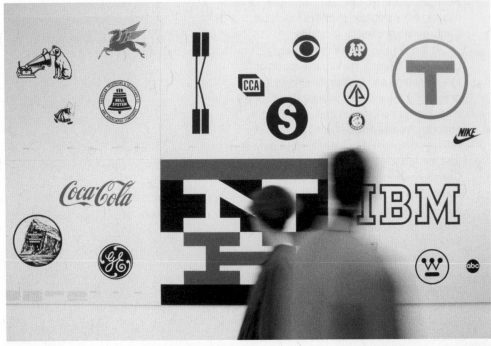

Above and right: Installation views of *Graphic Design in America: A Visual Language History*, Walker Art Center, Minneapolis, 1989

Graphic Design

Graphic design is a creative process–most often involving a client and a designer and usually completed in conjunction with producers of form (i.e., printers, programmers, signmakers, etc.)—undertaken in order to convey a specific message (or messages) to a targeted audience. The term "graphic design" can also refer to a number of artistic and professional disciplines that focus on visual communication and presentation. The field as a whole is also often referred to as Visual Communication or Communication Design. Various methods are used to create and combine words, symbols, and images to create a visual representation of ideas and messages. A graphic designer may use typography, visual arts, and page layout techniques to produce the final result. Graphic design often refers to both the process (designing) by which the communication is created and the products (designs) which are generated. —Wikipedia

Above and right: Installation views of *Mixing Messages: Graphic Design in Contemporary Culture*, Cooper-Hewitt, National Design Museum, New York, 1996

A sequence of images from Daniel Clowes' satirical comic *Art School Confidential*, first published in 1991, features three equally dismal career paths for the average art school graduate: clerking in an art supply store, flipping burgers in a diner, or becoming a "paste-up artist." Back then, paste-up occupied the lowest possible rank within the art world's lowest field of endeavor: graphic design. Paste-up belonged to production, a menial phase of the design process devoted not to high-minded forms and ideas but to hands-on execution.

During the same year that Clowes published his seminal work of cultural samizdat, a major point of passage occurred in the field of graphic design. It was then that digital files became a fully accepted means for transmitting artwork from designer to printing plant. The age of QuarkXPress and PostScript page assembly had finally dawned; the drudgery of manual paste-up was lost to memory. Graphic designers absorbed the labors of the paste-up artist like the body of a dead twin. Designers picked up numerous other production tasks as well, from typesetting to photo-retouching, processes demanding special skills and equipment that could now be performed from the narrow perch of the digital desktop. (Flipping burgers remained a separate calling, soon joined by new jobs such as Starbucks barista and Apple Store Genius.) Many designers feared their profession would collapse under the heavy weight of production. Worse, they predicted, desktop publishing would trigger a devastating transfer of power from designers to "secretaries," a population newly empowered with Times Roman and Helvetica.

These things did not come to pass. The design profession grew and grew. Arial outpaced Helvetica as an object of scorn, and secretaries became scarcer than exorcists and bank tellers. At art schools everywhere, design programs emerged from their dusty crawl spaces, becoming proud engines of growth for colleges and gleaming beacons of opportunity for young artists who were drawn to digital tools and were unashamed to openly consort with commerce. The World Wide Web soon joined Photoshop and *Ray Gun* (the '90s alt music magazine and graphic style guide) as gateways to graphic design. The field was no longer seen as the last resort of the failed painter, but as a genuinely interesting pursuit.

Alas, all that glitters is not Gotham Thin Reverse Italic. Graphic design is, indeed, a decent way to make a living, but as the largest design profession in the United States, it has ample room to bore the pants off its own practitioners. Among some quarter-million graphic designers working in this country alone, many love what they do yet experience the occasional pang of existential doubt or seller's remorse. How many banner ads, business cards, and restaurant flyers can a person churn out before longing for something more? As Rob Giampietro points out in his essay in this catalogue, "School Days," graphic design MFA programs are on the rise, attracting restless young professionals eager to explore territories of their own making. Designers frustrated with routine client work have looked to authorship as a source of artistic agency and personal satisfaction, searching for authority and self-expression in an all-access world of evaporating expertise.

While desktop publishing changed the journey from initial concept to printed page, recent innovations have transformed the means of manufacture and circulation. Mobile devices, print-on-demand systems, low-cost digital printing equipment, rapid prototyping, and web-based distribution networks have created new opportunities for designers, writers, artists, and anyone else—from doctors and lawyers to school kids and housewives—to take up the tools of creative production. Recent design practice has taken a pragmatic turn, emphasizing process, situation, and social interaction over a fixed and final outcome. Design is a process that anyone can use as well as a specialized discourse whose language is open to exploration and expansion.

Perhaps production—the down-market arena of the paste-up artist—can help cure what ails us. Referring to physical making and economic organization, "production" speaks of process, collaboration, and practical implementation, in contrast with the more solitary and cerebral implications of "authorship." Worldly, grounded, and pragmatic, production encompasses direct modes of action, from controlling the techniques of manufacturing to coordinating creative teams in order to realize complex projects.

Assembling a major exhibition on graphic design is a tough job. Graphic design touches on nearly every aspect of communication, from film and television titles to street signs and soup cans. Museum exhibitions on the subject, at least in the United States, have been few and far between. Precedents date back to the Cooper-Hewitt's *Mixing Messages* (1996) and the Walker Art Center's *Graphic Design in America* (1988). This scarcity of coverage means that when shows do appear, there is a vast amount of material to consider. Deciding where to begin is an initial challenge for any curator. We chose the year 2000 to bracket our search for material, providing us with roughly a decade to survey. Enterprising readers will discover that some projects date from the late 1990s; we included these works because they are symptomatic of important themes that were starting to emerge. An exhibition of this scale marks a moment in time: in the 1980s, it was the richness of the discipline's history that resonated with its time; in the 1990s, it was the search for graphic languages that freely mixed references from high and low culture; and now in the first decades of the twenty-first century, it is the increasingly open nature of design practices and the open access to tools that reign supreme.

A second major challenge is deciding where to draw the lines around a field such as graphic design. The forms of graphic design proper are endless: posters, brochures, books, magazines, logos, stationery systems, packaging, signage systems, fonts, motion graphics, and information graphics, to name a few. Our curatorial instinct was to avoid genres, thus eliminating this representational burden. However, for the public, graphic design *is* these genres. Thus, in order to create a more accessible entry point into the material and to provide a more familiar starting place—if only to deviate from it—we chose to organize the exhibition in a way that reflects and reinforces these categories of activity. We chose not to focus on the more process-oriented and immaterial forms of design practice, leaving these for another day and another show—one attuned to the particular issues and challenges of such endeavors. Numerous examples of interactive media and screen-based design appear throughout this exhibition, as is evident in the dozens of video monitors, mobile devices, and computers in the gallery. This condition speaks to the rapidly expanding world of electronically publishable material, the surge in mobile computing technologies, and the role of screen-based media in nearly every genre of graphic design.

A third challenge is to address the difference between a curated exhibition and those mounted by professional trade organizations. Such profession-based shows, often coordinated around an open call for entries, typically employ a jury of peers to recognize individual designers' achievements. In contrast, this exhibition is not an attempt to select the best logo

or book designs of the decade; rather, we have selected the works on view in relation to a curatorial framework or thesis. Undoubtedly, some of these projects have been honored and awarded by various professional groups over the years. However, because our focus is on ways that contemporary designers are using their talents to create, author, edit, produce, publish, and distribute works, our exhibition is not an exhaustive attempt to showcase the work of "deserving" designers (a list so long we could not shelter them in one museum, let alone in a couple of galleries). Nor is this exhibition an overview of typical works encountered in daily life. Instead, we have sought out innovative practices that are pushing the discourse of design in new directions, expanding the language of the field by creating new tools, strategies, vocabularies, and content.

In this book's opening series of essays, we trace a recent history of the thinking that lies behind the work we've selected. We interweave this conversation with new arguments as well as pivotal ones from the past. Picking up from the territory first explored in the 1980s by designers who sought to claim a mantle of authorship and control over their work, we chart the schism engendered by this split between conceptual and physical activities, the role of craft and labor, or new definitions of research and work undertaken without client commissions. Michael Rock reiterates his critique of authorship claims in his essay "Fuck Content," while Lorraine Wild in her new essay "Unraveling" reflects on her 1998 piece "The Macramé of Resistance" and the opportunities and challenges designers encountered in the intervening years. Daniel van der Velden's provocative 2006 missive "Research and Destroy: Design as Investigation" provides a more recent historical snapshot of the search for alternative possibilities of design practice in the wake of larger shifts in notions of labor and value in the new global economy. Lupton's seminal "The Designer as Producer" foreshadows the kind of practices this exhibition puts on display, while Andrew Blauvelt's essay "Tool (Or, Postproduction for the Graphic Designer)" explores ways that traditional notions about labor, craft, and authorship are being challenged by the contemporary cultural climate of the remix and the reissue, in which designers don't simply use tools anymore, but make and share them.

Although both of us have extensive backgrounds in graphic design as practitioners and curators as well as educators and writers, we do not pretend to have the necessary expertise to be able to select all of the work for a show of this scale. Recognizing some of our own shortcomings, we employed the help of three key individuals and teams to organize sections of the exhibition as guest curators. Embracing the true meaning of the old French word amateur (lover of), we enlisted this team of amateur-experts whose deep knowledge of their respective areas helped us select, organize, and comment upon the work in the show in three major sections: magazine publishing, branding and identity, and television and film title design. The resulting exhibition is a reflection of this pro-am (professional-amateur) alliance and a first for both the Walker's and Cooper-Hewitt's curatorial practice.

Jeremy Leslie, a designer and publishing consultant based in London, produces the blog magCulture, a virtual clearinghouse of some of the world's most interesting and innovative publishing projects. Leslie worked diligently to select work from around the world that testifies to the vibrancy and resilience of the magazine format as the industry struggles with, among other things, the search for viable new business models. He considers projects that actively reinvent such stalwart genres of the industry as fashion, business, and celebrity as well as those that question the very notion of what defines a magazine. Additionally, he explores the role that design itself plays in the creation and revitalization of magazines, or as he describes it, "making the most of design in print," and the reciprocity between print and digital forms as content increasingly migrates from page to screen. Leslie also arranged for a special commission of Åbäke's ongoing "parasite" publication series I Am Still Alive for this catalogue.

Armin Vit and Bryony Gomez-Palacio, designers and writers who operate Brand New, helped us formulate our approach to the vast territories of logo design, branding, and identity program work. Their brand matrix, published in this catalogue, was used to map this territory along the axes of scale (individual/conglomerate) and place (local/global), leading to unexpected projects both inside and beyond the corporate arena. Accordingly, this section of the exhibition explores the impact of branding on individuals, subcultures, and communities. Identity programs in the cultural sector have tended to push the boundaries of traditional branding by emphasizing the flexibility and variability that systems can provide, often including the creation of new tools for implementation. At our suggestion, a project of Brand New is also on view in the gallery, where we have presented a series of excerpts from the popular blog, which posts new logos and changes to existing branding programs and solicits reactions and commentary from visitors. Taking a page from this strategy for our own show, we are soliciting the feedback of gallery visitors, judging the before and after designs. As Blauvelt notes in his essay "Brand New Worlds," this form of instant commentary and appeals to mass judgment are part and parcel of the contemporary condition that brings us everything from our next American Idol to the very real reactions that gave us an aborted Gap logo redesign or the uproar over the 2012 Olympic Games symbol for London. Other projects in this section explore the world of branding as a cultural manifestation—whether the need to identify secret military groups or black metal bands, or the implications of Facebook acting as a new kind of community and transnational agent with its more than 750 million users.

The art of designing and directing film and television titles or music videos represents a new area of interest for graphic designers. Although this realm of motion graphics has a history as long as motion pictures itself, as Ben Radatz notes in his essay, it was only with the invention of desktop computing and cheaper, faster, and more sophisticated software that access for graphic designers opened to this once obscure practice. We asked Ian Albinson, founder and editor-in-chief of the website Art of the Title, to select a series of projects that would provide a cross section of contemporary practice. In these examples, the role of the designer as producer is perhaps most literal and apparent. Bringing together the work of animators, illustrators, photographers, cinematographers, and graphic designers under a single creative vision, these works testify to the growing sophistication of contemporary title design. Today's titles are mini-narratives that not only introduce the talent associated with a production, but also help orient the viewer to the impending storyline or otherwise set the tone for what has happened or what is to follow.

While we worked collaboratively across the entire exhibition, the section devoted to typography was led by Ellen Lupton. As she notes in her essay "The Making of Typographic Man," the rise of digital design tools in the 1980s forever changed the field of typography, allowing graphic designers to engage with this specialized endeavor

while opening up new markets for fonts. Graphic designers, whose access to typefaces was no longer mediated by costly typesetting services, could now purchase fonts directly and manipulate them in real time on their own desktops. Typeface design became a new form of underground publishing. Today, designers around the world are producing, distributing, and using digital typefaces at an astonishing rate. Out of the limitless array of contemporary faces, Lupton selected twenty-five font families that indicate current issues and ideas, including the interest in combining soft, rounded forms with geometric structure, the continued search for anonymous typefaces, the revival of the neoclassical Didone idiom of the eighteenth century and the slab serifs of the nineteenth, and the challenge of designing for international language communities. The section on typography also looks at custom letterforms used in posters, packaging, publishing, and other media that embrace both geometric and organic systems of growth and change. Two essays by typographer and designer Peter Bil'ak, reprinted in this volume, question the nature and limits of so-called experimental and conceptual typography.

Blauvelt took the lead on the poster section, which has a particular emphasis on projects from designers who actively explore the genre and test its limits. Modes of interactivity and the merger of the printed poster with new technologies can be seen in a variety of projects. As he notes in his essay, the poster also remains an outlet for personal expression—whether a self-initiated or self-commissioned work or an exploration of printmaking. The poster is an iconic form that persists today despite the ubiquity of bland corporate ad campaigns and hostile anti-posting ordinances. The contemporary poster is not so much a medium of mass communication as a proving ground for new languages and techniques.

Blauvelt also organized the section dedicated to information design and data visualization, which is witnessing tremendous growth and activity. The Internet has revealed new sources of data to analyze, while the creation of new software and tools facilitates its visualization. A growing appetite for information by the general public has helped make this area of practice perhaps the most fluid across disciplines, merging aspects of investigative journalism, statistical analysis, and creative coding and application development with traditional visual design skills of illustration and typography. Today's

information designers serve as storytellers, journalists, and translators, seeking to organize data in understandable, engaging, and memorable ways by operating, as Peter Hall notes in his new essay "Bubbles, Lines, and String: How Information Visualization Shapes Society," from one of three positions: scientific, journalistic, or artistic.

Blauvelt and Lupton curated the section on books and publishing by organizing and winnowing an unlimited array of material into three main modes of practice. Traditional book designers are people who have dedicated their practice to the creative expression of content and have explored and reasserted the materiality of the medium in the wake of the hardships facing the publishing industry today. These designers have expanded their roles to include the editing and conceptualizing of content—pouring over hundreds of images or spending years in an archive sorting out potential material. Another category explores the idea of authorship in a more traditional sense of the term. Here, designers are originating new content: researching design history, writing polemical texts, authoring fiction and even children's books. At the same time, authors themselves are becoming designers, configuring and laying out their material in unconventional ways that better suit their texts. Finally, designers have become publishers, distributors of volumes and texts utilizing more fully their knowledge of making and selling books. The proliferation of new presses is fully consistent with the age of self-publishing, as the tools and systems that were once difficult to access are now more readily available—a theme of Lupton's new essay "Reading and Writing" and James Goggin's 2009 text "Practice from Everyday Life," reprinted in this book.

We also conceived and curated a section of the exhibition devoted to the marketplace of designer-created goods, where graphics seem to cover any imaginable surface—from T-shirts, tote bags, gift wrap, and wallpaper to more offbeat merchandise such as bespoke axes, custom birdhouses, and hand-illustrated ceramic plates. No longer satisfied to simply design the packaging for goods or to conceive of brands for new products, many graphic designers today are turning their own entrepreneurial ambitions into marketable goods, as Steven Heller chronicles in his essay, charting its evolution from key designers over the decades to its pedagogical instantiation in school curricula. Collaborating with our respective museum retail staffs, we have selected a mix of archival and purchasable goods for sale

inside the gallery, creating a storefront for the exhibition, which becomes, à la Banksy, a place to exit and enter through the gift shop. In what many museum traditionalists may find off-putting—mixing art and commerce inside the gallery—we recognize as natural for graphic design, which has never shied away from its roots in "commercial art." In Dmitri Siegel's essay "Designing Our Own Graves," we confront the "prosumer," the empowered consumer of design-it-yourself culture, who has access to the tools of production and isn't afraid to wield them. Siegel provides fair warning to the ranks of professional designers, asking: "What would be the role of the designer in a truly do-it-yourself economy?"

This book itself is a work of production. Conceived by Blauvelt and Walker Art Center design director Emmet Byrne, the book's graphic format addresses today's hunt-and-gather culture. Contemporary designers absorb countless bits of inspiration and influence via visual blogs and social networks, where helpful hints and indie zine covers collide with an unlimited supply of new typefaces, custom letters, and photos of topless girls. Designers inhale this atomized data flow while exhaling back their own identities, publishing themselves across the web via portfolio sites and Tumblr feeds. The boundary between new and old constantly collapses as designers up- and downcycle an ever-adapting vocabulary.

Gently inspired by *The Last Whole Earth Catalog* (the classic hippie guide to off-the-grid survival), our book combines short chunks of text with images from contemporary practice, anchored by a series of long-form essays. Aggregated rather than authored, *Graphic Design: Now in Production* is disordered and nonhierarchical, preferring to cluster and group rather than argue and explain. The texts on hand include plain-vanilla definitions of terms and practices (emulating the anonymous hivespeak of *Wikipedia*) as well as signed entries and quoted excerpts from notable designers and thinkers (peppering the mix with voice and opinion). The format served as a scaffold that we populated with content over time. The result is a borderless enterprise whose cut-and-paste methodology embraces the open conflation of design, authorship, and production today. ⊠

1998
The Designer as Producer
Ellen Lupton

Anthony Velonis

Artist/producer Anthony Velonis helped transform screenprinting into a viable fine arts medium. In the 1930s, the WPA's Federal Art Project was created to employ artists during America's Great Depression and to bring art into the lives of ordinary citizens. Velonis saw screenprinting as an affordable medium with great aesthetic potential. His pamphlet *Technical Problems of the Artist: Technique of the Silkscreen Process* helped to popularize screenprinting in the postwar period. After leaving the WPA, he founded the Creative Printmakers Group, which produced fine arts prints as well as commercial posters. —EL

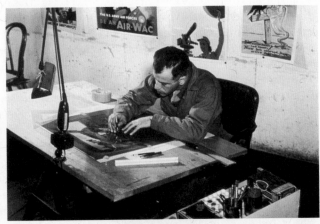

Anthony Velonis working on a poster matrix in the photography and reproduction department, Lowry Field, Denver, circa 1943 Courtesy Library of Congress Prints and Photographs Division

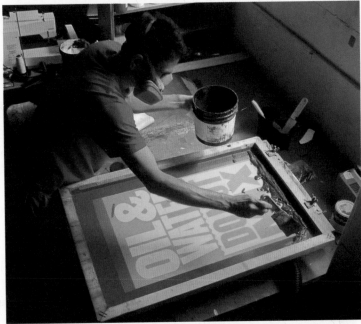

Silkscreening the print *Oil & Water Do Not Mix*, 2010, designed by Anthony Burrill, conceived and produced in collaboration with Happiness, Brussels Courtesy Anthony Burrill

Will Holder and Stuart Bailey (as Will Stuart) explain the concept of vertical integration using a replica of Michelangelo Pistoletto's *Structure for Talking While Standing* (1965–1966), Chelsea Space, London, 2010 Courtesy Will Holder

Jürg Lehni and Uli Franke, creators of *Hektor*, executing a wall drawing for Cornel Windlin's contribution to the exhibition *Public Affairs*, Kunsthalle Zürich, 2002 Courtesy Jürg Lehni

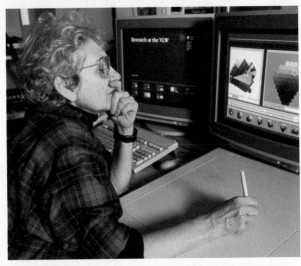

Muriel Cooper at work in the Visible Language Workshop at MIT Photo: L. Barry Hetherington

Muriel Cooper

A pioneer of design for digital media, Muriel Cooper founded the Visible Language Workshop (VLW) at MIT in 1975. In 1985, the VLW moved to the MIT Media Lab as one of its founding research groups. Cooper worked with her students to create an electronic language for building "typographic landscapes"—complex, malleable documents that function in real time and three-dimensional space. Cooper brought typography to life, imparting dynamic interactivity to such principles as layered information, simultaneous texts, and typographic texture. She aimed to restructure the language of design in four dimensions. In an interview with the author shortly before her unexpected death in 1994, Cooper said, "In the traditional model, the designer tries to interpret what given elements are 'supposed to do' together. So what happens with computers (beyond the primitive desktop publishing model)? On the 'information highway,' all sorts of things are up for grabs—authorship, how people read, how people gather and generate material for their own purposes." —EL

The Death of Walter Benjamin

Walter Bendix Scönflies Benjamin (15 July 1892–26 September 1940) was a German-Jewish intellectual, who functioned variously as a literary critic, philosopher, sociologist, translator, radio broadcaster and essayist. ¶ Benjamin committed suicide in Portbou at the French-Spanish border while attempting to escape from the Nazis. The people he was with were told by the Spanish police that they would be deported back to France, which would have hampered Benjamin's plans to get to the United States. While staying in the Hotel de Francia, he apparently took some morphine pills and died on the night of 25/26 September 1940. ¶ The fact that he was buried in the consecrated section of a Roman Catholic cemetery would indicate that his death was not announced as a suicide. The other persons in his party were allowed passage the next day, and safely reached Lisbon on 30 September. ¶ A manuscript of Benjamin's "On the Concept of History" was passed to Theodor Adorno by Hannah Arendt, who crossed the French-Spanish border at Portbou a few months later, and was subsequently published by the Institute for Social Research (temporarily relocated to New York) in 1942. A completed manuscript, which Benjamin had carried in his suitcase, disappeared after his death and has not been recovered. Some critics speculate that it was his *Arcades Project* in a final form; this is very unlikely as the author's plans for the work had changed in the wake of Adorno's criticisms in 1938, and it seems clear that the work was flowing over its containing limits in his last years. As the last finished piece of work from Benjamin, the *Theses on the Philosophy of History* is often cited; Adorno claimed this had been written in the spring of 1940, weeks before the Germans invaded France. While this is not completely certain, it is clearly one of his last works, and the final paragraph, about the Jewish quest for the Messiah provides a harrowing final point to Benjamin's work, with its themes of culture, destruction, Jewish heritage and the fight between humanity and nihilism. —*Wikipedia*

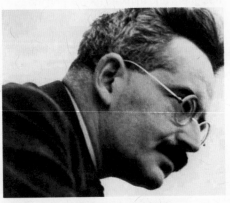

Walter Benjamin, Paris, 1937 Courtesy Archive: DHM Berlin

The slogan "designer as author" has enlivened debates about the future of graphic design since the early 1990s. Behind this phrase is the will to help designers to initiate content, to work in an entrepreneurial way rather than simply reacting to problems and tasks placed before them by clients. The word *author* suggests agency, intention, and creation, as opposed to the more passive functions of consulting, styling, and formatting. Authorship is a provocative model for rethinking the role of the graphic designer at the start of the millennium; it hinges, however, on a nostalgic ideal of the writer or artist as a singular point of origin.

The avant-garde movements of the 1910s and 1920s critiqued the ideal of authorship as a process of dredging unique forms from the depths of the interior self. Artists and intellectuals challenged romantic definitions of art by plunging into the worlds of mass media and mass production.

As an alternative to "designer as author," I propose "designer as producer." Production is a concept embedded in the history of modernism. Avant-garde artists and designers treated the techniques of manufacture not as neutral, transparent means to an end but as devices equipped with cultural meaning and aesthetic character. In 1934, the German critic Walter Benjamin wrote "The Author as Producer," a text that attacked the conventional view of authorship as a purely literary enterprise. He exclaimed that new forms of communication—film, radio, advertising, newspapers, the illustrated press—were melting down traditional artistic genres and corroding the borders between writing and reading, authoring and editing.

Benjamin was a Marxist, committed to the notion that the technologies of manufacture should be owned by the workers who operate them. In Marxist terminology, the "means of production" are the heart of human culture and should be collectively owned. Benjamin claimed that writing (and other arts) are grounded in the material structures of society, from the educational institutions that foster literacy to the publishing networks that manufacture and distribute texts. In detailing an agenda for a politically engaged literary practice, Benjamin demanded that artists must not merely adopt political "content," but must revolutionize the means through which their work is produced and distributed.

Benjamin attacked the model of the writer as an "expert" in the field of literary form, equipped only to craft words into texts and not to question the physical life of the work. The producer must ask, Where will the work be read? Who will read it? How will it be manufactured? What other texts and pictures will surround it? Benjamin argued that artists and photographers must not view their task as solely visual, lest they become mere suppliers of form to the existing apparatus of bourgeois publishing: "What we require of the photographer is the ability to give his picture the caption that wrenches it from modish commerce and gives it a revolutionary useful value. But we shall make this demand most emphatically when we—the writers—take up photography. Here, too, therefore, technical progress is for the author as producer the foundation of political progress."

Benjamin claimed that to bridge the divide between author and publisher, author and reader, poet and popularizer is a revolutionary act, because it challenges the professional and economic categories upon which the institutions of "literature" and "art" are erected.

Benjamin's Marxist emphasis has a tragic edge when viewed from the vantage point of today. By the time he wrote "The Author as Producer," abstract art was already at variance with Stalin's state-enforced endorsement of social realism. Benjamin applauded Dada and Surrealism for challenging the institutions of art, and yet such experimental forms were forbidden in the Soviet state he so admired. Benjamin's theory of the author as producer remains relevant today, however, even if one proposes more modest challenges to the existing structures of media and publishing, opening new paths of access to the means of manufacture and dissemination.

In the 1920s, Benjamin met Laszlo Moholy-Nagy, the Hungarian Constructivist whose work as a photographer, typographer, artist, and writer made him a prominent figure at the Bauhaus. Benjamin's 1928 collection of essays, *One-Way Street*, reflects on experimental typography and the proliferation of such commercial media as the pamphlet, poster, and advertisement, which were upending the classical book as literature's sacred vessel. Benjamin wrote: "Printing, having found in the book a refuge in which to lead an autonomous existence, is pitilessly dragged out onto the street by advertisements and subjected to the brutal heteronomies of economic chaos. This is the hard schooling of its new form." Describing the relation of authorship to technology, Benjamin predicted that the writer will begin to compose his work with a typewriter instead of a pen when "the precision of typographic forms has entered directly into the conception of his books. One might suppose that new systems with more variable typefaces might then be needed."

Such "new systems" are, of course, ubiquitous today in the form of software for word processing and desktop publishing. These tools have altered the tasks of graphic designers, enlarging their powers as well as burdening them with more kinds of work to do. Such is the rub of de-specialization. Benjamin celebrated the proletarian ring of the word "production," and the word carries those connotations forward into the current period. Within the professional context of graphic design, "production" is linked to the preparation of "artwork" for mechanical reproduction, rather than to the intellectual realm of "design." Production belongs to the physical activity of the base, the factory floor: it is the traditional domain of the paste-up artist, the stripper, the letterer, the typesetter. The "desktop" revolution that began in the mid-1980s brought these roles back into the process of design. The proletarianization of design offers designers a new crack at materialism, a chance to reengage the physical aspects of our work. Whereas the term "author," like "designer," suggests the cerebral workings of the mind, production privileges the activity of the body. Production is rooted in the material world. It values things over ideas, making over imagining, practice over theory.

When Benjamin called for authors to become producers, he did not mean for them to become factory workers alienated from the form and purpose of the manufactured thing. The challenge for designers today is to help become the masters, not the slaves, of technology. There exist opportunities to seize control—intellectually and economically—of the means of production, and to share that control with the reading public, empowering them to become producers as well as consumers of meaning. As Benjamin phrased it in 1934, the goal is to turn "readers or spectators into collaborators." His words resonate in current models of practice that view the reader as a participant in the construction of meaning. ⊠

Originally published in *The Education of a Graphic Designer*, ed. Steven Heller (New York: Allworth Press, 1998), 159–162.

2005
Fuck Content
Michael Rock

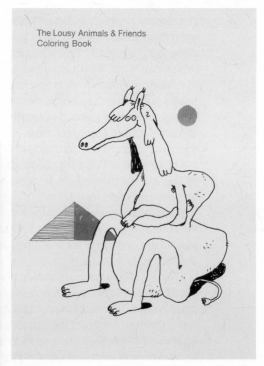

Stefan Marx, *The Lousy Animals & Friends Coloring Book*, 2010, designed by Urs Lehni
Courtesy Rollo Press

Bruno Munari among his children's books, circa 1951 Courtesy Corraini Edizioni

Bruno Munari, *Bruno Munari's ABC*,
©1960 by Bruno Munari. All rights
reserved. Maurizio Corraini Srl-Italy
Courtesy Corraini Edizioni

A good children's book with decent story and appropriate illustrations, modestly printed and produced, would not be such a success with parents, but children would like it a lot. —Bruno Munari, "Children's Books," *Design as Art*, 1966

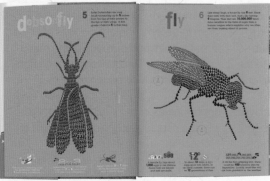

Sharon Werner and Sarah Forss, *Bugs by the Numbers*, 2011, Werner Design Werks, Inc.,
published by Blue Apple Books Courtesy the artists

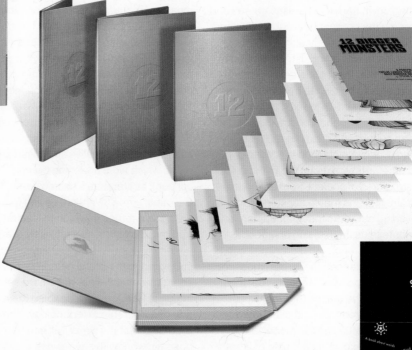

Stefan G. Bucher, *12 Bigger Monsters*, 2011 Courtesy the artist

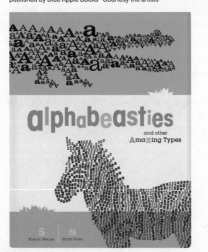

Sharon Werner and Sarah Forss, *Alphabeasties and Other
Amazing Types*, 2009, Werner Design Werks, Inc., published
by Blue Apple Books Courtesy the artists

Ann Rand and Paul Rand, *Sparkle and Spin:
A Book About Words*, ©2006 Ann Rand, Paul
Rand Courtesy Chronicle Books

In "Designer as Author" I argued that we are insecure about the value of our work. We envy artists and authors for their power, social position, and cachet, and we hope, by declaring ourselves "designer/authors," to garner similar respect. That deep-seated anxiety has motivated a movement in design, pushing us to value the origination over the manipulation of content.

"Designer as Author" was an attempt to recuperate the act of design itself as essentially linguistic—a vibrant, evocative language. I have found, however, that it has often been read as a call for designers to generate content; in effect, to become designers *and* authors, not designers *as* authors. While I am all for more authors, that was not quite the point I wanted to make.

The problem is one of content. I think the misconception is that without deep content, design is reduced to pure style, a bag of dubious tricks. In graphic circles, form-follows-function is reconfigured as form-follows-content. If content is the source of form, always preceding it and imbuing it with meaning, form without content (as if that is even possible) is some kind of empty shell.

The apotheosis of this notion, repeated *ad nauseam* (still!) is Beatrice Warde's famous Crystal Goblet metaphor, which asserted that design (the glass) should be a transparent vessel for content (the wine). Anyone who favored the ornate or the bejeweled was a knuckle-dragging oaf. Agitators on both sides of the ideological spectrum took up the debate: minimalists embraced it as a manifesto; maximalists decried it as aesthetic fascism. But both camps accepted the basic, implicit premise: it's all about the wine.

This false dichotomy has circulated for so long that we have started to believe it ourselves. It has become a central tenet of design education and the benchmark against which all design is judged. We seem to accept the fact that developing content is more essential than shaping it, that good content is the measure of good design.

Back when Paul Rand wrote, "There is no such thing as bad content, only bad form," I remember being intensely annoyed. I took it as an abdication of a designer's responsibility to meaning. Over time, I have come to read it differently: he was not defending hate speech or schlock or banality; he meant that the designer's purview is to shape, not to write. But that shaping itself was a profoundly affecting form. (Perhaps this is the reason that modern designers—Rand, Munari, Lionni, etc.—always seem to end their careers designing children's books. The children's

book is the purest venue of the designer/author because the content is negligible and the evocative potential is unlimited.)

So what else is new? This seems to be a rather mundane point, but for some reason we don't *really* believe it. We don't believe shaping is enough. So, to bring design out from under the thumb of content we must go one step further and observe that treatment is, in fact, a kind of text itself, as complex and referential as any traditional form of content.

A director can be the esteemed auteur of a film he didn't write, score, edit, or shoot. What makes a Hitchcock film a Hitchcock film is not the story but a consistency of style that winds intact through different technologies, plots, actors, and time periods like a substance of its own. Every film is about filmmaking. His great genius is that he is able to mold the form into his style in a genuinely unique and entertaining way. The meaning of his work is not in the story but in the storytelling.

Designers also trade in storytelling. The elements we must master are not the content narratives but the devices of the telling: typography, line, form, color, contrast, scale, weight, etc. We speak through our assignment, literally between the lines.

The span of graphic design is not a history of concepts but of forms. Form has evolved dramatically from one year to the next, and suggests a profession that continually revises and reshapes the world through the way it is rendered. Stellar examples of graphic design, design that changed the way we look at the world, are often found in the service of the most mundane content: an ad for ink, cigarettes, spark plugs, or machinery. Think of Piet Zwart's industrial work. Think of the posters by Cassandra or Matter or Crouwel. In these, form has an essential, even transformative, meaning.

Because of the limited nature of the designed object, individual objects are rarely substantial enough to contain fully rendered ideas. Therefore ideas develop over many projects spanning years. Form itself is indexical. We are intimately, physically connected to the work we produce, and so it is inevitable that our work bears our stamp. The choice of projects in each designer's oeuvre lays out a map of interests and proclivities. And the way those projects are parsed out, disassembled, reorganized, and rendered reveals a philosophy, an aesthetic position, an argument, and a critique.

This deep connection to making also positions the designer in a modulating role between a user and their world. By manipulating form, the designer reshapes that

essential relationship. In this way, form is replaced by exchange. The things we make negotiate a relationship over which we have a profound control.

The trick is to find ways to speak through *treatment*, via a whole range of rhetorical devices—from the written to the visual to the operational—in order to make those proclamations as poignant as possible, and to consistently revisit, reexamine, and re-express central themes. In this way we build a body of work, and from that body of work emerges a singular message. As a popular film critic once wrote, "A movie is not what it is about, it's how it is about it." Likewise, for us: our What is a How. Our content is, perpetually, Design itself. ⊠

2006
Research and Destroy: Graphic Design as Investigation
Daniel van der Velden

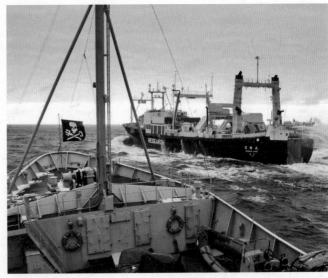

Sea Shepherd *M/Y Robert Hunter* trails Japanese whaling fleet's factory ship, the *Nisshin Maru*, in the Southern Ocean Whale Sanctuary off the coast of Antarctica, February 9, 2007 Photo: Sea Shepherd Conservation Society

Introductory Remarks to Research on Research III Symposium

The unpleasant picture shown here is important for a number of reasons. Ecological, environmental and ethical ones—yet just one of those reasons concerns us today. What are we looking at? In fact, the picture's taken from aboard one of the ships of an organization called Sea Shepherd. Sea Shepherd is a radical conservation society, founded by Paul Watson, a co-founder of Greenpeace. Sea Shepherd, contrary to Greenpeace, when it encounters a ship hunting for whales, it will warn once, and upon ignorance of that warning, will attempt to disable it. And that's what is about to happen here. This picture was taken while Sea Shepherd was pursuing a Japanese whaling fleet in the Southern Ocean. The targeted ship was the *Nisshin Maru*. It was the last remaining one of the so-called factory ships. These ships are used to process whales into canned meat while at sea. Now since commercial whaling is forbidden, the Japanese had tried to do something to prevent their mothership, the *Nisshin Maru*, from being targeted by the international treaties. They had painted a text on the ship's side. The text read: Research. Now I would wholeheartedly agree if you would claim that this is far from the ideal way to start today's symposium about graphic design. However, what I want to isolate from the case just outlined is the particular usage that the term "Research" is getting here. It is of course used as a sign or logo that lets the ship, its crew, and its fleet, be *exempt* from rules and laws that define commercial

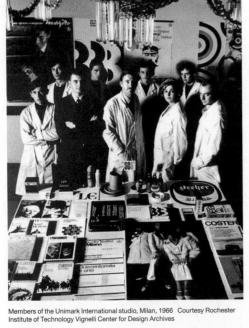

Members of the Unimark International studio, Milan, 1966 Courtesy Rochester Institute of Technology Vignelli Center for Design Archives

whaling as a punishable crime. It is a way to dissociate the ship and its crew from their true intentions. This is, I think, comparable and analogous to what is at risk of happening in art and design practices today. That risk is that we start naming them research practices while what's going on below the surface is business as usual. Not every practice is a research. On the other hand: not every research is a practice. If we want to describe how design practice at present *tends towards research*, or defines conditions for it, one way to start is by looking at what it is designers are doing, and how they bring their interests and their obsessions into the work they do, and how their working methods are changing, and how, in fact, all-embracing definitions of design practice are increasingly hard to draw. It is still quite normal to assume that actually, designers are pragmatists and all they want to do is solve problems. ¶ But under the

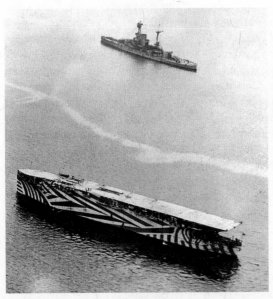

HMS *Argus*, with "razzle dazzle" warship camouflage, 1918

HMS *Mauretania*, with "razzle dazzle" warship camouflage, 1918

influence of the information revolution, graphic design is set adrift and has begun finding new mandates and possibilities: simply because the computer has brought typesetting into the designer's studio, and that computer has email in it and is connected to the internet, many different faculties of and in designers are potentially being activated and developed. ¶ For example, many graphic designers nowadays are writers and work extensively with forms of discourse and written exchange as part of shaping practice. The works they produce visually, as designers in the classical sense, cannot be seen independently from these writings. In that, they are not unlike some of their avant-garde predecessors from the modernist movements. ¶ Some designers have changed what used to be the common design practice of stealing from each other's work: they have started *referencing* their visual sources instead, which is indeed a meaningful departure from the implicit notion of competition and appropriation that underpin design as a fashion and trade. ¶ The agency of designers in other fields than their own craft, results in many designers being invited into their context with a clean sheet, no agenda, a *carte blanche*. ¶ Here, in a way, they can design their own role from scratch. Rather than being asked to serve a pre-defined objective, designers often become wildcards, chameleons, adaptively changing color by the minute. Solving a traditional design problem is just one out of many roles that the designer is performing simultaneously. ¶ One of the other consequences of our changing tools is that we can set up a studio now anywhere we want. There is no need to be contained within the four walls of an expensive metropolitan office space stuffed with Vitra chairs. ¶ Many examples of cutting edge design are now being produced by collectives and entities who are not studios in the classical sense, and who operate from the unlikeliest of places, often mobile, sometimes unglamorous, and even at times from remote natural resorts where life is still good and affordable. ¶ Other designers have started expanding their skills to formulate models and speculative scenarios. As such, they are bringing design thinking into areas off-limits to the strictly *productive* reach of what it is designers do, into a more *strategic* understanding of what design might become. They actively seek for an involvement in issues which are none of their business, in which they are introducing an outside perspective. ¶ We can say that a lot of conditions to speak of graphic design as research are in place. Writing, agency, authorship, mobility, post-studio field work, new collaborations, strategic and theoretical activities, are all transforming design into a knowledge-intensive multi-disciplinary discipline. ¶ But just like the commercial whaling Research shown here entails a risk, so does what I just briefly spoke about. The manifold positions which designers find themselves capable of occupying, eventually bring the risk that there's no time left to actually make work. We may become so incredibly smart that we will be left in between all our knowledge-intensive networking activities with nothing to show. ¶ Let this never happen. Do research. Make work. And let's talk about it. —Daniel van der Velden, Jan van Eyck Academie, 2007

Total Design studio portrait featuring Wim Crouwel (front left), 1982 ©Total Design Photo: Paul Huf/MAI Courtesy Unit Editions

"Since the production of services results in no material and durable good, we define the labor involved in this production as *immaterial labor*—that is, labor that produces an immaterial good, such as a service, a cultural product, knowledge, or communication."
—Toni Negri & Michael Hardt, *Empire*, 2000

Does your desire for Dior shoes, Comme des Garçons clothes, an Apple iPod, and a Nespresso machine come from need? Is design necessary? Is it credible when a designer starts talking about need, the moment he arrives home from a weekend of shopping in Paris? Can you survive without lifestyle magazines? Can you live without a fax machine that sends an SMS to the supplier whenever the toner needs replacing? Is it necessary to drive a car in which, for safety, nearly all the driver's bodily functions have been taken over by the computer—while the driver, at a cruising speed of 170 kilometres per hour, is lulled to sleep by the artificial atmosphere in his control cabin with tilting keyboard, gesture-driven navigation, television, and Internet service?

We no longer have any desire for design that is driven by need. Something less prestigious than a "designed" object can do the same thing for less money. The Porsche Cayenne brings you home, but any car will do the same thing, certainly less expensively and probably just as quickly. But who remembers the first book, the first table, the first house, the first airplane? All these inventions went through a prototype phase, to a more or less fully developed model, which subsequently became design. Invention and a design represent different stages of a technological development, but unfortunately, these concepts are being confused with one another. If the design is in fact the aesthetic refinement of an invention, then there is room for debate about what the "design problem" is. Many designers still use the term "problem-solving" as a non-defined description of their task. But what is the problem? Is it scientific? Is it social? Is it aesthetic? Is the problem the list of prerequisites? Or is the problem the fact that there is no problem?

Design is added value. En masse, designers throw themselves into desires instead of needs. There is nothing wrong with admitting as much. Konstantin Grcic, Rodolfo Dordoni, and Philippe Starck are found in *Wallpaper* boutiques, not in Aldi supermarkets. Unvaryingly, the poorest families—for they are always around—are still living with secondhand settees in grey, postwar neighborhoods, in a total absence of design. Orchestration of "third-world" design assembled for the cameras cannot escape the image of the world in poverty having to make do without the luxury gadgets that are so typical of contemporary design. The hope that some designers still cherish, of being commissioned to work from the perspective of objective need, is in vain. Design only generates longing. The problem is the problem of luxury.

Graphic design

There is one discipline in which, less than ever before, the definition of the problem and the solution are bound to a scientific, technical, or even just a factual state of affairs. That discipline is graphic design—or visual communications. Even Paul Mijksenaar cannot deny the fact that passengers still manage to find their flights in airports where he did not design the airport signposting. Meanwhile, the letter type that he developed for Amsterdam's Schiphol Airport is also the airport's logo. In graphic design, every "problem" is coloured by the desire for identity on the part of the client. They are the problems and the solutions of the game of rhetoric, expectations, and opinions. The graphic designer, therefore, has to be good at political maneuvering.

The effect of this depends, among other things, on his position in regard to his client. What has historically come to be referred to as "important graphic design" was often produced by designers whose clients considered them as equals. See, for example, Piet Zwart, Herbert Bayer, Paul Rand, Wim Crouwel, and Massimo Vignelli, all designers who worked for cultural organisations as well as for commercial enterprises.

Today, an "important graphic design" is one generated by the designer himself, a commentary in the margins of visual culture. Sometimes the design represents a generous client. More often, it is a completely isolated, individual act, for which the designer mobilized the facilities at his disposal, as Wim Crouwel once did with his studio. It always concerns designs that have removed themselves from the usual commission structure and its fixed role definitions. The designer does not solve the other person's problems, but becomes his own author. [1]

As a parallel to this, innovating designers pull away from the world of companies and corporations, logos and house styles. Their place is taken over by communications managers, marketing experts and, for some ten years now, design managers, engaged on behalf of the client to direct the design process. The design manager does what the designers also want to do—determine the overall line. In contrast to the "total design" of the past, there is now the dispirited mandate of the "look and feel"— a term that catches designers in the web of endless manipulating of the dimensions of form, colour, and feeling.

It is not so strange that a branch of graphic design has evolved that no longer hangs around waiting for an assignment, but instead takes action on its own accord. It has polarized into the "willing to work," who often have little or no control over their own positions, and the "out of work," who, with little economic support beyond re-channelled subsidies or grants, work on innovation for the sake of innovation.

Designing as factory work

In the *NRC Handelsblad* newspaper, Annette Nijs, cultural spokesperson for the VVD (People's Party for Freedom and Democracy), wrote, "We are making a turn, away from the assembly line to the laboratory and the design studios, from the working class to the creative class (estimates vary from 30% to 45% of the professional population)." [2]

According to a study by the TNO, the Netherlands Organization for Applied Scientific Research, the major portion of economic worth derived from design (about € 2.6 billion in 2001) is from visual communications. [3] Can a designer, if he is in fact seen by the VVD politician as the successor to the factory worker, still encompass the strategic distinction that Alvin Lustig, Milton Glaser, Gert Dumbar, Peter Saville, and Paula Scher made in the meeting rooms of their respective clients? Is a designer someone who thinks up ideas, designs, produces, and sells, or someone who holds a mouse and drags objects across a computer screen?

If designers are labourers, then their labour can be purchased at the lowest possible price. The real designer then becomes his own client. Emancipation works two ways. Why should designers have the arrogance to call themselves author, editor in chief, client, and initiator, if the client is not allowed to do the same? Only the price remains to be settled, and that happens wherever it is at its lowest. Parallel developments here find their logical end: the retreat of the innovative designer away from corporate culture and the client's increasing control over the design.

Designing and negativity

In recent years, the graphic designer has shown himself as—what has he not shown himself to be? Artist, editor, author, initiator, skillful rhetorician, architect.... [4] The designer is his own client, who, like Narcissus, admires himself in the mirror of the design books and magazines, but he

is also the designer who does things besides designing, and consequently further advances his profession.

The ambition of the designer always leads beyond his discipline and his official mandate, without this above-and-beyond having a diploma or even a name of its own. Still, it is remarkable that design, as an intrinsic activity, as an objective in itself, enjoys far less respect than the combination of design and one or more other specialisms. A pioneering designer does more than just design—and it is precisely this that gives design meaning. Willem Sandberg was a graphic designer, but he was also the director of the Amsterdam Stedelijk Museum (for which he did his most famous work, in the combined role of designer and his own client). Wim Crouwel was a graphic designer, but also a model, a politician, stylist, and later, also a museum director.

Is the title of "designer" so specific that every escape from it becomes world headlines? No, it is not that. The title is not even regulated: anyone can call himself a designer. It is something else. The title of "designer" is not specifically defined, but negatively defined. The title of designer exists by way of what it excludes.

Designers have an enormous vocabulary at their disposal, all to describe what they are not, what they do not do, and what they cannot do. Beatrice Warde, who worked in-house for the Monotype Corporation when she wrote her famous epistle, "The Crystal Goblet," impressed on designers the fact that their work is not art, even though today it is exhibited in almost every museum. [5] Many a designer's tale for a client or the public begins with a description of what has not been made. In the Dutch design magazine *Items*, critic Ewan Lentjes wrote that designers are not thinkers, even though their primary task is thorough reflection on the work they do. [6] Making art without making art, doing by not doing, contemplating without thinking: *less is more in die Beschränkung zeigt sich der Meister; kill your darlings*. Add to this, the long-term obsession with invisibility and absence. Sometimes it is self-censorship, sometimes disinterest, but it is always negative. The cause is undoubtedly deference or modesty. Designers often consider themselves very noble in their through-thick-and-thin work ethic, their noblesse oblige.

Graphic design is still not developing a vocabulary, and hence has not begun developing an itinerary to deepen a profession that has indeed now been around for a while. This became very clear in October of 2005, when the book presentation for *Dutch Resource* took place in Paris, at an evening devoted to Dutch design, organized by the Werkplaats Typografie in Arnhem, who published the book. The French designers who attended praised "typography at this level," as though it were an exhibition of flower arrangements, whereas the entire textual content of the book had been compiled by the designers at Werkplaats Typografie, and there was more to speak about than just the beautiful letter type. At the presentation, it was this search for depth and substance for which there was no interest and most of all, no vocabulary. One attending master among the Parisian designers, who rose to fame in the 1970s and 1980s, did not have a good word to say about the design climate and the ever-increasing commercialization. He dismissed out of hand a suggestion that this could be referred to as a "European" situation. Although commercialization is a worldwide phenomenon, for him, the fight against it was specifically French.

Design as knowledge

Despite the interesting depth in graphic design, its vocabulary is made up of negative terms. This frequently turns meetings of more than three practitioners of this noble profession into soporific testimonies of professional frustration. The dialectic between client and designer, the tension between giving and taking and negotiating is threatened with extinction, because both designer and client avoid the confrontation. The former becomes an autonomous genius and the latter an autocratic "initiator" for freelancers offering their services. We have already talked about need. Instead of giving the wrong answers, design should instead begin asking interesting questions.

In the future, design might have to assume the role of "developer" if it wants to be taken seriously. The Netherlands still enjoys a grants system. Internationally, things are not so rosy. Denying this fact would be the same as saying, "I have enough money, so poverty does not exist." The market conditions that are beginning to seep into the Netherlands, France, and the rest of Europe are already the norm for the rest of the world.

Consequently, the knowledge economy—the competitive advantage, according to Annette Nijs, the VVD politician—will quickly become a thing of the past, if holding a mouse proves cheaper in Beijing than in the west of Holland. The true investment is the investment in design itself, as a discipline that conducts research and generates knowledge—knowledge that makes it possible to seriously participate in discussions that are not about design. Let this be knowledge that no one has asked for, in which the designer is without the handhold of an assignment, a framework of conditions, his deference, without anyone to pat him on the shoulder or upbraid him. Let the designer take on the debate with the institutions, the brand names or the political parties, without it all being about getting the job or having the job fail. Let designers do some serious reading and writing of their own. Let designers offer the surplus value, the uselessness and the authorship of their profession to the world, to politics, to society.

But do not let designers just become walking encyclopaedias, adorned with such titles as "master," "doctor," or "professor," their qualifications dependent on a framed certificate hanging on the wall. Let there be a design practice in which the hypothesis—the proposal—has higher esteem than need and justification.

In 1972, for the catalogue for the exhibition *Italy: The New Domestic Landscape* at the Museum of Modern Art in New York, Emilio Ambasz wrote about two contradictory directions in architecture: "The first attitude involves a commitment to design as a problem-solving activity, capable of formulating, in physical terms, solutions to problems encountered in the natural and socio-cultural milieu. The opposite attitude, which we may call one of counter-design, chooses instead to emphasize the need for a renewal of philosophical discourse and for social and political involvement as a way of bringing about structural changes in our society." [7]

With the removal of need and the commissioned assignment as an inseparable duo, the door is open to new paths. The designer must use this freedom, for once, not to design something else, but to redesign himself. ⊠

Originally published in *Metropolis M* 2, April/May 2006.

Notes
1. See also Camiel van Winkel, *Het primaat van de zichtbaarheid* (Rotterdam: NAi Publishers, 2005), 177.
2. *NRC Handelsblad*, 9 February 2006.
3. The TNO report, *Vormgeving in de Creatieve Economie*, January 2005, can be found at www .premsela.org.
4. From the jury report for the 2003 Rotterdam Design Award: "More or less all the positions that designers have taken in recent years have passed revue: the designer as artist, the designer as technocrat, the designer as editor, as director, as a servant for the public cause, as comedian, as critic and as theorist."
5. Beatrice Warde, "The Crystal Goblet or Printing Should Be Invisible," in *The Crystal Goblet, Sixteen Essays on Typography* (Cleveland: World Publishing Company, 1956).
6. Ewan Lentjes, "Ontwerpers zijn geen denkers," in *Items* 6, 2003.
7. Peter Lang, "Superstudio's Last Stand, 1972–1978," in *Superstudio: The Middelburg Lectures*, ed. Valentijn Byvanck (Middelburg, the Netherlands: Zeeuws Museum, 2005), 46.

2011
Unraveling
Lorraine Wild

Desktop Publishing

This term was meant to describe the use of page layout software and personal computers to print and format documents. As designer and educator William Bevington once pointed out, the phrase "desktop publishing" is a deceitful misnomer: the equipment doesn't really fit on your "desktop" (unless your desk is the size of station wagon), and the outcome isn't really "publishing" (a process that includes distribution as well as design and manufacturing). In the 1980s, this term struck fear into the hearts of designers and art directors, many of whom worried that amateurs and office workers equipped with PCs and Times New Roman would swallow up their jobs. By the early 1990s, graphic designers had become desktop publishers themselves, absorbing numerous phases of technical production into their own workflows. —EL

John Cage, *Fontana Mix*, 1958 (detail) Edition Peters 6712 ©1960 Henmar Press Image © John Cage Trust

Fontana Mix

This 1958 composition by John Cage is of indeterminate duration and performance. Employing random processes, the score consists of twelve transparencies and ten sheets of paper. The paper pages are imprinted with curved lines drawn in varying thickness, whereas the transparencies contain a random distribution of dots. (One of the transparencies has a grid, while the final one contains a single straight line.) By overlaying the pages with transparencies in various ways, the performer creates a unique score. The *Fontana Mix*, which is named after Cage's landlady in Milan, may be performed with or without parts written for the *Concert for Piano and Orchestra*, *Aria*, *Solo for Voice 2*, and/or *Song Books*. —EL See *John Cage Database*, www.johncage.info

Defining the Decorational

I suspect it is time to move the computer past the "machine age," derail the persistent perception that it should only reproduce form languages originally invented for another techno-logic…. The decorational dares the attempt to be true to now. It honors many meanings in many forms; honors histories and contemporary currents, communal and technological invention. The decorational intends to engage the discourse of ornament with that of rational design. The decorational finds pride in craft, joy in materials (Our material is digital! Our digital is material!). The aim is not nostalgia, nor pastiche nor irony, but to reflect and be the complexity of our time (which could be nostalgic! ironic!). —Denise Gonzales Crisp, "Toward a Definition of the Decorational," 2003

Rudy VanderLans, *Emigre No. 70*, the Look Back Issue, 2009 Courtesy Emigre, Inc.

Emigre Magazine

Emigre magazine was published between 1984 and 2005 on a mostly quarterly basis with a total of sixty-nine issues. Issue 70 is a compilation of material drawn from previous issues and produced in a book format and copublished with Princeton Architectural Press. Created by Rudy VanderLans, himself an emigrant from the Netherlands to the United States, *Emigre* magazine was the most influential graphic design magazine of the period. *Emigre* covered emerging graphic designers and typographers seldom profiled in typical industry publications. It showcased experimental layout strategies by VanderLans and numerous guest designers as well as the digital font designs of his wife and business partner, Zuzana Licko, and other type designers, propelling the independent font movement. It also published spirited design criticism in its pages—finding itself to be both the message and the messenger of many debates. —AB

Josef Müller-Brockmann, *The Graphic Artist and his Design Problems*, 1961 Courtesy Verlag Niggli AG

"Design with an explicit interest in ways of working; in method; in method as form itself." —Stuart Bailey [1]

In an essay I wrote thirteen years ago titled "The Macramé of Resistance," [2] I called for a renewed recognition of the value of craft in graphic design as counterbalance to the then prevailing notion that graphic design was to be reframed as driven predominantly by research. An attitude expressed in graphic design magazines, and in various conferences at that time had developed that basically said that graphic designers who focused on expressing ideas through the visual side of their work were going to be relegated (downgraded?) to the implementation and styling of ideas developed by an (implicitly) higher order of designers, who called themselves things like "information architects" or "brand architects." This bias against the traditionally defined graphic designer (the designer who was hired to come up with *visual* ideas) placed a higher value on work that was derived from language-based, analytical, conceptual, methodological, testable ways of framing and approaching problems. From that point on, problems were deemed to be too complex and beyond the scope of the kind of communications that conventional graphic design, even at its most beautiful and sophisticated, even at its most modernist and disciplined, had ever been called upon to solve.

As several others have observed, by the mid-1990s the entire panoply of digitization pointed at editorial, imaging, design, and printing processes had been reinvented, and radically democratized the tools of design, so that anyone could jump in and make things that up until that point had been the territory of the trained (or of the trade). The same digital tools also compressed conceptualization, visualization, and production into the same beige plastic box: so while a more totalized control had been returned to the designer, at every phase of production, the designer was now saddled with the minutiae of production, emphasizing the "service provider" aspect of practice in a way that made some parts of graphic design seem newly monotonous.

One could generalize that the designers who were proclaiming that graphic design should be defined as "conceptual" were slightly older, running offices, and less adept at the digital tools now required to produce the visual (a task that could be delegated to the computer-literate kids that the office had just hired). One could imagine that the surge of interest in graphic design history and theory that began to percolate in the 1970s and 1980s, not only mirrored the then-contemporary obsession with critical theory in other disciplines, but also gained special energy in design as the practice itself was being turned inside out. History and theory (in graphic design) offered another way to transcend the "trade" or "commercial art" aspect of design. Graphic design could lay claim to a new, more reified cultural significance; smarter, more informed graphic designers would be able to bring invention and creativity to their typography, along with an understanding of why they were doing it, and in what contexts—historical and contemporary, social and cultural—they were operating. The ability to use this information to communicate to both the client and the audience would be what distinguished the professional, degree-laden graphic designer from a mere workaday user of desktop publishing systems.

When the history of the graphic design of this period is written (and this publication points to the onset of this looking back at that not-so-distant past), there is no doubt that one of the terms that will pop up for discussion is the "designer's voice" (or, in another version, the "designer as author"). There's a literature and argument around these terms too complex to outline completely, but by the late 1990s, the designer's voice laid claim to visual authorship—the insistence that graphic designers, through their forms, created content—and contributed to the culture of communication to the audience at large; and that the designer could and should develop an individual signature to their work. This could be a methodological "signature"—a consistent approach to the problem at hand—or, more commonly, a formal signature for one's own work that stamped it with a particular visual originality, not unlike an artist's individual style. Though "the designers' voice" was a relatively new term (which probably can be traced to the "crit rooms" of many MFA programs), deep down it signified an allegiance to the traditional graphic designer's role, of the designer as a maker of meaning through work that expressed itself through form. Design history, which often focuses on the form of the artifact, only increased the sense of value attached to form. To the designer's voice camp, the information architects and brand managers seemed to be trading in some sort of murky verbiage that was uninteresting (other than the fact that they had figured out how to invoice for it at much higher rates, just when the democratization of design was putting downward pressure on conventional design fees).

When I wrote "The Macramé of Resistance," I was, in fact, already bothered by the solipsism inherent in graphic designers' pursuit of their own voices (*and* the "two camps" scenario flaunted by the research-oriented). Designers' voices had been making themselves heard mostly through rampant typographic experimentation that regarded things like legibility and logic as issues that had already been covered in favor of a free-floating experimentation with word and image. It is critical to note that these experiments had their beginnings largely in academic settings, informed by contemporary semiotic and structuralist theory. Those experiments *were* a critical step in broadening the visual possibilities and being more responsive to the instability and subtlety of actual communication (something ignored by standard modernist typography). But just like everything else, the look of that typographic experimentation entered the inevitable style-cycle, and became the look of many youth-oriented magazines and marketing campaigns. So what had began as a deep engagement of typography with language devolved into a set of ubiquitous clichés, which paradoxically seemed to signify the impossibility of communication!

In "Macramé," I observed that there was a new energy around understanding and developing one's craft in typography, composition, and color beyond the repetition of the baroque experiments of the early 1990s. The new contexts that we worked in (rather than trying to nostalgically re-create the past) would produce an environment in which graphic design could continue to operate as an intelligent, culturally viable communicative medium that the audience and even clients could actually see and appreciate. I was really only interested in the designer's voice if it had something to say and the rest of us could see (and read) it: I felt that the way to get there was to go beyond the repetition of the same visual chaos that had come to signify "voice," and direct the designer's energy toward heightened capabilities of visual expression. That I cited the work of several eccentric designers as critical examples was my vote in favor of work that did not pose one particular formal solution over all others, but which in fact would reflect personal interpretations turned *outward* to the audience.

However, the designer's voice lingers and has become code for the desire on the part of young designers to define their own problems. The reasons for this are complex and I acknowledge my own context of working with young designers within the

"hothouse" of an MFA program inside an art school). But to this day, the model of the *artist* stands for "freedom from the man." In the same issue of *Emigre* that contained "Macramé" appeared Stuart Bailey's essay "Chance," which described a designer afloat in the world of trying to interpret random phenomena, besotted with the work of John Cage and of creating rules and "operations" to be manipulated with a minimum of artistry or personal interpretation, to see where it could take him. [3] At one point Bailey describes his interest in an "intellectual rather than visual aesthetic," complaining that "conceptual" is a term to be avoided since he maintains that it is used to defend work that is "lowest common denominator design at its most sterile" (perhaps the only point where my essay and Bailey's agree). "Chance" describes a set of conversations that Bailey has with mostly Dutch and British contemporaries who are rejecting the typographic experimentation of the time as being too ego-driven, "inappropriate and unnecessary graphic noise." Bailey's essay also marks an early reference to "default"—the idea that the graphic designers' creativity was going to be concentrated on the deployment of a system or methods of operations, logic, or chance-based: the composition ordinary, the typography limited to the same fonts that anyone with a computer would be able to access, signifying an indifference to or distaste for the expression or communication afforded by a more considered or artful typography. While the default camp decried the self-indulgence of indecipherable typographic experimentation, the austere formal flatness of Default was hardly an exercise in generosity toward an audience, either.

The irony here is that both the *decadence* of the Designer's Voice and the *deadpan* of Default are variants of the same thing, where the "Designer and his Problems" (to quote Joseph Müller-Brockmann) still occupy the foreground, and are thought to be more interesting than anything that graphic design might actually be applied to. From our current perspective, this debate might seem like a pre-2008 academic luxury: yet something interesting has emerged from the excesses of both camps, as the context in which we all work has morphed yet again. The attention to craft (and expanded technologies) in font design has brought about an explosion of interesting typographic work for print and the array of digital formats, and the accessibility of that array has become too big to ignore. You can trace the Default camp's fascination with "ways of working" in the contemporary interest of young designers in the utilization of various platforms and tools to reach audiences, and the engagement of the designer with users to deal directly with the definition of problems and the democratization of tools. The obsessions of the Designer's Voice camp are there to be seen in the enthusiasm for individual production, DIY methods, design that starts with one's own fonts, low-tech printing, and the shift toward self-publishing.

When you join both camps together, you can see the DNA of where things are now, with designers creating work as producers: where the past is informative; theory is after the fact; and the question as to whether design can be art is no longer interesting, but where the independence of design practice is assumed to be a given. When you put all this together with the now common desire on the part of so many designers to produce work that is engaged, in one way or another, with social relevance, it does seem that we are faced with evidence of a possible renaissance in graphic design pointed at an audience (or many, many audiences) in which imagination and creativity are applied not only to the language of style, but also to the generation of projects themselves, how they live in the world, how they reach out, and which purposes they serve.

Whether due to the bleak economy, or their commitment to independence, many young designers do not imagine that there are opportunities for this new integration out there, waiting for them; I think they imagine a mostly DIY future for themselves, and they may well be right. Time to shut up about the voice, or randomness: time to get to work bringing these new scenarios to life. Being the producer of one's own work in this moment is way more challenging than the triangulated arguments of the late 1990s could even imagine. The ante continues to be raised as to just how much the Designer's Brain will be called upon to handle. And as the scenarios and the productions become more complex and independent of models of the past, one needs to ask whether the thing we are still calling graphic design is an adequate description of what is being made these days. ⊠

Notes
1. Stuart Bailey, "Chance," *Emigre* 47 (Summer 1998): 24.
2. Lorraine Wild, "The Macramé of Resistance," *Emigre* 47 (Summer 1998): 15–23.
3. Bailey, "Chance," 24–31.

2011
Tool (Or, Post-production for the Graphic Designer)
Andrew Blauvelt

James Craig, *Production for the Graphic Designer*, 1974 Courtesy Random House

Hans Hollein, *ManTransFORMS*, 1976 (detail) Photo: Jerzy Survillo Courtesy Cooper-Hewitt, National Design Museum

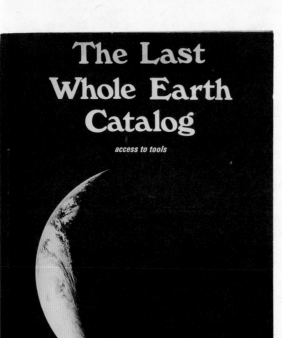

The Last Whole Earth Catalog: Access to Tools, 1971 ©Portola Institute

Why haven't we seen a photograph of the whole Earth yet ?

Stewart Brand, button from 1960s campaign for NASA to release a photo of Earth from space, 1966

Ed Fella, Skidmore Sahratian, Inc., moving announcement, circa 1975 Courtesy the artist

Image of a human fetus sent aboard *Voyager*, 1977

Photograph of Earth from the moon taken by *Apollo 8*, 1968

Fetal Photography

The April 30, 1965, issue of *Life* magazine contained a selection of ground-breaking images of the human fetus taken by Lennart Nilsson, a Swedish photographer and scientist. Nilsson had begun his experiments in extreme macro photography in the 1950s and by the 1960s had begun using a very wide angle lens and a tiny flash attached to the end of an endoscope. Taken about an inch away from his subject, this was the first image of a living embryo inside the mother's womb. The issue sold more than eight million copies in the first four days of its release. The accompanying photo essay contained images from Nilsson's book, *A Child Is Born* (1965), which were also included on the *Voyager* spacecrafts launched to explore the solar system in 1977. The mesmerizing and powerful effects of fetal photography ushered in by Nilsson's pioneering work would eventually form the cornerstone of the visual rhetoric of the anti-abortion campaign in American politics. As historian Maud Lavin points out in her essay "A Baby and a Coat Hanger: Visual Propaganda in the U.S. Abortion Debate": "As Rosalind Petchesky and others have argued, when viewers become familiar with seeing the fetus independent of the mother, they can more easily begin to consider fetal rights as if separable from maternal ones." —AB

Susan Kare, various icons designed for the Macintosh computer, circa 1984 Courtesy the artist

Mac Icons

Pioneering interface designer Susan Kare created the simple black-and-white icons that once greeted users of Apple Macintosh computers. Kare's classic trash can and smiling CPU, which appeared on the earliest Macs in the 1980s and remained part of Apple's legendary GUI for well over a decade, bring us such concise and poignant symbols as the wrist watch and the system-error bomb. Kare designed her first icons by coloring in squares on sheets of finely gridded graph paper. With the introduction of the Mac OS X operating system in 2001, Apple replaced Kare's minimal, flat symbol set with a glossy, jellybean aesthetic, exemplified by the candy-colored "pinwheel of death." Today, Mac users dissatisfied with their dock icons can make or find their own, using software such as CandyBar. —EL

In a recent lecture, Ed Fella references a collage he made earlier in his long and prolific career as both a self-proclaimed "commercial artist" and iconoclastic figure in the graphic design avant-garde. It shows various tools: a T-square, a compass, a bottle of ink, a cup of coffee, a burnisher, an ashtray—re-creating the work surface of a typical graphic designer, circa 1975. He deadpans to the audience: "The only thing left is the coffee." [1] Today, the typical desktop of the graphic designer is a virtual one invented for them in the famed confines of Xerox Park and Apple Computer: some folders, a ticking wristwatch, a trash can, and a bomb. Perhaps nothing better illustrates the transformation of a profession from handicraft to technocrat, from skilled labor to managed service, than this metaphorical transformation of a workspace.

What supposedly distinguishes humans from their primate ancestors is their ability not to use tools but to integrate them into everyday activities, find fresh uses for them, and to create new ones. This evolutionary sequence was famously immortalized on the silver screen in Stanley Kubrick's *2001: A Space Odyssey* (1968), which opens with a group of early apelike humans learning to use a bone as both a tool and a weapon. After they triumphantly defeat a rival group, the bone is tossed into the air and transforms into an orbital satellite, a scene set some four million years in the future. The film's main characters, Dave the astronaut, and HAL, his spaceship's computer, eventually play out another cautionary tale about technology, as the human triumphs over the machine only to discover even higher-level and functioning extraterrestrial life, setting the stage for humankind's next transformative evolution. Dave reborn as a kind of "star child" fetus gazes back upon the whole Earth—two spheres filling the screen, an amniotic sack and the proverbial big blue marble. (Of course, this creative vision would not have been possible without the invention of the tools for fetal photography at one extreme, and satellite imagery taken from planetary orbit at the other.)

Later in the same year as this epic film's release, counterculture guru Stewart Brand would publish the first edition of *The Whole Earth Catalog* (1968), aptly subtitled "access to tools." This sixty-four-page premier issue, which would eventually grow to more than four hundred pages, brandished a cover image of our entire planet taken from a satellite. This compendium of the latest ideas, best practices, low-cost technologies, and useful tools of its time was part lifestyle bible and part workaday reference manual. Its lofty objective stated: "We are as gods and might as well get good at it. So far remotely done power and glory—as via government, big business, formal education, church—has succeeded to the point where the gross defects obscure actual gain. In response to this dilemma and to these gains a realm of intimate, person power is developing—power of the individual to conduct his own education, find his own inspiration, shape his own environment, and share his adventure with whoever is interested." [2] *The Whole Earth Catalog* presaged the introduction of the ultimate tool, the personal computer, and the technological ethos of today's Internet culture that it would spawn: the world of self-publishing, user-generated and aggregated content, open source systems, distributive platforms such as app stores, and the networks and connectivity of social media, cloud computing, and file sharing. As Steve Jobs explained it to a graduating class at Stanford in 2005, "It was sort of like Google in paperback form, 35 years before Google came along." [3]

Human use of tools has been theorized as an explanation for human evolution stimulating such things as increased brain size coupled with the unique human ability to mimic behavior and thus spread ideas and techniques, which led to the rise of agriculture, the domestication of animals and, well, civilization itself. [4] The tool in effect transforms our material and virtual realities and, by doing so, it transforms us. Despite the grandiosity of the vision, the typical segregation one sees in the culture at large and in the design profession in particular, between hand skills and head skills—making and thinking—seems therefore both regretful and artificial. Nevertheless, this segregation of conception and production remains at the heart of much professional discourse and angst.

Graphic design was the first profession to be impacted by the introduction of the personal computer in the 1980s; its strategic objective was, after all, "desktop publishing." More precisely, it transformed and eventually eliminated the work of various production artists, photomechanical technicians, keyliners, paste-up artists, typesetters, color separators, and even some printers. It disrupted a field that has always had a rather confused and conflicted relationship between the spheres of creation and production, often separating conception from the labor and skill required to transform intentions and instructions into reproducible mass commodities. This separation reflected the divide created between the white-collar world of intellectual labor and the blue-collar world of manual labor—a division that continues to play itself out. However, what the personal computer took away from the workforce in jobs, it gave back to the graphic designer in ways both good and bad by increasing the ease and speed of visualizing ideas while simultaneously shortening the expected turnaround time of projects. The computer's efficiency exponentially increased both the number of variations designers thought possible and the amount of changes clients deemed necessary. Its synthesis of formerly discrete functions in the process of designing promised designers a return to control over the craft and execution of work without properly preparing them for the types of skills that were formerly outsourced.

Optimistic by nature and eschewing initial angst, graphic designers embraced the computer as just another tool on their creative workbench rather than as a replacement for them or their colleagues in the production process. Writing in 1998, about a decade after the personal computer was introduced in graphic design, Lorraine Wild would note the paradox of the situation at hand: "… many designers believe that our futures depend on our ability to deliver conceptual solutions; but, ironically, digital technology has driven production back into the office, requiring constant attention. Design practice today requires the intellectual power of a think tank and the turnaround capacity of a quickie-printer." [5]

Of course, this new tool was made not just for designers, but targeted at a general audience. Graphic design had emerged as a professional service similar to fields such as industrial design and architecture by relying on a cadre of skilled technicians and industries to realize its products. The sudden open access to the tools of producing graphic design meant that the traditional gatekeeping function of the profession was eroded and would eventually be circumvented. On the upside was demystification: not only did lay people such as your mother know what a font was, but general awareness of the activity of designing also increased, thereby fueling broader interest and producing more designers. This, in turn, produced a corresponding downside for the profession, which experienced increased competition, cheaper wages, a flood of amateur work, and an erosion of craft. Perhaps the most ominous effect for designers was the recasting of graphic design as just another tool.

Of course, the computer is not just another tool, nor is it simply a combina-

tion of discrete tools, a kind of digital Swiss army knife. Rather, the computer is a meta-tool: it makes other tools. Or as Jonathan Puckey, creator of tools such as Text Pencil and the online dictionary for the Stedelijk Museum Bureau Amsterdam (SMBA) states: "Instead of collectively agreeing to the same streamlined tools sold to us by large software companies, we need to reclaim the personal relationship we used to have with our tools. We need to reintroduce interesting points of friction in our highly optimized software. We must learn to create tools ourselves. After all, the computer is exactly that: a tool for creating tools." [6]

A new generation of designers is doing precisely this. For instance, Jürg Lehni wrote Scriptographer, a program that translates digital vectors to more analog devices such as Hektor, a robot-operated spray-paint device; Empty Words, a machine for making die-cut message posters; or Viktor, a chalk-drawing machine. Casey Reas and Ben Fry created Processing, an open source programming language that many other designers have used to create visualizations. Nicholas Felton and Ryan Case's app Daytum, which can help track personal data, was originally created for use in his personal Annual Report projects. These examples point to a new phase of maturation for design's relationship to technology, when the definition of design extends to the creation of new tools that enable and empower others to design.

Ever since the demise of the medieval craft guild, modern design had sought to separate itself from one-off hand production in favor of mass-produced objects that bore few traces of the hand and more of the machine, the new laborer. Freed from production, the modern designer had to devise methods so that his intentions could be faithfully realized by others. Drawings, pasted-up layouts, instructional overlays, coordinated color systems, standardized ink formulation and paper sizes, prototypes, models, and reprographic proofs were just some of the instruments invented to ensure that the faithfulness of a designer's vision was executed according to plan. The separation of conception and planning from making and production were therefore part and parcel of being a modern designer. Craft, as such, did not disappear. It remained with acts of manual fabrication and was called precision in the case of machine production. For the designer, the values of craft were personally embodied in the acts of designing—all the processes and techniques necessary to envision and produce executable plans: drawing, rendering, making comps (a collage of materials used to simulate a printed piece) and mechanicals (a layout of type and images that was photographed for reproduction). Knowledge about production was a necessary part of any design education, gained in the classroom through books such as James Craig's 1974 classic Production for the Graphic Designer, or in the workplace, whether it was how something was printed or bound in the case of graphic design, or manufactured and engineered in the case of products.

Wild's aforementioned essay offered another definition of craft for graphic designers, one positioned against the prevailing wisdom of the marketplace and the winds of technological change sweeping through the profession in the 1990s. Her essay was not a nostalgic impulse to save graphic design; rather, it articulated the value of craft as integral, tacit knowledge, the type gained through direct experience and know-how, just as valid as theoretical knowledge, which is more distanced and descriptive. She quotes Malcolm McCullogh from his book Abstracting Craft: "The meaning of our work is connected to how it is made, not just 'concepted.'" [7] For Wild, the ultimate value of craft is tied to how we view the work of graphic designers over many years and across disparate projects. It is the connective thread that makes sense of so much labor and identifies that body of work with a particular person: "When craft is put into the framework of graphic design, this might constitute what is meant by the 'designer's voice'—that part of design that is not industriously addressing the ulterior motives of a project, but instead follows the inner agenda of the designer's craft. This guides the 'body of work' of a designer over and beyond the particular goal of each project. So craft is about tactics and concepts, seeking opportunities in the gaps of what is known, rather than trying to organize everything in a unifying theory." [8] While Wild's definition of craft made sense for graphic designers, it was not enough to halt the juggernaut of self-doubt that plagued the profession, which wasn't so worried about the loss of craft as much as the perceived devaluation of their skill.

After all, if what you used to produce could be done by anyone with a computer, what does anyone need a designer for? Or, in business-speak: as a designer, what's your value-added? The natural instinct for self-preservation on the part of graphic designers required a new story about the value of design. Since the immediate impression was that the computer simply devalued traditional skills, the answer was to be found not in production, but in the realm of conception. This path was chosen despite the fact that the computer could not immediately demystify the more intangible aspects of design work: the craft of typography, the form-making skills honed in years of education and practice, the passion and devotion to an activity that many likened to an artistic pursuit, or the problem-solving skills, communication strategies, and ideation techniques learned typically through experience. Despite these important distinctions between novices and professionals, the field pursued a trajectory that emphasized its more verbal (as opposed to visual) and businesslike (rather than artistlike) attributes.

Entire new sectors emerged devoted to left-brain pursuits such as design management, design strategy and innovation for business, and the design of services and systems, including consumer experiences, whether in bricks and mortar spaces or online. What these kinds of practices share is a belief in the power of ideas, words, and research to shape design, one that recasts design's productive labor as a primarily conceptual and managerial activity. Sometimes inadvertently, and occasionally purposefully, this pursuit devalues the formal, the visual, and the material aspects of design as it shuns what it considers the more decorative, trendy, and superficial characteristics associated with design. If only they had taken a page from critic Virginia Postrel, who argues for the virtues and importance of aesthetics, style, and surface in an age dominated by the visual: "This new era challenges all of us—designers, engineers, business executives, and the public at large—to think differently about the relation between surface and substance, aesthetics and value. Designers have long lived in fear that people will think that they're frivolous, treating their work as 'pretty but dumb,' denigrating their hard-won expertise, and putting them first in line for budget cuts. Nearly every definition of design starts emphatically by stating that the profession isn't just about surfaces." [9] But of course, graphic designers are in fact producers of surfaces, millions of them. This production is so vast that it is comparable to the built environment, as Metahaven notes: "The production of surface is design's equivalent to the production of space." [10]

Perhaps ironically, just as graphic designers were making their way out of the wilderness of "dumb" form to a higher conceptual plane, many other people—amateurs, lay people, and younger

Above and right: Jürg Lehni and Alex Rich, installation view of *Empty Words* and posters, Kunst Halle Sankt Gallen, 2008, furniture by Martino Gamper Courtesy the artists

Jürg Lehni and Uli Franke, creators of *Hektor*, executing a wall drawing for Cornel Windlin's contribution to the exhibition *Public Affairs*, Kunsthalle Zürich, 2002 Courtesy Jürg Lehni

Scriptographer

Graphic designers typically employ a standard suite of software products. Jürg Lehni's Scriptographer is a JavaScript plug-in that extends the prepackaged features of Adobe Illustrator with functions both useful and unusual. Lehni's website, Scriptographer.org, is a place for sharing and downloading new scripts. Contributed by an international community of designers, Scriptographer's mouse-controlled tools range from a Lorem ipsum generator to aMaze, which automatically fills a given space with a perfect maze, complete with entrance and exit. In his own work, Lehni employs Scriptographer to drive a variety of mechanical drawing machines, from *Hektor*, a spray-paint device, to *Empty Words*, which produces die-cut posters. —EL

2x4, wallpaper installation design for the Prada Epicenter Store, SoHo, New York, 2010
Courtesy the artists

Prada Wallpaper

The design consultancy 2x4 has collaborated with the Italian fashion house Prada on the design of store graphics, websites, books, exhibitions, and more. 2x4 began creating temporary wallpaper installations for Prada's New York flagship store in 2001. Covering a wall 200 feet long, the wallpapers have adorned Prada's SoHo epicenter with themes ranging from pornography and guilt to the museum as mass media. 2x4 has also created wallpapers for Prada's Los Angeles store and other locations worldwide. —EL

Jürg Lehni and Alex Rich, *Things to Say* installation featuring *Viktor*, Kunsthalle St. Gallen, 2009, produced with Defekt GmbH, with support of Swiss Federal Office of Culture and Migros Courtesy the artists

designers—were discovering a renewed passion for making, largely through hand processes and occasionally in reaction to digital technologies. This is the do-it-yourself entrepreneurial culture that has found a way to seize both the means of production and the systems of distribution, whose immense inventory can be found on websites such as Etsy, Threadless, and Supermarket, or bought, traded, and shared at gatherings such as Flatstock or the NY Art Book Fair. A "handmade nation" is seen in the resurgent popularity of more hands-on printing techniques such as letterpress and silkscreen, but is equally present in the general cultural renaissance of artisanal endeavors of all sorts, whether it be fashioning classic cocktails, cultivating heirloom vegetables, butchering and curing your own meats, or the impassioned fringe production of guerrilla gardening and urban knitting. [11]

Where an older generation of designers used to worry about transforming professional (i.e., conventional) practice to accommodate their work or fret about how to reach a more sympathetic audience for their wares, today's designers simply produce now and ask questions later. It is symptomatic of a younger generation of graphic designers who have in essence created a market largely by themselves and targeted to people like them. This torrent of production is accessible and circulated around the Internet on various sites, the names of which give some indication of both the sense of discovery and the seemingly ad hoc nature of the hunt: Tumblr, StumbleUpon, Flickr, VVork, Ffffound!, Behance, ManyStuff. This is the twenty-first-century version of show-and-tell, or more appropriately, make-and-post—a visual, self-perpetuating archive of millennial portfolio culture. [12]

The atmosphere and tone of these sites and the work on them is quite different than it was in decades past. Gone is the air of skepticism, criticism, and even pessimism of the 1990s. In its place is a newfound optimism, the ecstasy of production. As Experimental Jetset notes: "It's almost a punk/DIY explosion of graphic design: bold geometric forms, bright colors, large sheets of printed paper, experiments in folding. People proudly displaying posters that they made, by simply holding them in the air. Work that is unapologetically graphic. When we look at all these young students, shaping their immediate environment in such a concrete, direct way, we feel really happy." [13] And who wouldn't? The attitude, like a smile, is infectious. But if I could channel my old '90s-era skeptical

self for a moment, I would note how most of this work circulates in a free-floating, contextless, post-critical space (or less charitably, I would use the word "vacuum" or "bubble"). The speed of information and the constant flow of new material and reactions to it create an intense feedback loop, like a call-and-response of graphic design. It isn't surprising then that so much of the work looks and feels of the same spirit. However, I wouldn't want to judge by past standards. Old-school concepts such as original, copy, and imitation make little sense in this new postproduction world. It isn't about what is trendy (forms) as much as what is trending (topics).

The old world of graphic design and production was, in effect, a preproduction enterprise. Design was everything before the reproduction of it: ideas made visible and intentions made transmittable. Today, for graphic designers, there is little debate or angst about this sphere of activity. Of course, designers are still expected to know about aspects of production, and many tasks are fully integrated into the layout and design software itself. Rather, the action lies elsewhere. On the one hand, we see the activity of an all-encompassing, self-sustaining concept in the renaissance figure of the designer-as-producer—the creator and maker and perhaps even the distributor of the work. [14] This activity still carries with it overtones of authorship, originality, and singularity. Its reference points are often premodern. On the other hand, we have the realm of postproduction, which is characterized by notions of coauthorship, reference, and collectivity.

As its name suggests, this is an aftermarket world of preexisting forms that are in effect remade by the designer who stands in the position of the user, which is to say as the recipient or consumer of an existing work. But unlike traditional ideas of consumption, the object of postproduction is no longer simply consumed or used up, but rather extended, remade, and transformed. In this way, postproduction adds value to the product, occasionally through new use value (recycling, upcycling, or downcycling of products, for instance), but it more often gains in symbolic value. Take, for example, a competition sponsored by Greenpeace UK to redesign BP's logo in the wake of the Gulf of Mexico oil spill. [15] Hundreds of people submitted new versions based on BP's official (award-winning) logo, and a kind of virtual tar and feathering of the corporation ensued. Approaching the project in the same way they would an official brand redesign, these designers needed to trade carefully and strategically on the so-called

brand equity of the original mark: too much transformation and the connection to the original mark would be lost; too little and it might go unnoticed. For the 2008 US presidential election, the campaign of Barack Obama employed a critically acclaimed logo that soon found its way to myriad reuses: hand-rendered on everything from yard signs and temporary tattoos to jack-o-lanterns and home-baked cookies. [16] This spread of unintentional usage is what ad industry types call "viral," a cultural meme that finds its way into the hearts and minds of consumers. It's a coveted strategy that money can't buy—literally.

The designer in the realm of postproduction is a producer or orchestrator of frameworks, systems, and actions that enable design to happen. The traditional role of the designer as the sole creator of a work has been displaced; usurped by "contributors," sometimes thousands of them. Take for instance three recent music video projects that employ crowdsourcing through the participation of numerous users who each contribute their part of the collective whole. Director Chris Milk and media artist Aaron Koblin collaborated on the creation of *The Johnny Cash Project* (2010), an online music video project set to the late musician's song "Ain't No Grave." Visitors to the site can contribute to the video, which is continuously updated, by drawing over randomly selected key frames. Users can also choose several options for viewing, such as the highest rated frames, a director's cut version of selected or curated images, or by style: realistic, abstract, etc. Both Milk and Koblin also collaborated on *The Wilderness Downtown* (2010), an online film for the band Arcade Fire. Exploiting the browser capabilities of Google Chrome, the project asks viewers to type in their childhood home address. Using Google Maps aerial and street views of the location, the video integrates this specific geographic information into the narrative of Arcade Fire's "We Used to Wait." Both projects emphasize not only the desire for personalization of content and customizable viewing options, but also the underlying capacity of collective creativity. Designers Jonathan Puckey and Roel Wouters have created a participatory interactive video for the band C-Mon & Kypski entitled *One Frame of Fame* (2010). Viewers can select frames of the video that accompany the song "More or Less," and using their webcams shoot a replacement frame and upload the result. More than 34,000 users have struck their pose, contributing a piece of themselves to the collective whole. The project's philosophical

Aaron Koblin and Chris Milk, *The Wilderness Downtown*, 2010, for Arcade Fire, featuring "We Used to Wait" Courtesy @RadicalMedia

Crowdsourcing

A method of generating intellectual property by throwing out a question, problem, or task to an undefined group of people and choosing among the responses that come in. Crowdsourcing can be an effective and inclusive way to tackle complex social and environmental problems, sidestepping the typical reliance on known networks of experts. Crowdsourcing is also a cheap way to generate intellectual property. The organizers of a crowdsourced endeavor benefit in several ways from this arrangement. In addition to acquiring low-cost content and ideas, they can use the interactive process to connect with their stakeholders, making participants feel personally involved with a brand or issue. The results of a crowdsourced endeavor form a body of market research, offering a snapshot of what a group of engaged people are thinking about a particular product, problem, or topic. Finally, a crowdsourced endeavor has the potential to tap into the so-called "wisdom of crowds," yielding insights and solutions arising from a distributed population with diverse experiences and viewpoints. Contributors to such endeavors can benefit from each of these outcomes as well, but they may also leave the experience feeling exploited, underpaid, and underutilized in a process that favors breadth over depth. —EL

Jonathan Puckey and Roel Wouters, *One Frame of Fame*, 2010, for C-Mon & Kypski
Courtesy the designers

Aaron Koblin and Chris Milk, *The Johnny Cash Project*, 2010 Courtesy @RadicalMedia

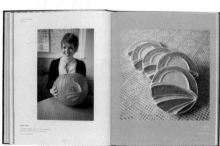

Scott Thomas, *Designing Obama*, 2009/2011 Courtesy the artist

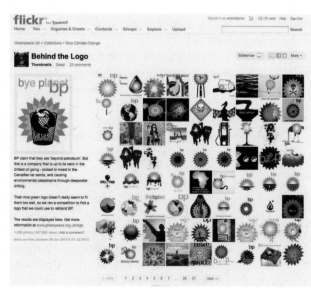

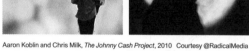

Various artists, "Behind the Logo" competition sponsored by Greenpeace UK, 2010

BP Logos After the Spill

The explosion of the Deepwater Horizon oil rig, operated by BP, in April 2010, led to eighty-seven days of oil spilling into the Gulf of Mexico, causing extreme damage to the coastlines, wildlife, economy, and population of Alabama, Florida, Louisiana, and Mississippi. BP's reputation was deeply damaged as well. Its logo—designed in 2000 by brand and identity consultancy Landor and quite celebrated at the time—became an icon that represented BP's environmental malfeasance, eliciting a flurry of satiric versions from people around the world. Greenpeace UK corralled most of these through a competition inviting everyone to design a new BP logo that "shows that the company is not 'beyond petroleum'" and a logo that is "more suitable for their dirty business." Over the course of one month, more than 1,900 submissions were posted on Flickr, offering everything from professionally designed to amateurishly composed satires. Execution didn't matter; volume and opinion did. And the now ironically sunny, leafy, green icon of BP and its acronym proved to be too good of a conduit for people's frustrations. The BP Helios, as the icon was originally nicknamed after the Greek God of Sun, will never be seen as it once was. —Armin Vit and Bryony Gomez-Palacio

gravity seems to exist somewhere between Jean-Luc Godard's claim that cinema is truth twenty-four times per second and Andy Warhol's prediction that everyone will be famous for fifteen minutes. In the aggregated, participatory, user-generated content world of Web 2.0, cinematic truth is not stranger than fiction, but ever more compressed slices of reality.

Another example is Experimental Jetset's influential Beatles T-shirt design with the words "John & Paul & Ringo & George" emblazoned on the front, which soon became so enticing and useful that it spawned variations running the gamut from knockoffs to homages to parodies. [17] In its broadest terms, the world of postproduction design can be stretched to encompass the design of otherwise preexisting but blank objects: tote bags, wallpaper, T-shirts, buttons, plates, posters, coffee cups, and so on. This is the projection of graphic design to every sort of surface. It is not by coincidence that these surfaces tend to be the commodity forms of design itself—available and handy formats, empty vessels waiting to be filled—affectionately known in the marketplace as "merch." It should be noted that (also unlike it was in the '90s) there is no sense of shame in engaging consumption in such an overt way. Thus, designers are like rock bands that sell their merchandise at concerts to their fans (which for many bands is a major source of revenue).

Typically, the concept of postproduction in design comes from the world of film and media production, where prerecorded bits of cinematography, sound, special effects, and so on are brought together and edited to form an integrated whole. But this analogy suggests that the new product is greater than the sum of its parts. I don't think that this can be said of postproduction in the cultural sense. In terms of art, postproduction is said to be about riffing on, reproducing, even reexhibiting existing artworks or using objects outright that, in a context other than a gallery, might be called design. This suggests a kind of equivalency or tacit relationship between the preexisting work and the new one. Nicolas Bourriaud, who has written about these ideas in the context of contemporary art, invokes the DJ and the programmer as quintessential figures of postproduction. He writes positively: "These artists who insert their own work into that of others contribute to the eradication of the traditional distinction between production and consumption, creation and copy, readymade and original work. The material they manipulate is no longer *primary*." [18]

The language of postproduction speaks of sampling rather than appropriation, sharing as opposed to owning, formats instead of forms, curation (i.e., selection) over creation, and context as the prime determinant of form rather than content. It is a culture of re- : remix, reformat, reshuffle, reinterpret, reprogram, reschedule, reboot, repost, recycle.

These strategies can be seen within the world of publishing in the form of the reissue or bootleg edition—material previously out of print, but not necessarily out of copyright. Miriam Katzeff and James Hoff of Primary Information republish "lost" historical material that expands contemporary discourse, such as their facsimile edition of the *Great Bear* pamphlet series (2007), a 1960s art journal. Four Corners Books reissues literary works in a series called Familiars, which are done in collaboration with artists who provide a new spin on classics such as *Dracula* (2008), *Vanity Fair* (2010), and *The Picture of Dorian Gray* (2007). The more surreptitious bootleg strategy can seen in works such as St. Pierre & Miquelon's *Sexymachinery Issue A: Super Replica* (2008), a facsimile copy of a journal originally created by members of Åbäke; in Winterhouse Editions' *The National Security Strategy of the United States of America* (2003), which simply republished and distributed the official document from the US government that would become known as the Bush Doctrine; or Rollo Press' *How to Build Your Own Living Structures (Revisited)* (2009), a one-color, Riso-printed copy of Ken Issacs' classic 1974 book on DIY furniture, which can be obtained only by exchange, not purchase. The remix or extended play strategy can be seen in *Extended Caption (DDDG)* (2009), a reinterpretation of the content from the influential design-cum-art magazine *Dot Dot Dot* that Bailey published and from which forty-three artifacts and essays were selected for display and inclusion in the book as captions.

Just as the introduction of the personal computer opened the sphere of publishing to broader access and participation, the Web 2.0 world not only blurs the distinctions between designers and users but also between production and consumption. Labor is no longer discrete but dispersed, creation is no longer autonomous but interdependent. Consider three examples: 99designs is an online service that provides buyers a logo design for the low, low price of $99 (or, if you want exclusive rights to a design, then add another $199). Here, the art comes before the horse. Like earnest profiles on a dating site or a catalogue

of mail-order brides, more than 13,000 preexisting logo designs are waiting for your "match." Choose one and the name of your business will be added to the design, which can be further customized to meet your needs. Mechanical Turk is a service offered by Amazon.com that brings together people who need simple, so-called human intelligence tasks performed that cannot be done yet by a computer (such as judging the quality of images, identifying singers on music CDs, writing product descriptions) with those who perform them for a small fee, often just a few cents per job, resembling the digital equivalent of piecework. In both situations, the labor of thousands of freelancers (i.e., contract workers) has been aggregated: outsourcing through crowdsourcing. The dubious quality and the ethical ambiguities of these enterprises aside, both of these examples are symptomatic of a larger cultural transformation around the notion of increasingly immaterial labor and atomized work, and their effects on production and consumption. [19] Philip M. Parker, a business professor, is a prolific self-publisher who has produced more than 100,000 books using an automated process of online research, writing, and layout. He issues printed books and digital reports on a staggering range of topics, from a history of anime and medical sourcebooks in areas such as restless leg syndrome and cataract surgeries to business reports about everything from the demand for wood toilet seats in China and lemon-flavored bottled water sales in Japan to golf bag sales in India. Parker uses a "long tail" approach of selling fewer copies of many more books to niche customers. [20] This strategy, coupled with the near elimination of human labor, have produced an inverted publishing venture, one in which a detailed report highly beneficial to just a few or even one person can yield a profit with prices in the hundreds of dollars. These tasks are often accomplished in less than thirty minutes using fully automated systems, most often including print-on-demand (eliminating inventory expense), whose production expense can be measured as "12 cents of electricity." [21]

The old schism between intellectual and manual labor that seems at the heart of the graphic design profession's internal debates is outmoded not only because this division is theoretically suspect, but also because it considers only the actions and possible roles of its own official agents (designers) instead of the complex and fluid social relationships and networks in which they are entwined with other players,

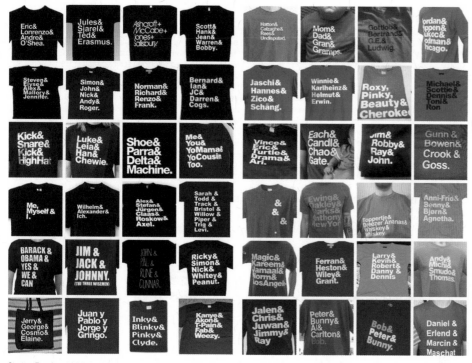

Courtesy Experimental Jetset

T-Shirtism

In 2001, we designed "John & Paul & Ringo & George", a t-shirt for Japanese label 2K/Gingham. ¶ A couple of years after we designed the shirt, we noticed something interesting: people started sending us images of self-produced shirts that were referring to our shirt, either as homage, tribute or as parody. These images were floating around in our mailboxes and attachment-folders, until, in 2005, Karen Willey, then a student at the Werkplaats Typografie, asked us to use these images for a chapter in *Dutch Resource* (Valiz Publishers, 2005), a book published on the occasion of the Chaumont Poster Festival. Around that time, we also posted some of these images on our website. ¶ Since then, we have received literally hundreds and hundreds of these images. Honestly, not a week goes by without a couple of these images being sent to us. We know of foreign students that have built complete graduation projects around the shirt, and publications and exhibitions showing all kinds of variations. ¶ We have been often wondering why our shirt became such a popular subject. Our way of designing is actually quite closed and hermetic: we never think in terms of target audiences, we never try to guess what will be popular or not. We just concentrate on the aesthetical/conceptual integrity of the design itself, and we always try to fully focus on the inner-logic of the designed object. The phrase "but does it communicate?" is used in our studio only as a joke. So it's really interesting to see that such a dry, minimal design can suddenly become a big hit. It's amazing to see that the John & Paul & Ringo & George shirt has become a format, a standard, for other people to work with. (To us, it proves an important point: that a popular design doesn't have to be made with populist intentions). —Experimental Jetset, "T-Shirtism: Homages, tributes, parodies," www.experimentaljetset.nl, 2005

St. Pierre & Miquelon, *Sexymachinery Issue A: Super Replica*, 2008 Courtesy the artists

Primary Information, *Great Bear* pamphlet series, 2007 Courtesy the artists

Urs Lehni, *How to Build Your Own Living Structures (Revisited)*, 2009 Courtesy Rollo Press

William Drenttel and Kevin Smith, *The National Security Strategy of the United States of America*, 2003 Courtesy Winterhouse Editions

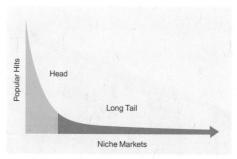

The Long Tail

The rise of self-publishing reflects what writer Chris Anderson, in his 2006 book *The Long Tail: Why the Future of Business Is Selling Less of More*, has called the "long tail." The traditional dominance of the mass media is succumbing to a new ecology that supports an enormous range of content tailored to an endless diversity of appetites. A graph of this new media ecology shows a tall but narrow peak at the front end, representing the best-selling "hits" that used to rule the marketplace. The long, skinny tail of the graph represents the niche products that sell far fewer copies individually than any one hit, but as a group command a growing share of the market. The long tail is populated by blogs, independent music and video, zines, short-run books and novels, fan literature, and other small-scale endeavors. The long tail is fed by the democratization of production tools (blogging software, digicams, Photoshop) and the rise of web-based forms of distribution (Netflix, Amazon, eBay, Etsy, YouTube, Google). As the tail winds down to its skinniest point, there is still content out there that will be accessed somewhere by someone—usually by people closely allied with the producer. At this far end of the tail, the line between maker and audience, producer and consumer, becomes very thin indeed. —EL

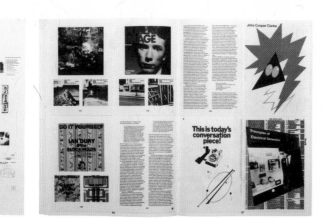

Roger Willems and Sam de Groot, *Extended Caption (DDDG)*, 2009 Courtesy Roma Publications

Metahaven, *White Night Before A Manifesto*, Eindhoven: Onomatopee, 2008 Courtesy the artists

Immaterial Labor

Hardt and Negri define immaterial labour as producing "an immaterial good, such as a service, a cultural product, knowledge, or communication." For the sociologist Maurizio Lazzarato, the immaterial labour of advertising, fashion and software development, comprises "intellectual skills, as regards the cultural-informational content; manual skills for the ability to combine creativity, imagination, and technical and manual labour; and entrepreneurial skills in the management of social relations (…)." ¶ A new common ground for designers and users is provided by the changing links between production and consumption, of which immaterial labour is the "interface." The products of immaterial labour not only materialize "needs, the imaginary, consumer tastes, and so forth," but also generate and produce new needs, imaginaries, and tastes, so that the act of consumption is not the destruction of the commodity but the establishment of a relationship which links production and consumption (read: designer and user) together. Lazzarato holds the social, aesthetic and communicative aspects of immaterial labour (which for him extend into the act of consumption) capable of producing direct social and political ties which escape traditional capitalist appropriation. —Metahaven, *White Night Before A Manifesto*, 2008

The Origin of Tux

The concept of the Linux mascot being a penguin came from Linus Torvalds, the creator of Linux. Tux was created by Larry Ewing in 1996 after an initial suggestion made by Alan Cox and further refined by Linus Torvalds on the Linux kernel mailing list. Torvalds took his inspiration from a photograph he found on an FTP site, showing a penguin figurine looking strangely like the *Creature Comforts* characters made by Nick Park. The first person to call the penguin "Tux" was James Hughes, who said that it stood for "(T)orvalds (U)ni(X)". However, *tux* is also an abbreviation of tuxedo, the outfit which springs to mind when one sees a penguin. Tux was originally designed as a submission for a Linux logo contest. Three such competitions took place; Tux won none of them. This is why Tux is formally known as the Linux *mascot* and not the *logo*. ¶ Tux was created by Larry Ewing using the first publicly released version (0.54) of GIMP, a free software graphics package. It was released by him under the following condition: Permission to use and/or modify this image is granted provided you acknowledge me lewing@isc.tamu.edu and The GIMP if someone asks. A Little Penguin, also known as the Fairy Penguin in Australia and the Blue Penguin in New Zealand, inspired Torvalds to suggest using a penguin as the Linux mascot. According to Jeff Ayers, Linus Torvalds had a "fixation for flightless, fat waterfowl" and Torvalds claims to have contracted "penguinitis" after being gently nibbled by a penguin: "Penguinitis makes you stay awake at nights just thinking about penguins and feeling great love towards them." Torvalds' supposed illness is a joke, but he really was bitten by a Little Penguin on a visit to the National Zoo & Aquarium, Canberra, Australia. Torvalds was looking for something fun and sympathetic to associate with Linux, and a slightly fat penguin sitting down after having had a great meal perfectly fit the bill. ¶ In an interview Linus commented on the penguin bite: I've been to Australia several times, these days mostly for Linux.Conf.Au. But my first trip—and the one when I was bitten by a ferocious Fairy Penguin: you really should keep those things locked up!—was in 93 or so, talking about Linux for the Australian Unix Users Group. —*Wikipedia*

Copyleft symbol

Aurelio A. Heckert, GNU symbol, 2005

Copyleft

This symbol is a play on the word *copyright* to describe the practice of using copyright law to offer the right to distribute copies and modified versions of a work and requiring that the same rights be preserved in modified versions of the work. In other words, copyleft is a general method for making a program (or other work) free (*libre*), and requiring all modified and extended versions of the program to be free as well. ¶ Copyleft is a form of licensing and can be used to maintain copyright conditions for works such as computer software, documents and art. In general, copyright law is used by an author to prohibit others from reproducing, adapting, or distributing copies of the author's work. In contrast, an author may give every person who receives a copy of a work permission to reproduce, adapt or distribute it and require that any resulting copies or adaptations are also bound by the same licensing agreement. ¶ Copyleft licenses require that information necessary for reproducing and modifying the work must be made available to recipients of the executable. The source code files will usually contain a copy of the license terms and acknowledge the author(s). —*Wikipedia*

Tux, the Linux mascot ©Larry Ewing, Simon Budig, and Anja Gerwinski

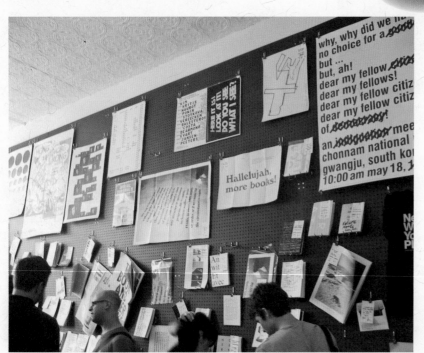

Installation by Werkplaats Typografie at the NY Art Book Fair, MoMA PS1, 2009 Photo: Dante Carlos

Copy Shop

The Werkplaats Typografie, a graduate program of graphic design based in Arnhem, installed a copy shop in their project space at the 2009 NY Art Book Fair at MoMA PS1. One wall featured a display of publications designed by the acclaimed Dutch program, which were available to browse. Visitors were invited to make their own bootleg catalogue from the available content by bookmarking their favorite pages (dubbed "editing"). A student would then copy, print, and bind two copies: one for the visitor and one for the school. —AB

who may or may not perform their own creative and productive roles. Metahaven, in *White Night Before A Manifesto* (2008), explores the inability of design manifestos to effect change: "Now that the principal tools of design—the computer and its software—have been homogenized among practitioners and democratized among people, professional distinction is an unlikely perspective for a future design manifesto to gain support. User-generated content accounts not for an amateurish supplement to a stable, professional core, but for a fundamental transformation of the workforce and the value it creates. The professional core of designers will not regain the central role it once could claim based on its mastery of tools and services unavailable to users. It seems instead more probable that among those professional designers, a gap will increase between those who design as celebrity, and those who design as labourer. Such a gap has already appeared in the architectural profession. Subsequently, for a design manifesto, a new alliance between designers and users may be a potentially more successful way forward." [22]

Metahaven goes on to cite the "GNU Manifesto" (1985) by Richard Stallman as a successful example of radically rethinking the entire notion of commissioned work, intellectual property rights, and collective ownership. Stallman's proposal was one that would form the basis of the free software movement, and would inspire the open source computing, filesharing, and copyleft movements. All of these take as their foundation the rights of creators to form an alliance directly with users to share their work. This declaration originally took place within a social framework very different from today's, but prescient of its emergence. Its radical yet simple proposition, offered by a programmer—the symbolic figure of postproduction—declares: "I consider that the golden rule requires that if I like a program I must share it with other people who like it." [23] ⊠

Notes

1. Ed Fella, lecture at the Walker Art Center, Minneapolis, March 25, 2008, http://channel.walkerart.org/play/ed-fella/.
2. Stewart Brand, "Purpose," *The Whole Earth Catalog* (Menlo Park, CA: Portola Institute, 1968), 3.
3. Steve Jobs, commencement address at Stanford University (June 12, 2005), accessed June 20, 2011, http://news.stanford.edu/news/2005/june15/jobs-061505.html.
4. Charles Q. Choi, "Human Evolution: The Origin of Tool Use," November 11, 2009, accessed June 20, 2011, LiveScience.com.
5. Lorraine Wild, "The Macramé of Resistance," *Emigre* 47 (Summer 1998), 15.
6. Jonathan Puckey, "On Tools," unpublished manuscript provided to the author, June 11, 2011.
7. Wild, "The Macramé of Resistance," 23.
8. Ibid., 20.
9. Virginia Postrel, *The Substance of Style: How the Rise of Aesthetic Value Is Remaking Commerce, Culture, and Consciousness* (New York: HarperCollins, 2003), 178.
10. Metahaven, *White Night Before A Manifesto*, (Eindhoven: Onomatopee, 2008), unpaginated.
11. See Faythe Levine and Cortney Heimerl, *Handmade Nation: The Rise of DIY, Art, Craft, and Design* (New York: Princeton Architectural Press, 2008); and Ellen Lupton, *DIY: Design It Yourself* (New York: Princeton Architectural Press, 2006).
12. See R. Gerald Nelson, *DDDDoomed: Or, Collectors & Curators of the Image—A Brief Future History of the Image Aggregator* (Lulu.com, 2010).
13. Interview by Mark Dudlik, Adria Robles-Morua, and Tanner Woodford with Experimental Jetset, *Fill/Stroke Magazine*, January 2008; republished 2011, accessed June 20, 2011, http://www.experimentaljetset.nl/archive/fillstroke.html.
14. See Ellen Lupton's essay, "The Designer as Producer," on pages 12–13 in this catalogue.
15. A Flickr set of submitted BP logo redesigns can be viewed at http://www.flickr.com/photos/greenpeaceuk/sets/72157623796911855/.
16. Scott Thomas, *Designing Obama* (Chicago: Post Press, 2009/2011).
17. Experimental Jetset, "T-Shirtism" (October 2005), accessed June 20, 2011, http://www.experimentaljetset.nl/archive/t-shirtism.html.
18. Nicolas Bourriaud, *Postproduction* (New York: Lukas & Sternberg, 2007), 13.
19. See Maurizio Lazzarato on "Immaterial Labor," and Michael Hardt on "Affective Labor," texts available at generation-online.org and in Michael Hardt and Antonio Negri, *Empire* (Cambridge, MA: Harvard University Press, 2001).
20. For an explanation of the long tail theory, see Chris Anderson, *The Long Tail: Why the Future of Business Is Selling Less of More* (New York: Hyperion, 2006).
21. Noam Cohen, "He Wrote 200,000 Books (but Computers Did Some of the Work)," *New York Times*, April 14, 2008, accessed June 20, 2011, http://www.nytimes.com/2008/04/14/business/media/14link.html?pagewanted=all.
22. Metahaven, *White Night Before A Manifesto*, unpaginated.
23. Richard Stallman, "GNU Manifesto," 1985, wikipedia.org.

2011
Design Entrepreneur 3.0
Steven Heller

Target A Guest

AMOXICILLIN 500MG

Capsule Generic for: Amoxil

PATIENT INFO CARD

Take one capsule by mouth three times daily for 10 days

qty: **30**

refills: **No**

Dr. C Wilson

disp: 03/17/06 TST

mfr: NDC: 00781-2613-05

(877)798-2743 ℞ 6666056-1375

⊙ TARGET PHARMACY
900 Nicollet Mall
Minneapolis, MN 55403

Deborah Adler, ClearRx bottle for Target, 2005 Courtesy Deborah Adler Design

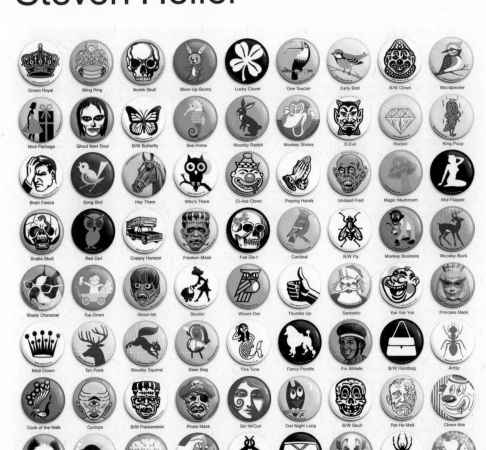

CSA Images, 72 Button Set for Pop Ink, 2008 Courtesy Charles S. Anderson Design

Aaron Draplin and Coudal Partners, *Field Notes*, 2011 Courtesy Draplin Design Company

Abbott Miller, *Ink* series wallpaper for Knoll, 2011 Courtesy Pentagram

M&Co Labs, 5 O'Clock wall clock, 1990–1998

M&Co Labs, Legal Paperweight, 1984

Charles and Ray Eames, House of Cards, 1952 Courtesy Eames Office

"Design authorship" emerged during the late 1980s, promising a counterintuitive shift in graphic design practice from designers solely serving clients to becoming one's own client. It seemed radical at first, but the design authorship movement, such as it was, never really gave the proverbial asylum keys to the inmates. In truth, the buzzword "design author" was transitional, leading the way for designers to embrace the even more provocative "design entrepreneur" movement, which developed later in the 1990s.

Design authorship was wishful design thinking—a dream that designers could ultimately command their own creative destinies while contributing something of value to the culture. Design entrepreneurship, on the other hand, is a more demonstrative business construct, moving beyond traditional service design into self-starting and self-sustaining design endeavors. The design entrepreneur movement (drumroll please) demands that designers take greater responsibility as creators of their own marketable products. Consequently, design entrepreneurs are not merely handmaidens to business; they are a new breed of barons and baronesses, intimately ruling their own fiefdoms (as long as they can find markets). Which is, of course, a risky proposition for those with little exposure to the true rigors of business.

Therefore, many designers who have tried becoming entrepreneurs judiciously hold on to their day jobs. In the late 1980s and 1990s, most designers who claimed to be design authors took baby steps, if any at all, toward becoming what Ellen Lupton termed "Designer as Producer," a designation derived from Walter Benjamin's 1934 essay "The Author as Producer," which famously challenged the conviction that authorship is solely a literary endeavor. In fact, the first generation of design authors, in addition to designing things, quite literally wrote books and articles—critical and otherwise—about design for a new group of graphic design publishers (who were indeed the true risk-taking entrepreneurs). From the early to mid-1990s, when design authorship was being touted in these magazines as "a" next big thing, very few graphic designers were seriously exploring ways to transform self-generated ideas for consumables into realized products that could be practical investment opportunities.

My own 1998 essay "The Attack of the Design Authorpreneur," published in the *AIGA Journal*, called for designers to take control and ultimately profit from "authorial and entrepreneurial wares." But at the time, design entrepreneurism was not

yet considered part of the graphic design playbook. Professional organizations were reluctant to embrace the concept (other than as "self-promotion") and entrepreneurship (especially business strategy) was not taught in art and design schools. Yet as digital desktop media began to redefine the role of the graphic designer, in the mid-1990s design entrepreneurship began picking up steam as a viable alternative to the status quo. This was ironic, since design entrepreneurship was not a new phenomenon.

It started in the late nineteenth century, an outgrowth of the Industrial Revolution, and rejection thereof. Social critic and designer William Morris was one of the early pioneers of design entrepreneurism (though that term was a long way from being coined). In addition to his storied Kelmscott Press, dedicated to making fine hand-press editions of classics for popular consumption, the Arts and Crafts workshops, which he helped found, produced wallpaper, textiles, and furniture. His acolytes in the United States and Europe included Elbert Hubbard, eccentric founder of the Roycroft Press in Aurora, New York, who also ran a workshop and produced a wealth of books, journals, and related products. Other design workshops in the United States and Europe set standards for designers as "producers" of goods and wares.

Jump to the 1920s: The Bauhaus was pioneering experimental design entrepreneurship on an interdisciplinary level. And around the same time, Contempora in the United States, a consortium of industrial, furniture, and graphic designers, conceived and fabricated a broad range of entrepreneurial retail objects. Slowly but surely, graphic designers were entering the fray. In the 1920s, Kurt Schwitters opened an advertising studio and published *Merz*, a journal devoted to arts and design. In the late 1940s, Swiss graphic designer Walter Herdeg cofounded *Graphis*, an international design magazine, which grew into a full-fledged entrepreneurial publishing house. These pioneers were both design authors and entrepreneurs, still long before the terms were common.

Design entrepreneurial gadflies surfaced through the 1950s to the 1980s, but they almost always created one-offs as sidelines to their design practices. Pitching, hawking, and selling goods simply did not appeal to most designers. Well-known exemplars included Charles and Ray Eames, who produced games, toys, furniture, and films as part of their authorial-entrepreneurial practice (which

still bring income into their estate). The Push Pin Studios, in addition to its monthly promotional magazine titled the *Pushpin Graphic*, produced, as a respite from the rigors of client work, a novelty brand called Pushpinoff candies, which began as a self-promotional gift sent to clients, but later was licensed for retail. In the 1980s and 1990s, the New York graphic design studio M&Co launched M&Co Labs, which developed watches, clocks, paperweights, and other entrepreneurial goods—influencing a slew of other enterprising designers to produce similar products (watches being the most popular). Minneapolis-based Charles Spencer Anderson initially started selling clip art to other designers and then launched CSA Images, thus "controlling" copyright-free images by retrofitting them on all manner of gift items, from soaps to plates. Like M&Co Labs, the CSA product business developed a loyal clientele.

By the mid-1990s, digital desktop tools had enabled designers to become "producers" of "content"—everything from T-shirts and street fashions to housewares and beyond. For some, initial entrepreneurial timidity evolved into business savvy. By 2002, when I published the book *The Education of a Design Entrepreneur*, various designers were already engaged in all manner of entrepreneurial practices— among the firmly entrenched, dating back to the pre-digital '80s, were Richard Saul Wurman's *Access Guides* publishing series, Stephan Van Dam's *Unfolds* map series, and Byron Glaser and Sandra Higashi's popular Zolo toys.

A major shift occurred owing to the computer revolution of the mid-1990s and specifically the Apple Macintosh (the designer's best friend). Digital type foundries became among the first independent desktop businesses to make serious entrepreneurial headway by selling proprietary type fonts to business and the public. Emigre Graphics, founded in 1984 by Rudy VanderLans and Zuzana Licko, was the earliest entrant (and now most venerable). House Industries (founded in 1993) and T-26 (founded 1994) also remain in business today, offering type and other designer-made "goodies." With essentially minimal investments, starting with their own DIY fonts, these foundries could amass enough capital to purchase other designer's typefaces, which would generate royalties. Each foundry had distinct business strategies that enabled growth and diversification. Emigre, for instance, also published their eponymous journal, which ostensibly codified the new digital type trends of the '90s.

33

The term "democratization" often brings credibility to independent activities, as it did with design entrepreneurism, which owed its democratic adoption to an array of what might be termed "creationist" software. These tools provided designers with greater access to the means of prototyping and production. Design entrepreneurism was analogous to Benjamin's prediction that with the switch from handwriting to the typewriter, the modern writer will find "the precision of typographic forms" and would enter into the "conception of his books." Similarly, the computer enabled designers to do what only facilitators and vendors could do in the days before integrated technologies. Where once entrepreneurial inventors required vast resources to produce prototypes, it was becoming easier to source out or personally make the needed components. What's more, the Internet bubble released more newly minted, skilled technology jockeys into the marketplace to become enthusiastic partners in the entrepreneurial process.

Yet a significant gap existed before investors would take seriously any design entrepreneur movement. In a word: *education*. It is one thing to conceive a great idea, another to fabricate it and still another to make it viable for and in the marketplace. Honestly, with a certain amount of luck and a modicum of research, almost anyone with ambition can stumble on the formula, at least once. But in the current venture capital environment, design entrepreneurs are required to do more. It is not enough to be the ersatz or naive inventor; with the rise in protected intellectual property and the demand for smart and novel ideas, design entrepreneurs must be educated in the ins and outs of business—which is still shaky territory for most young designers.

The School of Visual Arts (SVA) MFA Designer as Author program (which I cofounded in New York with Lita Talarico in 1996) was the first entrant into the entrepreneurial pedagogic field. The title of the program, which two years later included "& Entrepreneur," was predicated on the notion that content creation was foremost in graphic design's future. At the outset, some people were reluctant to combine entrepreneurship with an MFA degree, feeling the former perhaps wasn't academically rigorous enough. But once the early jitters subsided and the rigor was clearly apparent, the writing was on the wall that DIY and entrepreneurial sensibilities were on the rise and educational institutions needed to take a role. MICA's (Maryland Institute College of Art) MFA design program, founded and chaired

by Lupton, threw its weight behind real-world independent publishing ventures in conjunction with Princeton Architectural Press, pursuing one aspect of entrepreneurism. Eventually, Savannah College of Art (SCAD) announced its own program tasked to put products into the marketplace. In each program, the goal was not to simply speculate in blue-sky "senior projects," but to actualize conception and production—and put viable things into the world.

This means that entrepreneurial concepts demand research and more research to prove whether creativity equals viability. The old fiddling-in-the-garage scenario may be the way ideas are conceived and mocked-up, but when actualizing their projects, designers put themselves at a disadvantage when they pass the entrepreneurial nitty-gritty to "the business people." Team collaborations are essential; it is necessary for a design entrepreneur to understand how the entrepreneurial birthing process works. Learning the difference, for instance, between "angels" and "venture capitalists"; how to network and make useful contacts; what is necessary to protect intellectual property; and many more tools and strategies endemic to the design entrepreneur's pedagogy.

Design entrepreneurs differ from garden-variety entrepreneurs. They don't just fund any old potential project; they conceive products that usually have deep personal roots. Designers' ideas stem from personal experience and are the manifestations of events, narratives, and autobiographies. Take the genesis of the highly publicized ClearRx bottle for Target Pharmacy, the most successful product to emerge from the SVA MFA Designer as Author & Entrepreneur program, developed by Deborah Adler. It derived from a very personal story—indeed, a near tragedy. Adler's grandmother, faced with dozens of faceless yet confusing prescription bottles, took the wrong pill, which could have resulted in dire consequences. Adler's decision to build her thesis around an easier to read and friendly prescription drug bottle had both personal and universal appeal. Growing out of prototypes and research findings, her concept was ultimately purchased by Target for filling all of its prescription medications.

Another former SVA student, Peter Buchanan-Smith, enthusiastically adopted the entrepreneurial models. He started his Best Made Company during the recession in 2009, when he faced a dwindling client base in his traditional service-oriented practice and began making and selling bespoke axes in his backyard. The

endeavor was a curious gamble. To say that this market had yet to be cornered is an understatement. In fact, bespoke axes were not in the remotest consciousness of most consumers. The novelty of his brand earned him considerable press within the New York hiperati. Like Adler's, Buchanan-Smith's product is grounded in personal history, derived from a background working on cattle farms and paddling and portaging the lakes of Northern Canada.

The common refrain at any writers' workshop is that everyone has a novel somewhere inside them waiting to emerge. Likewise, everyone has a backstory that is potentially the seed for a design product—either mainstream or eccentric. The goal of SVA's MFA program is to help materialize that narrative in an appropriate medium. Handheld media is the next and current platform, and selling online is the outlet. Design entrepreneurs are becoming more familiar and involved with this form of digital communications technology, from games to retail sites. The app market is growing exponentially, and while many designers continue to covet physical objects, virtual ones are proving to be a source of entrepreneurial gratification and a wellspring for innovation. The key to making hay in the Design Entrepreneur 3.0 world is not to be timid.

Graphic designers will doubtless continue to be service providers—that is the tradition and legacy of the field. Indeed, design entrepreneurism may never replace design's other functions. But it is a creative and business option to apportion some of the designers' services, skills, and talents on the entrepreneurial potential, which is arguably hardwired in the circuitry of each and every designer. ⊠

American Felling Axes

Axe Maker's Kit

Axe Sling

Red Cap of Courage

Peter Buchanan-Smith, various Best Made Products, 2009–2011 Courtesy Best Made Products

The Secret of Happiness

The secret of happiness is this: let your interests be as wide as possible, and let your reactions to the things and persons that interest you be as far as possible friendly rather than hostile.—Bertrand Russell

C.C.G.F. Badge Set

Courage American Felling Axe

Best Made Axe Box

EVERYTHING HERE IS *Wonderful*

Everything Here Is Wonderful Map

Best Made Company

Founded by Peter Buchanan-Smith in 2009, Best Made Company took shape around an axe. Each axe is a beautiful work of art, whose sculptural beauty speaks to centuries of basic utility. Partnering with traditional axe makers, Buchanan-Smith creates painted handles inspired by functional finishes and symbolism, from nautical insignia and wooden pencils to enameled porch steps. Produced in limited editions, the axes have become cult objects at the center of a growing family of products designed and sourced by Buchanan-Smith, ranging from survival guides to cloth-covered extension cords. —EL

Semaphore Flags

BEST MADE
ALL-PURPOSE
FIRST AID KIT

First Aid Kit

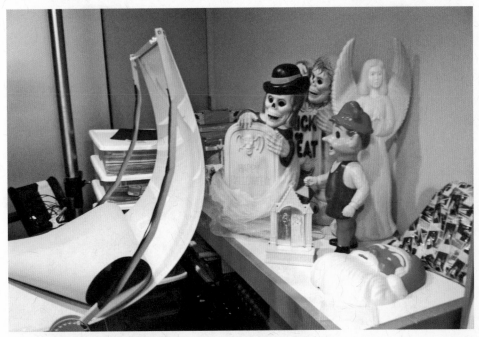

Photo studio at CSA Images, 2011 Photo: Andrew Blauvelt

Glazed and Confused paper kit

Pop Ink and CSA Images

In 2006, Charles S. Anderson Design, in collaboration with his longtime client the French Paper Company and Laurie DeMartino Design, launched a series of products under the Pop Ink brand. Pop Ink products utilize the extensive CSA Images library and are printed on French Paper. Pop Ink lines have ranged from gift wrap, stationery systems, note cards, and image source books, to specialty items such as melamine resin dinner plates, clear plastic handbags with changeable card inserts, and a series of soaps. ¶ The CSA Images collection currently contains nearly 50,000 finished images online, and an additional 100,000 images in process culled from millions of found images compiled over the past thirty-five years. The image archive represents a cross-section of American popular culture: cartoon characters, toys, dolls, holiday novelties, even dog and baby portraiture in addition to ornaments, patterns, and borders. ¶ Charles Anderson began this pursuit with his first collection of material given to him by a childhood mentor, Clyde Lewis, a former commercial artist who had drawn hundreds of illustrations over the course of his career. Building upon that original cache, Anderson has found, created, and commissioned thousands of additional artworks. ¶ Today CSA Images is one of the most extensive resources of licensable artwork. This massive archive has been assembled through untold hours of work, including: exhaustive research, combing through hundreds of volumes of historic printed material to select those elements that hold the most interest and potential; obtaining and vetting legal issues of copyright; photographing and scanning artwork, transforming and correcting it for reproduction; redrawing and redesigning art to convey new concepts; commissioning and creating new art; and tagging and indexing works for search and retrieval. The CSA Image archive functions as a design resource, while preserving elements of America's graphic history. —AB

Dog-on-It paper kit

Stranger Manger and Glazed and Confused memo books

Garden Variety and Water Garden memo books

Goth-Icky book

Flight of Fancy card

How You Bean card

72 Button Set

Cannibal Kingdom melamine plates

Food for Thought melamine plates

Soap Opera soap

Skinny Dip soap

Tiny Bubbles soap

Wash & Wear soap

CSA Images, various Pop Ink products, 2008– Courtesy Charles S. Anderson Design

37

MeBox Customizable Storage System

The ends of each *MeBox* have a grid of perforated discs that can be pressed out to create initials, numbers, symbols and texts. When assembled, the double-thickness construction presents the message against a contrasting color of the box lining. The *MeBox* system was used in a joint presentation by GTF and Paul Elliman in a former garage in the French town of Chaumont, site of an annual graphic design festival. Acknowledging the venue's previous function and referencing a traveling show, a timber-framed truck was dressed in tarpaulins that displayed Elliman's roadside finds. A retrospective of GTF projects was displayed in vitrines atop a stack of palletized *MeBoxes*. —AB

Graphic Thought Facility, *MeBox* customizable storage system, 2002 Courtesy the artists

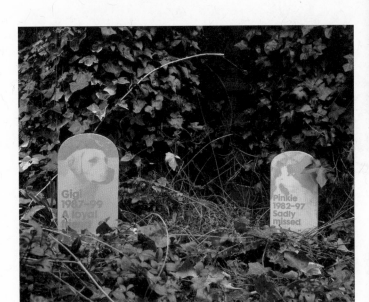

Graphic Thought Facility, *Earth Baskets*, 2002 Courtesy the artists

Earth Baskets

This idea for a memorial to dead pets was GTF's contribution to *Hardcore*, an exhibition presented by the Royal Institute of British Architects that explored the design applications of concrete. The concept made use of a process that allows photographs to be permanently rendered into the surface of concrete during its curing process. As it states in a guide to the exhibition: "the image—like the memory—never fades." —GTF

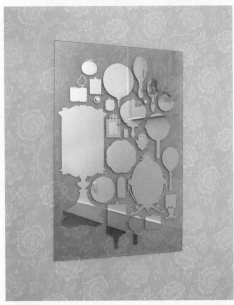

Graphic Thought Facility, *The Mirror Mirror* for Victoria & Albert Museum, 2006
Courtesy the artists

The Mirror Mirror

An exclusive product for V&A Enterprises inspired by the museum's diverse collection of hand-mirrors from Europe and the East. Spanning a period of one thousand five hundred years, the silhouettes are hand-silvered onto green body-tinted glass. —GTF

Graphic Thought Facility and Paul Elliman, *The/Le Garage*, installation for the International Poster and Graphic Design Festival, Chaumont, France, 2004 Photo: Joel Tettamanti
Courtesy the artists

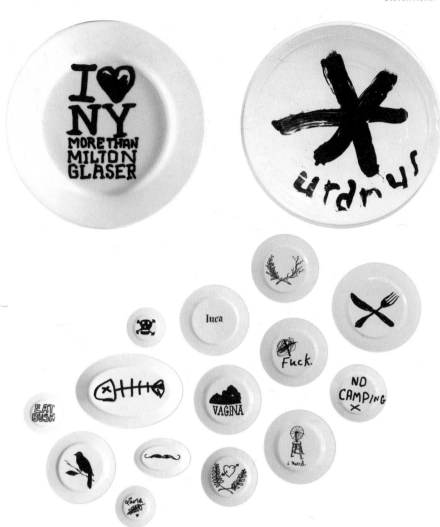

James Victore, *Dirty Dishes*, 2005–2011 Courtesy the artist

Dirty Dishes

When I was a young designer, my apartment was never much to speak of, and my "studio" nonexistent. I often sought out a satellite studio in a local bar, pub, or restaurant. This was not the ideal setup but always yielded interesting results. My habit of drawing on everything is enhanced after a drink or two, and facilitated by the Sharpie I always carry with me. Inhibitions gone, I would invariably end up drawing on the establishment's plates, sometimes trading bread-plate drawings for a beer or a cute bartender's phone number.
—James Victore, *Victore or, Who Died and Made You Boss?*, 2010

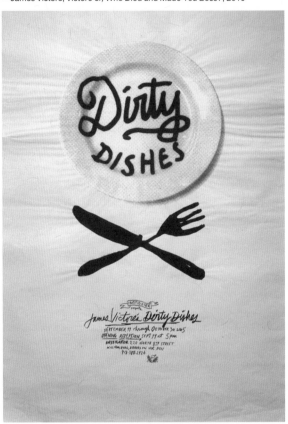

James Victore, announcement for an exhibition of *Dirty Dishes*, 2005 Courtesy the artist

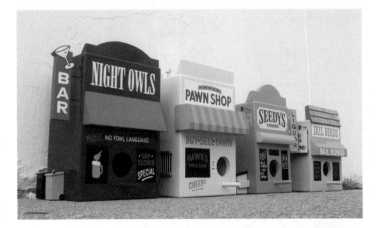

Jeff Canham and Luke Bartels, *For the Birds*, 2010–2011 Courtesy the artists

For the Birds

Birdhouses are miniature forms of architecture to be shared with our feathered friends. Lettering artist Jeff Canham teamed up with sculptor Luke Bartels to create a series of one-of-a-kind storefronts that speak to urban avians—from a peep show for naughty birds to a bail bonds shop for jailbirds. Latest in the series are a tattoo parlor and a mortuary. Canham applies the traditional craft of sign painting to custom signage as well as to works of art and designs for apparel and print. —EL

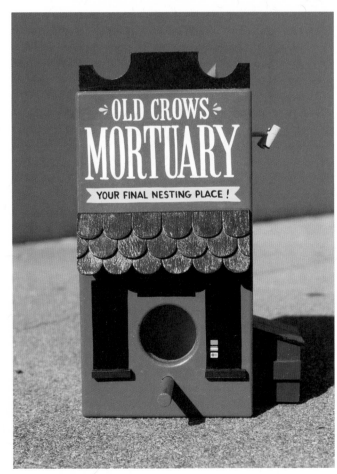

39

Aaron Draplin and Coudal Partners, *Field Notes* (50 States version), 2011 Courtesy Draplin Design Company

Aaron Draplin and Coudal Partners, *Field Notes* (dry transfer letter version), 2011
Courtesy Draplin Design Company

Aaron Draplin, Factory Floor Issue Action Cap, 2005

Aaron Draplin, *Official Merch Store* poster, 2009 Courtesy Draplin Design Company

Aaron Draplin, Space Change Containment Apparatus, 2009
Courtesy Draplin Design Company

Draplin Design Company

Need a cap, a comb, a rubber coin purse? Low-cost, high-energy "merch" is available in abundance from Aaron Draplin's online store, all emblazoned with DDC's bullshit-resistant graphics. Draplin is also the instigator behind *Field Notes*, a line of handy memo books designed for capturing ideas on the move. Offering an all-American alternative to the popular Moleskine line, the *Field Notes* brand speaks more to the inner lumberjack than to the hipster artiste. Designed by the Draplin Design Company (Portland, Oregon) in league with Coudal Partners (Chicago), the brand invokes the can-do, make-do spirit of plumbers, farmers, and software engineers. Limited-edition series such as the *Dry Transfer Edition* (2011) have been known to incite frenzy among hard-core collectors. —EL

Aaron Draplin, *Pretty Much Everything* poster, 2009 Courtesy Draplin Design Company

Aaron Draplin, *Everything Minnesota*, 2009 Courtesy Draplin Design Company

Aaron Draplin, Factory Floor Issue Longhand Set, 2008 Courtesy Draplin Design Company

Stefan Sagmeister, *Money Doesn't Make Me Happy* wallet from the Saved by Droog Project, 2010 Photo: Stefanie Grätz Courtesy Droog Design

Saved by Droog Project
Since the early 1990s, the Dutch design collective Droog has brought together international artists and designers to create products that comment on material life. To launch the Saved by Droog Project, Droog took possession of substantial lots of remaindered items, low-cost outcasts from the commercial maelstrom. Meike Gerritzen's *Beware of Software* vest is covered with commentary about the dangers of digital culture. Stefan Sagmeister's plastic wallet proclaims, "Money doesn't make me happy." Sofie Lachaert and Luc d'Hanis' *Sad* hankies combine images of pastoral calm with wartime violence; a portion of proceeds goes toward War Child programs. —EL

Sofie Lachaert and Luc d'Hanis, *Sad Hanky* from the Saved by Droog Project, 2010
Photo: Stefanie Grätz Courtesy Droog Design

Stefan Sagmeister, *Money Doesn't Make Me Happy* wallet from the Saved by Droog Project, 2010 Photo: Stefanie Grätz Courtesy Droog Design

Meike Gerritzen, *Beware of Software* vest from the Saved by Droog Project, 2010
Text: Geert Lovink Photo: Stefanie Grätz Courtesy Droog Design

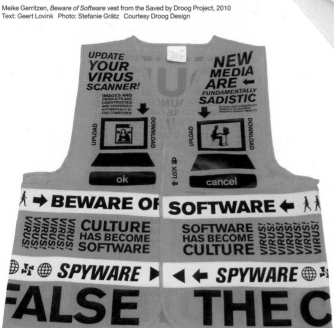

Meike Gerritzen, *Beware of Software* vest from the Saved by Droog Project, 2010 Text: Geert Lovink Photo: Stefanie Grätz Courtesy Droog Design

Sofie Lachaert and Luc d'Hanis, *Sad Hanky* from the Saved by Droog Project, 2010 Photo: Stefanie Grätz Courtesy Droog Design

41

Daniel Eatock, *Price Label Gift Wrap*, 2003 Courtesy the artist

An idea for ...

An idea for a drinks company: I would like to pour a complete bottle/can of water/olive oil/orange juice etc. in one continuous stream from a pre calculated height, and take a single photograph before the first drip hits the ground. ¶ An idea for a skateboard manufacture: I would like to make a skateboard coated with blackboard paint that comes with pack of chalk and a board duster. I would also like to make a skateboard coated with a Whiteboard surface that comes with pack of dry markers and a board wipe. ¶ An idea for a trainer/shoe manufacture: I would like to replace the laces on a pair of trainers/shoes with some very long ones, tie them together and then throw them over a telegraph wire so they hang down until they almost touch the ground. ¶ An idea for Heinz or another similar food manufacture: I would like to mix together every single Heinz food product, then package in small cans labelled as a limited edition of everything Heinz. —Daniel Eatock, *An idea for ...* , eatock.com/project/an-idea-for, 2007

Daniel Eatock, *Everything Heinz*, 2009 Courtesy the artist

Daniel Eatock, *See-Through Tie*, 2007 Courtesy the artist

Daniel Eatock, *Thailand Tie*, 2007 Courtesy the artist

Daniel Eatock, *Neckclasp*, 2005 Courtesy the artist

Daniel Eatock, *Tiedye Tie*, 2007 Courtesy the artist

Daniel Eatock, *Neckclasp*, 2005 Courtesy the artist

Daniel Eatock, *Taiwan Tie*, 2007 Courtesy the artist

Birthday Card

Before giving card, tick box or specify which birthday is being celebrated.

- First
- Eighteenth
- Twenty-first
- Fortieth
- Fiftieth
- Sixtieth
- Hundredth
- Other*

*Please specify

Late Card

Write an excuse or apology in no more than fifty words to explain why this card is late.

Sign and date

Occasion Card

Before giving card, tick the box relevant to the occasion being celebrated.

- Birthday
- Valentine
- Mother's Day
- Easter
- Father's Day
- Christmas
- New Year
- Anniversary
- Good luck
- Congratulations
- Well done
- Other*

*Please specify

Greeting Card

Using a red pen delete all descriptions that are not relevant to card's recipient.

Mum	Cousin	Enemy
Dad	Nephew	Stranger
Daughter	Niece	Teacher
Son	Twin	Boss
Sister	Girlfriend	Neighbour
Brother	Boyfriend	Other*
Grandma	Wife	
Grandad	Husband	
Aunt	Friend	
Uncle	Lover	

*Please specify

Daniel Eatock, *Utilitarian Greeting Cards* (second edition), 2003 Courtesy the artist

Experimental Jetset, *Flag Sabbath Big*, 2006/2010 Courtesy the artists

Dialectics of Erasure

It is this myth or metaphysics of "objective narratable knowledge" that Nietzsche targets in "On the Uses and Disadvantages of History for Life." Thus "Forgetting is essential to action of any kind," and "there is a degree of sleeplessness, or fulmination, of the historical sense, which is harmful and ultimately fatal to the living thing, whether this living thing be a man or a people or a culture." Nietzsche argues that "the unhistorical and the historical are necessary in an equal measure for the health of an individual, of a people and of a culture," and in favour of "the art and power of forgetting and of enclosing oneself within a bounded horizon." ¶ Nietzsche's critique of the fetish of objective knowledge finds validation—or exemplification—in my third design example, which is from a genre even more culturally humble than the book cover: a t-shirt. Purchased at an L.A. gallery, the black t-shirt (designed by the Dutch studio Experimental Jetset) lists three bands with the word "black" in their names: Big Black (a punk band from Chicago), Black Sabbath (the British heavy metal band), and Black Flag (a punk band from L.A.). But in each case, the word "black" is represented by a white stripe: again, suggesting erasure or deletion. Here the design works best on viewers being able to guess the missing words, working from the best-known "Sabbath," to the less-well-known but still fairly familiar "Flag," then sometimes (and, in my experience, sometimes not) "Big." But the play of chromatic and racial codes here (is the t-shirt white washing these band names?) discouraged me from wearing the shirt right after it, when I was staying in South Los Angeles and Oakland, that is, in fairly black neighbourhoods. Too, the erasure or absence here denotes a stable signifier, indeed the same one: different work is going on in the MacMillan and Persky/Dixon covers. That is, as Nietzsche argues, here it is the forgetting of the bands names, of their blackness if you will, that makes the t-shirt design possible; too, the very erasure, at least in my case, made me uncomfortably aware of my whiteness. Indeed, arguably what the t-shirt's erasure did was to make me aware of the sudden non-transparency of my whiteness. —Clint Burnham, "The Dialectics of Erasure," *Capilano Review*, 2009

Experimental Jetset, *Anti.*, 2000 Courtesy the artists

John & Paul & Ringo & George

With "John & Paul & Ringo & George," we wanted to design a shirt that would refer to a certain t-shirt genre. What we were trying to do was to come up with a shirt that would function as an archetypical "band shirt" (in the same way that the "Anti" shirt, which we designed a year earlier, was meant to function as an archetypical "slogan shirt"). ¶ When we designed the shirt, our idea was to strip down the idea of a rock band to a list of four names, in an attempt to reach the of essence of a group. In a way, the shirt is very much about abstraction: the process of translating figurative images into something less figurative. There's also an iconoclastic streak running through the shirt: the idea of puncturing through the world of images, by using text. In short, we took the idea of the most archetypical band ever (a band that has been a constant source of inspiration to us), and replaced the image with a simple list of names. —Experimental Jetset, www.experimentaljetset.com, 2001

Experimental Jetset, *John & Paul & Ringo & George*, 2001/2010 Courtesy the artists

Mike Perry, Poketo x Target Weekender Bag, 2010 Courtesy the artist

Mike Perry, silkscreened tote bag, 2010
Courtesy the artist

Mike Perry

Few designers have done more than Mike Perry to promote the recent revival of drawing, painting, and lettering in the applied arts. Working as a designer, illustrator, author, editor, and publisher, Perry exemplifies a hands-on, independent ethos: designer as maker. One-of-a-kind pieces like his hand-painted Eames chair complement a roster of printed tote bags, clothing, housewares and more. He even has his own line of adhesive bandages. Perry's books on lettering, pattern design, and screenprinting have attracted a devoted horde of followers. —EL

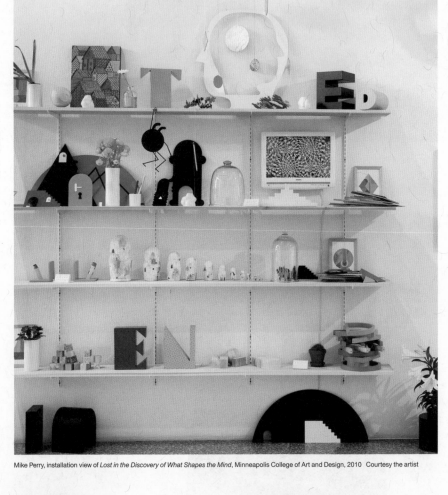

Mike Perry, installation view of *Lost in the Discovery of What Shapes the Mind*, Minneapolis College of Art and Design, 2010 Courtesy the artist

Mike Perry, *Eames Eiffel Side Chair*, 2010 Courtesy the artist and Outdoorz Gallery

Mike Perry, Vipp trash can for DIFFA, 2010
Courtesy the artist

Mike Perry, plate for Nylon with Urban Outfitters, 2008 Courtesy the artist

Karel Martens, *Dutch Clouds*, 2009 Courtesy Maharam Digital Projects

Maharam Digital Projects

The textile company Maharam has become a leading voice in contemporary surface design, commissioning artists and designers to bring new concepts to the firm's historic library. Maharam Digital Projects is a collection of mural-size images that are printed on-demand to the specifications of an architect or designer. Many of the designs have no repeat, making them more like works of art than traditional wallcoverings. Patterns range from candy-colored bands of *New York Times* headlines (A. J. Boocchino) to a field of pixelated clouds composed from intricate rosettes (Karel Martens). —EL

45

Marian Bantjes, *Spaceman* wallpaper, 2010 Courtesy Maharam Digital Projects

A. J. Bocchino, *New York Times Headlines (1990-2005)*, 2010 Courtesy Maharam Digital Projects

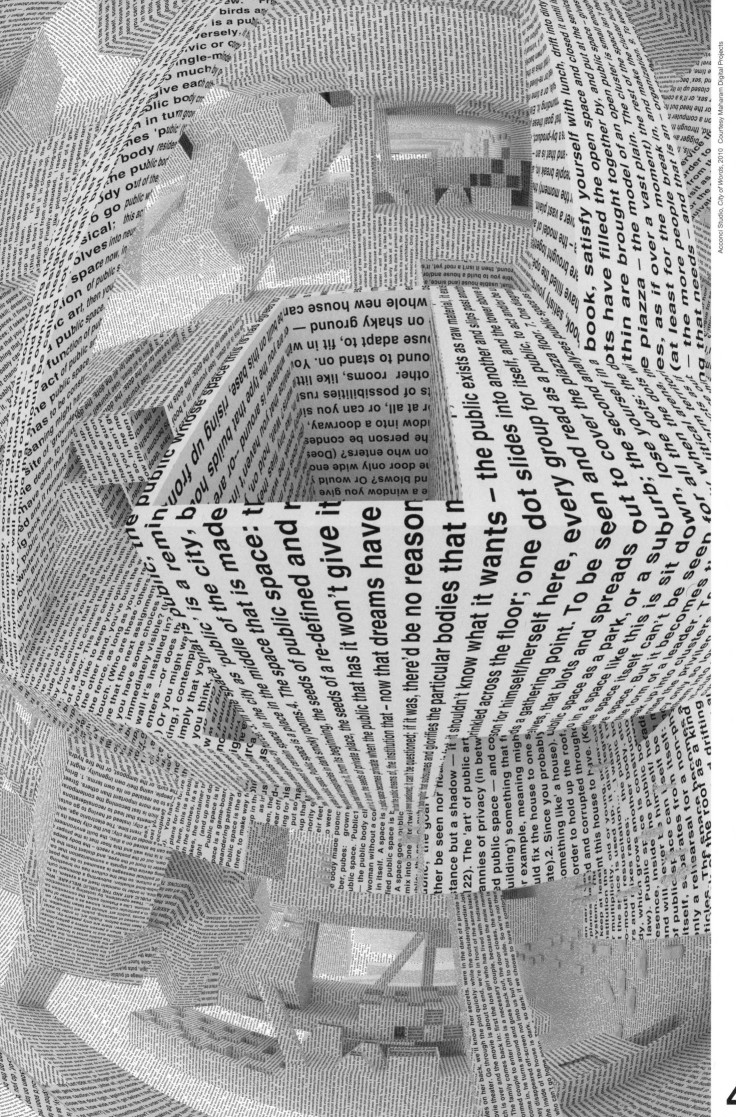

Acconci Studio, City of Words, 2010 Courtesy Maharam Digital Projects

2x4, *Pause*, 2004 Courtesy Knoll

KnollTextiles: *Pause*

KnollTextiles, a division of the legendary modern furniture company, has produced a number of wallcovering patterns with noted graphic designers. *Pause* is part of the *Chatter* series, designed in 2004 by the New York firm 2x4. *Pause*'s large-scale punctuation marks invite viewers to slow down and take note of the alphabet's silent partners. —EL

Abbott Miller, *Drop*, *Drip*, and *Run* from the *Ink* series, 2011 Courtesy Knoll

KnollTextiles: *Ink*

Abbott Miller and his team at Pentagram created *Ink* in 2011, a collection of wallcoverings for KnollTextiles. The patterns originate from a series of drawings made by dripping, dropping, and pouring ink. To create his *Drip* patterns, Miller jiggled large sheets of paper in order to make rivulets of liquid flow in semi-controlled directions. The patterns composed from these drawings are at once structured and organic, handmade and digital. —EL

51

Top to bottom: Geoff McFetridge, *Dead Trees, Lines Forest, Shades of the Paranormal* wallpapers, 2008. Courtesy Pottok

Pottok

These wallpapers, designed by designer, illustrator, and animator Geoff McFetridge, are screenprinted by hand in Los Angeles. The papers bring McFetridge's dark, witty view of an urbanized natural world to the domestic interior. Hooded wood sprites are armed with hacksaws in *Dead Trees*; abominable snowmen merge with the mountains in *Shades of the Paranormal*. —EL

53

2009
Practice from Everyday Life: Defining Graphic Design's Expansive Scope by Its Quotidian Activities
James Goggin

The RISOGraph MZ970, launched 2008, designed by RISO Kagaku Corporation
Courtesy RISO, Inc.

RISOGraph
This low-cost, high-speed printing method is similar to the mimeograph stencils of yore though unique in that it is a two-color, single-pass technology. The machine forces ink through tiny perforations in a digitally generated master created via a thermal process (heat spots burn through the master to create a stencil). RISO printing is appropriate for runs between 50 and 10,000, making it a cost-effective bridge between photocopying and offset printing. Whereas most large-scale book publishers outsource offset printing to manufacturers in distant locations, many independent presses use digital duplicating technology to bring manufacturing directly on site. Publishers using digital duplicators include Rollo Press (Zürich) and Bedford Press (London). —EL

Messages and Means class, taught by Muriel Cooper and Ronald L. MacNeil at MIT, 1974

Cornel Windlin, *Project Vitra*, 2007 Courtesy the artist

Manuel Raeder, *BLESS Nº 39 Heart Ringers*, insert for *Girls Like Us*, vol. 2, issue no. 1, 2011
Courtesy the artist

BLESS Nº 39 Heart Ringers
Design and concept of the lookbooks for the fashion designers BLESS. Since this close collaboration with BLESS started, all the lookbooks have been published inside existing magazines, allowing us to spread ideas and projects by BLESS in a field broader than only the regular press offices or inside the fashion industry. Joined together in new ways, making friends or unusual encounters happen. The BLESS lookbook *Nº 39 Heart Ringers* has been published inside the magazine *Girls Like Us* (vol. 2, issue 1) and is always folded differently for each issue. Photography by Heinz Peter Knes. —Manuel Raeder

Laurenz Brunner, *The Most Beautiful Swiss Books: The Future Issue*, 2010, Carl Burgess and Thomas Traum (3-D rendering and design) Courtesy the artist

Relational Design
I have used the word relational design, but it could go by several others including contextual, collaborative, situational, or conditional design. I chose the word I did because it embraces the broadest spectrum: it could include collaborative practices but it also leaves room for more singular approaches. It points outward from design's mute artifacts to other possible connections, affiliations, and associations. The opposite of relational is autonomous, independent, isolated, and closed. The relational is synonymous with interdependence, connectedness, and openness. The relational evokes today's networked culture, literally and metaphorically, where a web of associations, uses, constraints, and contexts determines design. Relational design is preoccupied with design's effects, extending beyond the form of the design object and its attendant meanings and cultural symbolism. This trajectory takes us through three distinct phases of modern design in this past century, moving from form to content to context, or in semiotic terms, from syntax to semantics to pragmatics. —AB, "'Was it lunch, or was it relational design?'" *Items*, May 2009

NORM | Dimitri Bruni and Manuel Krebs, *Bruce Lee: The King of Kung Fu, His life, his art, his films and his death*, 2005, based on a book of the same title from the New Sport Series (Beirut: Modern Library, 1975) Courtesy NORM

"In the broadest aspects of communication, much work has recently been done to clarify theories and make them workable."
—Ray and Charles Eames, *A Communications Primer*, IBM, 1953

"Production is a concept embedded in the history of modernism. Avant-garde artists and designers treated the techniques of manufacture not as neutral, transparent means to an end but as devices equipped with cultural meaning and aesthetic character." —Ellen Lupton, "The Designer as Producer," 1998

"Graphic design" has been defined by a plethora of titles, terms, subcategories, movements, and zeitgeist-capturing phrases: communication design, visual communication, communication art & design, "designer as author," "designer as producer," and recently, "relational design" and "critical design." Additionally, certain extra-disciplinary concepts from art, cinema, architecture, and literary spheres are frequently applied to and compared with graphic design: auteur theory, deconstructivism, postmodernism, relational aesthetics, etc. This discourse is essential for graphic design, and can ideally provide critical viewpoints from which to consider the discipline and its position(s) in wider cultural and social contexts. From the practising designer's position, however, the particular phrasing of new movements or tendencies can at times result in a restrictive form of pigeonholing. Graphic design becomes accountable not to its own activities and contexts, but to preconceived ideas and categorisations. Attempts at new names and definitions often betray an assumption that "graphic design" itself is too limited, merely the term means the simple service-oriented industry that many still see it as. Instead, I would argue that graphic design has always occupied a unique position between reading, writing, editing, and distribution and is a discipline nuanced and expansive enough in its everyday activities and processes to make renaming unnecessary. Rather than seeing "graphic design" as too narrow for the multidisciplinarity of contemporary practice, designers, design critics, and historians might instead widen their own perceptions of what exactly the term can logically encompass.

Everywhere and Nowhere
An important part of reading "graphic design" as an inherently multidisciplinary practice is the recognition of "designing" as including ostensibly banal, supposedly "non-design" activities in its definition: dia-logue, research, organisation, management, and the reading, writing, editing mentioned above are all facets open to analysis, exploration, and even subversion. In accepting this definition, the idea of a graphic designer doing things like editing a book, publishing a zine, performing a public reading or curating an exhibition should not be unexpected, let alone seen as exotic. The experienced graphic designer—whether working only by commission, or with a mix of commissioned and self-initiated projects—becomes naturally skilled in all of these areas, so it is only logical to apply this knowledge both in the service of a client and as a means of self-production, analysing all channels of interpretation, production and distribution for potential creative and critical scope.

London-based Swiss designer Laurent Benner and Switzerland-based Brit Jonathan Hares' in-situ printing and sampler-assembly system for *The Most Beautiful Swiss Books* catalogues (2005–2007)[1] perhaps embodies this approach taken to its logical conclusion, where the designers were explicitly coordinators of, and participants with, the editor, paper merchant, printer, and binder: the approach itself determining the form of the book. As the designer of the following *MBSB* triptych (2008–2010), designer Laurenz Brunner took on the related (and conceptually crucial) roles of picture researcher and coeditor with Swiss writer-editor Tan Wälchli, emphasising the idea of the *MBSB* catalogue being a kind of meta-book: a book about books. In a past *MBSB*-awarded project, Cornel Windlin's design and editing roles for *Project Vitra*, taking in content-specific art-directed photography, extended to comprehensive content and picture research (also evident in his art direction for *Tate Etc.* magazine). Where in 2005, Swiss designers Norm operated as publisher, editor, and producer for pseudo-reissue *Bruce Lee*,[2] in 2008 Urs Lehni featured not only in the designer, printer, and publisher categories (with his Rollo Press imprint) for Linus Bill's *Tu m'as volé le velo*, but also simply as "Printer" for Simplex Grafik's *Transfer*, using his eBay-sourced Risograph GR 3770 stencil duplicator. This is nothing new, of course, as countless other polymathic precedents show, historically from William Morris' Kelmscott Press through Kurt Schwitters' *Merz*, Herbert Spencer's *Typographica* to Muriel Cooper's MIT Visible Language Workshop, and more recently the designer-editor-publisher output of Will Holder, Jop van Bennekom, and Dexter Sinister (David Reinfurt and Stuart Bailey), to name just a few.

Graphic design operating beyond its usual assumed boundaries often provokes an art vs. design debate, but one should instead judge the idea of an inherently expansive design practice less as a renegotiation of design and art boundaries and more as an acceptance of graphic design as emphatically "graphic design," with all the aforementioned scope, activities, and contexts the term encompasses. Indeed, we should embrace the idea that graphic design might happily operate as a paradoxically ubiquitous yet overlooked system. Rather than aspiring to a perceived higher level of "authorship" in the cultural hierarchy (be it art, literature, architecture), we can instead take advantage of the discipline's invisibility, its spectral qualities. To quote Stuart Bailey: "[Graphic design] isn't an a priori discipline, but a ghost; both a grey area and a meeting point."[3] This slightly ambiguous position, a distinctly in-between discipline that is both everywhere and nowhere, is to our benefit, allowing graphic design to talk without boundaries to a wider audience, while also enabling us to infiltrate and use the systems of other disciplines when desired and where relevant. As M/M (Paris) point out: "[Graphic design] has neither a target group, nor fixed points of distribution, as do art or cinema. We have […] the opportunity of utilising the various communication networks simultaneously, the very specialised ones, as well as those of the general public."[4]

When invited to contribute work for standard design magazine showcases, London designers Åbäke instead often propose to "publish" their own parasitic magazine *I Am Still Alive*, which "only exists in other people's publications." Issues have appeared variously, and irregularly, in such periodicals as *IDEA*, *A Magazine*, and *Lodown* [see *I Am Still Alive #21* on pages 145–160 in this catalogue]. Berlin-based designer Manuel Raeder similarly appropriates existing distribution networks with his work on seasonal lookbooks for fashion collective BLESS: publishing them as features in fashion magazines, thereby making their work visible to a wider and seasonally varied audience than the usual exclusive fashion world mailing list of editors and buyers. Dutch designer/researchers Metahaven achieve a kind of ominous legitimacy for their self-published speculative geopolitical polemics with the simple deployment of such readymade formats as postage stamps, currency, passports—even fruit labels.

Art and Design
Designers initiating a more expanded involvement in given projects are today less likely to be doing so for motives of personal expression, a common misunderstand-

ing of 1990s "designer as author" notions. Rather than simple signature statement or addition of subjective opinion, the designer now more frequently aims to add more intangible, almost invisible elements to a given project: particular functional and conceptual inputs that all work to support (and, admittedly, sometimes subvert) the given content. Sensitivity becomes a signature, as opposed to an overtly stylised aesthetic. In this sense, the designer recognises the aforementioned invisibility of the graphic designer and uses it to their (and the project's) advantage. This kind of authorship perhaps conforms to László Maholy-Nagy's definition: an "anti-signature" based on process rather than craftsmanship. We could also take German typographer and book designer Hans Peter Willberg's definition of an "image author" (working in tandem with the "text author"), where any book project ideally involves direct collaboration right from its conception between author, designer, printer, and publisher.

This is why the false dichotomy of "constrained commissioned work" vs. "experimental self-initiated work" does not really represent the reality of current graphic design practice. While constraints are happily adopted and essential to creative outcomes for most designers, they do not exclusively belong to commissioned projects. Designers also regularly impose constraints and rules on self-initiated work, and conversely find and explore open critical frameworks within commissioned projects. My use of the word "constraint" here is chosen very carefully against the more familiar "compromise," a frequent caveat used by designers to blame a client for a project's unsuccessful outcome. Charles Eames made this important difference of attitude clear when describing his work ethic: "I don't remember ever being forced to accept compromises, but I have willingly accepted constraints." [5]

A common criticism of contemporary progressive graphic design is its ostensibly narrow field of projects and clients: invariably within the cultural sector, a kind of ghetto in which, it is argued, little effect or positive influence on society at large can take place. To a certain degree the criticism can be valid, and the point is particularly interesting to note in relation to the above *Most Beautiful Swiss Books* examples, both in light of Jan Tschichold's original motivation for the award to encourage standards and values for the broader industry, and with the acknowledgment that a growing proportion of the books awarded are art catalogues. However, such criticisms often ignore the realities of graphic design prac-

tice and modes of commissioning. Rather than designers exclusively approaching cultural organisations as an aesthetic choice or ethical stance (the art world: ethical?), for many, arts clients seemingly remain the only ones willing to entrust projects to independent designers and small studios. While most of these studios would happily take on the challenges of mass-market publishing—trade paperbacks, technical books, corporate annual reports, etc.—given the chance, the opportunity seems largely absent. The days of Paul Rand, Bruno Munari, Derek Birdsall, Karl Gerstner, et al. combining writing, self-publishing, research, even painting, with publication, identity, or advertising work (in their case for the likes of IBM, Campari, Mobil, or Geigy, respectively) seem well and truly over.

There is therefore a particular irony to be found in the renewed value contemporary book design places on the very production models no longer employed by the mass market: materials and design quality that have now seemingly become the sole domain of cultural sector publishing. References to dictionaries and technical manuals (screenprinted PVC covers), travel guides (pattern-embossed covers, colour section inserts), newspapers (mixes of newsprint and lightweight gloss stock), and trade paperbacks (pocket formats and cheap book wove stock) can be found re-contextualised in many contemporary design projects. A potential danger with the use of now-rarified methods originally found in "inexpensive books for people" is that we conversely end up with the very "luxury books for snobs" Jan Tschichold warned against in his demands for the ideal "new book." [6]

Everyone as Author
The recent prominence of notional "critical" and "relational" design movements in graphic design discourse is partly due to the wider availability of systems facilitating such expanded activities, particularly small presses, office printer/duplicators, and online print-on-demand services (Lulu.com, Blurb, et al.). But in encouraging designers' scope for self-production, we must acknowledge the simultaneous democratisation of such processes for a much wider general audience in the past ten years or so. Having customised Myspace and Facebook pages, published comments on newspaper stories, uploaded content to Flickr and YouTube, and become 24/7 broadcasters on Twitter, it is no longer a stretch for web users to submit PDFs to print-on-demand services, transforming themselves instantly —if unwittingly—into authors, editors, pro-

ducers, printers, and distributors. Whether designer or reader, will this phenomenon begin to affect graphic design as a professional discipline? Perhaps it already has: looking at *MBSB*-awarded publications, digitally printed books in the past few years include Cynthia Tuan's *Intersection: 4 Cities/360 People* (in an edition of only fifteen) and *Silex No. 20*. Print-on-demand productions also feature groenland.berlin. basel's *Buchstaben, Bilder, Bytes,* published with German POD service Books on Demand (bod.de) in 2004; and Rafael Koch and Urs Hofer's *Encyclopaedizer 2006–04*, with Lulu.com in 2006.

In this democratised public realm, graphic design remains what it has always been: an open-ended discipline where analysis of its everyday activities and tools reveals an inherent scope for a systematic approach to commissioned work and a logical capacity for self-production. Rather than debating art vs. design or authorship vs. subservience, we are free to focus on meaning, relevance, and context. The dichotomies are simplified: good or bad, beautiful (i.e., appropriate, functional, or even just, well, "beautiful") or ugly, useful or useless. Urs Lehni's William Morris riff on Rollo-press.com's "About" page sums it up well: "To own the means of production is the only way to gain back pleasure in work, and this, in return, is considered as a prerequisite for the production of (applied) art and beauty." [7] ⊠

Originally printed in the catalogue *The Most Beautiful Swiss Books 2008* (Bern: Swiss Federal Office of Culture, 2009); edited by the author for *Graphic Design: Now in Production*, Walker Art Center, 2011.

Notes
1. From 2005 to 2007, Laurent Benner and Jonathan Hares designed the annual award catalogues *The Most Beautiful Swiss Books,* in which eight pages of each of the winning books were reprinted on their respective original papers at various printers in Switzerland and abroad.
2. Norm's Manuel Krebs and Dimitri Bruni's *Bruce Lee* is a self-published reprint and adaptation of a small book originally published in Lebanon about thirty years ago.
3. Peter Bil'ak, "Graphic Design in the White Cube," 22nd International Biennale of Graphic Design, Brno, 2006, http://www.typotheque.com/articles/graphic_design_in_ the_white_cube.
4. M/M (Paris), interview by Lionel Bovier, "Design in an Expanded Field," in *Berlin/Berlin*, ed. Miriam Wiesel, Klaus Biesenbach, Hans-Ulrich Obrist, and Nancy Spector (Ostfildern: Cantz Verlag, 1998).
5. Charles & Ray Eames, *Design Q&A* (Herman Miller Inc., 1972).
6. Jan Tschichold, *Die Neue Typographie* (1928), from Robin Kinross, "Old Ideas of the New Book: The Phantom of 'Beauty,'" in *The Most Beautiful Swiss Books 2007*, ed. Tan Wälchli and Laurenz Brunner (Bern: Swiss Federal Office of Culture, 2008).
7. Rollo Press, "About Rollo Press™," http://rollo-press .com/about/.

Stuart Bailey, Angie Keefer, and David Reinfurt, *Bulletins of The Serving Library Nº 1*, 2011 Courtesy the artists

Dexter Sinister, *Portable Document Format*, 2009 Courtesy the artists

Project Projects, *Art in General New Commissions Program Book Series*, 2009 Courtesy Art in General

Dear Lulu,
Please try and print these line, colour, pattern, format, texture and typography tests for us.

Alex, Alice, André, Andreas, Anja, Christoph, Frank, James, Juliane, Michael, Patrick, Rimma & Tim
Hochschule Darmstadt, FB Gestaltung
Practise, London

Dear Blurb,
Please try and print these line, colour, pattern, format, texture and typography tests for us.

Alex, Alice, André, Andreas, Anja, Christoph, Frank, James, Juliane, Michael, Patrick, Rimma & Tim
Hochschule Darmstadt, FB Gestaltung
Practise, London

Dear BoD,
Please try and print these line, colour, pattern, format, texture and typography tests for us.

Alex, Alice, André, Andreas, Anja, Christoph, Frank, James, Juliane, Michael, Patrick, Rimma & Tim
Hochschule Darmstadt, FB Gestaltung
Practise, London

Dear Kolofon,
Please try and print these line, colour, pattern, format, texture and typography tests for us.

Alex, Alice, André, Andreas, Anja, Christoph, Frank, James, Juliane, Michael, Patrick, Rimma & Tim
Hochschule Darmstadt, FB Gestaltung
Practise, London

Above and below: James Goggin, *Dear Lulu, Calibration*, created with Frank Philippin and Michael Helmle, Patrick Gasselsdorfer, Alice Matthess, Anja Grunert, Tim Heiler, Juliane Karnahl, Christoph Kronenberg, André Schubert, Andreas Strack, Rimma Khasanshina, and Alexander Lis, 2008 Courtesy the artist

Print on Demand

With a print-on-demand system for manufacturing copies of a book or other documents in response to customer orders, a publisher can create as few as just one copy of a document instead of investing in producing and storing bulk inventory. Equipment such as the Espresso Book Machine (ABM) is designed to print, bind, and trim documents in a single process. Print-on-demand books have a relatively high unit cost yet require little investment for publishing short runs. Some bookstores have installed POD equipment on-site in order to provide customers with out-of-print titles as well as self-published editions. Online services such as Lulu, Blurb, and HP MagCloud allow customers to upload documents and offer them for sale; in addition to printing and binding the books, these services fulfill orders and keep track of sales and royalties. The design firm Project Projects employed print on demand for an ongoing series of exhibition catalogues for Art in General, an alternative space in New York City. Although the internal design varies from book to book, each is packaged in a standard POD format; a white band wrapping the spines imparts consistency across the series. The "demand" in "print on demand" tends to be low, making this technology suitable for niche projects such as exhibition catalogues, family albums, local histories, and fund-raising brochures. —EL

Portable Document Format (PDF)

Created by Adobe Systems in 1993, PDF is an open standard for exchanging documents through electronic means. Each PDF is a description of a page document that includes text, graphics, images, and fonts as well as other information needed to display its contents as originally designed. Unlike web-based page displays in browsers, the PDF is a fixed representation of its content, although it is possible to edit and append such documents outside of read-only modes. ¶ Dexter Sinister published *Portable Document Format* (2009), a collection of articles ("bulletins") originally available as PDFs on the Library section of their website, dextersinister.org. It also serves as a precursor publication of *The Serving Library*, their latest venture that draws upon their interest in modes of production with concepts such as just in time publishing and expands it to explore on-demand systems and networks of distribution. The downloadable PDF format is utilized as a corpus of content as bulletins accumulate to form a printed and bound volume, which is published semi-annually. As the initiators of *The Serving Library* acknowledge: "publishing and archiving have traditionally existed at opposite ends of the trajectory of knowledge production, but here, in accord with the cheap and easy distribution afforded by an electronic network, they coalesce into a single process. In this way *The Serving Library* diagrams a reversible, looping principle: it is an archive that publishes and a publisher that archives." ¶ Ben Fry, one of the cofounders of Processing, the open source programming language, has published *Frankenstein*, a print-on-demand version of the famous novel by Mary Shelley. Fry explains the process: "This book was laid out using characters and glyphs from PDF documents obtained through Internet searches. The incomplete fonts found in the PDFs were reassembled into the text of *Frankenstein* based on their frequency of use. The most common characters are employed at the beginning of the book, and the text devolves into less common, more grotesque shapes and forms toward the end." Like Frankenstein, Fry reassembles the words to Shelley's text letter by letter, creating a new definition of a "typeface." His resulting creation does not draw upon conventional typographic notions of family resemblance among letterforms to form a unity, but rather introduces extreme variability to each letterform and in the process achieves true discord and visual dissonance. —AB

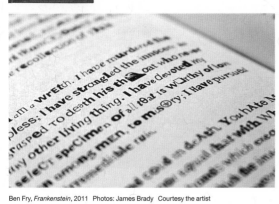

Ben Fry, *Frankenstein*, 2011 Photos: James Brady Courtesy the artist

Just-In-Time Production

At the beginning of the 20th century, Ford Motor Company established the first widely-adopted model of factory production. Breaking down the manufacture of a Model T automobile into its constituent processes and assigning these to a sequence of workers and inventories, significant efficiencies could be realized. This Assembly-Line approach utilized increasingly specialized skills of each worker on a coordinated production line as the manufactured product proceeded from beginning to end. Large inventories, skilled laborers and extensive capital investment were required. Design revisions were expensive (if not impossible) to implement and the feedback loop with its surrounding economy was largely absent. Complicit with its early-Capitalist context, manufacturing at this scale remained necessarily in the hands of those with the resources to maintain it. ¶ By the mid-1950s, Toyota Motor Corporation of Japan began to explore a more fluid production model. Without the massive warehouse spaces available to store inventories required for an Assembly-Line, Toyota developed the Just-In-Time production model and inverted the stakes of manufacturing. By exploiting and implementing a fluid communications infrastructure along the supply line of parts, manufacturers, labor and customers, Toyota could maintain smaller inventories and make rapid adjustments. A quicker response time was now possible and products could be made when they were needed. All of the work could be handled by a wider number of less-specialized workers and design revisions could be made on-the-fly without shutting down production and re-tooling. The result was an immediate surplus of cash (due to reduced inventories) and a sustainable, responsive design and production system—smaller warehouses, faster communications networks, responsive and iterative design revision and products made as they are needed: Just-In-Time. It isn't difficult to imagine a correspondence between these two models (Assembly-Line, Just-In-Time) and contemporary modes of print production. The prevailing model of professional practice is firmly entrenched in the Fordist Assembly-Line. Writing, design, production, printing and distribution are each handled discretely by specialists as the project proceeds through a chain of command and production. Recently, laser printers, photocopiers, page-layout softwares, cell phones, and word processors have split this model wide open. A project might reasonably be written by the publisher who begins a layout and works with the designer who commissions a writer, and sources a printer that will produce fifty copies by Wednesday. —Stuart Bailey and David Reinfurt, dextersinister.org

2011
Reading and Writing
Ellen Lupton

Iñaki Bonillas and Roger Willems, *White Book*, 2002 Courtesy Roma Publications

Sara De Bondt, *The Portable John Latham*, 2010
Courtesy Occasional Papers

Sara De Bondt, *The Form of the Book Book*, 2009
Courtesy Occasional Papers

Occasional Papers
Based in London, Occasional Papers describes itself as a nonprofit publisher of affordable books about the history of art, design, architecture, film, and literature. The press was founded by graphic designer Sara De Bondt and writer Antony Hudek. Their publications include *The Form of the Book Book*, the proceedings of a conference organized by De Bondt at St Bride Library in 2009, and *The Portable John Latham*, a selection of documents drawn from the archive of the late British artist. Marshall McLuhan described the printed book in *The Gutenburg Galaxy* as a kind of natural resource: "Typography is not only a technology but is in itself a natural resource or staple, like cotton or timber or radio; and, like any staple, it shapes not only private sense ratios but also patterns of communal interdependence." In a similar spirit, the plain-spoken products of Occasional Papers speak to the elemental necessity and social value of print. —EL

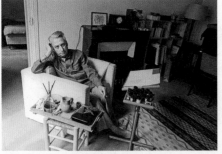

Roland Barthes, 1978 Photo ©Sophie Bassouls/Sygma/Corbis

Fanette Mellier, *Bastard Battle*, a novel by Celine Minard, 2008 Courtesy Dissonances

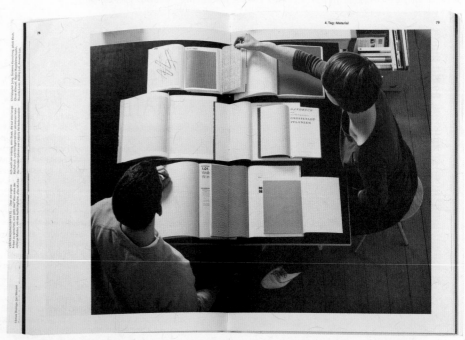

Markus Dressen, Lina Grumm, Anne König, and Jan Wenzel, *Liner Notes*, 2009, designed by Markus Dressen and Lina Grumm Photo: Sally Foster
Courtesy Spector Books

"To give a text an Author is to pose a limit on that text, to furnish it with a final signified, to close the writing."
—Roland Barthes, 1968

Long ago and far away, Roland Barthes pronounced "the death of the author." The year was 1968 and the place was Paris, epicenter of the postmodern mind-set. Banished to the grave was the myth of the artist as sole originator of a work, an autonomous creator whose life story and personal psychology might unlock a sacred inner truth. The text became a nexus of connections at the mercy of history, context, and use. Closing the author's casket meant liberating a new figure—the reader—to find and construct meaning: "The reader is the space on which all the quotations that make up a writing are inscribed; a text's unity lies not in its origins but in its destination."[1] The author was dead, and the reader was born.

Did the author truly perish, or did he stumble off to heal himself, returning as a different kind of creature, monstrous perhaps, or fractured into a million little pieces? What status do "the author" and "the reader" hold today within the discourse of design and within the broader tech-saturated culture? How have the roles of reader and writer, sender and receiver, evolved in our networked, open-sourced, all-in media world? The phrase "designer as author" has stirred two decades of debates about design's agency (or lack thereof) in the manufacture of content, while successive generations of makers have plunged into the surging workflow of reading, writing, editing, and publishing. The process of design (a tool that anyone can use) has become more important than the identity of designers (a specialized caste of professionals).

Taking on the role of producer, many contemporary designers are pursuing self-initiated endeavors alongside commercial work, seeking balance between personal and economic satisfaction. They are building collaborative businesses while organizing exhibitions and publishing books, blogs, and magazines. Enabled by digital distribution systems, today's long tail media ecology harbors an endless range of niche markets, inviting new players to jump in and reap rewards whose value is more social than monetary. It is against this backdrop of a pragmatic, collaborative, hands-on creative community that we revisit questions about the life and death of reading, writing, and graphic design.

The Designer as Author

Let's begin this story of calamity and renewal by reviewing graphic design's troubled narrative about authorship. It's a tale that hinges on our Oedipal battle with clients and content-makers, fought from our gravy-stained seats at the kids' table. What does authorship mean within graphic design's own anxious discourse? Does becoming an author entail forging a distinctive visual approach—a recognizable style equivalent to the signature voice of a writer—or does authorship require originating content and initiating projects? Design critic Rick Poynor helped launch this now-familiar debate in 1991 with his article "The Designer as Author," published in the prominent UK magazine *Blueprint*. Back in that mind-blinding period of typographic invention, "new wave" designers like Neville Brody and Jonathan Barnbrook were creating subversive visual readings of given texts. Poynor, looking at the practice of annotating a client's message with layers of visual complexity, approached his subject with both interest and skepticism, wondering when these gifted and form-frenzied designers would figure out what they wanted to say.[2]

As founding editor of *Eye* magazine, Poynor commissioned Michael Rock to write a piece on "The Designer as Author."[3] Published in 1996, Rock's far-ranging critique took note of numerous modes of design authorship (illustrated books, artists books, portfolio monographs, curated exhibitions, and so on), but like Poynor, Rock was especially interested in designers whose distinctive methods constituted their own form of invention. Rock's piece inspired a wave of would-be design authors, especially among those who equated authorship with self-initiated projects. Rock became the unwilling poster child of a "designer as author" epidemic, even though his essay had sought, at bottom, to cast doubt on the cult of content, encouraging designers instead to focus on visual techniques that construct meaning above and beyond that of the text or message.

Lashing back, Rock published his passionate rant "Fuck Content" in 2005. Rock admonished designers to focus on how things look and how they communicate, not on what the message is: "to fully recuperate design from its second-class status under the thumb of content you must … say that treatment is a kind of text itself, equal to, and as complex and referential as, traditional forms of content. The materiality of a designer's method is his or her content and through those material/visual moves, a designer speaks."[4] Rock confronted head-on the anxiety many designers feel about their marginal role in the communications cycle—called in at the end of the process to make things look good. According to Rock, designers are better off asserting the importance of frame-making and form-giving than trying to borrow prestige from the Author (a figure who, after all, is long since dead and departed). Dmitri Siegel delivered a similar scold on *Design Observer*, asking, "Is the allure of the legitimacy of authorship pulling design away from the defining characteristic of the profession—the designer/client relationship?" Siegel warned that designers who want to produce their own content won't find much of an audience anyway and will have bigger impact doing client work in the commercial arena.[5]

Ignoring such stern counsel, countless designers have kept at it anyway, embracing the tasks of writing, editing, and publishing alongside layout and typography. Publishing books has become the site of heated social activity, as seen in the rash of book fairs and short-run publishing houses worldwide. *Liner Notes* (2009), a book about the art of book design, speaks in several registers about the sudden outbreak of independent publishing. Created by a team of young designers and editors, *Liner Notes* is packed with photographs depicting books in a living human context: books are handled, sorted, and stacked, rarely isolated as pristine objects. The authors of *Liner Notes* ask, "What does it mean to design a book? As design produces an independent text, the designer's role could be compared to that of an author. As design marks a position regarding the content, the designer's frame of action could be compared to that of a critic."[6] While such a statement falls in line with Rock's insistence on form-making as content-making, these designers have become authors in a more direct sense as well, gathering material for their own book and writing page after page of text. *Liner Notes* speaks in a loose, conversational tone; a similar demeanor characterizes much contemporary design authorship, where transcripts and notes take precedence over carefully crafted arguments—more chat than treatise.[7] *Liner Notes* was published by Spector Books (Leipzig), one among dozens of small publishing houses that have sprung up in recent years, including Roma Publications (Netherlands) and Occasional Papers (London).

59

These small-scale publishing endeavors, launched by designers, writers, and artists, align with the pragmatic social outlook of the contemporary creative scene. Rob Giampietro has observed that his peers are more inclined to collaborate with a group than push their individual identities: "The designers I know are Pragmatists. Their preferred site is not commerce, the state, the academy, or the design press, but the Internet and the nonprofit organization. Neither hierarchical nor individualistic, the Pragmatists' chief structure is the collective, the band, or the project working group.... Their mode is not one of mass but of localized production. Their interest in the design object extends beyond its construction to encompass the circumstances of its distribution and circulation." [8] Embracing action over form, such work looks outward, striving less to craft a personal voice than to shape a situation.

Working in more familiar commercial territory, graphic designers have long counted publishing houses among their clients. Design often steps away from the spotlight, especially in literary publishing. Yet the very poise and discretion of a well-produced book legitimates the work, signaling that it has survived the publishing world's brutal gauntlet of selection and exclusion. In contrast, commercial media (textbooks, magazines, junk mail) invite the frame to interfere with the way readers read and the way writers write. Headlines respond to layouts; copy conforms to word counts; captions, decks, and pull quotes carve inroads to the main story. The frame takes over.

Occasionally, a graphic designer proves that this labor of frame-making is not only *akin* to authorship but actually *is* authorship—and thus deserves a share of the credits, royalties, and other privileges the title accrues. A hugely successful precedent is the book *The Medium is the Massage*, coauthored by Marshall McLuhan and graphic designer Quentin Fiore in 1967. Fiore initiated the project, sifting through McLuhan's published writings in order to produce a compact paperback packed with high-contrast photos and high-speed aphorisms. The book had no manuscript; it was pulled into shape by the editorial hand and eye of the designer. [9] The history and impact of the McLuhan/Fiore collaboration is the subject of a new book, published in a similarly compact form, by Inventory Books in 2011.

Bruce Mau's book *S, M, L, XL* is a six-pound collaboration with architect Rem Koolhaas (1996). [10] Mau, who had made his name designing luxurious volumes of critical theory for Zone Books, now laid claim to the *authority* of authorship by asserting that his treatment, selection, and sequencing of visual material deserved cover credit. He went on to produce his own mid-career monograph *Life Style* (2000) [11] and the ecological treatise *Massive Change* (2004). [12] The making of *Massive Change* required a team of writers, researchers, designers, and editors. In elevating the designer's role within the publishing enterprise, Mau was rethinking what an author is as well.

Books about art and design are especially conducive to graphic engagement. Mau published *Life Style* and *Massive Change* with Phaidon, a leading international publisher of texts about visual culture (including food). Numerous designers have formed their own publishing companies or imprints. Inspired to produce books from the bottom up, they have wielded their taste, skill, and connections to launch such ambitious endeavors as Lars Müller Publishers (Baden), Unit Editions (London), and Fuel Publications (London).

The phrase "designer as author" harbors a refusal, a bleep of denial. The humble preposition "as" marks a fissure between identity and aspiration—a gasp of disbelief between who we are and who we wish to be. How has authorship changed from the point of view of the writer? What became of the character said to have met his demise in the murderous hands of postmodernism? Let us now observe the rakish ways of the undead.

The Author

In 2004, Bernadette Corporation, a collective of artists known for organizing "spontaneous, purposeless events" and producing a fashion label, an art magazine, and a series of films, wrote the novel *Reena Spaulings*. [13] As an object, *Reena Spaulings* resembles any other—bound in paper, set in Garamond, and printed on creamy, medium-grade stock. What makes the book unusual is the way it was written. *Reena Spaulings* is said to be composed by one hundred fifty writers, who worked together like a "stable" of Hollywood screenwriters. The resulting book is as "generic and perfect" as any other corporate product. As Bernadette Corporation proclaimed in the preface: "An author is a routine, which makes for good conversation whenever that routine climbs down from the windswept seclusion that walks and breathes centuries of the word.... (A)n author is a person who writes, but also a role to be negotiated and trained by those who choose the books that can be read today. Becoming an author is a process of subjectivation, and so is becoming a soldier, becoming a cashier, becoming a potted plant (vii–viii)."

Bernadette Corporation thus defined authorship as a performance, a ritual enactment of social roles. Michel Foucault referred to this special kind of role-playing as the "author function." The notion of authorship emerged during the Renaissance, when church and state moved to hold people accountable for transgressive speech: the author became someone who could be punished for what he said. As the publishing industry formalized in the eighteenth century, the author became a person who owned the rights to a work and enabled it to be sold and circulated.

An author is a particular kind of individual whose identity is tied not to specific human actions or attributes but to a body of texts. Writing in 1972, Foucault predicted that as society changed, the author function would disappear. Questions about the originality and intentions of the writer would succumb to new questions about the social life of the text: "What are the modes of existence of this discourse? Where has it been used, how can it circulate, and who can appropriate it for himself?" [14] In the age of self-publishing and social media, the author function has splintered and multiplied. Society has changed, and so have the means of composing, consuming, and spreading the written word. "Author" is now a role that anyone can play.

Writer Tao Lin experiments with authorship as performance. The deadpan, short-beat prose of his harsh little novella *Shoplifting from American Apparel* (2009) aspires to the voicelessness of text messaging. [15] (Read it on your iPhone.) Mocking the media hype that ricochets around contemporary writers, Lin produces a flurry of self-promotion around his toneless novels, including a third-person, self-authored, *New Yorker*–style profile published in Seattle's *The Stranger*. (The profile comes with a dramatic headshot modeled after Jonathan Franzen's portrait on the cover of *Time* magazine). [16] As founder of Muumuu House, Lin has become an indie publisher as well, issuing such unlikely works as Megan Boyle's book of poems *Selected Unpublished Blog Posts of a Mexican Panda Express Employee* (2011).

It's easier to play publisher if you know something about graphic design. Accessible digital tools invite writers to play with the space of the book while enabling designers to become authors and editors.

Designer as Author

In the age of *Wikipedia* and online publishing, "authorship" has become a collaborative, often anonymous activity as well as a phenomenon so widespread that nearly anyone can sign his or her name to a text and share it with the world. Whereas authors were once esteemed individuals who laid claim to a fixed, canonical body of work, we now understand authorship as a fluid enterprise shaped by editors, designers, publishers, retailers, readers, and critics as well as writers. ¶ In practical terms, an author is someone whose name appears on the front of a book. Today, many designers are putting their own names on their own content, often presenting the history and discourse of their field in visually dynamic ways. Filling their volumes with pictures, words, and their own secret codes, designers are producing books for children, for adults, for other designers, and for themselves. ¶ Just as designers are embracing writing and authorship, so, too, are writers using the tools of layout and production to design their own books. As accessible software makes writers feel at ease with font names and photo editing, authors have embraced the book as both artifact and idea. Many writers are collaborating with designers and illustrators to create new kinds of literary experiences. —EL

Woman's World

Graham Rawle's *Woman's World* is a cut-and-paste novel about transgender love and trauma, constructed entirely from scraps of vintage women's magazines. This remarkable book succeeds in sustaining a reader's interest both verbally and visually. No mere design experiment, it is an arresting work of literary art. —EL

Graham Rowle, *Woman's World*, 2008 Courtesy Counterpoint Press

Maira Kalman, *And the Pursuit of Happiness*, 2010
Courtesy Penguin Press

Peter Buchanan-Smith with Maira Kalman,
The Principles of Uncertainty, 2007 Courtesy
Penguin Press

Reif Larsen with Ben Gibson, *The Selected Works of T. S. Spivet*, 2009, illustrated by Ben Gibson Courtesy The Penguin Group

The Selected Works of T. S. Spivet

Reif Larsen has described his novel *T. S. Spivet* as hypertext fiction mapped onto print. Back in the '90s, "hypertext" promised to spawn a brave new genre by letting readers click on links to choose their own plot. During the height of hypertext hysteria, when Larsen was a student at Brown, he despised the notion of point-and-click fiction, but eight years later he realized that *T. S. Spivet* was his own version of interactive lit: "It was essentially an exploded hypertext novel.… The key difference here was the exploded part. In *Spivet*, all the links had been expanded and mapped out on the page… It was up to the reader to break the narrative by following the arrow into the subconscious arena of the margins, but in doing so, he or she also knew this disruption was scripted and somehow purposeful to a larger whole." —EL See Reif Larsen, "The Crying of Lot 45: How Will a Page Change the Way We Tell Stories?," *The Believer* 77, 2011

Visual Writing

The way we think about visual writing is this: writing that uses visual elements as an integral part of the writing itself. Visual elements can come in all shapes and guises: they could be crossed out words, or photographs, or die-cuts, or blank pages, or better yet something we haven't seen. The main thing is that the visuals aren't gimmicky, decorative or extraneous, they are key to the story they are telling. And without them, that story would be something altogether different. —Anna Gerber and Britt Iverson, Visual Editions, www.visual-editions.com

Sara De Bondt, *Tree of Codes*, 2010 Courtesy Visual Editions

Tree of Codes

Jonathan Safran Foer authored *Tree of Codes* (2010), produced with Visual Editions, a design-driven press committed to what the publishers call "visual writing." To create *Tree of Codes*, Foer started with a short story by Bruno Schulz and then cut away most of the words to create a new text. The resulting production—printed in Germany, die-cut in the Netherlands, and hand-finished in Belgium—draws constant attention to the physical properties of the book. Foer has spoken frankly about his interest in design: "Why wouldn't—how couldn't—an author care about how his or her books look?… We've drawn a deep line in the sand around what we consider the novel to be, and what we're supposed to care about. So we're in the strange position of having much to say about what hangs on gallery walls and little about what hangs on the pages of our books." —EL See Steven Heller, "Jonathan Safran Foer's Book as Art Object," nytimes.com, 2010

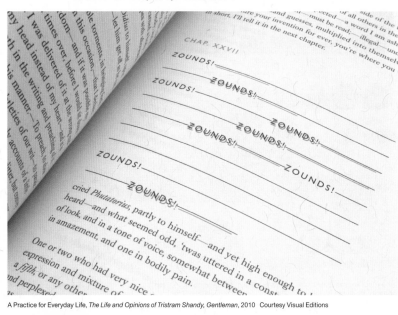

A Practice for Everyday Life, *The Life and Opinions of Tristram Shandy, Gentleman*, 2010 Courtesy Visual Editions

Anne Carson with Robert Currie, *Nox*, 2010, cover design by Rodrigo Corral Photos: Sally Foster Courtesy New Directions

Nox

Anne Carson's *Nox*, an elegy to her dead brother, is an accordion-fold scrapbook, photographically reproduced from her own cut-and-paste collages. Carson, an esteemed poet and classics scholar, has combined personal reflection with scholarly rigor while intrepidly embracing image, layout, and typography. Whether slicing a landscape into lean slivers or shredding photographic negatives into illegible ribbons, Carson displays an instinctive command of design. Even her typography—executed as it is with crude word processing software—conveys intuitive skill. She succeeds in performing in high gear with commonplace tools. —EL

M/M (Paris), *THE ALPHADICKS: Twenty-six Loaded Cowboys*, 2010, drawings by Mathias Augustyniak, introduction in rhyme by Glenn O'Brien Courtesy M/M (Paris)

Kenya Hara, *White*, 2010 Courtesy Lars Müller Publishers

Gerlinde Schuller, *Designing Universal Knowledge*, 2008 Courtesy Lars Müller Publishers

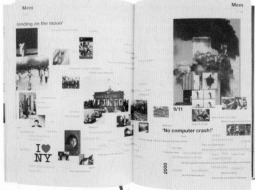

History Begins at Home

James Sholly of Commercial Artisan, a graphic design firm in Indianapolis, appropriated the stalwart promotional vehicle to undertake an exercise in researching and publishing the stories of important but overlooked figures of his local design scene. Published irregularly as the series *Commercial Article*, issues have shone a light on the life and work of Gene and Jackie Lacy, area pioneers in their introduction of modernism to the city, as well as the iconoclastic figure of Avriel Shull, who as a young woman operated her own design business in the 1950s branching out to design and build several modernist houses without an architectural license or training but which have found their way onto the historic register. In 2009, David Bennewith researched, designed, and published a book on Joseph Churchward, a prolific and fascinating Samoan-born, New Zealand-based designer and typographer. Both of these projects demonstrate the untapped potential to draw from local histories to expand and enrich the canon of graphic design and have inspired initiatives such as Unusual Suspects, a local design history project undertaken by Winterhouse Institute as a venture between *Design Observer* and AIGA. —AB

James Sholly and Jon Sholly, *Commercial Article Nº 3*, 2010 (left) and *Nº 1*, 2005 (right) Courtesy Commercial Artisan

Above and left: David Bennewith, *Churchward International Typefaces*, 2009 Photo: Franz Vos, Jan van Eyck Academie Courtesy the artist

Above and left: Rick Valicenti and John Pobolewski, *Intelligent Design*, 2006 Courtesy 3st

NORM | Dimitri Bruni and Manuel Krebs, *The Things*, 2002 Courtesy NORM

"It's not about the world of design. It's about the design of the world."

Sporting this tagline, *Massive Change* was an ambitious project initiated by Bruce Mau Design and the Institute without Boundaries created by Mau under the auspices of George Brown College in Toronto. Comprising an exhibition, a book, a radio program, an online forum, and various events and public programs, *Massive Change* was a multiplatform operation that harnessed the vision of its impresario to the research capacity of its many student participants. The project fused the utopian spirit of the power of design to solve global problems with the dystopian worldview of a planet facing enormous social and ecological challenges. Premised on the answer to the fundamental question, "Now that we can do anything, what will we do?" the project begun in the early 2000s was a bellwether of several trends, including social impact or humanitarian design, research-based design practices, transdisciplinary investigations and collaborations, and professional offices offering educational experiences, such as Weiden & Kennedy's W+K12 program (Portland, Oregon) and Benneton Group Communication's Fabrica (Treviso, Italy). —AB

In fact, the secret ambition of design is to become invisible, to be taken up into the culture, absorbed into the background. The highest order of success in design is to achieve ubiquity, to become banal.

Bruce Mau, *Massive Change*, 2004 Courtesy Phaidon

Bruce Mau, *Massive Change*, 2004 Courtesy Phaidon

Åbäke, *Utopia in Utopia*, 2011 Courtesy Dent-De-Leone

Christien Meindertsma, *Pig 05049*, 2008 Courtesy Idea Books

Everything but the Squeal

Christien Meindertsma's book *Pig 05049* methodically documents the 185 different parts of a slaughtered pig and its varied uses throughout contemporary life. Premised on examining the assumption that today's society is wasteful in general compared to the days of yore, Meindertsma charts the various products and by-products of the animal's skin, bones, meat, organs, blood, and fat. The result is a fascinating chronicle that ranges from the expected to the unexpected (X-ray film, beer, collagen, matches, fabric softener, and so on). The simple but evocative book design by Julie Joliat includes rosy, pigskin-colored paper and an earmark used to tag swine on the spine—the only unnatural part of the pig left over after its processing. —AB

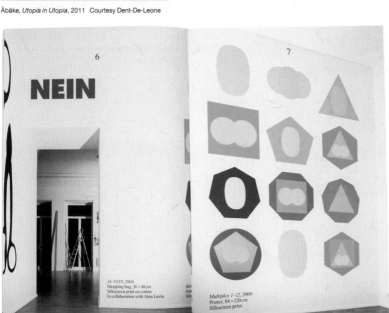

J4/NEIN, 2004
Shopping bag, 36 × 40 cm
Silkscreen print on cotton
In collaboration with Alon Levin

Multiplex 1–12, 2009
Poster, 84 × 120 cm
Silkscreen print

Above and right: Julia Born and Laurenz Brunner, *Title of the Show*, 2009 Courtesy the artists

Title of the Show

An exhibition and a catalogue by Julia Born and Laurenz Brunner, *Title of the Show* conflates the spaces of both productions while exploring the re-contextualization of design in a gallery setting. Created for the Museum of Contemporary Art, Leipzig, *Title of the Show* includes selections taken from Born's projects— books, posters, postage stamps—enlarged and presented on the gallery walls. Absent the actual artifacts, the show relies instead on strategies of graphic design to represent itself. Photographed by Johannes Schwartz and transposed in scale, these displays become the pages of the accompanying catalogue, creating a mise en abyme of representations. —AB

Modernist Cuisine

This six-volume, 2,400-page, 52-pound set explores the theory and practice of contemporary cooking. Combining art, science, and technology, *Modernist Cuisine* examines the new techniques and ingredients that are transforming haute cuisine, from water baths and centrifuges to emulsifiers and enzymes. Authored by Nathan Myhrvold, Chris Young, and Maxime Bilet with a team of twenty assistants, *Modernist Cuisine* is at once an extravagant visual production and a utilitarian tool. This is no coffee table book (indeed, it could cause your coffee table to collapse). A monumental work of self-publishing, the set was produced and financed by Myhrvold, a former Microsoft executive and professionally trained chef. Photographs by Ryan Matthew Smith and Myhrvold examine food and equipment from up close and inside out. Art directed by Mark Clemens, the project unfolded in an 18,000-foot warehouse equipped with its own photo studio and machine shop. The result is without doubt the most ambitious cookbook in history. —EL

Above and left: Nathan Myhrvold, Chris Young, and Maxime Bilet, *Modernist Cuisine*, 2011 Courtesy the Cooking Lab

An Infographics of Baking

Stylist Evelina Bratell and photographer Carl Kleiner have created stunning tableaux for *Homemade is Best*, an unconventional cookbook using baking ingredients to visualize recipes. Forsman & Bodenfors, the agency behind the project, explain: "We wanted to ensure a connection between IKEA's kitchen appliances and one of the best things you can do in a kitchen, some great baking. So the main attraction in the campaign became a 140-page coffee-table baking book presented in a very visually unique and spectacular way. The idea of the book became to tone down the actual cake and put the ingredients in focus. The recipes are presented as graphic still-life portraits on a warm and colourful stage. And when you turn the page you see the fantastic result." —AB

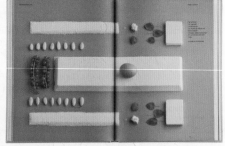

Forsman & Bodenfors, with Evelina Bratell (stylist) and Carl Kleiner (photographer), *Homemade is Best*, 2010 Courtesy Forsman & Bodenfors

Branding Authors

A designer can brand the output of an individual author as well as that of a whole company. Paul Sahre's covers for the pop-culture anthologies of Chuck Klosterman combine hard-core Helvetica with images of deranged consumerism, while Rodrigo Corral has brought visceral intensity to the novels of Chuck Palahniuk. Such sustained design work fabricates a graphic voice for authors to match their verbal ones. —EL

Left to right: Paul Sahre, *Why Some Politicians Are More Dangerous than Others*, 2011 Courtesy John Wiley & Sons; *Eating the Dinosaur*, 2009, illustration by Arline Simon Courtesy Simon & Schuster; *Sex, Drugs, and Cocoa Puffs*, 2004 Photo: Michael Northrup Courtesy Simon & Schuster

Left to right: Rodrigo Corral, *Tell-All*, 2010; *Rant*, 2007; *Super Sad True Love Story*, 2010 Courtesy Random House

Chip Kidd, *Conversations with Woody Allen*, 2009 Courtesy Random House

Chip Kidd, *Possible Side Effects*, 2006 Courtesy Picador

Chip Kidd, *The Learners*, 2008 Courtesy Harper Collins

Chip Kidd

Well before turning thirty, Chip Kidd had earned notoriety in the New York publishing world for his deftly seditious book covers, designed for Knopf and other houses beginning in the mid 1980s. He would soon become an author himself—writing two original novels, reissuing the classic '80s style guide *True Prep*, and compiling half a dozen books about comic book heroes. Kidd released his second novel, *The Learners*, in 2008. His jacket for a book of Woody Allen interviews offers a witty verbal solution in lieu of a celebrity photograph. Kidd's covers seduce and subvert. —EL

David Pearson, *Pocket Penguins* (boxed-set edition), 2005 Courtesy Penguin UK

Penguin Press

Designers may not be authors, but they do sell books, a fact recognized with exceptional constancy and conviction by Penguin Press in the UK. As a freelance designer for Penguin, David Pearson has used rich colors and tactile printing techniques to transform the company's classic backlist into seductive new commodities. (Do you really want to read Saint Augustine's *Confessions of a Sinner*? With a suggestive quote letterpressed on the cover, maybe.) —EL

David Pearson, *Great Ideas* series, 2004–2010 Courtesy Penguin UK

Angus Hyland, *The Books of the Bible and the Pocket Canons*, 2001 Courtesy Pentagram

Unpacking the Bible

This Bible series attempts to make the world's most influential publication more relevant to contemporary audiences by repackaging it into handy excerpts. Designed by Angus Hyland, the books' striking black-and-white photographic covers emphasize their contemporary appeal. Hyland selected a nuclear explosion to represent Revelation and a receding road for Exodus. —EL

Designer as Auteur

Book design has an enduring place in the tradition of publishing. In books with complex and varied content, the designer's role becomes as crucial as that of the author and editor. Designers determine the materiality of a publication—paper, binding, page size, printing methods—while creating a visual framework that invites readers to seek, find, and wander. Often working with vast archives of potential subject matter, designers actively gather, edit, frame, and sequence content. The possibilities become even broader in digital books, with their complex navigation and diverse media components. ¶ While e-readers have proven especially conducive to the linearity of fiction, visual books provoke a different kind of experience; an atlas or an artist's monograph aims to be collected, preserved, and perused out of sequence rather than to be read from front to back. Some visual books may remain well matched to the physicality of print, even as new types of media open up new ways to combine words and pictures. —EL

Irma Boom, *Every Thing Design*, 2009
Courtesy the artist

Irma Boom

Over the course of her career, Irma Boom has redefined the visual book through layout and physical construction. Her stunning monograph on product designer Hella Jongerius, *Misfit*, uses the physical production of the book to comment on Jongerius' own dialogue with imperfection. *Misfit* is stitched together in a single signature more than three hundred pages long; this unusual binding causes the pages to creep steadily beyond the confines of the cover—a seeming defect that makes the book exceptionally easy to flip through. Dysfunction yields unexpected functionality. —EL

Irma Boom, *James, Jennifer, Georgina*, 2010 Courtesy the artist

Irma Boom, *Sheila Hicks: Weaving as Metaphor*, 2006
Courtesy the artist

Irma Boom, *Hella Jongerius: Misfit*, 2011
Courtesy the artist

Irma Boom, *Biography in Books*, 2010 Courtesy the artist

Abbott Miller, Pentagram, *Matthew Barney: The Cremaster Cycle*, 2003 Courtesy the artist

Materiality of Method

Michael Rock of 2x4 has argued against the notion of the designer as author—that designers should not be obsessed with authorship as a way of influencing the design, but should rather explore the form and formats of design itself, seeking the highest level of "materiality of method." Abbott Miller's weighty tome for artist Matthew Barney's *The Cremaster Cycle*—equipped with an over-sized biomorphic thumb index—offers an alternative experience of a sprawling work of art. Julia Hasting, designer of numerous books for Phaidon, has created elaborate material experiments that underscore the notion of the book as an object of desire. Designers such as Lorraine Wild and Mevis & Van Deursen have transformed our notion of the museum exhibition catalogue experience, with editorial strategies such as close readings of texts, collaborations with artists, and explorations of book structure and pacing that helped invigorate an otherwise convention-laden genre. —AB

Julia Hasting, *10 x 10 / 3*, 2009 Courtesy Phaidon

Julia Hasting, *Sample: 100 Fashion Designers, 010 Curators, Cuttings from Contemporary Fashion*, 2007 Courtesy Phaidon

Julia Hasting, *A Day at El Bulli*, 2008
Courtesy Phaidon

Lorraine Wild, *The World from Here: Treasures of the Great Libraries in Los Angeles*, 2001 Courtesy the artist

Dave Eggers, a self-described hack designer and Macintosh temp, founded *Timothy McSweeney's Quarterly Concern* in 1998. Since then, McSweeney's has celebrated the physicality of print while actively exploring the business of independent publishing. Today, a wide range of digital technologies are enabling authors to become publishers. Seeking to break into the restricted world of publishing or to break away from unfavorable royalty schemes, designers and writers are experimenting with print on demand, self-publishing, and digital editions. Borrowing the concept of just-in-time production from Toyota Motor Corporation, David Reinfurt and Stuart Bailey have looked at ways to publish material responsively in small batches, consuming fewer resources and less warehouse space. Scott Thomas, design director of Barack Obama's 2008 US presidential campaign, self-published the book *Designing Obama*, selling print and digital editions directly from his own website; Thomas used the online crowd-funding platform Kickstarter to finance the project.

Desktop publishing started closing the divide between design and writing in the 1980s. Muriel Cooper, founder of the Visible Language Workshop at MIT's Media Lab, was among the first to take the leap. With access to early-generation digital typesetting equipment, Cooper was equipped to imagine a new mode of production: "The author would be the maker contrary to the specialization mode which makes the author of the content the author, the author of the form the designer, and the author of the craft the typographer/printer." [17] Implicit but not stated in Cooper's proposal was a further revolution: authorship would become a collaborative effort.

Shared authorship is now commonplace, ranging from the infinite enterprise of *Wikipedia* to smaller projects such as *Collaborative Futures*, a book successively rewritten and reissued via group "book sprints." [18] Such activities speak to a generation of readers and writers whose view of intellectual property is skeptical at best. Seth Grahame-Smith spawned a grossly successful literary franchise when he issued *Pride and Prejudice and Zombies* (2009), a book he created by downloading Jane Austen's public domain classic and adding zombie action to every page. [19] In the UK, the Piracy Project is exploring bootleg publishing in the developing world, where unauthorized editions often tamper with the original text. [20] Will Holder's project *The Middle of Nowhere* is authored by

"translating" William Morris' 1876 utopian fantasy *News from Nowhere* into a new guide for design education and practice set in the year 2135. [21]

For many authors working today, visualizing text is part of the writing. Anne Carson, Jonathan Safran Foer, Aleksandar Hemon, W. G. Sebald, Reif Larsen, and others have let pictures, typography, and layout intrude upon the hushed interior of literary discourse. Ignoring critics' complaints about graphic "bells and whistles" [22] and "razzle-dazzle narrative techniques," [23] these authors can't resist the seductive allure of the self-reflexive page. [24] Foer's novel *Extremely Loud and Incredibly Close* (2004) includes drawings, editor's marks, pages left blank, and pages set so tight the text becomes an unreadable blotch. [25]

Larsen sparked a storm of publicity when, as a young Columbia MFA graduate, he unleashed a bidding war among top publishers for *The Selected Works of T. S. Spivet*, the not-yet-coming-of-age tale of a prepubescent cartographer raised on a ranch in Montana. The margins of Larsen's book contain dozens of maps, diagrams, drawings, and footnotes depicting the protagonist's curious and precocious mind. The reading experience is surprisingly intuitive; not so surprisingly, critics have griped about the book's visual showmanship. Writing for the *New York Times*, Ginia Bellafante described *T. S. Spivet* as "burdened by device." [27] Writers, it would seem, should stick to writing.

Although Larsen's book employs the old medium of ink on paper, its production required the suite of digital tools that have transformed book design over the past quarter-century. These tools have changed the way a generation of writers thinks about books. What a page looks like—its shape and scale, its deployment of type and white spaces, its use of photographs, diagrams, and scholarly devices—are functions of the visual frame. The ability to engage that frame is among the defining resources of writers working today.

In their everyday lives, people today are writing more than ever. The vocabulary of SMS has upgraded "text" from noun to verb. The telephone, invented to deliver the living human voice, is now used for writing more than talking. Design is becoming universal as well, losing its expert edge and slipping into the mainstream culture. The production of websites, brochures, news articles, and even business cards is now part of basic college writing courses. [27] In schools of journalism, the phrase "everyone works on everything" marks the col-

lapse of thinking, making, and publishing into a continuous process. [28]

For all this talk of the self-empowered page, the lateral spread of publishing may have degraded its status overall. In a culture where everyone is a writer and writing is everywhere, the socioeconomic value of text production is falling. Terms like "content management," "content provider," and "content farm" underscore the generic, by-the-yard exchange of text in the digital marketplace. As Foucault pointed out, not all writing achieves the imprimatur of authorship: a letter or a contract may have a signatory, but we do not call this person an author. [29] Others who may fail to qualify as authors are the writers who pump out responses to commonly posed questions on Ask.com, or the readers who submit their personal stories to the *Chicken Soup for the Soul* franchise. Crowdsourcing lowers the manufacturing cost of content—that elusive commodity that so many people want but few are willing to pay for. Meanwhile, "black hat" search engine optimization uses phony content to send unwitting clicks to dubious websites. Phrases such as cloaking and auto blogging populate this wild frontier of non-authored content, whose primary purpose is to game Google.

In Barthes' boldly envisioned future, the reader would be beneficiary to the author's estate, inheriting a wealth of opportunity. Authorship was about pinning down the edges of a text and sealing off its borders; reading, in contrast, would be active, open, generative, infinite. So what became of the reader? Since the turn of the twenty-first century, we have seen collaborative, automated, and self-authored publishing endeavors assault the norms of authorship, while writers and designers alike have employed typography and page formats as world-shaping devices. The recipient of this lavish surplus was supposed to be the reader. Where, oh where did she go?

The Reader

In a 2011 interview, novelist Gary Shteyngart observed that in our contemporary culture of self-expression, many people would rather write than read. MFA programs in creative writing are swarmed with applicants while bookstores die of thirst. [30] The tables at international book fairs sag beneath a bounty of self-published volumes, yet the wares on view—often insular and obscure—celebrate the social act of publishing as much as any end-user experience. If you are reading this text now (and you started perusing it

Rob Cockerham (design) and Windell H. Oskay (fabricator), *Amazon Kindling*, 2009 Photo: Windell H. Oskay Courtesy evilmadscientist.com

Digital Readers

A physical device and/or software product that allows users to download and read books, digital readers have existed since the 1990s; however, the introduction of the Amazon Kindle in 2007 marked a watershed in product usability and customer acceptance. By interfacing with Amazon's online library, the Kindle eliminated the hassle of purchasing and loading books that beleaguered earlier digital book endeavors. The Kindle employs "electronic paper," a technology created by E Ink in Cambridge, Massachusetts. Unlike a typical computer screen, which glows, the Kindle screen is reflective, like paper. Digital ink consists of tiny capsules filled with black and white fluid. An electrostatic charge pushes white capsules to the top layer and pulls black capsules downward, creating a highly readable surface that remains in place until a new charge is received. Other digital readers, such as Apple's multipurpose iPad, use light-emitting touch screens. Digital readers are converging with tablet computers, supporting numerous other functions in addition to reading. Owing to a conflicting range of file formats, digital books purchased for one device can't necessarily be read on others. Many users hope that as the medium evolves, books will become interchangeable from one device to another. —EL

News Readers

An application or website that collects headlines, blogs, podcasts, and other syndicated content into a single stream or window, a news reader allows users to quickly scan information harvested from diverse sources. Also called a news aggregator or RSS feed, these readers take content from one context and present it in a new one, stripped of its distinctive typographic features and endowing with new. Websites that aggregate news stories can be carefully edited or curated (*Drudge Report*), or they can be wholly automated (*Google News*). For mobile devices, apps such as Flipboard, Pulse, and MyTaptu allow users to build custom streams from news and social media sites. Flipboard, described as a "personal magazine," samples text and images from various feeds and presents them in a dynamic grid—content-rich tweets or posts occupy more space than those containing just a short line of text. Several designers have experimented visually and editorially with the idea of a news reader. Jonathan Puckey's *The Quick Brown* gathers links to Fox News articles and uses typography to note changes in the headline copy. Information Architect's *The TPUTH* is a "machine generated, hand-polished news site" that employs i/A's web trends engine to collect links from online opinion leaders; custom-written headlines displayed in bold, bombastic capitals add a dash of tabloid spunk. —EL

Courtesy Flipboard

iA Writer

Oliver Reichenstein and his colleagues at Information Architects have embraced the iPad's status as a holding cell for the distracted mind by creating the hugely successful tool iA Writer, a word processor equipped with just one monospace font. (Starve the eye, and the mind will flourish.) When struggling to compose a tough sentence in iA Writer, the aspiring author can switch into FocusMode, which grays out the surrounding text; the icon for this constrained state of consciousness is a padlock. Put your brain on lockdown. —EL

Information Architects, Inc., iA Writer, 2010 Courtesy Information Architects, Inc.

Read Later

Read-later apps allow users to bookmark web pages for consumption at a future time. Services such as Readability (www.readability.com) and Instapaper (www.instapaper.com) display content in a streamlined format, stripped of advertising, navigation, and other competing elements. By creating a reading environment that minimizes distraction, such services allow users to harvest content from the crowded, action-oriented environment of the web and then consume it in a place of refuge. Bookmarked content can be read from a web browser, synced to a mobile device, or printed on paper. Readability, whose elegant typographic format recalls the conventions of print, offers to support the publishing industry by sharing membership fees with content producers. Unlike publishing models based on advertising, which bombard the user's "eyeballs" with commercial pitches, Readability focuses on delivering content to people willing to pay for a focused experience. The concept is built around mutual respect for readers and writers. —EL

Marco Arment, Instapaper, founded 2008 Courtesy Instapaper LLC

Screen Readers

Software applications designed to convert screen-based information into speech or Braille, screen readers can be applied to websites, electronic books, and other media, allowing blind, low-vision, illiterate, and learning-disabled users to access a broad range of content. For screen readers to be effective, content must be presented in a linear form, and visual elements such as images and buttons must be captioned and explained. Features such as "speech verbosity" allow users to skip over formatting descriptions or lists; "language verbosity" allows a text originating from the United Kingdom to be read in an English accent. —EL

MGMT Design, *An Inconvenient Truth*, 2006 Courtesy the artists

Melcher Media/Push Pop Press, *Our Choice*, 2010 Courtesy Melcher Media

Publishing Across Media

Al Gore's project *Our Choice* is an iPad app that combines text, video, sound, and interactive infographics to create a dynamic translation of Gore's famous public performances. Published in 2011, *Our Choice* follows upon the success of *An Inconvenient Truth*, a book designed by MGMT Design that has also appeared as a feature film and a PowerPoint lecture. Today's publishing environment invites content to flow across media, translating ideas for a range of appetites. —EL

Designer as Editor

Editing is the act of selecting and preparing materials—particularly texts and images—for publication. Using processes of selecting, condensing, managing, correcting, modifying, and ordering these materials, editors work with authors and designers to help shape and realize books. Designers have begun acting as editors in various publishing projects. For instance, designer Irma Boom performs the role of a photo editor in projects such as *Every Thing Design*, an 800-page exploration of the collection of the Gestaltung Museum, Zürich, or choosing a couple hundred postcards from among the more than a thousand exchanged between family members in *James Jennifer Georgina*. Lorraine Wild, working with her publishing partners in Greybull Press, helped source and edit the image material and orchestrate the ebb and flow of personal style in *Height of Fashion*; 2x4 performed a similar act when confronting the archives of Prada. Conny Purtill's design for *After Nature*, an exhibition of a confabulated post-ecological aftermath, literally wraps itself around an existing paperback edition of W. G. Sebald's work of the same name in one editorial masterstroke. The roles of editing and designing are joined in many projects undertaken by Will Holder, who happens to edit the journal *FR David*, or in the work of Stuart Bailey and David Reinfurt, who edited and designed the influential art and design journal *Dot Dot Dot*. Whether working with text or images, designers are increasingly called upon to gauge and orchestrate a potential cache of materials in order to create a tighter relationship between a book's form and its content. —AB

Purtill Family Business, *After Nature*, 2008 Courtesy the artist

Mevis & Van Deursen, *If/Then: Play*, 1999 Courtesy the artists

2x4, *Prada Libro*, 2010 Courtesy the artists

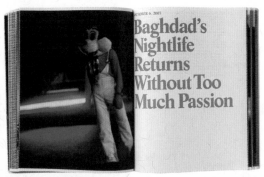

Mevis & Van Deursen, *Geert Van Kesteren: Why Mister Why?*, 2005 Courtesy the artists

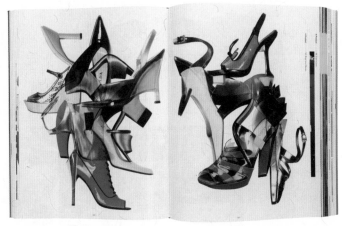

2x4, *Prada Libro*, 2010 Courtesy the artists

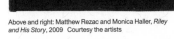

Above and right: Matthew Rezac and Monica Haller, *Riley and His Story*, 2009 Courtesy the artists

Dot Dot Dot

With twenty issues produced over a ten-year period, *Dot Dot Dot* presented itself as a new kind of design magazine. Upon founding their journal in 2000, the editors announced, "We are not interested in re-promoting established material or creating another 'portfolio' magazine. Instead, we offer inventive critical journalism on a variety of topics related both directly and indirectly to graphic design." Articles ranged from a cross-media reappraisal of plagiarism to a close reading of Robert Musil's unfinished novel *The Man Without Qualities*. Published under the aegis of Stuart Bailey and David Reinfurt's organization Dexter Sinister since 2006, the magazine ceased publication in January 2011 when Dexter Sinister initiated its next project, *The Serving Library*. —EL

Dexter Sinister, *Dot Dot Dot*, issue 10, Summer 2005, and issue 14, Summer 2007 Courtesy the artists

Anne Burdick, *Fackel-Schimpfwörterbuch*, 2008 Courtesy the artist

Anne Burdick, *Wörterbuch der Redensarten zu der von Karl Kraus 1899 bis 1936 herausgegebenen Zeitschrift Die Fackel*, 1999 Typographic consultant: Jens Gelhar Photo: Jeremy Eichenbaum Courtesy the artist

Wörterbuch der Redensarten

Complex reference works often demand typographic intervention. Anne Burdick's design for *Wörterbuch der Redensarten* (1999) is a dictionary of ideas drawn from Karl Kraus's early twentieth-century journal *Die Fackel*. Because Kraus himself was an avid typographic interventionist, the authors of this new work chose to scan some entries directly from the original printed pages while typesetting others. Burdick's design employs a pale background to indicate degrees of separation from the printed source: "raw white" for direct scans, a light tint for typeset quotations, and a deeper shade for new content. The format challenges the supposed "fungibility" of text—its ability to maintain its meaning over time even as its form changes through reprints, new editions, and so on. —Anne Burdick, "Graphic Design: Constructing Identities and Mapping Interactions," *Wörterbuch der Redensarten: Die Fackel*, 1999

Lorraine Wild, *Height of Fashion*, 2001 Courtesy the artist

Bik Van der Pol, *Past Imperfect*, edition of 10 publications, 2006, artist and concept by Bik Van der Pol, compiled and edited by Bik Van der Pol and Lisette Smits, designed by Will Holder, published by Casco Courtesy Bik Van der Pol

Falke Pisano, *Figures of Speech*, 2010, designed by Will Holder, edited by Falke Pisano and Will Holder Courtesy Christoph Keller Editions

DesignWriting

DesignWriting is defined as written communication that depends as much on verbal content as it does on visible form to convey the full breadth of its meaning. Examples of DesignWriting are most frequently found in popular culture where words and images mix freely, such as comics or advertising. Poetry, hypertext, charts, and diagrams are examples from the more conservative realm of scholarly discourse. It is in this land of "serious discourse" that my design research activities take place. DesignWriting in action requires that both words and visual form be developed in tandem, either by a single author or through tight collaboration. My DesignWriting process begins with a close reading of the content—which doesn't mean subject matter as much as writing strategy: the internal rhythms, sequence of ideas, range of voices and organizational logics—in order to develop visible form that is specific to each project. My goal is to interpret, through structure and form, the nuances, opportunities, and semantic requirements of each unique piece of writing. Ironically—or obviously—it is through focusing on the micro that I have been able to create innovations that answer to the macro: imagining new forms of writing through design. —Anne Burdick, "DesignWriting," *Design Research: Methods and Perspectives*, 2003

Designer as Publisher

To publish a work is to make it public, delivering content to an audience large or small. While writing a diary or making a scrapbook may be a deeply personal act, publishing is a social endeavor that involves not only making a book, but also getting it into the hands of readers. In the traditional business model, publishers supply the capital required to manufacture and distribute books, paying a printing plant to produce books in volume and then providing copies at low cost for resale by bookstores. Today, technologies such as print-on-demand, low-cost digital printing, and web-based distribution—to name just a few—are challenging this familiar model by enabling small presses and individual artists or authors to create books for narrower markets at lower risk. Publishers serve as gatekeepers for quality, deciding which projects are worthwhile to pursue. As curators of content, publishers make choices believed to bring value to potential readers. Many designers today are using their knowledge of the book industry to become publishers themselves. Meanwhile, self-publishing has become a viable option for authors wishing to walk past the gatekeepers and deliver content on their own terms. —EL

Spin, *Supergraphics–Transforming Space: Graphic Design for Walls, Buildings, and Spaces*, 2010 Courtesy Unit Editions

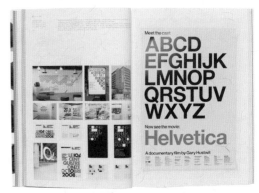

Spin, *Studio Culture*, 2009 Courtesy Unit Editions

Spin, *TD 63–73: Total Design and Its Pioneering Role in Graphic Design*, 2011 Courtesy Unit Editions

Unit Editions

Committed to producing books "for graphic designers by graphic designers," Unit Editions is the ambitious undertaking of designer Tony Brook and designer/writer Adrian Shaughnessy. Building on years of combined experience working within the established publishing industry, Brook and Shaughnessy decided to use their knowledge and connections to begin producing original books from the bottom up, taking on the role of publisher. In addition to producing weighty tomes on museum-worthy subjects, Unit Editions creates books such as *Studio Culture*, geared toward the practical concerns of students and young designers. Looking at broader ways to stimulate discourse via print, Unit produces posters and broadsides as well as books. —EL

Helvetica (the film)

Gary Hustwit directed this pioneering documentary about the famed Swiss typeface, which has garnered critical acclaim and popular appeal. Premiering in 2007 to coincide with the fiftieth anniversary of Helvetica's release, the film features interviews with a range of graphic designers, typographers, and design critics. Although it focuses on a single typeface, the film unravels the larger discourse between modernist and postmodernist positions on design. Intercut with beautiful cinematography of urban life in which the ubiquitous typeface makes an appearance, the documentary has been influential in both its filmic style and choice of subject matter, spawning a number of design documentaries. Hustwit considers *Helvetica* the first in a trilogy of design films, followed by *Objectified* (2009), about our relationship to products, and *Urbanized* (2011), which explores how global cities are shaped and shape us. —AB

Lars Müller with Séverine Mailler, *Helvetica Forever: Story of a Typeface*, 2009
Courtesy Lars Müller Publishers

Lars Müller Publishers

Graphic designer Lars Müller founded his own publishing house in Baden, Switzerland, in 1983. Lars Müller Publishers has since become a leading voice in the production of books about art, architecture, and design. While professing a special interest in the trajectory of Swiss design (from Helvetica to Weingart and beyond), Lars Müller publishes original content from around the world, from Kenya Hara's *Designing Design* (Japan) to Metahaven's *Uncorporate Identity* and Gerlinde Schuller's *Designing Universal Knowledge* (the Netherlands). Many of these books represent substantial works of design authorship, voicing incisive theories and social analysis as well as documenting visual work with extraordinary care, in formats devised by the designers themselves. —EL

Lars Müller with Séverine Mailler, *Super Normal*, 2007
Courtesy Lars Müller Publishers

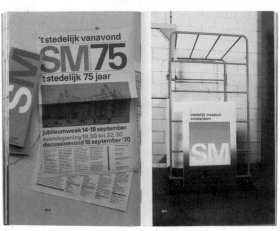

Spin, *Wim Crouwel: A Graphic Odyssey*, 2011 Courtesy Unit Editions

FUEL Publications

Based in the United Kingdom, FUEL was founded in 1991 as a design agency. Initially, the studio pursued publishing as a side project, creating a magazine as well as two monographs of the firm's own work. Its publishing venture soon evolved into a separate enterprise, FUEL Publishing. FUEL produces high-quality books about design, art, and popular culture. It works collaboratively with authors and artists to create distinctive books such as *Russian Criminal Tattoo*, an encyclopedia of body art featuring drawings by Danzig Baldaev and photographs by Sergei Vasiliev. —EL

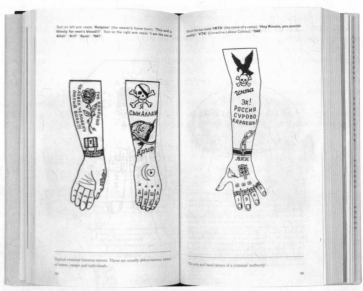

FUEL, *Russian Criminal Tattoo Encyclopedia*, Volumes I, II, and III, 2003/2006/2008 Courtesy FUEL Publications

FUEL, *Russian Criminal Tattoo Encyclopedia*, Volume II, 2006 Courtesy FUEL Publications

McSweeney's

Based in San Francisco, McSweeney's has published numerous books and magazines as well as launching the 826 Writing & Tutoring Centers, a national program for kids ages six to eighteen. Founded in 1998 by writer Dave Eggers, McSweeney's has consistently experimented not only with the form of the book, but also with the business of publishing. Amassing a devoted fan base through its web presence and its printed matter, it has built a rare bond between publisher and reader—an atypical relationship since readers are most often drawn to a particular writer. Innovative business strategies include offering subscriptions to a year of McSweeney's books; subscribers get a discount on whatever the company will publish, taking on faith that the material will be worthwhile. Authors receive more modest advances but higher royalties than the industry norm. Although advertising has entered its journals, the company relies primarily on sales to cover costs. Graphic design is a big part of the McSweeney's success story. From books and magazines to websites and mobile apps, every McSweeney's product employs typography, layout, and production (along with a deep-seated sense of humor) to enhance the experience of reading. —EL

FUEL, *Ideas Have Legs*, 2006 Courtesy FUEL Publications

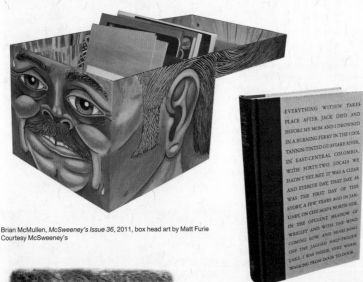

Brian McMullen, *McSweeney's Issue 36*, 2011, box head art by Matt Furie
Courtesy McSweeney's

Dave Eggers, *You Shall Know Our Velocity!*, 2002
Courtesy McSweeney's

Project Projects, *Street Value: Shopping, Planning, and Politics at Fulton Mall*, 2010 and *Above the Pavement—The Farm! Architecture & Agriculture at P.F.1*, 2010 Courtesy Inventory Books

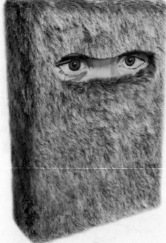

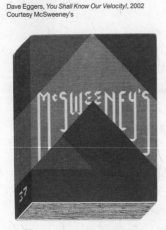

Dave Eggers, *The Wild Things*, 2009 Courtesy McSweeney's

Brian McMullen, *McSweeney's Issue 37*, 2011
Courtesy McSweeney's

Inventory Books

Inventory Books produces pocket-size studies of urban space and culture. With topics ranging from extremely local (the history and politics of Brooklyn's Fulton Mall) to broadly theoretical (Marshall McLuhan and the radical paperback), Inventory Books takes an outlook both scholarly and accessible. These modestly scaled books employ two-color printing and active page layouts to present scholarly ideas in a dynamic, visually engaging way. The volume on McLuhan is the third in the series, providing, in retrospect, a frame for the whole enterprise. Titled *The Electric Information Age Book: McLuhan/Agel/Fiore and the Experimental Paperback*, it explores the making and impact of *The Medium is the Massage*, a publication that distilled big ideas into a compact, tendentious volume and spawned a new publishing genre. The scale and texture embraced by Inventory Books recalls that of McLuhan's media manifesto. Inventory Books has pursued an intriguing publishing strategy as well. The series is edited and designed by Adam Michaels, cofounder of Project Projects. The series is copublished by Princeton Architectural Press. —EL

Four Corners Books

Published by Four Corners Books in London, the *Familiars* series presents classic works of literature with contemporary art and typography. Rather than embrace a common brand identity, each book in the series has its own look, feel, and format. Designer John Morgan and artist Gareth Jones have recast Oscar Wilde's *The Picture of Dorian Gray* as a costume drama set in Paris in the 1970s; the large-format edition has the personality of a magazine. In contrast, Bram Stoker's *Dracula*, a bookish volume covered with plain yellow cloth and a red painted edge, recalls the first UK edition. —EL

John Morgan, *Vanity Fair*, 2010, art by Donald Urquhart, text by William Makepeace Thackeray Courtesy Four Corners Books

John Morgan, *The Picture of Dorian Gray*, 2007, art by Gareth Jones Courtesy Four Corners Books

John Morgan, *Dracula*, 2008, art by James Pyman
Courtesy Four Corners Books

Above and left: Triin Tamm, *A Stack of Books*, 2011 Courtesy Rollo Press

On the Self-Reflexive Page

Louis Lüthi's exquisitely authored and designed book *On the Self-Reflexive Page* (2010) documents the history of the page as a material arena to be foregrounded and exploited. This discourse of the page began with Laurence Sterne's *Tristram Shandy* in the eighteenth century and was revived with the explosion of "metafiction" in the 1960s, continuing today in the work of Jonathan Safran Foer and others who dare to violate the verbal purity of literature. Lüthi's book presents selected pages directly reproduced as whole objects. He writes, "*Tristram Shandy* marks what could be archly called the 'invention' of the page—the page not as the recto or verso of one of the leaves of paper that when bound together make up a book, but as a determined space at a specific point in a narrative." The self-reflexive page has long attracted the distrust of critics, who view the incursion of non-linguistic elements into the space of literature as an indulgent diversion. —EL See Louis Lüthi, *On the Self-Reflexive Page*, 2010

Rollo Press

This small press in Zürich is operated by Urs Lehni, producing books directly on-site with a RISOGraph GD3770 digital duplicator machine. With its small editions on art and design, Rollo Press seeks to control the process of production from initial idea to printing, binding, and distribution. —EL

Roma Publications

Based in the Netherlands, Roma is an independent, nonprofit art publisher. Working in collaboration with artists, institutions, writers, and designers, Roma develops an appropriate format and distribution plan for each book. With print runs ranging from two to 150,000, some books are given away for free, while others are sold through bookshops, museums, or exclusively online. Founded in 1998 by artist Mark Manders and graphic designer Roger Willems, the press began as a side project and soon became an intensive and influential publishing program. Many of Roma's books document the work of Manders, extending his sculpture and installation work into print. Many of Roma's books document the work of Manders, extending his sculpture and installation work into print. In an interview in the web magazine *Rosa B.*, "Making a book is addictive, like making an exhibition." Each book is conceived as a work of art in itself, made without concessions to traditional institutions or publishers. According to Willems, "I am interested in graphic design as an autonomous thing. A book is an object that relates only to its direct surroundings." —EL

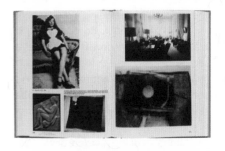

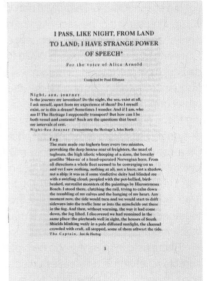

I PASS, LIKE NIGHT, FROM LAND TO LAND; I HAVE STRANGE POWER OF SPEECH*

For the voice of Alice Arnold

Louis Lüthi, *On the Self-Reflexive Page*, 2010, cover from Laurence Sterne, *Tristram Shandy* Courtesy Roma Publications

Above and right: Batia Suter, *Parallel Encyclopedia* with special edition insert by Paul Elliman, *I pass, like night, from land to land; I have strange power of speech*, 2009 Courtesy Roma Publications

from the beginning, some three thousand words ago), you are a stalwart slogger indeed. The super sad truth is, this essay is a last-ditch effort at so-called "long-form writing."

Whenever I hear the word "reader," I reach for my mobile device. Today's "reader" is as likely to be a digital apparatus or a software interface as a living person leafing through the pages of a book. Countless hardware and software products are designed to display, filter, push, and aggregate published matter. Screen readers turn text into speech, creating accessible material for sight-impaired users. News readers digest blogs and news posts, feeding them back to users in quick-view formats stripped of context, while digital readers serve up books and magazines for instant consumption.

Consumer gear such as Amazon's Kindle and Apple's iPad are changing the way we buy and read books. Such devices appear ideally suited for consuming linear narratives. Whether pushing a button or swiping a screen, the user of an e-book tends to move steadily ahead through a document, loading one screen of content after another. Although digital bookmarks supposedly free users to wander about, it takes courage to resist the forward momentum of the medium. (In contrast, it feels less risky to flip back and forth through the pages of a printed book.)

The insistent linearity of e-pubs reflects how these publications are made. The process of designing a digital book requires linearizing its content, ensuring that one element follows the next in a strict sequence. Tables, illustrations, and captions—which might appear in countless configurations on a printed page—obey strict marching orders in the e-pub world: single-file, one by one. [31]

Attributes of the physical device further tighten the shackles of linearity. If networked computing signaled the ascendance of nonlinear communication, e-readers are funneling content back in line. While the desktop favors a layering of windows—and frequent movement among them—the tablet grips the user firmly in place, creating focus and limiting distraction. Interface designer Oliver Reichenstein has observed, "On a computer ... the user visually moves between monitor, OS, app window, and the inner visual order of the window. On the iPad, eye and hand movement are brought together and held captive within a massive black frame." [32]

Being held in captivity can be a pleasurable relief from the relentless distractions of digital life—especially if one is

reading works of fiction. In a 2010 study conducted by user experience expert Jacob Nielsen, respondents reported having more "fun" reading an e-book than a printed book. [33] Nielsen's subjects were reading short stories by Hemingway; there may be no prose on Earth better suited to linear consumption.

Focus and distraction, linearity and nonlinearity: these conflicting categories of form and experience define who we are as contemporary makers and users of media. We hunger for focus because we feast on distraction; we crave linearity because we so often drift off task. Read-later apps enable users to gather links and absorb them at another time in an ad-free, typographically hygienic environment.

Sometimes, distraction is just what you're looking for. When I ask groups of graduate students if they have ever read a book on Google Books, most solemnly shake their heads no and then muse upon print's undying fitness to a proper reading experience. Then I reword the question: "Have you ever *used* Google Books?" The answer now shifts to yes. The screens generated by Google Books have nothing to do with focused immersion in a linear work of art (what school teachers call "reading for pleasure"). Instead, Google Books fuel that hungry, acquisitive, purpose-driven mode of reading known as "research." At the root of "research" is "search," the core business of the Google enterprise.

Google Books offers up pages (or rights-restricted snippets of pages) scanned directly from printed volumes. Slicing through entire bodies of literature, Google preserves the typographic layout of the original work and marks it with yellow highlights where the search engine has found a match. Floating around these fragments of slaughtered books are ads and links beckoning readers to go elsewhere: buy this book, find it in a library, see more like this, and so on. In the domain of search, distraction reigns triumphant. An author who has drafted an essay in the pastoral seclusion of iA Writer, or a reader who has drifted through a context-free news feed, may eagerly return to the bustling metropolis of the digital desktop, where texts unwind amidst the clamor of notes, outlines, search windows, abandoned drafts, e-mail streams, to-do lists, and other (welcome) distractions.

Reading means many things. A word that once evoked ladies perched on shady park benches now refers to machines and software. Reading, like writing, has become a social activity, as consumers use digital means to rate, review, share,

and annotate texts in networked spaces. Reading can be active or passive, quick or close, public or private, willfully archaic or electronically juiced. Designing environments to support these diverse functions draws on many areas of contemporary practice, from graphic identity, page layout, typography, and user experience to product design and software engineering.

Designers and writers are using digital publishing tools to grow their own content and grapple with the materiality of text. Web distribution and print-on-demand technologies offer accessible channels for short-run, low-risk publishing. The efflorescence of homespun media is part of the far-flung do-it-yourself impulse, reflected everywhere from Etsy to Creative Commons, from yarn-bombing to desktop manufacturing. At the heart of DIY is *doing*. To do something is to perform an action. (What did you do today? Made my bed, brushed my teeth, fed my sustainable robot, watered my urban farm.) For the do-it-yourself author or entrepreneur, design is often the means to a larger end, whether it's publishing a book or promoting a business (or publishing a book to promote a business).

In our day and age, what are books for? What do they *do*? Books serve not just to be read but also to be displayed, exchanged, reviewed, collected, shelved, archived, reproduced online, and circulated in libraries. Designers today use books, blogs, and zines as outlets for so-called "personal work." Projects once called "promotional pieces" are now said to be "self-published." For writers, the jaunty motto "independent publishing" has replaced the dismissive "vanity press." At some level, self-publishing is a tool for disseminating the self, serving to manufacture evidence of a coherent voice and put it on display. A creative career becomes a brand. Authors, artists, designers, and collectives use publishing to construct public practices that might include lectures, teaching, workshops, and exhibitions along with professional commissions.

In addition to serving such social functions, books are made in order to be made. The process of publishing—and the allure of a tangible outcome—becomes its own reward. As we labor to make a book, the pulsing hallucination of the finished thing beckons us onward. In the end comes the end product, but looking back we often find that doing the thing was the best part.

Has authorship met its end? When the author died, his ashes drifted over the open seas of digital connectivity, equip-

ping new populations to broadcast ideas. Today's all-access mediascape has flattened out many areas of expertise, casting shadows of doubt upon the future of journalism, graphic design, book publishing, and other specialized practices. As the creative process merges with production, some designers will grow more involved with systems and services than with bespoke page layouts and letterpress business cards. Yet the object of art, no matter how small, still propels us into the orbit of its making. Aesthetic artifacts—whether physical or digital, unique constellations of word and image or code-driven aggregates—are part of communication's uncertain future. ⊠

Notes

1. Roland Barthes, "The Death of the Author," in *Image/Music/Text* (New York: Hill and Wang, 1977), 142–148.
2. Rick Poynor, "The Designer as Author," reprinted in *Design without Boundaries: Visual Communication in Transition*, ed. Rick Poynor (London: Booth-Clibborn, 2000), 97–102.
3. Michael Rock, "The Designer as Author," excerpted in *Graphic Design Theory: Readings from the Field*, ed. Helen Armstrong (New York: Princeton Architectural Press, 2009), 108–114. Many of the designers mentioned in Rock's piece participated in the 1996 exhibition *Designer as Author: Voices and Visions* (organized by Steven McCarthy and Cristina de Almeida, Northern Kentucky University), accessed June 12, 2011, http://www.episodic-design.com/writings/DAVV.html.
4. Michael Rock, "Fuck Content" (2005), accessed May 24, 2011, http://2x4.org/_txt/reading_6.html. See also pages 14–15 in this catalogue.
5. Dmitri Siegel, "Designers and Dilettantes," *Design Observer* (September 18, 2007), accessed May 22, 2011, http://observatory.designobserver.com/entry.html?entry=5947.
6. Markus Dressen, Lina Grumm, Anne König, and Jan Welzel, eds., text from back cover of *Liner Notes* (English supplement) (Leipzig: Spector Books, 2010).
7. The conversational turn in contemporary design writing can be seen in *The Reader: Iaspis Forum on Design and Critical Practice* (Berlin: Sternberg Press, 2009). Dieter Roelstraete discusses conversation as a broader phenomenon in art criticism in *F.R. David: The "Iditorial" Issue* (Winter 2009).
8. Rob Giampietro, "Remarks from the New Museum, 13 June 2009," *Lined & Unlined*, accessed June 1, 2011, http://blog.linedandunlined.com/post/403586912/remarks-from-the-new-museum-13-june-2009.
9. Marshall McLuhan and Quentin Fiore, *The Medium is the Massage: An Inventory of Effects* (New York: Bantam Books, 1967). On the making of this book, see J. Abbott Miller, "McLuhan/Fiore: Massaging the Message," *Design Writing Research: Writing on Graphic Design* (London: Phaidon, 1999), 90–101.
10. Rem Koolhaas and Bruce Mau, *S, M, L, XL* (New York: Monacelli Press, 1996).
11. Bruce Mau, *Life Style* (London: Phaidon, 2000).
12. Bruce Mau, Jennifer Leonard, and Institute without Boundaries, *Massive Change* (London: Phaidon, 2004).
13. Bernadette Corporation, *Reena Spaulings* (New York: Semiotext(e), 2004).
14. Michel Foucault, "What Is an Author?," in *The Foucault Reader*, ed. Paul Rabinow (New York: Vintage Books, 2010), 120.
15. Tao Lin, *Shoplifting from American Apparel* (Brooklyn: Melville House, 2009).
16. Tao Lin, "Great American Novelist," *The Stranger*, September 21, 2010, accessed May 26, 2011, http://www.thestranger.com/seattle/great-american-novelist/Content?oid=4940853.
17. From a 1980 letter written to *Plan* magazine, reproduced by David Reinfurt in "This Stands as a Sketch for the Future: Muriel Cooper and the Visible Language Workshop," *Dot Dot Dot* 15 (October/November 2007): 33–48.
18. "Collaborative Futures: The Future of Collaboration," accessed June 2, 2011, http://collaborativefutures.org.
19. Jane Austen and Seth Grahame-Smith, *Pride and Prejudice and Zombies* (New York: Quirk Editions, 2009).
20. "The Piracy Project," accessed June 2, 2011, http://www.andpublishing.org/projects/and-the-pirate-project/.
21. Graham Rawle, *Woman's World* (Berkeley, CA: Counterpoint Press, 2009).
22. Boris Kachka, "Reinventing the Book: Jonathan Safran Foer's Object of Anti-Technology," *New York Magazine*, November 21, 2010, accessed May 27, 2011, http://nymag.com/arts/books/features/69635/.
23. Michiko Kakutani, "A Boy's Epic Quest, Borough by Borough," *New York Times*, March 22, 2005, accessed April 12, 2011, http://www.nytimes.com/2005/03/22/books/22kaku.html.
24. Louis Lüthi, *On the Self-Reflexive Page* (Amsterdam: Roma, 2010), unpaginated.
25. Jonathan Safran Foer, *Extremely Loud and Incredibly Close* (New York: Mariner Books, 2004).
26. Ginia Bellafante, "Map Quest," *New York Times*, June 19, 2009, accessed April 12, 2011, http://www.nytimes.com/2009/06/21/books/review/Bellafante-t.html.
27. College writing textbooks that feature design instruction include *Picturing Texts* by Lester Faigley, Diana George, Anna Palchik, and Cynthia Selfe (New York: W. W. Norton, 2004). On the history of visual literacy instruction, see Diana George, "From Analysis to Design: Visual Communication in the Teaching of Writing," in *Teaching Composition: Background Readings*, ed. T. R. Johnson (Boston: Bedford/St. Martin's, 2005).
28. Publicity material from the NYU Arthur L. Carter Journalism Institute, Studio 20, accessed May 25, 2011, http://journalism.nyu.edu/graduate/courses-of-study/studio-20.
29. Foucault, "What Is an Author?" 108.
30. "Gary Shteyngart: A 'Love Story' in a Sad Future," National Public Radio, May 13, 2011, accessed May 25, 2011, http://www.npr.org/2011/05/13/136240501/gary-shteyngart-a-love-story-in-a-sad-future. In Shteyngart's dystopian vision of the future, people will communicate by transmitting images via portable "äppäräts," and young people will be revolted by the stench of printed books; a young jock scolds the novel's book-loving protagonist on the plane: "Duder, that thing smells like wet socks." Gary Shteyngart, *Super Sad True Love Story* (New York: Random House, 2010), 37.
31. The first practical manual to designing e-pubs is Elizabeth Castro's *EPUB: Straight to the Point* (Berkeley, CA: Peachpit Press, 2011).
32. Oliver Reichenstein, "Designing for iPad: Reality Check," *Information Architects*, April 12, 2011, accessed May 27, 2011, http://www.informationarchitects.jp/en/designing-for-ipad-reality-check/.
33. Jacob Nielsen, "iPad and Kindle Reading Speeds," *Use It*, July 2, 2010, accessed May 27, 2011, http://www.useit.com/alertbox/ipad-kindle-reading.html.

2011
Magazine Culture
Jeremy Leslie

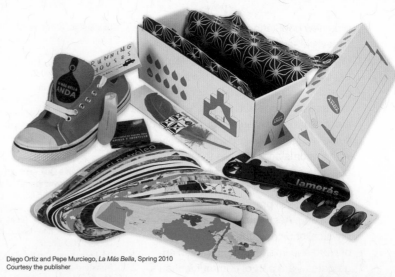

Diego Ortiz and Pepe Murciego, *La Más Bella*, Spring 2010
Courtesy the publisher

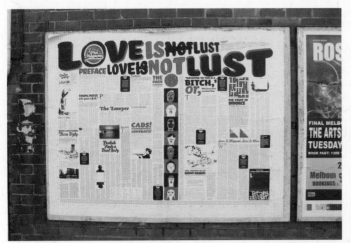

Penny Modra, *Is Not Magazine*, issue 1, Love Is/Not Lust, 2005 Courtesy the publisher

Designer unknown, *Nice Magazine*, 2002
Courtesy Jeremy Leslie

ONE PAGE MAGAZINE

Joseph Ernst, *One Page Magazine*, *French Vogue*, March 2007
Courtesy the artist

Left to right: Nick Mrozowski, *i newspaper*, vol. 2, no. 392, August 9, 2010; *i newspaper*, vol. 2, no. 395, August 12, 2010; *i newspaper*, vol. 1, no. 249, February 23, 2010 Courtesy the publisher

magCulture Map
In 2009 Jeremy Leslie, editor of *magCulture*, launched this Google-based map, which pinpoints the best magazine stores around the world as identified by the blog's readers.
—EL See magCulture.com

Colophon Conference 2007, International Magazine Symposium Photo ©Eric Chenal

Colophon Conference
This international biennial event, launched in 2007, brings together independent magazine-makers from across the world. Events are held across Luxembourg, and the curators Mike Koedinger, Jeremy Leslie, and Andrew Losowsky oversee an online database of independent magazines and publish a series of books about the genre.
—Welovecolophon.com

Rethinking the Magazine

Magazines are such a ubiquitous part of today's media landscape that we easily take them for granted. But what is a magazine? The word brings to mind a specific physical object. We think of a standard package of full-color pages printed on glossy paper. But in recent years a number of publishing projects have challenged such assumptions, reminding us that magazines can in turn challenge their readers in terms of how they look, feel, and read.

Nice Magazine—a magazine-size piece of wood imprinted with just its name, or masthead—tests our basic physical expectations of what a magazine is, while *Naked woman covered in glitter, and words* and *One Page Magazine* are genre-specific critiques that use humour and visual analysis respectively to highlight the underlying banalities of much mainstream content.

The advent of the web as a common utility has led magazines to reexamine their physical properties, with some, like *Monocle*, deliberately adopting a more booklike format. *Monocle*'s cover design is composed similarly each issue, rejecting the received wisdom that covers should be a rotating series of familiar celebrity faces from issue to issue.

The web has had an acute effect on newspapers, many of which have turned to magazine-style content and design to justify their existence now that they are no longer the first source for breaking news. The Portuguese newspaper *i* is effectively a daily magazine rather than a newspaper in the traditional sense.

Other publishing projects have taken the word "magazine" back to its Arabic etymological roots, where it means emporium or warehouse, coming up with surprising ideas of what a magazine can be. The editors of *La Más Bella* produce themed collections of objects embellished with content, while South Africa's *Afro* presents new, non-magazine paper formats for delivering content.

Thanks to technology, it is cheaper and easier than ever to create a magazine, but the hardest part of the process, getting your publication to readers, remains as difficult as ever. The makers of *Is Not Magazine* solved this by posting their poster-size publication on city walls. *I Am Still Alive* appears as part of other magazines, taking over several pages as a parasite project that cleverly piggybacks its host.

Other publications with more recognizable formats challenge editorial conventions in their pages. *City* appears using a different person's name each month; *O.K. Periodicals* curates content submitted by readers in response to a theme; *Carlos* eschewed photography in favor of illustration; and *Kasino A4* and *Monika* play with the concept of the didactic editorial voice to subvert the idea of lifestyle advice. Perhaps most confrontational of all was *Re-Magazine*, which during its seven-year lifespan went through several distinct phases, such as embracing the ordinary lives of everyday people as its editorial subject matter, toying knowingly with the expectations of both publishers and readers. ⊠

Above and right: Peet Pienaar, *Afro*, Cube edition, 2006 Courtesy the publisher

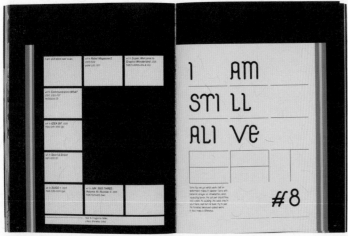

Åbäke, *I Am Still Alive #8*, in *Sugo*, issue 1, 2004 Courtesy the artists

Clockwise from top left: Mike Meiré, *Brand Eins*, vol. 2, no. 7, September 2000; vol. 12, no. 10, October 2010; vol. 1, no. 1, October 1999; vol. 2, no. 3, April 2000 Courtesy the publisher

O.K. Parking, *O.K. Periodicals*, issue 2: Failure, Winter/Spring, 2009 Courtesy the publisher

Jop van Bennekom, *Re-Magazine*, Hester issue, 2004 Courtesy the artist

Monika, *Monika*, It's About What Is Said issue, Spring/Summer 2010
Courtesy the publisher

Joseph Ernst, *Naked woman covered in glitter, and words*, 2005 Courtesy the artist

Pekka Toivonen, *Kasino A4*, issues 1–2, This Aggressive Melancholy, Summer 2006 Courtesy the publisher

Above and right: Warren Jackson, *Carlos*, issue 1, Spring 2003 Courtesy the publisher

Left to right: Richard Spencer-Powell, *Monocle*, vol. 5, no. 45, July/August 2011; *Monocle*, vol. 1, no. 1, March 2007 Courtesy the publisher

Left to right: Guido Kruger, *Anne's City Magazine Luxembourg*, June 2011; *Laurent's City Magazine Luxembourg*, April 2011; and *Dennis's City Magazine Luxembourg*, May 2011 Courtesy Maison Moderne

Reinventing Genres

Look across the shelves of any decent magazine store and you'll find a range of publications that reflect just about every human need and desire. What began one hundred fifty years ago as an upmarket vehicle for distributing news and opinion in a world facing major geographic and political upheaval has evolved into a sophisticated mass-market industry.

That industry developed alongside, and often as part of, the consumer boom of the late twentieth century. General advice became "lifestyle" as our interests in food, sex, fashion, sport, and travel were indulged and major publishing brands created. Many great magazines were launched as a result, but with success came a fear of failure and a blunting of the will to innovate. Lifestyle magazines became predictable and formulaic.

Against that background, a body of new independent magazines are reinterpreting these now traditional genres. Taking advantage of the cheaper, easier production methods provided by computers and encouraged by the Internet's forthright sharing of opinions, these magazines exist as implicit critiques of their mainstream rivals.

An early example is *Carl*s Cars*, founded in 1999. Auto magazines generally focus on speed, power, and statistics, but this biannual took a more realistic approach. Subtitling itself "A magazine about people," it revels in the day-to-day presence of cars in our lives and presents its subject with a light and often humorous touch that is reflected in its page designs. It is anti–car magazine rather than anti-car. The same is true of cycling title *The Ride Journal*, which represents a genuine shared interest rather than filling an advertising niche.

Shelter magazines are another genre that have tended toward an aspirational ideal. *Apartamento* offers a more honest approach, identifying with the limitations facing young city dwellers who have limited space and money. Its small format, matte paper stock, and informal design aesthetic reflect its vision. Children's magazines have a similarly positioned hero in *Anorak*, which shuns the usual commerciality and brand tie-ins of kids' magazines in favor of a well-designed and inventive approach to activities and storytelling.

Fantastic Man has already proven itself a commercial success in the men's lifestyle/fashion world. Built around creative director Jop van Bennekom's vision of modern masculinity, it favors "real" men instead of models and presents an ironic outlook that references an earlier age of etiquette guides and "proper" behavior. It is a world away—both editorially and graphically—from the confusing mix of camp fashion and explicit heterosexuality found in the mainstream men's titles. *Manzine* and *Port* provide two further examples of divergent men's magazines. It remains to be seen whether the recent launch of *The Gentlewoman*, a women's magazine from the publishers of *Fantastic Man*, can match its older brother's success.

An alternative take on the movie world is provided by *Little White Lies*, which has quietly developed a voice that has attracted a passionate following. Each issue is built around a single new release and addresses broader cultural themes around the movie as well the film itself.

Many other titles have found new ways to reinvigorate their respective genres, whether architecture (*Pin-Up*), sex (*Jacques*), food (*Fire & Knives*, *Put A Egg On It*, *Meatpaper*), fashion (*Rubbish*), music (*'Sup*), business (*Brand Eins*), or soccer (*Sepp*). Many have already had an outsized influence despite their modest sales figures, as their new approaches attract an international, media-savvy, and upmarket audience. ⊠

Sarah Keough and Ralph McGinnis, *Put A Egg On It*, no. 3, Winter/Spring 2011 Courtesy the publisher

Rob Lowe, *Fire & Knives*, 2007
Courtesy the publisher

Omar Sosa, *Apartamento*, issue 3, April 2009
Courtesy the publisher

Sasha Wizansky, *Meatpaper*, issue 15, Summer 2011 Courtesy the publisher

Cathy Olmedillas and Rob Lowe, *Anorak*, vol. 19, 2011 Courtesy the publisher

Stack

Based in the UK, this innovative distribution service offers subscriptions to a curated monthly selection of independent English-language magazines. Curated by founder Steve Watson, the Stack collection changes every month, delivering guaranteed surprises to subscribers' mailboxes. The service provides invaluable exposure to independent magazines, including many titles that are difficult to find on newsstands. A US service has been launched too. —Jeremy Leslie See Stackmagazines.com

Felix Burrichter and Dylan Fracareta, *Pin-Up*, issue 10, Spring/Summer 2011 Courtesy the publisher

Andrew Diprose, *The Ride Journal*, issue 5, 2011, cover illustration by ilovedust
Courtesy the publisher

Stephanie Dumont, *Carl's Cars*, issue 16; Summer 2006 Photo: Damien Bénéteàu and Xavier Cariou

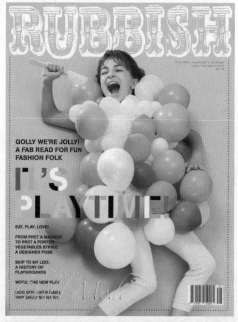

Bianca Wendt, *Rubbish*, issue 2.5, 2010 Courtesy the publisher

Brendan Duggan, *'Sup*, issue 22, 2010 Courtesy the publisher

Karen, *Karen*, issue 3, 2007 Courtesy the publisher

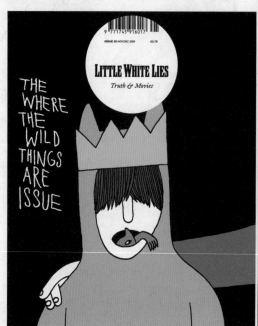

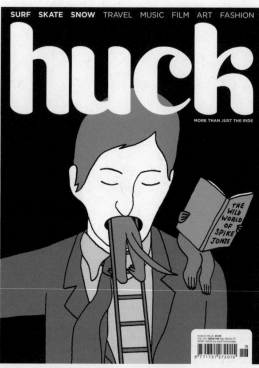

Paul Willoughby, The Church of London, *Little White Lies* #26, The Where the Wild Things Are issue, November/December 2009, illustration by Geoff McFetridge Courtesy the publishers

Rob Longworth, *Huck* #18, The Spike Jonze Tribute issue, December 2009/January 2010, illustration by Geoff McFetridge Courtesy the publishers

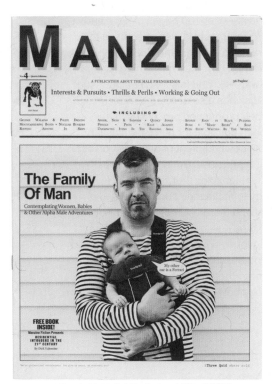

Warren Jackson/Kevin Braddock (editor), *Manzine*, issue 4, Winter 2010/2011
Courtesy the publisher

Matt Wiley and Kuchar Swara, *Port*, Spring 2011 Courtesy the publisher

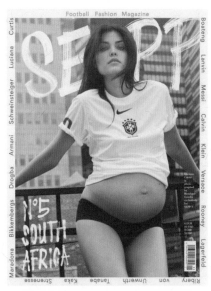

Mirko Borcshe, *Sepp,* issue 5, 2010 Courtesy the publisher

Jonathan Leder and Buro Svenja, *Jacques*, Winter 2011
Courtesy the publisher

Jop van Bennekom, *Fantastic Man*, issue 2, Autumn/Winter, 2005–2006 Courtesy the publisher

Jop van Bennekom, *The Gentlewoman*, issue 3, Spring/Summer 2011 Courtesy the publisher

Design x Content

Magazines are vehicles for content, and this raw material is the same in any magazine—words and images. Words are generally the responsibility of the editor, while images are tended by the art director. A design team combines these two elements to create the page layouts we recognize as magazine design.

Our basic expectation of design is that it presents the content in a clear and legible manner, just as the editor must ensure that the words are factually and grammatically correct. Rules have developed over many years to achieve this goal. Pages are labeled with page numbers and running heads that help readers find their way around the magazine. A hierarchy of information exists on each page–the headline attracts the reader's attention, the sell or deck explains more, and the text carries the story. Large initial letters or "drop caps" at appropriate points break the uniformity of columns of text, and pull quotes hint at points of intrigue to encourage the reader to remain engaged with the text.

Such conventions are just the beginning of the design process. Every magazine aspires to have a unique character, and to help achieve this the designer will make choices of scale, color, and relationship between elements on every page. This is part of what defines a publication as a magazine rather than, say, a book, and today this process has been extended by computerization, bringing almost limitless options to the desktop.

But it doesn't matter how stunning the page designs are if they don't reflect the tone of the written content. This is where the relationship between editor and art director is a vital one. A good editor must have a working knowledge of design and the art director must understand writing. The two must work together to create a synthesis of design and content that adds up to more than the sum of its parts.

Several magazines have recently epitomized great editor-art director relationships. *Wired* has developed a high-tech graphic style that perfectly reflects its content while bringing to visual life what might otherwise be quite dry science and technology content. Weekly magazines present their own challenges in terms of timing, and *New York* and *Bloomberg Businessweek* have made a speciality of applying monthly design standards to a weekly production routine. *New York* has a long history of strong editorial design, and the latest iteration combines intelligent templating of regular pages to help rapid page turnaround and bespoke feature designs at the front of the magazine.

The recent redesign of *Bloomberg Businessweek* has seen the introduction of a crisp and functional modernist design aesthetic that is softened by the use of illustration. This is most obvious on the front cover designs, which make a virtue of the spontaneity required of a weekly news title.

Such work relies on modern design software to achieve the detailing and quality of their typography and layouts. But some magazines react against the possibilities provided by the software. *Marmalade*, a London-based creative magazine, refused to use page layout programs such as QuarkXPress, the standard software of the time. Instead, the design team created pages as physical tableaux, complete with headlines, text, and imagery, to be photographed and printed as single images. This attempt to circumvent software was effective despite the irony that the final photographs had to be designed using the very software the magazine sought to avoid. The untitled magazine published by M-real paper corporation also used technology against itself to suggest copies of the publication had been scribbled over and marked up after its printing. German culture magazine *032c* has experimented with definitions of what is ugly and beautiful, deliberately subverting ideas of "good" design to reflect the edgy nature of its written content. In all three cases it can be argued that the design has *become* content.

Design also informs and directs the physical nature of a magazine. In part a response to the challenge of the Internet, publishers have looked to special printing finishes to emphasize their engagement with multiple senses (touch and smell as well as sight) and exaggerate their physical presence. *Wallpaper** has made a speciality of this, inviting guest creatives to contribute ideas, such as when architect Zaha Hadid created laser-cut paper sculptures based on one of her building designs. *Amelia's Magazine* also used laser cutting to execute Rob Ryan's intricate design. Shelter magazine *Nest* used different physical effects every issue, often giving its pages curved or asymmetrical edges, while *Mined* left its edges untrimmed, requiring the reader to tear the edges for access.

Taking a simpler but just as effective route, *mono.kultur* is always the same size but uses different folding and finishing techniques to vary its format every issue. Art magazine *Esopus* encourages artists to experiment with paper folding and other techniques. Other magazines rely on special fluorescent and metallic inks to help their covers demand the attention of readers, something *Sleazenation* mocked with

a cover featuring the line "Now even more superficial—over 100 pages of hype and lies." Foil stamping is also often used to add drama to a cover, and British *Harper's Bazaar* went further, embellishing its logo with Swarovski crystals for a special issue.

Magazines also develop new ideas from their production processes. It has long been possible for publishers to vary the front cover content of different editions of their magazines. British *Elle* is one of several magazines that adopted a clever strategy to make their subscriber issues special and therefore more desirable. Every month they now produce entirely different front cover designs for their newsstand and subscriber issues. With no need to sell the content to the subscriber, their cover can be more creative rather than commercial. ⊠

Above and right: Scott Dadich, *Wired*, vol. 18, no. 9, September 2010; vol. 17, no. 5, May 2009 Courtesy the publisher

Scott King, *Sleazenation*, vol. 4, no. 8, Even More Superficial issue, September 2001
Courtesy the designer

Above and right: Chris Dixon, *New York*, January 16, 2006, and December 22–29, 2008 Courtesy the publisher

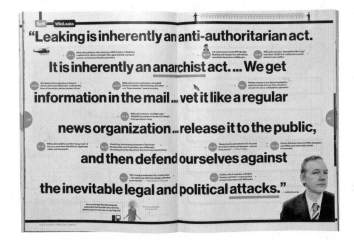

NODE Berlin Oslo, *mono.kultur* #23, Spring/Summer 2010 Courtesy Kai von Rabinau

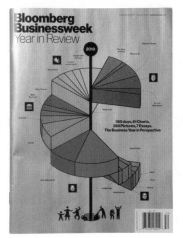

Above: Richard Turley, *Bloomberg Businessweek*, Year in Review 2010, December 20, 2010–January 2, 2011
Courtesy the publisher

Mike Meiré, *032c*, issue 14, Winter 2007/2008 Courtesy the publisher

Merion Pritchard, *Wallpaper**, Handmade issue, August 2010 Courtesy the publisher

Sasha Spence-Trace, *Marmalade*, issue 5, Winter 2004 Courtesy the publisher

Tom Usher, *Harper's Bazaar UK*, September 2007 Photo: Alexei Hay Courtesy Swarovski Crystals

Marissa Bourke, *Elle UK*, June 2010 issues Courtesy the publisher

JP Thurlow

These lovingly rendered magazine covers were created by illustrator JP Thurlow. Explaining the motivations behind the series, Thurlow says, "Like anyone I enjoy the beauty of fashion and marketing gloss but I'm not hypnotized or brainwashed by it. What lurks behind it is the desire to sell stuff, and having worked in and around advertising, I just like to corrupt that stuff to my own ends." Paying tribute to the tawdry allure of magazines, Thurlow's drawings convert mass media into intimate works of art. —EL

JP Thurlow, drawings from series *100 Covers*, 2010
Courtesy the artist

Above and right: Joseph Holtzman and Tom Beckham, *Nest*, Summer 1999, photography by Jason Schmidt and Summer 2000, photography by Nathaniel Goldberg Courtesy Jeremy Leslie

Tod Lippy, *Esopus*, issue 6, 2006 ©The Esopus Foundation, Ltd.

Amelia Gregory, Scott Bendall, and Asgur Bruun, *Amelia's Magazine*, issue 2, Autumn/Winter 2004 Courtesy the publisher

Christopher Harrison and Polly Glass, *Wrap*, issue 2, 2011 ©2011 The Wrap Paper Limited

Andreas Laeufer, *Mined*, Mind over Matter, issue 2, October 2001 Courtesy the designer

Jeremy Leslie, untitled, issue 9, 2004 Courtesy M-real Corporation

Print x Digital

Newer media always arrives to fanfare about replacing older media, and we've been hearing about the web replacing magazines for more than a decade. But the relationship between magazines and websites is far more complex than that, and still largely unresolved. Whatever their long-term relationship, in the short-term magazines have benefited creatively from the arrival of the Internet and other digital forms.

Many independent magazine-makers discovered their voices writing blogs; others, like *Karen*, have bypassed the web while applying a highly personal bloglike sensibility to content creation. Increasing numbers of bloggers have found a use for printed publications alongside their websites. *It's Nice That* launched a biannual print edition to counteract the disposability of their daily posts and enable a more precise editorial voice. Blog and magazine live side by side, supporting each other through their distinct roles. *magCulture* produced a printed publication to focus on several years of archive material, and *Linefeed* identified common themes in their posts and created the printed *LineRead* as a vehicle to investigate those themes in more depth.

Some of the most interesting crossovers occur when print and digital media are entwined. *Things Our Friends Have Written on the Internet* was a one-off newspaper project that combined multiple sensibilities. Content was sourced by its editors from a selection of their favorite blogs and websites and reproduced without the permission of the originators. Instead, the blogging convention of providing URL links was used. The result was a printed newsfeed—an aggregation or collection of unrelated content, a snapshot of the web.

Club Donny is a magazine that explores the relationship between nature and the city and is composed of folded poster-size sheets of paper left unbound. Its content—from a nudist camp in the Netherlands to a former Soviet resort overgrown by nature—is submitted unsolicited online through its website. Its editorial hand is largely absent, allowing the individual vision of its authors to be fully present.

Newspaper Club is an award-winning concept that takes advantage of newspaper printers' downtime to provide access for outsiders to print small-run newspapers. Users can either upload finished PDFs or take advantage of a series of ready-made design templates. Either way, a few days after uploading your content, printed newspapers—in runs as small as five copies—arrive by courier.

Print-on-demand services such as MagCloud (used by *LineRead*, for example) mean individual copies of a magazine are printed to order. While more expensive per unit, they allow the publisher to avoid the heavy investment involved in printing hundreds of copies in advance of sales.

The Internet has also revolutionized the distribution of magazines, vastly increasing the reach of magazines of all types and sizes. Smaller, specialist magazines can now find global niches they could only have dreamed of just five years ago.

The latest digital development is Apple's iPad, seen by many before its April 2010 launch as the savior of publishing. Less than two years on the market, it's too early to tell if iPad magazines will live up such lofty expectations, but huge resources continue to be devoted to editorial apps in the hopes that they will do so. To date, much creative effort has been spent trying to define how an editorial app should function, with major projects such as *Wired* defining a busy, clamorous visual direction, and the independent iPad-only publication *Letter to Jane* taking a calmer, more reflective route. There should be room for both approaches, but what will define their success will more probably be their ability to link and share content with other parts of the digital world through social networking, something the stand-alone Flipboard app has focused on since its launch. ⊠

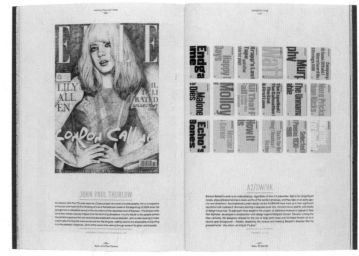

It's Nice That in collaboration with Joseph Burrin, *It's Nice That,* issue 3, April 2010 Courtesy the publisher

MagCloud

A service of HP, MagCloud is a print-on-demand tool that allows users to produce and distribute their own magazines. Readers order the magazines from the MagCloud site, which handles printing, fulfillment, and digital downloads. MagCloud's direct-mail service is a new kind of DIY marketing tool, allowing small producers to print and distribute catalogues and other collateral. —EL See MagCloud.com

Michael Bojkowski, *LineRead,* issue 3, March 2011 ok interrupt (design)
Courtesy the publisher

Above and right: Jeremy Leslie, *magCulture Paper,* 2010 Courtesy the publisher

Left to right: Frank Bruggeman, Ernst van der Hoeren, and Ben Lalova/Didier Pascal, *Club Donny, Nº. 1,* 2008, and *Nº. 5,* 2010, and *Nº 3,* 2009 Courtesy the publisher

Scott Dadich, *Wired*, August 2011 Courtesy the designer

Adobe DPS

From its April 2010 launch, the iPad was seen by many publishers as an ideal vehicle to adapt their printed content into digital form. Adobe, makers of the primary page layout software InDesign, quickly developed a set of add-on tools, Adobe Digital Publishing Suite, which bypassed the need for specialist coding skills. iPad "pages" are created using InDesign, enabling print designers to work concurrently on print and digital designs of the same content while adding simple interactive elements to the iPad material. *Wired* magazine were first to use this software, and many others have followed using the same software as well as competitors such as Woodwing, Mag+, and Aquafadas. —Jeremy Leslie

Zinio

An early entrant to the world of iPad publishing, Zinio offers subscriptions to digital magazines that closely resemble the print versions, incorporating additional features such as audio, video, and live web links. Content is presented via Zinio's proprietary reading platform. The service is compatible with multiple devices. —EL See Zinio.com

Courtesy Newspaper Club

Newspaper Club
Keep the engines of capitalism moving! Newspaper Club utilizes the high-capacity printing plants employed by major newspapers to produce short-run tabloid editions. Serving as a broker between manufacturers and DIY publishers, this web-to-print service allows users to upload PDFs online and order print runs as low as a single copy. (Unit cost goes down as volume goes up.) Publications have included everything from wedding keepsakes to community newspapers. Newspaper Club offers a "bespoke service" that assists customers with design and editorial; clients have included Penguin to the BBC. —EL See NewspaperClub.com

Tim Moore, *Letter to Jane*, 2011 Courtesy the publisher

Ben Terret, *Things Our Friends Have Written on the Internet 2008*, issue 1, 2009
Courtesy the publisher

2011
The Persistence
of Posters
Andrew Blauvelt

LUST, *Poster Wall for the 21st Century*, 2007 Courtesy the artists

Aesthetic Apparatus, installation view of *AAXI: A Decade of Aesthetic Apparatus, One Year Later*, Minneapolis College of Art and Design, 2010 Courtesy the artists

Parallel of Life and Art

In 1953, Alison and Peter Smithson, along with Nigel Henderson, Eduardo Paolozzi, and Ronald Jenkins mounted the exhibition *Parallel of Life* and *Art* at the Institute of Contemporary Arts (ICA) in London. Associated with the Independent Group, which emerged in postwar Britain seeking to introduce mass and popular culture into discussions of high culture. The installation was composed of 122 photographic panels with images drawn from a wide swath of society and culture arranged in a dynamic display utilizing the wall, floor, and ceiling planes. ¶ Dubbing themselves "editors" rather than curators of the exhibition, the group explains in a press release: "In this exhibition an encyclopaedic range of material from past and present is brought together through the medium of the camera which is used as recorder, reporter, and scientific investigator. As recorder of nature objects, works of art, architecture and technics; as reporter of human events the images of which sometimes come to have a power of expression and plastic organisation analogous to the symbol in art; and as scientific investigator extending the visual scale and range, by use of enlargements, X rays, wide angle lens, high speed aerial photography. The editors of this exhibition ... have selected more than a hundred images of significance for them. These have been ranged in categories suggested by the materials, which underline a common visual denominator independent of the field from which the image is taken. There is no single simple aim in this procedure. No watertight scientific or philosophical system is demonstrated. In short it forms a poetic-lyrical order where images create a series of cross-relationships." —AB

Alison and Peter Smithson et al., *Parallel of Life and Art*, installation at the Institute of Contemporary Arts, London, 1952 © 2011 Tate, London

Anthony Burrill, *Don't Say Nothing*, printed by Adams of Rye, East Sussex, UK, 2011
Courtesy the artist

"It cannot be seen whether, or for how long, the poster will have a future. Doubts regarding its future chances are justified when we consider the possible way of life of a post-industrial society with new technological resources in an environment planned according to human requirements." [1]
—Josef and Shizuko Müller-Brockmann, 1971

It is remarkable that the poster endures today, thirty years after Josef and Shizuko Müller-Brockmann speculated about its future demise. This prediction was the coda of their pioneering book, *History of the Poster*. By all rights, the poster should be dead. Its ancient role as a public proclamation, or posting, giving fair notice to citizens or passersby, was eventually supplanted by the newspaper, which became the official or unofficial mouthpiece of the state once the printing press was democratized. The poster was reborn in the emergent commercial contexts of the nineteenth century, advertising the multitude of new goods of the industrial age. While ancient forms of posting may have been unique messages tethered to a particular location, the modern poster was a product of the age of mechanical reproduction. The poster multiplied and spread throughout the city, with large and colorful sheets of paper posted on the sides of buildings and on street kiosks—the natural result of the advances made in large-scale reproductive technologies such as silkscreen, chromolithography, and photography connected to presses that can print thousands of copies per hour. Because of this capacity, we think of the poster today only as a multiple.

The role of the poster to sell the latest goods was eventually overtaken by printed advertisements in newspapers and magazines, which had a more intimate scale and personal form of address that befitted its audience as a collection of individuals rather than an undifferentiated mass—the culture of the street. The poster also lost ground to formats inspired by it, such as the billboard, which provided an even larger canvas to capture the attention of passersby, not on foot but in automobiles. The poster transformed the twentieth-century cityscape with a sea of messages, each competing with the other for attention. This cacophony eventually spawned public concern about "visual pollution," and with it restrictions such as no-posting ordinances and zoning regulations. The official regulation of posting started by legal decree that restricted where one could post, but later tightened through the consolidation of media companies and the outlets they owned, which denied access to those

coveted locations. The culture of posting remains on the street in a more limited, ad hoc, and spontaneous fashion: the lost cat notice, rubbish sale signs, realty placards on bus benches, or the bus shelter ad. There is still a posting culture in pedestrian heavy zones such as college campuses, where the notices about social and cultural offerings abound: a meeting here, a concert there. This is the culture of the flyer: a pint-sized poster, constrained by standardized paper sizes and the machines that handle it: duplicators, photocopiers, laser and inkjet printers. Desktop publishing software enabled people to design their own flyers, and coupled with the convenience of printing centers such as Kinko's, ensured a design culture for the zine and flyer that proliferated in the 1990s.

The contemporary cultural phenomenon of posting, putting your message out in the blogosphere, whether through online commentary or social media updates, is the opposite of the poster. These individual tweets and posts are personal expressions, often of a trivial nature, which are shared in the public and quasi-public sphere through services such as Twitter and Facebook. The poster is synonymous with public expression and creates an immediate sense of formality and authority. It is isolated, not connected, and its context cannot be reliably predicted; therefore it attempts to stand out by standing apart. As a method for giving voice, the poster retains its core function when used as a vehicle for messages about all sorts of social ills—against AIDS, homelessness, poverty, famine, racism, pollution, and global warming. In this capacity it mobilizes designers to act collectively to help visualize "the opposition." In many cases, however, the problem is not one of production, but of distribution and reception: how do you circulate posters in a broad way in an age of fragmented communications or overcome compassion fatigue?

The poster offers a convenient format—the proverbial blank slate. It is graphic design's equivalent to painting—a blank canvas. Sometimes the void is filled by self-reflexive exercises: a meditation on the medium and its systems of production and distribution. The poster is also kept alive through the revival of seemingly outdated technologies such as letterpress, woodblock, and silkscreen printing. The resurgent interest in these tools and techniques is both a backlash by designers against the immateriality of the screen and a testament to the desire for hands-on production. The poster also partakes of new technologies and systems, such as inkjet, print-on-demand, or digital printing, all cheaper

than offset printing and capable of producing small-run editions.

Created in workshops, exchanged through swaps, or purchased online, the contemporary poster thrives as a published edition of prints. The edition poster is akin to the autonomous work of art, a thing unto itself, which can be contrasted with the servile advertising function of the traditional poster. The poster persists not on the basis of its useful value as a device to reach the masses but on its aesthetic and symbolic value. This represents a surplus value of the poster—the contribution it makes to the culture at large as a reflection of an aesthetic impulse of a period or an artist—which exceeds or is in addition to the purely useful form it takes as a device to sell things. This kind of value is not new, as it can be found deeply entwined with the poster's modern history. In its most obvious sense, value is granted by the artist himself, who has applied his signature style to a poster, thus giving it added cultural resonance and appeal. But this cachet or aura does not fully explain the devotion accorded to the poster by consumers who collect them or the status granted to the form by designers. Rather, the poster's appeal is a product of both its absence—as a blank slate full of creative potential—and its presence as a physically autonomous, discrete object. Ultimately, and paradoxically, as Susan Sontag notes: "The poster, at its origins a means of selling a commodity, is itself turned into a commodity." [2]

The Müller-Brockmanns' prediction regarding the future of the poster is remarkably prescient about the impending technological future, with descriptions of things such as videophones and the connectivity of something resembling the Internet. Despite the accuracy of their vision, technology did not render the poster obsolete as a means of communication. Instead, technology expanded the tools, methods, and systems of production and distribution, freeing the poster from its typical burden of representation while sentencing it to a different kind of future. Their sobering conclusion that "retrospectively, the poster will be judged as a temporary solution of questionable information value," [3] still leaves room for the poster to possess a greater symbolic value. ⊠

Notes
1. Josef and Shizuko Müller-Brockmann, *History of the Poster* (Zürich: ABC Verlag, 1971), 239.
2. Susan Sontag, "Poster: Advertisement, Art, Artifact, Commodity" (1969), in *Looking Closer 3: Classic Writings on Graphic Design*, ed. Michael Bierut, Jessica Helfand, and Steven Heller (New York: Allworth Press, 1999), 217.
3. Müller-Brockmann, *History of the Poster*, 239.

Edward Fella, various flyers, 2009 Courtesy the artist

Ed Fella

Self-proclaimed "exit-level" (as opposed to entry-level) design veteran Ed Fella has co-opted the form of the poster in the guise of the flyer, albeit in the larger 11-by-17-inch size. Folded and printed on a paper in the office-culture color palette of tans, peaches, and grays, they are adorned with a sticker or a hand-applied marking. Hundreds of these flyers have been produced, each in multiple quantities, not to promote a lecture he is giving, but rather to commemorate it. Distributed to attendees at the event, these flyers function as keepsakes, which as writer Susan Sontag once noted, fulfill an important cultural function: "A poster is like a miniature of an event: a quotation—from life, or from high art. Modern poster collecting is related to the modern phenomenon of mass tourism. As collected now, the poster becomes a souvenir of the event." Here, we find another inversion by Fella, namely that the important gesture isn't one of collecting by the consumer, but of producing and distributing these flyers on the part of the designer. This seizing control of the means of production and distribution, becoming in effect both message and messenger, presages other important developments that constitute the afterlife of the contemporary poster, one that explains the persistence of this most iconic form of graphic design. —AB

Aesthetic Apparatus

As part of their practice, the studio Aesthetic Apparatus instigates and participates in the revival of the gig poster, silkscreened prints produced by them ostensibly as a commission from a venue to announce a particular concert. In this capacity, the poster functions in its conventional role as a promotional device. However, these types of posters live a greater and extended life as works that can be bought, sold, and exchanged as essentially limited-edition prints, available through websites such as Gigposter.com and at gatherings such as Flatstock, where collectors can view and purchase posters and meet the artists in person. The contemporary gig poster is an alibi of sorts, the functional prerogative of an event announcement masking a deeper desire on the part of the designer to simply make. —AB

Aesthetic Apparatus, *Untitled Test Prints*, circa 2002–2007 Courtesy the artists

Forms of Inquiry

Forms of Inquiry: The Architecture of Critical Graphic Design (2007) was an exhibition and publication organized by Zak Kyes and Mark Owens under the auspices of the Architectural Association in London. As such, it asked graphic designers to take architecture as its subject of inquiry primarily through the commissioning of prints that explored a diverse range of topics. Although framed as an exploration of one design medium by the practitioners of another, the project was an exploration of what constitutes a critical practice of graphic design without posing a definitive answer. Eschewing the term "research," the organizers instead adopted the less scientifically laden notion of "inquiry" as a more open-ended sense of exploration. Importantly, the exhibition and publication addressed the shifting, expanding, and liberating modes of production that "expand the limits of a studio practice," by distributing "their own information through self-initiated publications" and adopting "new critical positions through the use of archival and curatorial tactics." —AB

Forms of Inquiry: The Architecture of Critical Graphic Design, curated by Zak Kyes as installed at IASPIS, Stockholm, 2008 Photo: Jean-Baptiste Béranger

Fanette Mellier, installation of *Specimen* at the 19th International Poster and Graphic Design Festival, Chaumont, France, 2008

International Poster and Graphic Design Festival

For more than twenty years the town of Chaumont, France, has played host to an international festival of contemporary poster art and design. The festival, which has several components, including a competition, has engaged in more recent years not only the poster in its finished form, but also the nature of its process and production as well as the diminishing notion of specialization or exclusive focus on the form by practitioners. In 2011, the competition jury chaired by M/M (Paris) included, for the first time, members from beyond graphic design. ¶ In the following excerpt from the 2011 letter "A Poster Competition is not a Horse Show," Mathias Augustyniak of M/M (Paris) elaborates on the idea to Étienne Hervy, the festival's delegate general: "Yes, Étienne, Michaël and I agreed to chair the Chaumont competition because we believe that graphic designers are authors and artists, perpetually redefining their practice, in the sense that making graphic design involves handling images, signs and clues in order to articulate messages on every scale within every reality, whatever their temporal or spatial textures, with the aim of living better in the world we are passing through. Being a graphic designer is also a profession: not all graphic designers are authors, just as not all contemporary artists are authors; some are only great professionals, and that's fine. To elegantly articulate images, signs and clues to the reality of the world, in order to make symphonies of conversations whose consistency is akin to Yves Klein's 'zones of immaterial pictorial sensibility,' is a beautiful journey that brings happiness." —AB

Graphic Design in the White Cube

Organized in 2006 by Peter Bil'ak, *Graphic Design in the White Cube* was an exhibition of commissioned posters for the 22nd International Biennale of Graphic Design in Brno, Czech Republic. Conceived in opposition to taking design artifacts, which have been created a priori for specific contexts, and decontextualizing them by displaying them inside the "white cube" gallery space of the museum, the project avoids presenting works with "a frozen appearance stripped of meaning, liveliness and dynamism of use." Instead, nineteen designers from around the world were invited to create a work intended for display. The resulting posters were shown in the exhibition context but also placed around the city to promote the show. This approach is a self-reflexive use of the poster, as both object of contemplation and instrument of communication. As Bil'ak notes: "This is obviously a dangerous snake-eating-its-own-tail strategy, yet the self-referential nature of the brief makes it possible to illustrate otherwise invisible mechanics of the work process." —AB

Mevis & Van Deursen, *Graphic Design in the White Cube*, 2005 Courtesy the artists

I LIKE IT. WHAT IS IT?

THINK OF YOUR OWN IDEAS

IT ALL MAKES SENSE

WORK HARD & BE NICE TO PEOPLE

MAKE YOUR MARK ON THE WORLD

CLEAR YOUR HEAD

YOU KNOW MORE THAN YOU THINK YOU DO

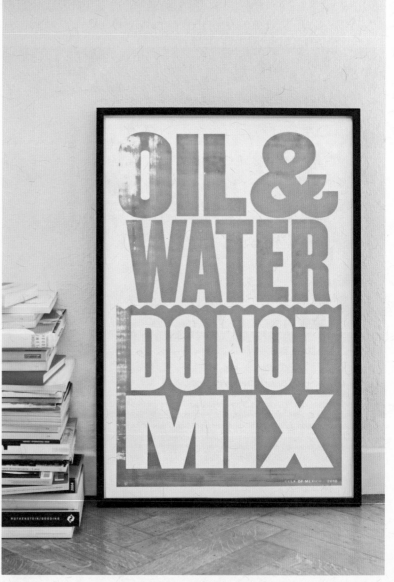

OIL & WATER DO NOT MIX

Anthony Burrill, woodblock poster series, 2004–2011, printed by Adams of Rye, East Sussex, UK Courtesy the artist

Anthony Burrill

The contemporary culture of the authority message—also on display in other ways, such as on T-shirts or bumper stickers—is the subject of Anthony Burrill's woodblock poster series in which large-scale letterforms spell out messages that admonish or uplift the reader. A more recent variant of this series proclaims "Oil & Water Do Not Mix." The poster was made using oil spilled in the 2010 Gulf of Mexico environmental disaster as silkscreen ink. —AB

Anthony Burrill, *Oil & Water Do Not Mix*, 2010, conceived and produced in collaboration with Happiness, Brussels Courtesy the artist

Albert Exergian

Albert Exergian's *Iconic TV* series of more than fifty posters mixes the high-minded, abstract, and minimalist style of classic Swiss modernism made famous by the likes of various mid-twentieth-century practitioners such as Josef Müller-Brockmann, Armin Hoffman, and Max Bill with the pop cultural excesses of American television programming. A new resonance is achieved when the designer uses this reductive style to depict the essence of any number of programs, including *Charlie's Angels* (pictured as the speaker phone of the otherwise anonymous main character), *Weeds* (a dime bag of pot), or *Dexter* (a bloody razor blade). Available through the web from print-on-demand poster service Blanka/Print-Process, Exergian's self-commissioned designs are intended solely for personal delectation and call upon the viewer's mental reservoir of knowledge, trivia, and memories. —AB

Albert Exergian, *Iconic TV* series, 2009–2010 Courtesy the artist

Michiel Schuurman

Michiel Schuurman, while working at Kinko's, began exploring the potential of large-scale black-and-white photocopiers to make posters. Using the action tools and repeat functions found in software programs such as Adobe Illustrator, Schuurman generates multiplied shapes and outlines of letterforms that pulsate and radiate. These works, which flirt with the extremes of legibility, recall the op art and Art Nouveau–influenced posters of the 1960s Haight-Ashbury scene, which were of course perfectly understandable to their target audiences. Although almost always typographic in origin, Schuurman's poster designs become an all-encompassing retinal image. —AB

Michiel Schuurman, *Quiet is the New Loud, February 2011*, 2011 Courtesy the artist

Michiel Schuurman, *BROKEN GLASS EVERYWHERE, JUNE 2010*, 2010 Courtesy the artist

Michiel Schuurman, *HORSEMOVEPROJECTSPACE, October 2007*, 2007 Courtesy the artist

Michiel Schuurman, *HORSEMOVEPROJECTSPACE, June 2008*, 2008 Courtesy the artist

Michiel Schuurman, *HORSEMOVEPROJECTSPACE, February 2008*, 2008 Courtesy the artist

Green Patriot Posters

A standard of protest movements, the activist poster in such instances transcends its life of service to capital in order to adopt the cause of the State and its challengers. A sense of urgency prevails. Everything is directed to the importance of the message and thus the genre often suffers from repetitive motifs (clichés), tired strategies (tried-and-true formulas), and exhausted symbolism (predictable depictions). Perhaps the most urgent issue today, environmental degradation, is the focus of the ongoing *Green Patriot Posters* project (2009–). Conceived to explore the potential ways that third and fourth wave environmentalism might be represented or depicted, the project solicits ideas in the form of posters that are crowdsourced through a website where new entries can be uploaded, existing designs rated and commentary appended, or designs downloaded for use. This endeavor, one that supports the creation, production, and distribution of posters, is a unique system or platform that vertically integrates formerly separate functions and processes in one environment. —AB

Dmitri Siegel and Edward Morris, *Green Patriot Posters: Images for a New Activism*, 2010
Cover © Shepard Fairey/ObeyGiant.com Courtesy the designers

Left to right

Row 1: Felix Sockwell, *Step on It*; Chester Jenkins and Tracy Jenkins, Village, *Unplug*; Marlena Buczek Smith, *Oil Spill Gulf of Mexico 2010*; Andrew Sloat, *If You Don't Like My Tone*; Jon-Paul Villegas, *You Shouldn't Have*; Steve Le, *Problem Me, Solution Me*; Phillip Clark, *Dirty Secret*; Keo Pierron, *c. 2050*; Joe Scorsone and Alice Drueding, *Consequences of CO2* **Row 2:** Rob Giampietro, *Water's Rising*; Eric Benson, *Green Patriot Wind*; Adam McBride, *Paint it White*; Xander Pollock, *Shit Be Meltin'*; Will Etling, *Sustain*; Jessica Colaluca, *Seed*; Kristina Kostadinova, *Friend in Trouble*; Lauren Perlow, *S.O.S.*; Bags of Joy, *Plenty Of* **Row 3:** Noel Douglas, *Dead End*; Geoff McFetridge, *Lumberjack*; Adam Gray, *Join the Revolution*; Everything Studio, *Earth*; Ben Barnes, *Sow*; Jason Hardy, *Let's Ride*; Ryan Dumas, *Eat Local?*; Jeremy Dean, *Let's Do This*; Mathilde Fallot, *Golab waminrg* **Row 4:** Diego Guitiérrez, *Keep Buying Shit*; Meredith Stern, *Justseeds, We Are Power*; Sara Stryjewski, *Being Green*; Justin Kemerling, *(Re)Make America*; JMR, *Rejuve a Nation*; Chris Sials Neal, *Eat Local, Buy Local, Grow Local!*; Mike Perry, *Let Them Grow*; Brandon Schaefer, *Don't Be Stuck Up*; Erin Pugliese, *Shorter Showers* **Row 5:** DJ Spooky (aka Paul D. Miller), *Manifesto for a People's Republic of Antarctica* (part of *Terra Nova: Sinfonia Antarctica*); Thumb, *In the Future Green Will Be Just Another Color*; Sinclair Smith, *Water Power Is Ready*; Nick Dewar, *Simplicity is the Key to Successful Living*; Shepard Fairey, *Power Up Windmill*; Frédéric Tacer, *Global Warming*; Guillermo Broton, *Global Excess*; Esteban Chavez, *Sustain*; Nancy Skolos, *Ignorance is Bliss* **Row 6:** James Victore, *Save the Plants*; Vier5, *Umwelt*; Paul Elliman, *Detroit as Refrain*; Ryan Arruda, *Efforts Up! Carbon Down!*; Jon Santos, *Washington Monument*

"Say Yes to fun & function & NO to seductive imagery"

Daniel Eatock's *Utilitarian Poster* (1999) provides a template for a do-it-yourself production on the part of its user. It methodically compartmentalizes the various components of a typical message: time, date, subject, contact information, etc. Silkscreened onto inexpensive newsprint, its simple and spare design strips away the glossy and colorful ambition of the typical poster to make room for another voice, one exercised by the user who fills it with his or her own specific content. Eatock's *Untitled Beatles Poster 02* (2006) contains the lyrics of all the Fab Four's songs rendered in very small type. This exercise in capturing everything of something merges the seemingly impossible task of making visible the completeness of an archive, while presenting it in a form that is typically about reduction, editing, and simplification. —AB

Daniel Eatock, *Utilitarian Poster*, 1999 Courtesy the artist

I read the news today oh boy About a lucky man who made the grade And though th Woke up fell out of bed Dragged a comb across my head Found my way downstairs you on... It's been a hard day's night and I been working like a dog It's been a hard d Owww! So why on earth should I moan 'cause when I get you alone You know I feel on and on across the universe Thoughts meander like a restless wind inside a letter change my world Whenever I want you around yeah All I gotta do Is call you on the p running home Yeah that's all I gotta do And the same goes for me Whenever you wa my loving to you All my loving I will send to you All my loving darling I'll be true One Love Love There's nothing you can do that can't be done Nothing you can sing that know that isn't known Nothing you can see that isn't shown Nowhere you can be tha I love her She gives me ev'rything And tenderly The kiss my lover brings She brings your bird is green But you can't see me you can't see me When your prized possess new I ain't no fool and I don't take what I don't want For I have got another girl anotl want For I have got another girl Another girl Who will love me till the end Through thi feeling sorry and sad I'd really sympathize Don't you be sad just call me tonight Any want to know And it's true that it really only goes to show That I know That I I I I sho That I know That I I I I should never never never be blue Ask me why I'll say I love yc to know What did you see when you were there? nothing that doesn't show Baby yc you're a rich man too You keep all your money in a big brown bag inside a zoo what he'll never come back she's dressed in black Oh dear what can I do? Baby's in blacl

Above and detail: Daniel Eatock, *Untitled Beatles Poster 02*, 2006
Courtesy the artist

Daniel Eatock

The poster format presupposes message content, which is the driving purpose or raison d'être of the modern poster. Is a poster without a message still a poster? For instance, Eatock's *Felt-Tip Print* (2006), which consists of 300 markers left uncapped and standing. Sheets of paper are balanced on the marker tips until the ink is drained from the pens. The resulting stack of paper, each with its own pattern of ink absorption, becomes an edition. While also a monoprint, *Felt-Tip Print* pushes the limits of the poster form, serving as an indexical record of the process of its own making. —AB

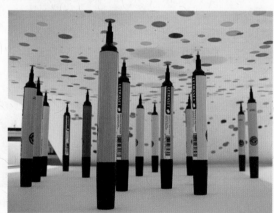

Above and left: Daniel Eatock, *Felt-Tip Print*, 2006 Courtesy the artist

M/M (Paris)

No Ghost Just A Shell (2000), a poster by M/M (Paris), features Annlee, a fictional anime character purchased in Japan by artists Philippe Parreno and Pierre Huyghe. Destined for narrative oblivion due to the marginal status of her role, Annlee was in a sense rescued by the artists through a licensing agreement and made available for various artistic pursuits, including an appearance in this work. The poster's title alludes to the character's arrested development; though spared from termination in her original context, she is consigned to perform different roles in perpetuity. Annlee is devoid of personal identity and becomes a surrogate, a cipher, or a blank slate onto which one projects an image, an identity, or a program. —AB

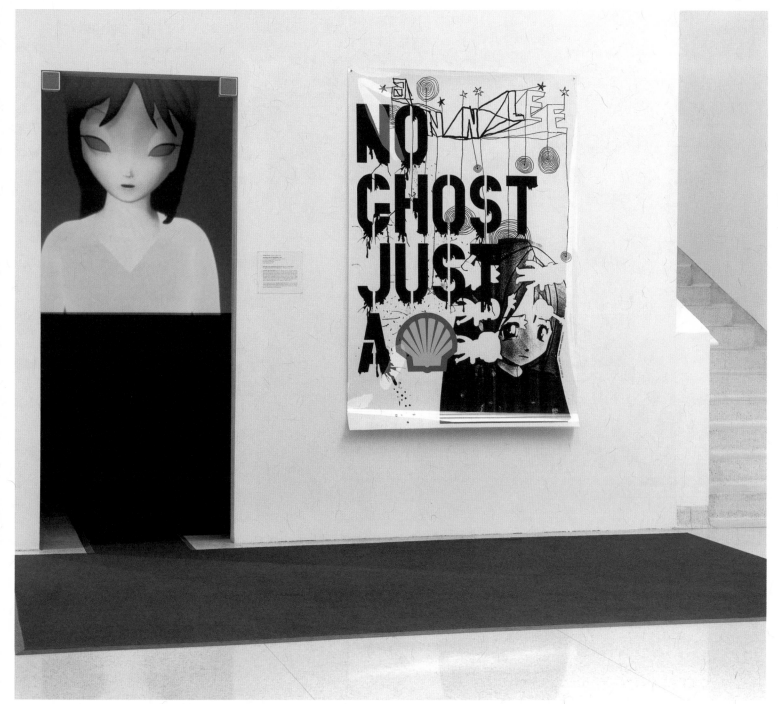

M/M (Paris), *No Ghost Just a Shell* [Pierre Huyghe and Philippe Parreno], 2000, poster shown in Pierre Huyghe, *Two Minutes Out of Time*, 2000, Collection Walker Art Center, Minneapolis Courtesy M/M (Paris)

LUST

The merger of personalized messages and automated design is the subject of LUST's *Poster Wall for the 21st Century* (2007/2011), a projected scrim of ever-changing posters. Using local websites to scavenge images and texts, computer algorithms produce designs for up to 600 posters a day. Viewers can send messages to a computer, which are then incorporated into the works. QR (Quick Response) codes readable by smartphone cameras relay viewers to websites where these customized designs are stored and can be retrieved. The wall itself is a layered palimpsest of projected posters, older messages sinking to the bottom, new ones surfacing on top. In a millennial twist, the LUST wall display responds to the movements of passersby. While the modern poster strove to capture and immobilize the viewer's gaze, this future poster senses and follows you. It compels you to provide your own message. In this way, it is the quintessential empty vessel, waiting to be filled with content—waiting to follow your lead. —AB

LUST, *Poster Wall for the 21st Century*, 2007 Courtesy the artists

Algorithm

A precise way of explaining how to do something. It is commonly used within the context of computer instructions. While most people wouldn't refer to a pattern for knitting a scarf as an algorithm, it's the same idea. Likewise, instructions to get from one place to another, instructions for assembling kit-of-parts furniture, and many other types of guidelines are also algorithms.... An algorithm requires assumptions. Hiking directions assume that you know how to hike, from knowing to wear the right shoes, to understanding how to follow a winding trail, to assuming that you know to bring plenty of water. Without this knowledge, the hiker may end up lost and dehydrated with blistered feet. An algorithm includes decisions. Directions often include instructions from different starting locations. The person reading the directions will need to choose a starting position. A complex algorithm should be broken down into modular pieces. Directions are often divided into small units to make them easy to follow. There may be separate directions for coming from the North or the South, but at a certain point the directions converge and both groups follow the same directions. —Casey Reas, Chandler McWilliams, and Jeroen Barendse, *Form + Code in Design, Art, and Architecture*, 2010

Fanette Mellier
Created for the annual international poster festival in Chaumont, Fanette Mellier's *Specimen* uses the iconography of the printer—color bars used to measure ink density, registration marks for trimming and aligning ink layers—as a substitute for a photograph or illustration of the typical poster. A reference to its own production, *Specimen* provides a patterned surface on one side and information about the exhibition on the reverse. These two surfaces—pure text and pure image—are brought together when the corner of the poster is folded back to the reveal the text beneath. While a gesture for functional reasons, the "dog-earring" of the paper cleverly relates the poster to the book page. In many ways, the contemporary poster exhibits traits more closely identified with the scale of the book, such as smaller-size type meant to be read at close range and more complex compositions and multiple images rather than an easily graspable main image. Mellier, who is comfortable designing at a variety of scales—posters, identities, typefaces, and books—is perhaps best known for her inventive use of color and shape to transform words and letterforms into imagistic compositions. —AB

Fanette Mellier, *Specimen*, 2008 Courtesy the artist

Experimental Jetset: Affichism
Dear Andrew,
Let us explain the concept. As one of the themes, you mentioned "the culture of making"... which immediately made us think about "the culture of unmaking", or better said, the relationship between creation and destruction (creation as destruction, destruction as creation). We have always been huge admirers of the work of the French "affichistes" (like Jacques Villeglé, Francois Dufrene, Raymond Hains, and the Italian Mimmo Rotella), artists who made collages using torn posters. To us, these layered collages perfectly encapsulate the whole idea of the "paper memory", of graphic archeology. These torn fragments offer an almost psycho-analytical portrait of graphic design—as if the artists are digging through different layers of consciousness. Moreover, by focusing on the material quality of paper, they show graphic design as what it is—a physical, human-made construction. They pierce through the sphere of images, to reveal the material base. These layers of posters also refer to another idea we're really interested in: the idea of printed matter as an actual environment, as an integral part of the city. In other words, we've always wanted to explore this notion, of "affichism," a bit further—and your exhibition was a perfect occasion to finally dig into this subject. ¶ What we did was this: we tried to recreate these "affichist" collages, using fragments of graphic languages that have influenced us. The late-modernist voice of people such as Crouwel (the visual landscape in which we were raised), the post-punk culture of the '80s (in which we grew up as teens), the early-modernist influences (which we came across through the practice of graphic design), and the counter-culture of the '60s (which we find extremely inspirational). By juxtaposing all these different (often conflicting) graphic languages, we hoped to come to a sort of psychological portrait of our own graphic sensibilities, while at the same time addressing some of your main themes (the culture of making, design labor and production, etc.). ¶ We then added a quote by Walter Benjamin, taken from *The Arcades Project*. Ever since we came across it, it's a quote that means a lot to us, as it provides us with a very useful model of how graphic design can be interpreted: as a landscape of conflicting voices, in which truth becomes something living. When we use this quote (in interviews, for example), we often suggest that Benjamin's words refer to the *flaneur*, walking through the 19th-century cityscape of Paris, being confronted with a multitude of affiches, billboards, signs, slogans, street names, sandwich men, newspaper kiosks, etc. And since this quote comes from *The Arcades Project*, this interpretation seems very plausible indeed. However, we have to admit that it is a bit of a lie. In reality, Benjamin describes the effect of hashish on reading. But we often neglect to mention this—which is also a way to keep truth a living thing, so to speak. ¶ Nevertheless, in combination with the torn posters, we think the quote refers really well to the whole idea of "affiche culture," the idea that every poster is part of an ongoing "dialogue" between posters. In that sense, it's a less cynical, more modernist, and more optimistic version of Susan Sontag's phrase "one part sentimentality, one part irony and one part detachment" (which is, roughly, how Sontag describes "affiche culture" in her essay "Posters: Advertisement, Art, Political Artifact, Commodity," in 1970). Also, the use of a Benjamin quote ties in quite well with some of the other themes (the designer as producer, means of production, etc.), as Benjamin wrote extensively about the relationship between aesthetics and production. So Benjamin feels natural within the context of the exhibition. ¶ What we also like about this set of posters is the fact that it almost becomes a "mini-exhibition" in itself. After all, the three posters feature a specific collection of posters, curated by us. True, only torn, unrecognizable fragments are shown, but still: it's an exhibition model. A sort of subjective and fragmentary history of modern graphic design, compressed to three posters, like a sort of miniature archive. ¶ Anyway. We think you get the idea. We hope you like these posters. We think they will fit perfectly in the show. Let us know what you think of it! All the best,
Danny, Marieke, Erwin (Experimental Jetset)

Experimental Jetset, 2011
for 'Graphic Design –
Now in Production'

René Azcuy Cárdenas, 1970
Roman Cieslewicz, 1969
Wim Crouwel, 1962
Wim Crouwel, 1968
Frémez Gómez Fresquet, 1967
Malcolm Garrett / Linder, 1977

Jan Lenica, 1964
Jamie Reid, 1980
Rob Stolk, 1969
Stop de Kindermoord, 1976
Throbbing Gristle, 1976

"Under these conditions, even a sentence (to say nothing of the single word) puts on a face, and this face resembles that of the sentence standing next to it...

1/3

Pages 109–111: Experimental Jetset, *Statement and Counter-Statement*, 2011 Courtesy the artists

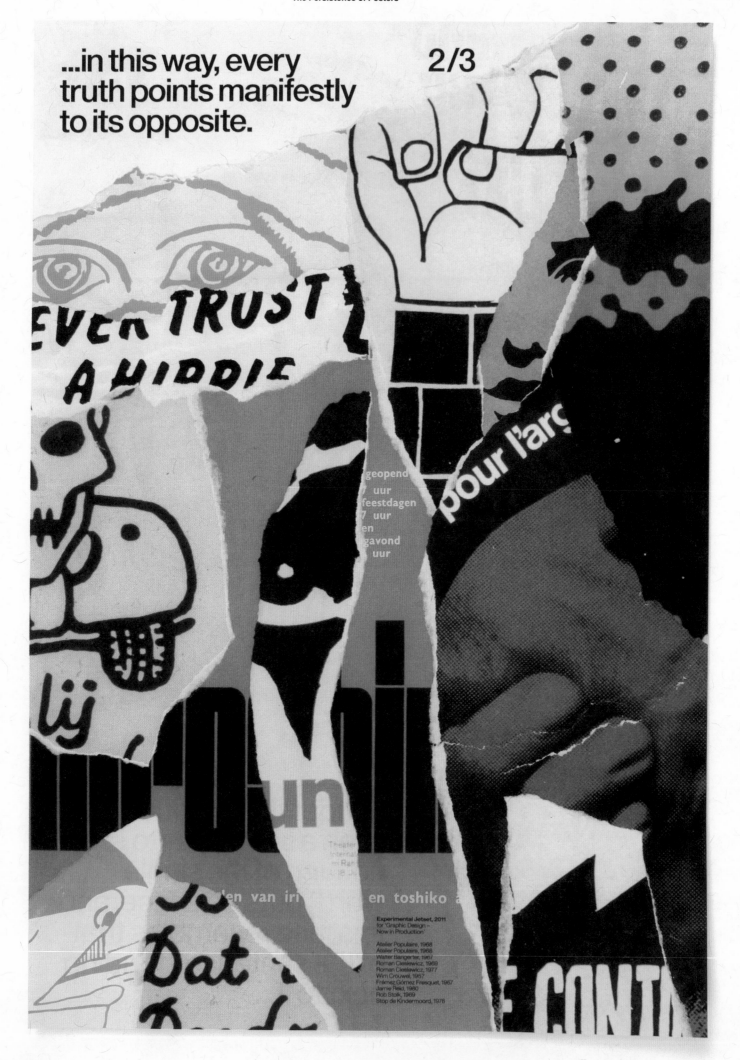

...in this way, every truth points manifestly to its opposite.

Experimental Jetset, 2011
for 'Graphic Design –
Now in Production'

Atelier Populaire, 1968
Atelier Populaire, 1968
Walter Bangerter, 1967
Roman Cieslewicz, 1968
Roman Cieslewicz, 1977
Wim Crouwel, 1957
Frémez Gómez Fresquet, 1967
Jamie Reid, 1980
Rob Stolk, 1969
Stop de Kindermoord, 1978

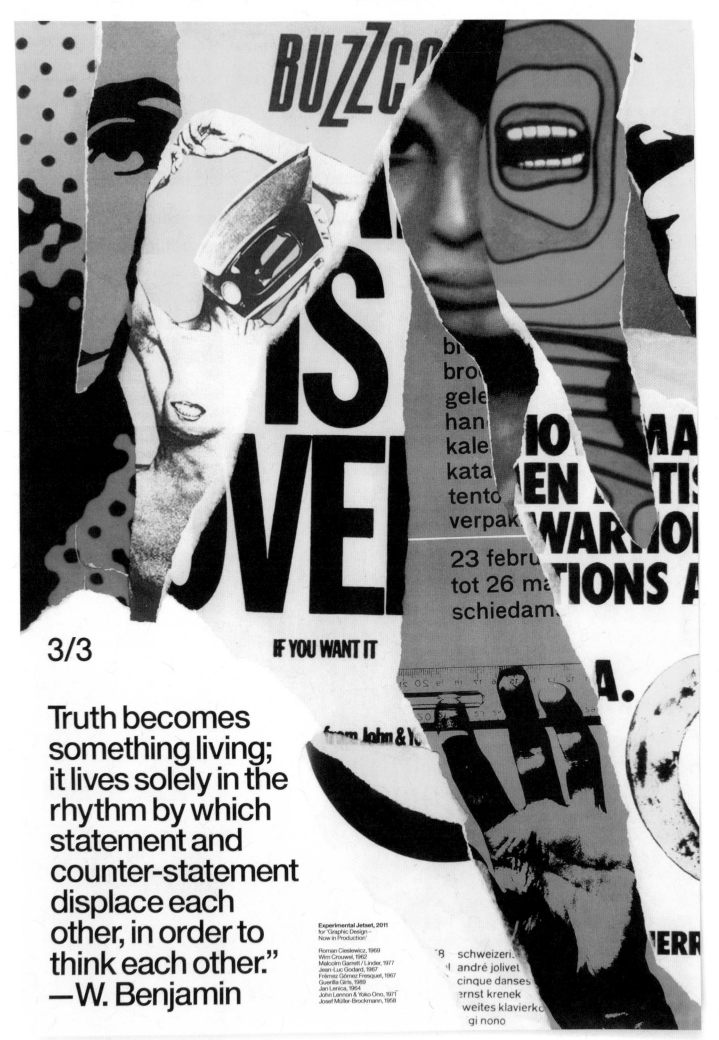

3/3

Truth becomes
something living;
it lives solely in the
rhythm by which
statement and
counter-statement
displace each
other, in order to
think each other."
—W. Benjamin

Experimental Jetset, 2011
for 'Graphic Design –
Now in Production'

Roman Cieslewicz, 1969
Wim Crouwel, 1962
Malcolm Garrett / Linder, 1977
Jean-Luc Godard, 1967
Frémez Gómez Fresquet, 1967
Guerilla Girls, 1989
Jan Lenica, 1964
John Lennon & Yoko Ono, 1971
Josef Müller-Brockmann, 1958

2011
The Making of Typographic Man
Ellen Lupton

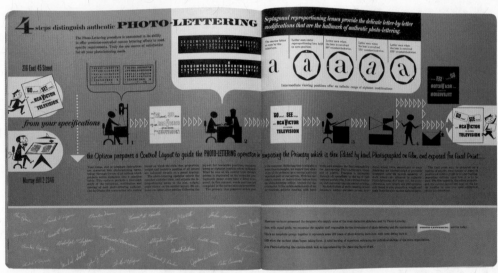

Photo-Lettering brochure showing typesetting process, 1960s Courtesy House Industries

Photo-Lettering catalogue, 1960s Courtesy House Industries

PLINC

Photo-Lettering, Inc., or PLINC, founded in 1936 by Edward Rondthaler and Harold Horman, became one of the most successful, long-standing type houses in New York City. Photo-based typesetting liberated typography from the confines of hot metal, and PLINC remained influential until the rise of new digital technologies forced them to close their doors in 1985. The Photo-Lettering legacy—more than 10,000 type designs—went dormant until 2003, when the Delaware-based digital type foundry House Industries purchased the entire collection, rescuing the archive from a storage facility on New York's Tenth Avenue. ¶ For the next eight years, designers at House Industries painstakingly parsed the thousands of film specimens, lettering catalogues, and original plates to hone in on a select series of original PLINC alphabets and transform them for the digital world. House Industries set out to construct a digital tool that matched the delivery of craftsmanship, innovation, and design established by the original company. ¶ Designer Ken Barber explains, "The idea evolved to create a service that would be a new incarnation of the original service, where you wouldn't buy typefaces per se but you would actually buy a setting." This service would allow users to generate the words they need while also adding color, changing weights, manipulating scale, and more, customizing the alphabets on the fly from directly within the online interface. "We thought, 'well...wow, these aren't typefaces, so let's push the fact that they can do things that typefaces can't do,'" says Barber. In April, 2011, House launched Photolettering.com in partnership with Erik van Blokland and Christian Schwartz; PLINC's legacy was reborn on the web. ¶ At the core of the Photo-Lettering site is the LetterSetter engine, created by Erik van Blokland and Tal Leming. This new tool allows letterforms to do things that fonts cannot. The lettering style D'Amico Gothic, which operates on six masters, permits the user to interpolate weight and width to any spot on a spectrum, right on a sliding scale on the interface, essentially allowing the user to create a unique version of the lettering style. Designers can now access a visual library of lettering styles, edit them, and download custom lines of type. Sounds simple, but simple doesn't take eight years. With Photolettering.com, House Industries shows its respect for typography's history, and in turn helps guide its future. —Jessica Karle Heltzel

Photo-Lettering Films
Each of Photo-Lettering's alphabets took more than 200 hours to complete, originally drawn with pen and ink by veteran lettering artists. These alphabets were first exposed on glass plates, but eventually were converted to film. Photo-Lettering films are approximately 28 inches wide by 5 inches tall. —AB See Photolettering.com

Photo-Lettering filmstrip for producing headlines, 1960s Courtesy House Industries

Ed Benguiat, Buffalo, 2011 Courtesy House Industries

Ed Benguiat's Buffalo lettering applied to Heath ceramic tile, 2010 Courtesy House Industries

Marshall McLuhan, *The Gutenberg Galaxy: The Making of Typographic Man*, 1962 Courtesy University of Toronto Press

Marshall McLuhan published *The Gutenberg Galaxy: The Making of Typographic Man* in 1962.[1] No easy read, this rather technical book overflows with opaque excerpts from seventeenth-century poetry and bulk quotes from pioneering scholarship about print's impact on the modern mind—readers today are advised to approach this book with a double shot of espresso. Despite its density, *The Gutenberg Galaxy* helped trigger McLuhan's own remaking from a Canadian English professor into a global intellectual celebrity. The book uses typography in a remarkably aggressive way, breaking up its soporific pages of academic prose with slogan-esque "glosses" set in 18-point Bodoni Bold Italic. Bam! McLuhan was using type to invent the McLuhanism. Five years later, he produced the radical mass paperback *The Medium is the Massage* with graphic designer Quentin Fiore, amplifying his early visual experiments to new levels of bombast.

Who is McLuhan's Typographic Man? The concept of the human individual (an isolated self walled off from the collective urges of society) was born in the Renaissance and became the defining subject of modern systems of government, law, economics, religion, and more. This individual was, McLuhan argued, both product and producer of the most influential technology in the history of the modern West: typography. The use of uniform, repeatable characters to manufacture uniform, repeatable texts transformed the way people think, write, and talk and triggered the rise of a money-based economy and the Industrial Revolution. The vast enterprise of modernity all came down to letters printed on sheets of paper.

Typography amalgamated past inventions, the most important being the phonetic alphabet itself—a concise set of symbols that could, in theory, translate the sounds of any language into a simple string of marks. (In contrast, the Chinese writing system, with its thousands of unique characters, was less conducive to automation.) Gutenberg's invention joined the phonetic alphabet with oil-based ink, linen-based paper, the printing press (derived from the wine press), and the crafts of goldsmithing and metal-casting (Gutenberg's personal areas of expertise). Movable type engendered the system of mass production. This new way of making things broke down a continuous process into a series of separate operations. The printed book became the world's first commodity.

What happened to Typographic Man, and what is he doing today? The eyeball was this creature's supreme sense organ, supplanting shared auditory experiences of preliterate society. McLuhan predicted that in the rising electronic age, the individualism of Typographic Man would succumb to the tribal chorus of the "global village," whose collective existence was defined by radio and television (dominated by sound) rather than by private acts of reading (dominated by sight).[2]

It hasn't really worked out that way. Today, our lives contain more typography than ever, served up via text messaging, e-mail, and the Internet. Letters swarm across the surface of TV commercials and cable news shows, while global villagers in the developing world have discovered SMS as an indispensable business tool. Meanwhile, the collective experiences forged by Twitter and Facebook rely largely on the transmission of text. The most famous McLuhanism of all, "The medium is the message," fared no better.[3] In today's world, the medium is often just the medium, as content seeks to migrate freely across platforms rather than embody the qualities of a specific medium. "Device independence" has become a goal more urgent than the task of crafting unique page layouts.

Although typography isn't dead yet, every good font designer works with one foot in the grave. Typographers feed on past traditions the way zombies lunch on brains. A survey of contemporary typefaces reveals a repetition or replay of the larger history of printed letters. And just as the first typographers were risk-taking entrepreneurs—seeking riches and facing ruin—type designers today are technical innovators and business advocates, building tools and standards for use by the broader type community while testing new markets and experimenting with alternative forms of distribution.

Strictly speaking, *typography* involves the use of repeatable, standardized letterforms (known as fonts), while *lettering* consists of custom alphabets, usually employed for headlines, logotypes, and posters rather than for running text. During the first hundred years of printing, calligraphy and type fluidly interacted, not yet seen as opposing enterprises. While it is well-known that Gutenberg and other early printers used manuscripts as models for typefaces, it is more surprising to learn that the scribes who were employed in the "scriptoriums" or writing factories of the day often produced handmade copies of printed books for their luxury clientele, using calligraphy to replicate print.[4] Today, a vital collision between the idioms of handwriting and mechanical and post-mechanical processes is shaping our typographic vocabulary.

With the introduction of desktop computing in the 1980s, the design and delivery of typefaces changed from a sequence of discrete processes requiring expensive equipment (mass production) into a fluid stream managed by a few producers at low cost (cottage industry). Using desktop software, a graphic designer could now manufacture digital fonts and ship them out on floppy disks. Emigre Fonts, founded in Berkeley, California, by Rudy VanderLans and Zuzana Licko, began producing bitmapped typefaces in 1984 that exploited the constraints of early desktop printers. An intoxicating discourse about experimental design sprang up around these fonts, documented in *Emigre*, its eponymous magazine. By the mid-'90s, the jubilant fascination with high-concept display alphabets (distressed, narrative, hybridized, futuristic) was joined by a demand for full-range, full-bodied type families suitable for detailed editorial design (crafted by highly focused typographers in a field that was becoming, again, more specialized).

The same technologies that changed the way designers produce typefaces also changed the way we use them. Graphic designers could now manipulate fonts directly, instantly seeing them in their own layouts and testing them in different sizes and combinations. As the procedures of typesetting and layout merged, designers became direct consumers of fonts, no longer separated by layers of mediation from the essential raw material of their craft. In this intoxicating new era of instant alphabetic gratification, designers could not only buy, borrow, and steal digital fonts but could crack them open, violating the original designs to create alternate characters and even whole new typefaces. Designers stirred up the historic confusion between lettering and type in new ways by altering the outlines of existing characters.

Custom lettering is a powerful current in contemporary design. Designers today combine physical and digital processes to create letterforms that grow, copulate, and fall apart. Vocabularies range from the lush organicism of Marian Bantjes and Antoine et Manuel to the geometric constructions of Philippe Apeloig, whose bitmapped forms suggest an animated process of assembly and dissolution. Letters drip, drag, and spring into life in the posters of Oded Ezer; they morph and metastasize across the CD and LP covers of Non-Format.

Handmade letters provide the model for many contemporary typefaces, from Hubert Jocham's Mommie (2007) to

Laura Meseguer's Rumba (2006) and Underware's Liza Pro (2009).

Many recent script fonts recall the funky headlines that flooded the typographic scene in the 1950s and '60s, when designers such as Ed Benguiat used ink, pen, and brush to create more than 600 original alphabets. The idea of seeking originality in letterforms is a product of nineteenth-century advertising culture. Before then, books were print's primary medium, and book typography sought to define norms rather than seduce the eye with novelty. The neoclassical typefaces of Bodoni and Didot, with their hairline serifs and severe contrast between thick and thin strokes, opened the way to commercial typography by envisioning letters as a set of structural features subject to endless manipulation (proportion, weight, stress, stroke, serif, and so on). Many of the digital era's most influential typefaces reference the work of Didot and Bodoni, including Jonathan Hoefler's HTF Didot (1991), Zuzana Licko's Filosofia (1996), and Peter Mohr's Fayon (2010).

One new arrival to the Didone scene is Questa, designed collaboratively by Jos Buivenga and Martin Majoor. Buivenga began his own career as a typeface designer by committing a typographic abomination: giving away his work online. So-called "free fonts"—which typically consist of poorly designed, badly programmed, incomplete, and/or pirated software—are, alas, the source of first resort for many students and clueless amateurs. Some people accustomed to free content on the web still find it difficult to pay serious money—or any at all—for typefaces. Buivenga, a self-taught type designer new to the field, released several weights of his Museo family for free download in 2007. It became hugely popular, and Buivenga soon expanded his free offering to a full-fledged super family available to paying customers. [5]

Museo joins a rich contemporary menu of low-contrast slab faces, including Tobias Frere-Jones' Archer (2000), Henrik Kubel's A2 FM (2006), Ross Milne's Charlie (2008), and Type Together's Adelle (2009). Adding another flavor to the slab serif tasting list, Hoefler & Frere-Jones' Sentinel takes its roots from the Clarendon faces of the nineteenth century, whose slab serifs and meaty strokes were designed for display. With numerous weights in roman and italic, Sentinel works for both text and headlines.

Adelle, Museo, and other slab serifs have proven especially popular on the web, where their sturdy body parts hold up well to presentation on screen. Type design has arrived surprisingly late to written communication's biggest event since the Renaissance. Typographic Man was born in 1450 and fattened up in the candy shops of commercial printing. Alas, during the opening decades of the World Wide Web, his diet was drastically reduced to the half-dozen fonts typically installed on end users' own computer systems. This situation has finally begun to change, as members of the type design and web communities have agreed on ways to deploy diverse typefaces online without exposing them to shameless piracy. Services such as Type Kit, which legally host fonts and serve them to specific sites, have become big players in the omnivorous expansion of web typography.

The evolution of modern typography is not, of course, all about novelty and spectacle. Countering the restless appetite for sugarcoated change is a parallel hunger for anonymous, recessive purity. Gill Sans, Futura, and Helvetica—standards from the twentieth-century playlist—once laid claim to a cool neutrality suited to international communication in the machine age and beyond. While these classic faces have endured the shifting storms of taste and fashion, designers have sought out ever more subtle shades of basic black. Laurenz Brunner's Akkurat (2004) has been heralded as "the new Helvetica," while Aurèle Sack's LL Brown (2011) recalls Edward Johnston's lettering for the London Underground. Paying soft-pedal homage to Futura, Radim Pesko's Fugue (2010) flaunts a tentative bravado, like a teenager on a motorcycle. Fugue, writes Pesko, "was conceived as an appreciation of and going-back-to-the-future-and-back-again with Paul Renner." [6]

Rounded end-strokes are another common craving among contemporary designers. Soft terminals restore a dash of humanity to the hard-edged realism of sans serif typography. Eric Olson has led the way with his widely used Bryant (2002) and his more recent Anchor (2010), a condensed gothic whose plump, sausage-like forms fit comfortably in narrow spaces. The rounded terminals of Jeremy Mickel's Router (2008) flare out slightly, recalling the mechanical process employed to manufacture routed plastic signs.

Exploring the freshly cleared frontier of web typography, Christopher Clark is inventing surprising uses for SVG (vector graphics for the Web), HTML5 Canvas, and other emerging tools and protocols. Clark's site WebTypographyfortheLonely.com not only showcases these startling prototypes but also provides instructive commentary and free code. At once generous and estranged, Clark's "lonely guy" persona speaks to the Typographic Man of our time, whose open-hearted desire to share and connect undercuts his self-mocking alienation.

Where is Typographic Man headed as he rides off with his serifs and spurs into the digitally remastered sunset? He may always keep slipping partly backwards, looking for glimmers of black gold in the post-industrial ghost towns and open mine shafts of history. Like the modern individual McLuhan so poignantly described, today's Typographic Man is an inward-looking loner, wrapped inside a personal cocoon of digital feeds. Yet Typographic Man has spun that protective, narcissistic cocoon from the flux of public life. Today's individual is the product of his own voracious immersion in the common watering hole of image/music/text; he is equipped as never before to bend typography with his own means to his own ends.

This self-involved creature is connecting to the social world in new ways. McLuhan described typography as an essential medium of exchange in the modern age: "Typography is not only a technology but is itself a natural resource or staple, like cotton or timber or radio; and, like any staple, it shapes not only private sense ratios but also patterns of communal interdependence." [7] As the first industrial commodity, the printed book was portable, repeatable, and uniform. Unfurling today across the networked horizon, text is now mutable, interactive, and iterative, no longer melded to a solid medium. Yet as a means of exchange that ebbs and flows through communities, text remains more than ever an essential "natural resource" that offers access to participation in a world economy and a shared public life. ⊠

Notes

1. Marshall McLuhan, *The Gutenberg Galaxy: The Making of Typographic Man* (Toronto: University of Toronto Press, 1962). McLuhan popularized the primary research of Harold Innis, Walter Ong, and other deeply original thinkers.
2. "Global village" is one of McLuhan's most famous phrases, coined in *The Gutenberg Galaxy*. See pages 21 and 31.
3. McLuhan coined the phrase "the medium is the message" in *Understanding Media* (Cambridge, MA: MIT Press, 1964).
4. McLuhan credits this stunning insight to the scholar Curt Bühler, quoting at length from his 1960 work *The Fifteenth Century Book: the Scribes; the Printers; the Decorators*, 153–154.
5. Martin Majoor, who says he will never ever give away a font, admits that the success of his typeface Scala was spurred in the early 1990s by its illegal circulation among young designers. See *Free Font Index 2* (Amsterdam: Pepin Press, 2010).
6. Radim Pesko, accessed July 10, 2011, http://www.radimpesko.com/fonts/fugue.
7. McLuhan, *The Gutenberg Galaxy*, 164.

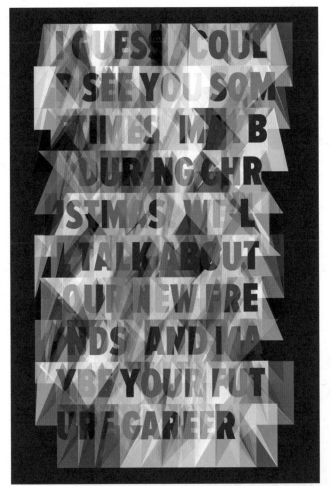

Christopher Clark, *Web Typography for the Lonely: Triangulate* poster, 2011 Courtesy the artist

Web Typography for the Lonely

Christopher Clark's code-based prototype "Triangulate," developed for his site WebTypographyfortheLonely.com, slices up the area staked out by each letterform into overlapping wedges of transparent color, yielding a shimmering crystalline mosaic. "Cluster" converts each letterform into an array of points and then substitutes the points with graphic shapes. The designer can program these shapes—large or small, regular or irregular—to do things such as float away on mouse-over. —EL

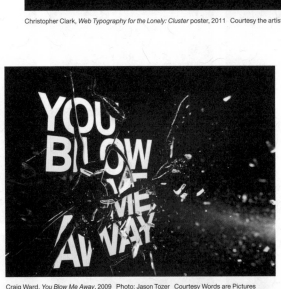

Christopher Clark, *Web Typography for the Lonely: Cluster* poster, 2011 Courtesy the artist

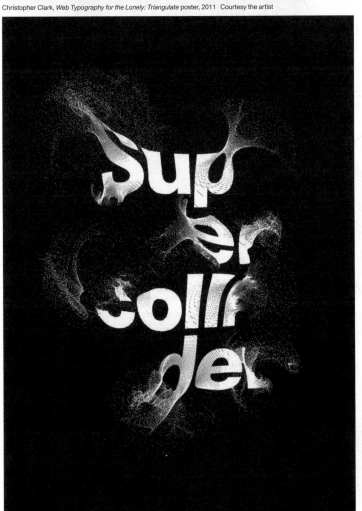

Craig Ward, *Super Collider*, 2010 Courtesy Words are Pictures

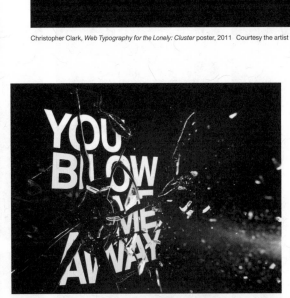

Craig Ward, *You Blow Me Away*, 2009 Photo: Jason Tozer Courtesy Words are Pictures

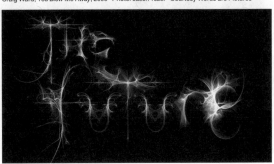

Sean Freeman and Craig Ward, *The Future*, 2008 Courtesy the artists

The New Photo Lettering

Designers Craig Ward and Sean Freeman use software and digital filters to create letterforms that appear to shatter, explode, or melt into the air. The boundary between physical and digital worlds dissolves in these custom compositions. —EL

115

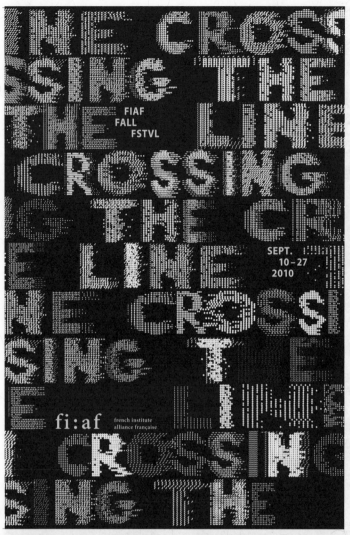

Philippe Apeloig, *Crossing the Line: FIAF Fall Festival* poster, 2010 Courtesy Studio Apeloig

Above and right: Philippe Apeloig, La Lorraine typeface, video stills, 2005 Courtesy Studio Apeloig

116

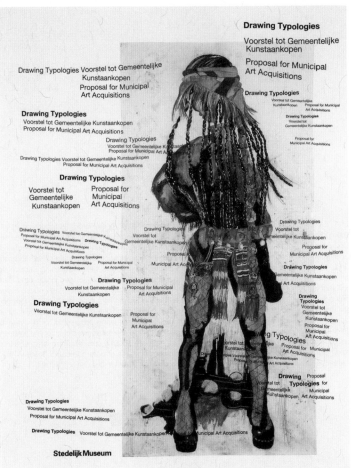

Text Pencil

Discontented with standard-issue software, Jonathan Puckey has developed new tools for forging new typographic experiences; Text Pencil for Scriptographer is a software plug-in that generates text along a moving baseline. The letters don't bounce along chaotically, however, but respond one to the next, as if a person writing them was trying (with mixed success) to keep the lines straight. Luna Maurer used Text Pencil to design the book *Drawing Typologies*, creating columns of text with gently wavering lines. Strange beauty arises from this relaxed congregation of rational, sans serif letterforms.—EL

Jonathan Puckey, Text Pencil application, 2007 Courtesy the artist

Luna Maurer, *Drawing Typologies*, using Jonathan Puckey's Text Pencil application, 2007 Courtesy the artist

Conditional Design: A Manifesto for Artists and Designers

Through the influence of the media and technology on our world, our lives are increasingly characterized by speed and constant change. We live in a dynamic, data-driven society that is continually sparking new forms of human interaction and social contexts. Instead of romanticizing the past, we want to adapt our way of working to coincide with these developments, and we want our work to reflect the here and now. We want to embrace the complexity of this landscape, deliver insight into it and show both its beauty and its shortcomings. ¶ Our work focuses on processes rather than products: things that adapt to their environment, emphasize change and show difference. ¶ Instead of operating under the terms of Graphic Design, Interaction Design, Media Art or Sound Design, we want to introduce Conditional Design as a term that refers to our approach rather than our chosen media. We conduct our activities using the methods of philosophers, engineers, inventors and mystics.

Process

The process is the product. The most important aspects of a process are time, relationship and change. The process produces formations rather than forms. We search for unexpected but correlative, emergent patterns. Even though a process has the appearance of objectivity, we realize the fact that it stems from subjective intentions.

Logic

Logic is our tool. Logic is our method for accentuating the ungraspable. A clear and logical setting emphasizes that which does not seem to fit within it. We use logic to design the conditions through which the process can take place. Design conditions using intelligible rules. Avoid arbitrary randomness. Difference should have a reason. Use rules as constraints. Constraints sharpen the perspective on the process and stimulate play within the limitations.

Input

The input is our material. Input engages logic and activates and influences the process. Input should come from our external and complex environment: nature, society and its human interactions.

—Luna Maurer, Edo Paulus, Jonathan Puckey, Roel Wouters

Farhad Fozouni, *7 Commandments for Becoming Contemporary* poster, 2008 Courtesy Visual Theater Group

Farhad Fozouni on Moshajjar

Tehran is a unique and strange city. A city like nowhere else, and quite different from New York, Tokyo, Warsaw, and Basel. A city with rules that are not always obeyed and unsaid rules that are. When I found that my posters were not resembling my city, I got upset. I decided to get to know Tehran better, so I began wandering around the town, discussing with my sociologist friends, and analyzing the culture of my hometown. The Moshajjar series is the result of these wanderings. The typography and the connection between type and image are what I extracted from Tehran. I had a vision to illustrate an image of Tehran with my works that would allow casual observers to see it more deeply. Neither old Tehran nor Tehran in the future, but today's Tehran: Tehran 2008.
—Chicago International Poster Biennial, 2008

Farhad Fozouni, *Moshajjar* poster, 2007 Courtesy Mirak Gallery

Biotypography

Before Oded [Ezer] decided to mix chemistry and typography, his work already explored the inner soul of letters by letting them channel the personality of a poet's or a musician's work. He let them become three-dimensional and animated in posters and book covers—a direction explored across the centuries by armies of type designers, declared or unaware, and reprised by Ezer with renewed elegance. In a project called *Tortured Letters*, he bound, gagged, and stretched single Latin and Hebrew characters with frightening sadism. In another, he moulded them to look like little ants, already on the path to being full-fledged organisms. The Biotypography project in particular holds great promise for the future. Ezer thinks that since, very often, a type designer chooses a typeface for its ability to embody and render the feeling of a project, the step from object to creature is direct and typefaces should really become living, biological beings. As he explains it, "The term *Biotypography* refers to any application that uses biological systems, living organisms, or derivatives thereof to create or modify typographical phenomena." These fantastical creatures not only literally embody the dream of design and science coming together, but also let us dream about a super-human language that is shaped by biology, rather than by culture—the dream of a universal means of communication that we have sought for centuries. —Paola Antonelli, *Oded Ezer: The Typographer's Guide to the Galaxy*, 2009

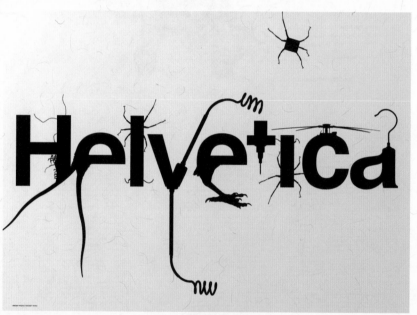

Oded Ezer, *Helvetica Live!* poster, 2008 Courtesy the artist

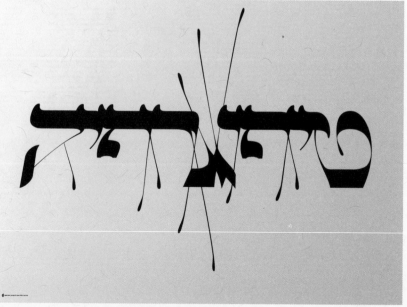

Oded Ezer, *Tipografya* poster, 2003 Courtesy the artist

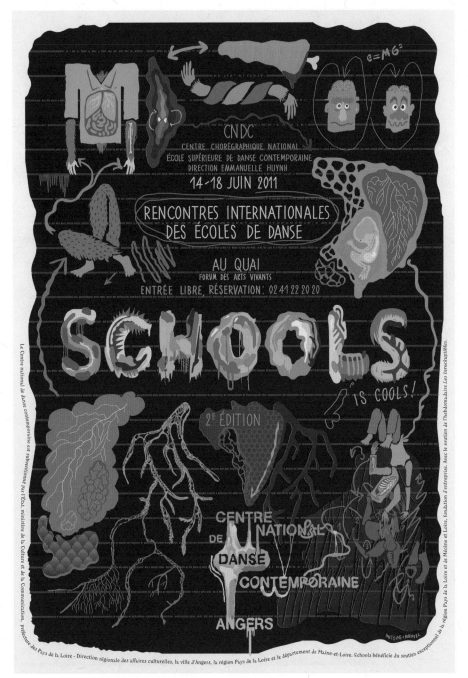

Antoine et Manuel, *Comedie de Clermont, Saison 2011–2012* poster, 2011 Courtesy the artists

Antoine et Manuel, *CNDC Journal No. 16*, 2010 Courtesy the artists

Antoine et Manuel, *CNDC Saison danse 2010–2011* card, 2010 Courtesy the artists

Antoine et Manuel, *CNDC Videodanse 2010*, 2010 Courtesy the artists

Antoine et Manuel, *CNDC Journal Nº 18*, 2010 Courtesy the artists

Antoine et Manuel, *CCNT Choré-graphique 3.3* poster, 2003 Courtesy the artists

Marian Bantjes, *All the Boys Who Loved Me Back* valentine, 2010 Courtesy the artist

Marian Bantjes, *TypeCon 2007: Letter Space* poster, 2007 Courtesy the artist

Marian Bantjes, *Design Ignites Change* poster, 2008 Courtesy the artist

Marian Bantjes, *Empathy Penny*, 2009 Courtesy the artist

Marian Bantjes, *I Wonder*, 2010 Courtesy the artist

Marian Bantjes on the Empathy Penny

There's this machine that squishes pennies, just like we used to do on the railroad tracks when we were kids (only it's safer) and it has the ability to impress a new image into the penny, turning the penny into an oval copper thing.... Anyway, so I thought about what one might conceivably want to have on a copper thing that might mingle with your change in your pocket. Ultimately I decided on "Empathy," because really that's all the world needs is a whole lotta empathy, and I imagined that you might look at that Empathy penny from time to time and it might actually influence how you viewed a situation. —Marian Bantjes, www.bantjes.com, 2009

Marian Bantjes, *GQ Italia: Tenth Anniversary Issue* magazine cover, 2009
Courtesy the artist

M/M (Paris), *1972 A Film by Sarah Morris*, 2008, Paralax Films Courtesy the artists

M/M (Paris), *François Curlet: Intuitive Galerie Légitime* poster, 2010
Courtesy the artists

Non-Format, *Milky Disco Three/To The Stars* music packaging, 2010
Courtesy the artists

Non-Format, *Vowels/The Pattern Prism* music packaging,
2009 Courtesy the artists

Non-Format, *LoAF* music packaging,
2006–2007 Courtesy the artists

Non-Format, *Jean-Jacques Perrey & Luke Vibert present Moog Acid* music packaging, 2007 Courtesy the artists

Non-Format, *Black Devil Disco Club presents The Strange New Worlds Of Bernard Fevre* music packaging, 2009 Courtesy the artists

Thick and Thin

Contemporary typography vacillates from thick to thin, geometric to organic, rigid to eccentric. Rectilinear alphabets sprout spurious limbs in the custom lettering of Non-Format. —EL

Non-Format, *The Chap: Mega Breakfast* music packaging, 2008 Courtesy the artists

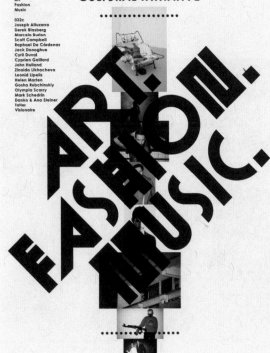

Non-Format, *Sanahunt Cultural Initiative* poster, 2011 Courtesy the artists

Non-Format, *The Sanahunt Times*, bimonthy fashion newspaper, 2010–2011 Courtesy the artists

Elliott Earls, *Cranbrook 2D Design* poster, 2008 Courtesy the artist

Elliott Earls, *Cranbrook Architecture* poster, 2008 Courtesy the artist

Cranbrook Image Space

Reed Kroloff, the new Director of Cranbrook Academy of Art, approached me in November of 2007 and asked me if I would design eleven new posters for the Academy. The posters were to serve as a new catalog for the Art Academy. Beginning on January 1, 2008, I designed and produced one poster a week for twelve weeks. Each department at Cranbrook is represented by a poster. Rather than exemplify, essentialize or encapsulate each department in its poster, I attempted to create a holistic picture of the Academy that can only be understood by approaching the posters as a series. No one poster in isolation accurately articulates either the Academy, or the department for which it stands. Rather, my goal was to illuminate the trans-disciplinary nature of the academy and within each poster create what I believe to be a very contemporary image space. —Elliott Earls, www.theapolloprogram.com

Elliott Earls, *Reign Delay*, 2008 Courtesy the artist

Elliott Earls, *Cranbrook Fiber* poster, 2008
Courtesy the artist

Elliott Earls, *Cranbrook Painting* poster, 2008
Courtesy the artist

Elliott Earls, *Cranbrook Ceramics* poster, 2008
Courtesy the artist

Stephanie DeArmond

Stephanie DeArmond's work explores the linguistic vernacular—slang phrases, common sayings, local place names—and turns them into sculptural forms. Using traditional hand techniques to make complex designs from clay, each piece is unique and finished with glazes and ceramic decals. The typographic forms she creates are based on her own hand-drawn lettering and vintage letterforms. DeArmond's pieces are sometimes individual letters, such as a "T" commissioned by the *New York Times Magazine*, or diptychs or triptychs that form words and phrases. The Minneapolis-based artist lived abroad in the Netherlands, where traditional delftware was a strong influence on her work. —AB

Stephanie DeArmond, *Tattoo Regret*, 2007 Courtesy the artist

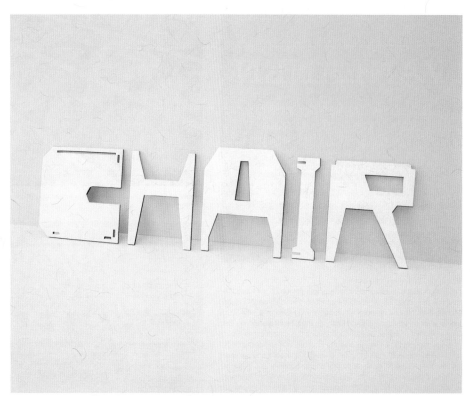

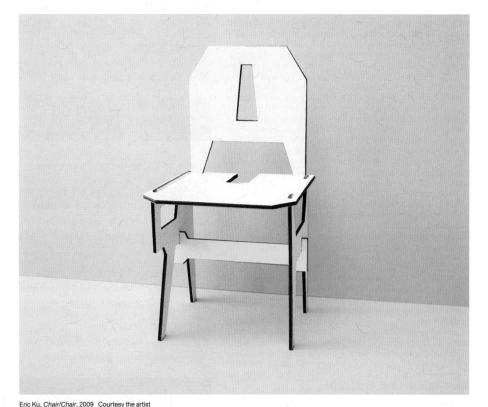

Eric Ku, *Chair/Chair*, 2009 Courtesy the artist

Keetra Dean Dixon and JK Keller, *I've Been Thinking of You for a While*, 2008 Courtesy the artists

Keetra Dean Dixon

Dixon developed many of her core objectives during her 2004–2006 masters studies at the Cranbrook Academy of Art. Her work has gained notoriety for its friendly, sincere absurdism. Her socially-themed objects & installations aim to involve the viewer as an active participant. The pieces create or exemplify heightened emotional moments and often rely on context or unique interactions to complete the work's narrative. —*It's Nice That* blog, August 2009

VANLANEN

MATTHEW CARTER (HAMILTON
WOOD TYPE MUSEUM, 2011)

DESIGNED IN BOTH POSITIVE
AND NEGATIVE VERSIONS,
VANLANEN IS PRODUCED AS A
WOOD TYPE FONT. THE TWO LAYERS
ENCOURAGE EXPERIMENTATION
WITH THE PRINTING PROCESS.

Matthew Carter, Van Lanen, 2011 Courtesy Hamilton Wood Type and
Printing Museum

Van Lanen Type-cutting process Courtesy Hamilton Wood Type and Printing Museum

Matthew Carter on Van Lanen

I'm not a printer, least of all a letterpress printer, but I have tried to think like one. So when the Hamilton Wood Type & Printing Museum in Wisconsin commissioned me to design a new wood face earlier this decade, I could imagine that the interaction of dual forms might provide interesting effects at the poster sizes typical of wood type. ¶ First I made a titling font of Latin capitals and figures (no lowercase) in PostScript, then duplicated it and reversed all the characters to make a pair of fonts, positive and negative, night and day, yin and yang. The set-widths are exactly the same in both fonts. I had no specific models for my Latin letters, except for the ampersand, which occurs on gravestones around Boston. ¶ I sent my digital fonts and proofs to the Hamilton museum, which cut a few trial characters by the traditional method: Norb Brylski used a fretsaw to cut enlarged plywood pattern letters to guide a pantographic router that cut the face in type-high maplewood blanks. ¶ Norb then hand-finished them, using a knife to sharpen corners rounded by the router bit. We took them to TypeCon in Minneapolis in 2003, where Richard Zauft and I gave a talk about the project that got an encouraging response from letterpress printers in the audience. ¶ Despite this promising beginning, the project languished until 2009, when Jim Moran and his brother Bill joined the museum. They found a local sign-manufacturer with a CNC router that could work directly from my digital data, and produce razor-sharp corners. ¶ By November 2009, when the Morans organised their Weekend Wayzgoose at the Hamilton museum, we had wooden fonts of both the positive and negative versions of the type at 12-line (2in) size. When the printers arrived, we had alphabets of both versions set up on Vandercook presses, with the positive letters inked in red and the negative in black, for them to try printing from. ¶ I was quite unprepared for the inventiveness of the first results with this two-faced type (which was then provisionally named Carter Latin). All manner of pages emerged from the presses: one-colour, two-colour, multiple impressions, in register, out of register, right way up, sideways and upside down…. ¶ The new typeface has now been named after Jim Van Lanen, the driving force behind the museum for a long time. Both wood fonts, Van Lanen and Van Lanen Streamer (the reversed version), can be bought from the museum, which also licenses digital versions to help plan work to be printed from the wood type. At 144pt, the digital letterforms should exactly match their wooden counterparts. ¶ It was a pleasure and privilege to see my design come to fruition under the same roof as the astonishing collection of historical wood types that Hamilton possesses. On the day I arrived at Hamilton I picked up a piece of maplewood type and realised that it was exactly 50 years since a type of my design had been in a physical form that I could hold in my hand. —Matthew Carter, *Type Tuesday*, *Eye* blog, April 12, 2011

Hamilton Wood Type and Printing Museum
Located in Two Rivers, Wisconsin, the Hamilton Wood Type and Printing Museum is the only institution dedicated to the preservation, study, production, and printing of wood type. Hamilton is a living museum, where its collection of 1.5 million pieces of wood type and its woodblock cuts of advertising illustrations are still used in numerous workshop settings by visitors and demonstrations by former employees. The museum is the contemporary instantiation of Hamilton Wood Type, founded in 1880 as the largest such manufacturer, which continued production until 1985. The museum hosts its Wayzgoose conference each fall, attracting speakers and participants from around the world, a modern day interpretation of a tradition that began among printing staff who used to paper the windows of the plant with pulp in preparation of the impending winter. —AB

Van Lanen wood type blocks
Courtesy Hamilton Wood Type
and Printing Museum

Van Lanen experimental proof, printed by Tracy Honn, Silver
Buckle Press

Router

Jeremy Mickel (Incubator, 2008)

Inspired by routed plastic
signs, the end strokes of these
rounded letters bulge slightly
outward. Weights range from
whisper thin to plump, hefty bold.

Jeremy Mickel/Village, Router, 2008 Courtesy Incubator

Routed plastic sign, 2008 Photo: Jeremy Mickel

Base 900

Zuzana Licko (Emigre Fonts, 2010)

This typeface is a sleek adaptation
of Base 9, a monospace font
designed in 1994, whose distinctive
details actively responded to
the limitations of screen display.

Zuzana Licko, Base 900, 2010 Courtesy Emigre

Base 900

Constraint is the mother of invention. Zuzana Licko, founding goddess of digital typography, used a minimal palette of curves and angles to create Base 9 in 1994. Licko derived the shapes of Base 9's printer font from the low-resolution screen version, yielding letterforms with intriguingly angled details and unusual proportions. Since then, those early screen limitations have fallen away, prompting Licko to issue Base 900 (2010), a revised typeface with improved spacing and sleeker, more open forms. —EL

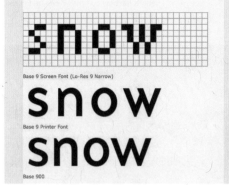

Base 9 Screen Font (Lo-Res 9 Narrow)

Base 9 Printer Font

Base 900

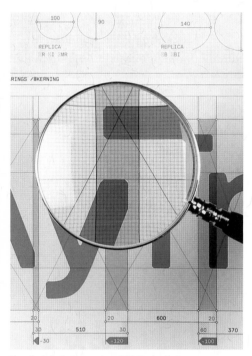

Norm, Lineto, Replica type specimen, 2009 Courtesy Lineto

Replica

Norm (Lineto, 2008)

Replica is built on a 70-unit
grid (an extreme reduction
from the 700-unit norm).
Vertical cuts in diagonal
strokes (see the letter R) allow
letters to sit tightly together.

Norm, Replica, 2008 Courtesy Lineto

Dimitri Bruni on Replica

Seeking to set their own constraints in a polymorphous world, the Swiss design duo Norm (Dimitri Bruni and Manuel Krebs) dialed down the defaults employed in standard font-design software to produce their typeface Replica (2008). By reducing the underlying grid from 700 units to 70, they produced unexpectedly clipped, truncated forms. Bruni explains the process: "The focus is on the exploration of the boundaries of the possibilities of drawing, or the precision of drawing offered by the FontLab software. We have reduced these possibilities by factor 10, a concept that was defined before the actual drawing process had started and which had a very strong impact on the resulting drawings. In this sense, both projects are about causal systems that are defined by rational or mathematical principles and have a strong impact on their results. A sort of numerical design process, as it were. But despite these formal definitions, Replica offered far more room and need for intuitive decisions than I would have expected." —EL See Jürg Lehni, "Typeface as Programme," Typotheque.com, 2011

UNITY

YOMAR AUGUSTO
(180 Amsterdam, 2010)

COMMISSIONED BY ADIDAS FOR THE
2010 FIFA World Cup in South Africa,
UNITY APPEARED ON UNIFORMS,
PRODUCTS, AND ADS SEEN BY
BILLIONS OF PEOPLE WORLDWIDE.

Yomar Augusto, Unity, 2010 Courtesy the artist

Yomar Augusto on Unity

I designed and produced this typeface whilst working at 180 Amsterdam. Their main client is Adidas, for whom they work on global projects. At that time the design team was developing a comprehensive visual language for the Adidas Football range for the 2010 FIFA World Cup. This custom typeface was an integral part of this project. Unity ended up being used across all products and packaging, in retail, advertising, film, and digital communication—in fact on any Adidas project relating to the World Cup in South Africa. ¶ Adidas had a vision that every element of their football identity was to be linked and unified by one basic shape. This shape can be found as a design element on the official match ball of the World Cup, so the first drawings came from the product designers at Adidas. We at 180 had the task to bring it to life and inject its personality into the whole alphabet. The core concept of the Unity project was to make the shape which is at the very heart of the world cup—the official match ball which was referenced throughout the whole identity—an essential part of this typeface, as you can see in the numerals 6, 8, and 9. So the same shape that is found on the ball, a rounded triangular form, is also at the heart of the font. That basically was the brief: keep the energy of the shape and build a typographic system around it, inspired by the Jabulani football itself. —Yomar Augusto interview with Yves Peters, *The FontFeed*, Fontfeed.com, June 2010

Lionel Messi wearing jersey with Unity typeface during 2010 FIFA World Cup
Courtesy the artist

Abi Chase, Anchor poster, 2010 Courtesy the artist

Anchor

Eric Olson (Process Type, 2010)

Rounded end strokes can restore
a dash of humanity to sans serif typefaces.
Anchor's narrow, sausage-like
forms fit comfortably in narrow spaces.

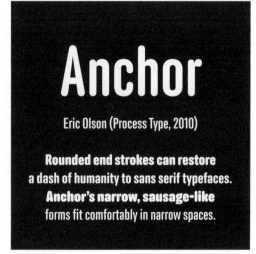

Eric Olson, Anchor, 2010 Courtesy Process Type Foundry

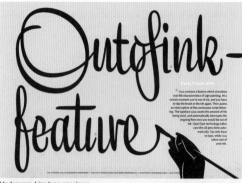

Underware, Liza type specimen

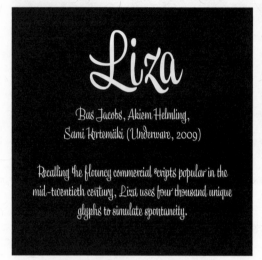

Underware, Liza, 2009 Courtesy Underware

Liza

The flirty, feminine strokes of Liza replicate the brushwork of mid-century sign painters. Created by the pan-European collective Underware, Liza Pro automatically inserts alternate characters into lines of text, simulating spontaneity with 4,000 unique glyphs. Although type designers have long experimented with automatic character substitution (known as "contextual alternates"), Liza may be the world's first font with an "out of ink" feature. When sign painters create brush lettering in real time, they must periodically stop to reload their brushes with paint, leaving a tiny gap in the flow of text. Liza simulates this pause by calculating a gap every so often rather than seamlessly linking all the letterforms together. —EL

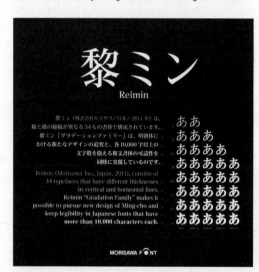

Morisawa & Company, Ltd., Reimin Gradation Family, 2011 Courtesy Morisawa Type Foundry

Morisawa

The Japanese language employs three different language systems: kanji, hiragana, and katakana, representing thousands of characters. This reality, coupled with the complex nature of character strokes, makes font design for the Japanese language especially difficult and demanding. Japan's leading maker of fonts is Morisawa, a company whose roots reach back to 1924. Morisawa typically spends up to four years to meticulously render its typefaces, which can be found throughout the country in use on everything from signs to screens. —AB See Kenji Hall, "Fonts of Knowledge," *Monocle* 33, May 2010

Hubert Jocham on Mommie Script

In the early 1980s, at the start of my career, I worked in a print shop with classic lead setting. In those days I would study issues of *U&lc* magazine. What really caught my attention were letterings in the Spencerian style. I've been fascinated by this American penmanship tradition ever since. A few years ago I developed a font. Boris Bencic used it when he was redesigning *L'Officiel* magazine in Paris. I took these initial forms and developed them into the font "Mommie" when I started my own foundry. Although I usually design text typefaces, working on Mommie taught me how complex it can be to create a script headline font. Characters need to overlap in harmony and I can't remember how many versions I did for the caps. The biggest challenge in this process has been to keep it alive and fresh. —Hubert Jocham, hubertjocham.de/item.php/type/display/Mommie/

Hubert Jocham, Mommie, 2007 Courtesy the artist

Hubert Jocham, Mommie specimen

Laura Meseguer, Rumba specimen

Laura Meseguer, Rumba, 2006 Courtesy the artist

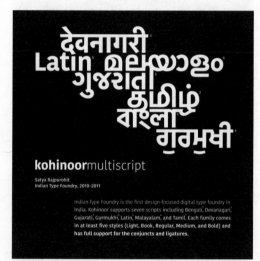

Satya Rajpurohit, Kohinoor, 2011 Courtesy Indian Type Foundry

Satya Rajpurohit on the Indian Type Foundry

There is no such thing as type design in India. People barely know about fonts or typefaces—not even the designers. There are a few big software companies whose core business is to design software for Indian languages, but in order to support their software they create fonts, too. Not having enough knowledge on the subject, they end up hiring people who have no clue about type design.… Our intention in starting the ITF was to make people aware of typography and to provide well-designed fonts for the Indian market. It is also important for us to educate people—both our clients and design students—about typography, fonts and font licensing. In order to do this, we're planning on giving lectures, holding workshops and publishing related articles on the web, in books and in magazines. Eventually, we want people to understand and appreciate the effort that goes into designing typefaces, so that they can start buying them legally and using them properly. —Satya Rajpurohit, interview with Dirk Wachowiak, "Peter Bil'ak and Satya Rajpurohit: Interview on Typography," *Design Observer*, 2010

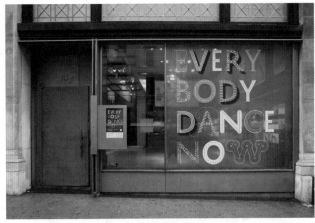

Peter Bil'ak, History, 2009 Courtesy Typotheque

History
Reenacting the collision between classicism and commerce, Peter Bil'ak's digital typeface History consists of twenty-one interchangeable layers mapped on to a common skeleton. History's armature is of classical proportion, while its library of layers is wildly eclectic, ranging from thin serifs and heavy slabs to inlines, outlines, shadows, swashes, polka dots, and bulbous psychedelic bell-bottoms. Layered into endless combinations, Bil'ak's History mixes traditions to produce monstrous forms of beauty, merging Didot's classical ideal with its resounding commercial aftershocks. —EL

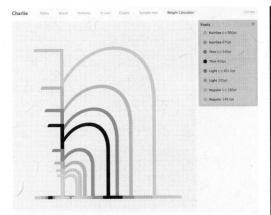

Ross Milne, Charlie type diagram

Ross Milne, Charlie, 2010 Courtesy Typotheque

Abbott Miller and Kristen Spilman, Pentagram, exhibition identity created using History typeface by Peter Bil'ak

Peter Bil'ak on History

The History type system was in development longer than any other project I ever worked on. Its beginnings can be traced to the early 1990's when I experimented with decorative layering systems inspired by 19th century types, trying to dissect Tuscan typefaces into their structural components. ¶ While most historians and designers regard this period with horror, and many history books call the typefaces decadent or regressive, I found Tuscans very charming and inspirational. I started drawing a layering font that incorporated the possibilities of Tuscan types, but because of technological limitations, I never completed the project. ¶ Years later (2002) the project took a new twist as I worked on a proposal for the Twin Cities typeface. Instead of proposing one new typeface for St. Paul and Minneapolis, I presented the idea of a typeface system inspired by the evolution of typography, a conceptual typeface that reused existing fonts. I called this proposal "History." A user would select "History" from the font menu, not knowing what font would be used. History would be linked with the computer's calendar and with a predefined database of fonts, presenting a different font every day. For example, one day it would use the forms of Garamond, but the next day when you opened the same document, the font would change and present the text in a new typeface, say Granjon, that was created later than Garamond. The idea was that the constant changes would confront the user with the continuous development of typography. —Peter Bil'ak, "The history of History," Typotheque.com

Ross Milne on Charlie

Each of Charlie's lighter weights (Hairline, Thin, Light, Regular) are available in two optical sizes, one lighter than the other. Unlike other typefaces with optical sizes, Charlie's exist to match together at specific intervals of display sizes. As an example of this system, the Regular weight is twice the stroke width of the Light. A consistent texture can be achieved by using the Light weight at double the size of the regular weight. This and similar combinations produce equally heavy letterforms at varying sizes. To easily understand and use Charlie's weight system, an online weight calculator has been developed. The weight calculator allows the user to input a type size at a specific weight and return a series of sizes for the corresponding optical weights. This creates a straightforward process, allowing the user to switch back and forth between design applications and the web-based tool. —Ross Milne, "Notes on the development of Charlie typeface family," Typotheque.com, 2010

Jeremy Tankard, Trilogy, 2009 Courtesy the artist

Trilogy

Jeremy Tankard's Trilogy (2009) is a multi-weight design that extends from sans to slab to a high-contrast "fatface," built from ultra black thick strokes and hairline thins. Trilogy joins a wide range of nineteenth-century idioms into a single genetically matched super family. —EL

Martin Majoor and Jos Buivenga, Questa, 2012 Courtesy the artists

Super Family

In the early 1990s, Majoor helped pioneer the idea of a "super family" through his typefaces Scala, Seria, and Nexus. The essence of a super family lies not in its enormous size (Scala has sixteen styles) but in the replication of common features across serif and sans serif variants. According to Majoor, the early grotesque Akzidenz, introduced in 1898, took its DNA from modern serif types. In contrast, such twentieth-century workhorses as Helvetica and Arial used Akzidenz as their immediate source, skipping what Majoor sees as a crucial step in creating soulful sans serif type. The Questa family provided Majoor and Buivenga with a fresh opportunity to implement this idea. —EL See Martin Majoor, "My Type Design Philosophy," Typotheque.com, 2004

SPECIMEN

YET

TSCHICHOLD

SNEEZES

Radim Pesko, *Yet Tschichold Sneezes: RP Digital Type Foundry Specimen Vol. 1*, 2010 ©Radim Pesko

Fugue

Radim Pesko (2010)

Paying homage to the modernist classic Futura, Fugue uses its funky, flawed geometry to travel "back-to-the-future-and-back-again."

Radim Pesko, Fugue, 2008–2010 Courtesy the artist

Akkurat

Laurenz Brunner (Lineto, 2005)

Intended for both text and display, this austere anonymous *sans has been dubbed* "the new Helvetica" by fans and enthusiasts.

Laurenz Brunner, Akkurat, 2005 Courtesy Lineto

Beauty and the Book
Laurenz Brunner's typeface Akkurat graces the cover of Julia Born's design for *Beauty and the Book* (2004), a look back at the sixty-year history of *The Most Beautiful Swiss Books* (*MBSB*) competition. Initiated by Jan Tschichold in 1943 and modeled after similar juried shows in the United States and England, *MBSB* was created to celebrate and cultivate the craft of Swiss bookmaking and to educate the public and the publishing industry about the virtues of exercising "due care and attention" in their work. From its inception, *MBSB* sought to expand the concept of fine bookmaking from the luxurious and elaborate productions of small private presses by embracing the entire book spectrum and its varied price points. Born's design, a modest paperback, reveals the apparatus of the book—from its ISBN book code on the front cover to the dog-eared pages used to mark each essay and the pencil-marked synopsis. —AB

BEAUTY AND THE BOOK —

N 269424 — ISBN 3-7212-0540-5

Julia Born, *Beauty and the Book: 60 Years of the Most Beautiful Swiss Books*, 2004

Aktiv Grotesk

Fabio Haag, Bruno Maag, *and Ron Carpenter* (Dalton Maag Ltd., 2010)

Conceived as a head-on challenge to the "over-hyped Helvetica," *this sans serif face aims to* be warmer than Univers *but less quirky than Helvetica.*

Fabio Haag and Ron Carpenter/Dalton Maag Ltd., Aktiv Grotesk, 2010 Courtesy Dalton Maag, Ltd.

LL Brown

Aurèle Sack with Urs Lehni and *Lex Trüb (Lineto, 2011)*

LL Brown's squarish proportions and circular Os recall the *early 20th-century lettering* of Edward Johnston, made famous by the London Underground.

Aurèle Sack, LL Brown, 2011 Courtesy Lineto

[PB] So let's talk about Aktiv, Dalton Maag's new Helvetica killer. Can you design a typeface in opposition to something? Is that what you set out to do or were you just trying to create as good a grotesk as you could for general use? [BM] Clearly, because we are competing against Univers, Akzidenz and Helvetica there are a lot of close similarities. The x height is fractionally higher than Helvetica but the rounds have a little bit of squareness about them that Helvetica's don't have. The differences are really subtle but give it just that bit of personality. It was two-pronged really. One was the fact that we were looking at our font library and felt that we were missing a pure grotesk in a Univers style, purely as a commercial entity. It has been at the back of our minds to do this for the last three or four years now. We wanted to have a grotesk font positioned somewhere between Helvetica and Univers – not as icy cold as Univers but devoid of all the quirks of Helvetica. To have a font that is beautifully crafted, spaced well, with not a chink in a curve or anything – perfectly drawn but hopefully with a bit of personality. We wanted to create something that could be used in a corporate environment but has that bit of warmth that Univers doesn't have.

SEA Design, *Natural is x 7* for GF Smith, 2010 Courtesy the designers

Bruno Maag on Aktiv Grotesk
Being a Swiss typographer, it's always been Univers. Even in my apprenticeship we didn't have Helvetica in the printshop. Then I went to Basel school of design and of course in Weingart's workshop it was Univers, never Helvetica. Then I come to England and there's all these designers using Helvetica! The Macintosh had just come out and Helvetica was on every single machine. Everyone was so fascinated with it … I never understood that. —Bruno Maag, *Creative Review*, www.creativereview.co.uk

Alfa[1] Bravo Charlie[5] Delta Echo[3] Foxtrot Golf Hotel India Juliet Kilo Lima Mike November Oscar Papa[2] Quebec Romeo[4] Sierra Tango Uniform[6] Victor Whiskey X-ray Yankee Zulu

Aperçu

The Entente/Colophon, Aperçu, 2010 Courtesy Colophon

Aperçu

The Entente (Colophon Foundry, 2010)

Aperçu, *whose name means* *digest or brief survey, references* several historic faces, including *Franklin Gothic (1903),* Johnston (1916), and *Gill Sans (1926).*

Elegant
Classical & Modern
Decorative
Pattern and Surface
Texture
Soft furnishing
Modernity
1852
timelessness
Antique

A2-TYPE, *A2-TYPE Specimen*, 2010

A2FM

Henrik Kubel (A2 Type, 2010)

This versatile slab serif typeface with **humanist details is available in** *weights ranging from light* to bold, suitable for text and *display in print and on screen.*

Henrik Kubel, A2 FM, 2010 Courtesy the artists

Sentinel

(Hoefler & Frere-Jones, 2010)

Sentinel revisits the **nineteenth-century Clarendon style. While Clarendon was** meant for accent and display, *Sentinel works for both text* **and headlines.**

Jonathan Hoefler and Tobias Frere-Jones, Sentinel, 2010 Courtesy Hoefler & Frere-Jones

Jonathan Hoefler and Tobias Frere-Jones, Sentinel specimens, 2009
Courtesy Typography.com

Hoefler & Frere-Jones on Sentinel

Sentinel was designed to address the many shortcomings of the classical slab serif. Unbound by traditions that deny italics, by technologies that limit its design, or by ornamental details that restrict its range of weights, Sentinel is a fresh take on this useful and lovely style, offering for the first time a complete family that's serviceable for both text and display. From the Antique style it borrows a program of contrasting thicks and thins, but trades that style's frumpier mannerisms for more attractive contemporary details. It improves on both Clarendons and Geometrics by including a complete range of styles, six weights from Light to Black that are consistent in both style and quality. Planned from the outset to flourish in small sizes as well as large, Sentinel contains features like short-ranging figures that make it a dependable choice for text. And most mercifully, it includes thoughtfully designed italics across its entire range of weights. —Hoefler & Frere-Jones, "Sentinel: the slab serif that works.," Typography.com

Fayon

Peter Mohr (Our Type, 2010)

Looking back to the Didot **typefaces created in the eighteenth century, this sturdy** new revival features high *contrast between thick* **and thin strokes.**

Peter Mohr, Fayon, 2010 Courtesy Our Type

Peter Mohr on Fayon

My research revealed that a number of elements influenced the development of high-contrast letter forms: convention, fashion, technical proficiency, and economic aspects. I examined their development in that precise context. To me Giambattista Bodoni or Firmin Didot were successful entrepreneurs in their day, who were very much in tune with the society they lived in, and who of course pursued the highest possible aesthetic quality. As the technical possibilities in printing increased tremendously by the end of the 18th century, there was more room for new ideas in type design, however there was also more room to fail. It produced typefaces that seem artificial and willful, and which incorporate fewer traces of the hand-made compared to 16th century type design. This was an interesting aspect I focused on when designing Fayon. I wanted to combine cool, upright strictness with dynamic elements, and used "artificial" elements to distance the design from the handwriting process. By mixing opposite qualities in a precise and harmonious way I attempted to draw a fresh and useful typeface. —Peter Mohr, interview with Yves Peters, *The FontFeed*, Fontfeed.com, 2011

Adelle

José Scaglione and Veronika Burian
(Type Together, 2009)

Designed for magazines and *newspapers, this slab serif face* *has become a popular web font.* **Heavy weights make strong headlines;** lighter ones function well in text.

José Scaglione and Veronika Burian, Adelle, 2009 Courtesy Type Together

Williams Caslon

William Berkson (Font Bureau, 2010)

This elegant digital revival recalls the decisive *heft and lyrical italics of Caslon's classic forms,* **which dominated printing in** *eighteenth-century Britain and America.*

William Berkson, Williams Caslon, 2010 Courtesy Font Bureau

2005
Experimental typography.
Whatever that means.
2010
Conceptual Type?
Peter Bil'ak

Revolutionary Struggle
This leaflet is by Epanastatikos Agonas, or Revolutionary Struggle, a Greek group known for its bombing attacks on Greek government buildings, banks, and the American embassy in Athens. Both the European Union and US Secretary of State Hillary Rodham Clinton have formally designated Revolutionary Struggle as a terrorist organization. The group has been quite consistent in using Fedra Sans for its flyers. And no, they didn't buy the license. —Peter Bil'ak

Louis Émile Javal
A French ophthalmologist born in Paris, Javal [1839–1907] is remembered for his studies of physiological optics and his work involving a disorder known as strabismus. With his student Hjalmar August Schiotz (1850–1927), he constructed an early keratometer, also known as the Javal Schiotz Ophthalmometer. This device is used to measure the curvature of the corneal surface of the eye, as well as to determine the extent and axis of astigmatism. Javal also made important contributions in regards to the study of eye tracking, and with his assistant Marius Hans Erik Tscherning (1854–1939), he performed studies of optics and astigmatism. ¶ Javal was the first to describe eye movements during reading in the late nineteenth century. He reported that eyes do not move continuously along a line of text, but make short rapid movements (saccades) intermingled with short stops (fixations). Javal's observations were characterized by a reliance on naked-eye observation of eye movement in the absence of technology. —Wikipedia

MINUSCULE 4 | MINUSCULE 2

ag | *ag*

MINUSCULE 3
Typographies
MINUSCULE 2
C□mpactes.
MINUSCULE 6
Minuscule, a typeface
for extremely small sizes.

Thomas Huot-Marchand, Minuscule, 2007 Courtesy the artist

Robert Rauschenberg, *Erased de Kooning Drawing*, 1953 Collection San Francisco Museum of Modern Art ©Estate of Robert Rauschenberg / Licensed by VAGA, New York

ABCD
EFGH
IJKL

Giambattista Bodoni, type specimen, circa 1798

FIVE-LINE PICA ITALIAN.
BOAT

Five-Line Pica Italian, circa 1850

aa gg

Peter Bil'ak, untitled, 2011 Courtesy Typotheque

Enrico Bravi, Mikkel Crone Koser, and Paolo Palma, Ortho-type, 2005 Courtesy the artists

Experimental typography. Whatever that means.

An epistemology of the word "experimental" as it applies to design and type, contrasted with its scientific connotations. Examples of past and current design, type and reading/language, as well as scientific experiment, are taken into account.

Very few terms have been used so habitually and carelessly as the word "experiment." In the field of graphic design and typography, experiment as a noun has been used to signify anything new, unconventional, defying easy categorization, or confounding expectations. As a verb, "to experiment" is often synonymous with the design process itself, which may not exactly be helpful, considering that all design is a result of the design process. The term experiment can also have the connotation of an implicit disclaimer; it suggests not taking responsibility for the result. When students are asked what they intend by creating certain forms, they often say, "It's just an experiment …," when they don't have a better response.

In a scientific context, an experiment is a test of an idea; a set of actions performed to prove or disprove a hypothesis. Experimentation in this sense is an empirical approach to knowledge that lays a foundation upon which others can build. It requires all measurements to be made objectively under controlled conditions, which allows the procedure to be repeated by others, thus proving that a phenomenon occurs after a certain action, and that the phenomenon does not occur in the absence of the action.

An example of a famous scientific experiment would be Galileo Galilei's dropping of two objects of different weights from the Pisa tower to demonstrate that both would land at the same time, proving his hypothesis about gravity. In this sense, a typographic experiment might be a procedure to determine whether humidity affects the transfer of ink onto a sheet of paper, and if it does, how.

A scientific approach to experimentation, however, seems to be valid only in a situation where empirical knowledge is applicable, or in a situation where the outcome of the experiment can be reliably measured. What happens, however, when the outcome is ambiguous, non-objective, not based on pure reason? In the recent book *The Typographic Experiment: Radical Innovation in Contemporary Type Design*, author Teal Triggs asked thirty-seven internationally recognized designers to define their understandings of the term experiment.

As expected, the published definitions couldn't have been more disparate. They are marked by personal belief systems and biased by the experiences of the designers. While Hamish Muir of 8vo writes: "Every type job is experiment," Melle Hammer insists that: "Experimental typography does not exist, nor ever has." So how is it possible that there are such diverse understandings of a term that is so commonly used?

Among the designers' various interpretations, two notions of experimentation were dominant. The first one was formulated by the American designer David Carson: "Experimental is something I haven't tried before … something that hasn't been seen and heard." Carson and several other designers suggest that the nature of experiment lies in the formal novelty of the result. There are many precedents for this opinion, but in an era when information travels faster than ever before and when we have achieved unprecedented archival of information, it becomes significantly more difficult to claim a complete novelty of forms. While over ninety years ago Kurt Schwitters proclaimed that to "do it in a way that no one has done it before" was sufficient for the definition of the new typography of his day—and his work was an appropriate example of such an approach—today things are different. Designers are more aware of the body of work and the discourse accompanying it. Proclaiming novelty today can seem like historical ignorance on a designer's part.

Interestingly, Carson's statement also suggests that the essence of experimentation is in going against the prevailing patterns, rather than being guided by conventions. This is directly opposed to the scientific usage of the word, where an experiment is designed to add to the accumulation of knowledge; in design, where results are measured subjectively, there is a tendency to go against the generally accepted base of knowledge. In science a single person can make valuable experiments, but a design experiment that is rooted in anti-conventionalism can only exist against the background of other—conventional—solutions. In this sense, it would be impossible to experiment if one were the only designer on earth, because there would be no standard for the experiment. Anti-conventionalism requires going against prevailing styles, which is perceived as conventional. If more designers joined forces and worked in a similar fashion, the scale would change, and the former convention would become anti-conventional. The fate of such experimentation is a permanent confrontation with the mainstream; a circular, cyclical race, where it is not certain who is chasing whom.

Does type design and typography allow an experimental approach at all? The alphabet is by its very nature dependent on and defined by conventions. Type design that is not bound by convention is like a private language: both lack the ability to communicate. Yet it is precisely the constraints of the alphabet which inspire many designers. A recent example is the work of Thomas Huot-Marchand, a French postgraduate student of type design who investigates the limits of legibility while physically reducing the basic forms of the alphabet. Minuscule is his project of size-specific typography. While the letters for regular reading sizes are very close to conventional book typefaces, each step down in size results in simplification of the letter-shapes. In the extremely small sizes (2 point), Minuscule becomes an abstract reduction of the alphabet, free of all the details and optical corrections which are usual for fonts designed for text reading. Huot-Marchand's project builds upon the work of French ophthalmologist Louis Émile Javal, who published similar research at the beginning of the twentieth century. The practical contribution of both projects is limited, since the reading process is still guided by the physical limitations of the human eye; however, Huot-Marchand and Javal both investigate the constraints of legibility within which typography functions.

The second dominant notion of experiment in *The Typographic Experiment* was formulated by Michael Worthington, a British designer and educator based in the United States: "True experimentation means to take risks." If taken literally, such a statement is of little value: immediately we would ask what is at stake and what typographers are really risking. Worthington, however, is referring to the risk involved with not knowing the exact outcome of the experiment in which the designers are engaged.

A similar definition is offered by the *E.A.T. (Experiment And Typography)* exhibition presenting thirty-five type designers and typographers from the Czech Republic and Slovakia. Alan Záruba and Johanna Balušíková, the curators of *E.A.T.*, put their focus on development and process when describing the concept of the exhibition: "The show focuses on

projects which document the development of designers' ideas. Attention is paid to the process of creating innovative solutions in the field of type design and typography, often engaging experimental processes as a means to approach unknown territory."

An experiment in this sense has no preconceived idea of the outcome; it only sets out to determine a cause-and-effect relationship. As such, experimentation is a method of working which is contrary to production-oriented design, where the aim of the process is not to create something new, but to achieve an already known, pre-formulated result.

Belgian designer Brecht Cuppens has created Sprawl, an experimental typeface based on cartography, which takes into account the density of population in Belgium. In Sprawl, the silhouette of each letter is identical, so that when typed, they lock into each other. The filling of the letters, however, varies according to the frequency of use of the letter in the Dutch language. The most frequently used letter (e) represents the highest density of population. The most infrequently used letter (q) corresponds to the lowest density. Setting a sample text creates a Cuppens representation of the Belgian landscape.

Another example of experiment as a process of creation without anticipation of the fixed result is an online project. Ortho-type trio of authors Enrico Bravi, Mikkel Crone Koser, and Paolo Palma describe ortho-type as "an exercise in perception, a stimulus for the mind and the eye to pick out and process three-dimensional planes on a flat surface...." Ortho-type is an online application of a typeface designed to be recognizable in three dimensions. In each view, the viewer can set any of the available variables: length, breadth, depth, thickness, colour, and rotation, and generate multiple variations of the model. The user can also generate those variations as a traditional 2D PostScript font.

Although this kind of experimental process has no commercial application, its results may feed other experiments and be adapted to commercial activities. Once assimilated, the product is no longer experimental. David Carson may have started his formal experiments out of curiosity, but now similar formal solutions have been adapted by commercial giants such as Nike, Pepsi, or Sony.

Following this line, we can go further to suggest that no completed project can be seriously considered experimental. It is experimental only in the process of its creation. When completed it only becomes part of the body of work which it was meant to challenge. As soon as the experiment achieves its final form, it can be named, categorized, and analyzed according to any conventional system of classification and referencing.

An experimental technique which is frequently used is to bring together various working methods that are recognized separately but rarely combined. For example, language is studied systematically by linguists, who are chiefly interested in spoken languages and in the problems of analyzing them as they operate at a given point in time. Linguists rarely, however, venture into the visible representation of language, because they consider it artificial and thus secondary to spoken language. Typographers, on the other hand, are concerned with the appearance of type in print and other reproduction technologies; they often have substantial knowledge of composition, color theories, proportions, paper, etc., yet often lack knowledge of the language which they represent.

These contrasting interests are brought together in the work of Pierre di Sciullo, a French designer who pursues his typographic research in a wide variety of media. His typeface Sintétik reduces the letters of the French alphabet to the core phonemes (sounds which distinguish one word from another) and compresses it to sixteen characters. Di Sciullo stresses the economic aspect of such a system, with an average book being reduced by about 30 percent when multiple spellings of the same sound are made redundant. For example, the French words for skin (*peaux*) and pot (*pot*) are both reduced to the simplest representation of their pronunciation—po. Words set in Sintétik can be understood only when read aloud, returning the reader to the medieval experience of oral reading.

Quantange is another font specific to the French language. It is basically a phonetic alphabet which visually suggests the pronunciation, rhythm, and pace of reading. Every letter in Quantange has as many different shapes as there are ways of pronouncing it: the letter *c*, for example, has two forms because it can be pronounced as *s* or *k*. Di Sciullo suggests that Quantange would be particularly useful to foreign students of French or to actors and presenters who need to articulate the inflectional aspect of language not indicated by traditional scripts. This project builds on experiments of early avant-garde designers, the work of the Bauhaus, Kurt Schwitters, and Jan Tschichold.

Di Sciullo took inspiration from the reading process when he designed a typeface for setting the horizontal palindromes of Georges Perec (Perec has written the longest palindrome on record, a poem of 1,388 words that can be read both ways (see http://graner.net/nicolas/salocin/ten.renarg//:ptth). The typeface is a combination of lower- and uppercase and is designed to be read from both sides, left and right. (This is great news to every Bob, Hannah, or Eve.) Di Sciullo's typefaces are very playful and their practical aspects are limited, yet like the other presented examples of experiments in typography, his works points to previously unexplored areas of interest which enlarge our understanding of the field.

Although most of the examples shown here are marked by the recent shift of interest of European graphic design from forms to ideas, and the best examples combine both, there is no definitive explanation of what constitutes an experiment in typography. As the profession develops and more people practice this subtle art, we continually redefine the purpose of experimentation and become aware of its moving boundaries. ⊠

Conceptual Type?

To begin with, let's be clear that conceptual type is an oxymoron. A typeface can't really be conceptual, because it is dependent on its execution. Typeface design is a craft, so the process that transforms the pure idea into a functional font is a critical part of the discipline. Before the typeface is executed, it is not a typeface; it is simply an idea. A few years back I was part of the jury at an art school in Antwerp, where a student proposed a conceptual font. Instead of defining the shapes, he came with a set of written instructions, so the capital *E* was defined as "three evenly spaced horizontal lines crossing one vertical line." It was fun and very clever, but technically it was merely a description (however witty) of the alphabet, not a font, which is based on the repetition of shapes.

Sol LeWitt's famous quote "banal ideas cannot be rescued by beautiful execution" does not apply to type design. There are plenty of examples of nicely designed and successfully exploited typefaces based on banal models. Nowhere else is revivalism as popular as in type design, and recycled versions of proven models seem to form the core of most type libraries. For example, how many

versions of Garamond or clones of Swiss Neutral Sans Serif do we really need?

Let's have a look what the term "conceptual" means in other disciplines. We can skip music, architecture, illustration, ceramics, or dance, which similarly to typography are also dependent on performance or execution. Obviously, there are some exceptions—for example, John Cage's *4'33"* or some projects of Rem Koolhaas or Peter Eisenman—but in essence all craft-based disciplines rely on the transformation of abstract ideas into material form. Should the idea remain in its semantic form, one has to rethink the whole frame of the discipline. Would you hire a "conceptual" plumber to fix your sink?

Where the term "conceptual" really prospers is in the domain of modern art. This term came into use in the late 1960s to describe a philosophy of art that rejected the traditional art object as a precious commodity. Instead, the typical work of conceptual art is generally semantic rather than illustrative, a self-referential, non-material meta-object, art of the mind rather than the senses. The work of Yves Klein, Robert Rauschenberg, Joseph Kosuth, Sol LeWitt, or the group Art & Language challenged viewers' expectations concerning the limits of what can be considered art. It even tried to bean anti-art.

Type design, by contrast, was originally dependent on the expertise of the maker: the final typeface was only as good as the skill of the punch-cutter. The first examples of type design separate from the craft of manufacturing come from the Enlightenment period. Romain du Roi, an exclusive typeface commissioned by the French King Louis XIV, departed from the traditions of calligraphy and worked with analytical and mathematical principles of drawing type. This then, if you like, could be considered the first "conceptual" typeface. The committee of the Academy of Sciences proposed a grid of 48 × 48 units, inventing the notion of vector outlines by defining characters in terms of geometry rather than physical mass. The committee also invented the notion of font metrics and suggested the idea of bitmap fonts. Some fifty years separated the conception of the typeface and the execution of a complete set of punches for it.

More recently, a type design project that approached the definition of conceptual art was *FUSE*, launched by Neville Brody and Jon Wozencroft in the early 1990s. *FUSE* consisted of a set of four original typefaces with corresponding

posters, and an accompanying essay. Each issue had a theme such as religion, exuberance, (dis)information, virtual reality, etc., but the designers had complete freedom as to how they interpreted that theme. In the first issue, Wozencroft described *FUSE* as "a new sensibility in visual expression, one grounded in ideas, not just image." Carrying forward the ideals of the avant-garde, Brody and Wozencroft wrote with an impassioned rhetoric as if they saw themselves fighting the repressive typographic establishment by making fonts that rejected functionality as the reason to design type. The fonts ranged from purely formal exercises to completely abstract shapes independent from Latin construction, purported "new forms of writing." *FUSE* typefaces were curiously diverse, making it hard to discern any criteria for selection.

And this is precisely the problem with the use of term "conceptual": very often it is simply synonymous with "idea" or "intention." Since every act of creation arguably stems from intent, regardless of the function of the product, is every artwork, object, or typeface therefore conceptual? Mel Bochner, American conceptual artist, disliked the label "conceptual" because the word "concept" is not always defined entirely clearly, and is therefore in danger of being confused with the author's intention.

I believe that the topic of this conference is to look at the underlying ideas of typography, the intentions of authors, rather than to claim that type itself is conceptual. That makes the discussion less problematic, but still not easy, since there is probably no other discipline where the difference between the intention of the author and intention of the user can be so great. For example, the original intention behind Fedra Sans was for it to be the corporate type of the insurance company that commissioned it, and it was designed precisely according to the stipulations of the company's brief. The original client, however, was acquired by a bigger fish, and development of the corporate font came to an abrupt halt. That was a disappointment at first, but a blessing in disguise in the longer term, as I could expand the family and offer it to the public myself. In the years that Fedra Sans has been available for licensing, it has been used in all kinds of applications from building facades to children's books to Bible typesetting to the identity of a terrorist organization, but as far as I know, not a single insurance company.

Children's books, Bibles, terrorists … it becomes quite obvious that the type de-

signer has no actual say in how the typeface is actually used. While the concept of the typeface might be very clever and original, what happens when the typeface is never used the way it was intended? Does it make the typeface less inventive? How about a font that never gets to be used? Can it still be called a font, or is usage at the core of the definition of a font?

So what would be a truly conceptual typeface? In 1953, Robert Rauschenberg's *Erased de Kooning Drawing* demonstrated that destruction could also be conceptual art. According to Rauschenberg's example, I narrowly missed a chance to be the co-creator of a similarly creative opus in 2001 when a thief broke into our studio and stole my computer and all the backup disks for Fedra Sans, then in the final phases of completion. Had the thief claimed responsibility, he could have become the designer of a rare example of conceptual type—by destroying months of work in mere minutes.

In 1953, Rauschenberg erased a drawing by de Kooning, which he obtained from his colleague for the express purpose of erasing it as an artistic statement. The result is titled *Erased de Kooning Drawing*.

On the other hand, some principles of conceptual art transfer well to type design. Sol LeWitt's statement "The idea becomes the machine that makes the art" can be neatly illustrated by Erik van Blokland and Just van Rossum, collectively known also as Letterror. Instead of designing fonts, they write code that makes fonts. Letterror examined the process of creation, suggesting that the engineers who make the tools we use have a greater impact on aesthetic trends than most designers do. It makes sense then for designers themselves to reclaim this field by designing their own creative tools. One Letterror project is Bitfonts, computer code that takes the structure of a bitmap font and interprets it in multiple ways. By deciding to design the process rather than controlling the end result, Letterror embraced the possibilities of unexpected results. It is the machine that makes the type.

I'll conclude with one of my current projects, for which the background idea is more interesting than the resulting forms. For centuries, art has been defined as something that gives rise to an aesthetic experience. Capturing beauty and avoiding ugliness were considered to be the prime responsibilities of the traditional artist. In this still untitled project I have tried to identify the most beautiful examples of typography known to mankind.

133

I settled on a series of serif typefaces designed by Giambattista Bodoni in the late eighteenth century.

In the second step, I tried to identify the ugliest examples of type that we know. That was a bit more difficult, but finally the prize went to eccentric Italian from the middle of the Industrial Revolution. This reversed-contrast typeface was designed to deliberately attract readers' attention by defying their expectations. Strokes that were thick in classical models were thin, and strokes that were thin became thick—a dirty trick to make freakish letters that stand out in the increasingly saturated world of commercial messages.

This project is not interesting because of the forms, which have been explored before, but because it creates a tight link between the two extremes, between the beauty and the ugliness. Time will tell if this project finds some suitable application, or whether it remains purely an aesthetic exercise, a "conceptual" type. ⊠

Adapted from a lecture presented at the conference Conceptual Type—Type Led by Ideas in Copenhagen, November 2010.

2011
Design in Motion
Ben Radatz

Tom Kan and Gaspar Noé, *Enter the Void*, 2009 Courtesy Fidélité Films, Wild Bunch, BUF

Gareth Edwards, *How We Built Britain*, 2007 By kind permission of the BBC

Jim Helton and Charles Christopher Rubino, *Blue Valentine*, 2010 Courtesy The Weinstein Company

Peter Frankfurt and Michelle Dougherty (Imaginary Forces), *The Number 23*, 2007 Courtesy New Line Cinema

Mark Gardner and Steve Fuller (Imaginary Forces), *Mad Men*, 2007 Courtesy Lionsgate Television

Daniel Kleinman, *Casino Royale*, 2006 Courtesy MGM

Eric Anderson, *Dexter*, 2006 Courtesy Showtime

Kyle Cooper (Prologue Films), *The Incredible Hulk*, 2008
Courtesy Universal Pictures

Gareth Smith and Jenny Lee, *Up in the Air*, 2009 Courtesy Paramount

ISO Design, *A History of Scotland*, 2008 By kind permission of the BBC

Angus Wall (Elastic), *Carnivàle*, 2003
Courtesy HBO

Gareth Smith and Jenny Lee, *Juno*, 2007 Courtesy Fox Searchlight

Johnny Kelly (Nexus), *Het Klokhuis*, 2010 Courtesy Nexus Productions

Film titles are containers of information about the film they're attached to. They denote its title, the key players, and a whole checklist of studio legalities and other folderol that comes with feature film production. They've grown in complexity and importance over the years, but their core function has always remained the same, if by definition alone.

What separates a good title sequence from those that are strictly functional are the artists behind them. Since the origins of the craft, title designers have used this precious real estate as a means to promote avant-garde thinking to mainstream audiences. From *Show Boat* (1936) and *Ben-Hur* (1959) to *Psycho* (1960) and the entire *Bond* catalogue (1962–), title design has come to be defined by its artistic and popular relevance, perpetuated by artists from all walks of life and encouraged by a studio system able to promote their work on a massive scale.

Title design has taken on many forms over the years. In the silent era it gave context to the audience, addressing key plot points and adding dialogue to muted conversations. Titles of this era borrowed heavily from print design of the early 1900s, as that proved a familiar format for audiences who were still marveling at the technology itself. During the golden era, titles became a branding tool for the films themselves, setting audience expectations by evoking the content of the film in their designs. Crime dramas were stamped with pulp-inspired headlines, romances were adorned with flowing ribbons, and Westerns evoked the brazen Wanted posters of the Wild West. These techniques set films apart in an increasingly saturated marketplace in which the major film studios competed not only against one another, but with a fierce new rival: television.

Throughout the 1950s and '60s—the birth of the modern school of title design—titles became works of art in and of themselves, challenging the audience and the industry with experimental techniques and a conceptual depth never before considered. Designers such as Saul Bass, Pablo Ferro, and Maurice Binder teamed up with visionary directors such as Alfred Hitchcock, Stanley Kubrick, and Terence Young to produce title sequences that not only redefined the medium but also helped to shape a new era of graphic design in which modernism and abstraction became the vocabulary for a postwar consumer culture.

The independent and B film movement of the 1970s produced a generation of future A-list directors, many of whom had become accustomed to shooting on a budget and did not consider film titles to be an essential line item. In fact, their school of verité filmmaking actively reduced the role of the title sequence to its most basic ingredients. These filmmakers carried this sentiment over into the '80s and early '90s, and combined with an established studio system that made it nearly impossible for outsiders to enter the field, the title industry fell into a slump. With notable exceptions, title sequences of this era were things that had to be sat through more than enjoyed.

The '90s saw a paradigm shift in feature film production, with the digital revolution influencing everything from the mechanical process of filmmaking to the content on the screen itself. Title sequence design underwent a similar transformation. Encouraged by a handful of new filmmakers who embraced this technology and sought to collaborate with like-minded artists, this era produced a number of influential title sequences, perhaps none more significant than Kyle Cooper's title design for David Fincher's film *Se7en* (1995).

With its frenetic typography, staccato pacing, and irreverent visual mash-ups, Cooper's work on *Se7en* is often considered a landmark in modern title sequence design, both for its craftsmanship and its lasting impression on the viewing public. It was the flagship entry for Cooper's new studio, Imaginary Forces, after he parted ways with R/GA—an industry giant for more than thirty years before it shifted its focus to advertising in the mid-'90s. *Se7en* also came to symbolize a fundamental shift in the production of title sequences. The industry had reached a critical mass before then, requiring expensive hardware and software unavailable to most artists, yet was unable to keep pace with a booming film industry. But a combination of affordable technology, the Internet, an available workforce, and audience demand allowed boutique studios to flourish, oftentimes under the guidance of industry vets who took full advantage of the vacuum left behind by the old guard. Equipped with the means to create and distribute work on their own, they became the luminaries of a new generation, followed by scores of artists and designers empowered by their success and able to compete on their own terms. Almost overnight, the entire industry shifted to accommodate this new model, and for the first time in decades, Hollywood was listening.

A more competitive industry also meant that quality work could be produced for a wider variety of media. Television quickly adopted the trend, commissioning title sequences on a par with anything found on the silver screen. HBO was at the forefront, commissioning elaborate sequences for shows such as *Six Feet Under* (2001–2005) and *Carnivàle* (2003–2005). Mainstream television soon followed suit, and by the mid-2000s, any show worth its salt had an opening sequence that rivaled the quality of the program itself, from FX's *Nip/Tuck* (2003–2010) and Fox's *House M.D.* (2004–) to AMC's *Mad Men* (2007–), *Breaking Bad* (2008–), and *Rubicon* (2010). More recently, video games have embraced title sequences as a means to reach beyond their niche demographics and promote a more cinematic sensibility, with franchises such as *Call of Duty*, *God of War*, and *Metal Gear Solid* pioneering a new sophisticated visual direction in title design.

Variety defines this new era. From the retro-inspired opening sequences of *Catch Me If You Can* (2002) and *Kiss Kiss Bang Bang* (2005) to the tech-heavy montages of *Iron Man* (2008), *The Incredible Hulk* (2008), and everything in between, artists continue to breathe new life into an age-old craft. While past title sequences relied on an entire shoe-in industry for support, husband-and-wife teams and small studios are now the norm. Available technology has broadened the playing field in a way never before possible, giving individuals access to many of the same tools available to the pros. Artists who were once confined to the print medium or low-budget experimental films—which, incidentally, have always inspired title design—can now cross over and put their work in front of a much wider audience.

This trend, established by Cooper and his peers in the mid-1990s, continues with increased momentum, and will likely follow an upward trajectory so long as there are artists and designers bringing new and exciting ideas to this ever-evolving medium. ⊠

2011
The Art of the Title Sequence
Ian Albinson

How We Built Britain
2007, UK, 31 seconds
Title Designer: Gareth Edwards
By kind permission of the BBC

A tangle of utility in both architecture and typography offers a fascinatingly structured title sequence for the BBC's *How We Built Britain* that bespeaks an acquisitive England. The artificial monuments of type seem proportionally sound; the final title card an achievement of engineering. —Alexander Ulloa

Gareth Edwards on the development

"Once we had agreed on the concept, everything else fell into place very easily. None of the footage was specifically shot for the titles, so I spent a day sitting through all their helicopter footage that they had filmed for the series, looking for shots where I might be able to add giant letters. I then did a very rough edit and tracked the footage adding a simple 'Arial' font as an example of where each letter would go. They really liked what they saw and didn't want me to change anything, including the font! (Although I have nothing against Arial either.)"

On what he learned designing this title sequence

"That it's good to be open-minded and listen to your producers (sometimes). They know their project much better than you ever will. I think if I had gone with any of my original designs, I might have created something that I would have liked, but would not have been as good for the show. I also learned that some people care a lot more about fonts than me!"

Enter the Void
2009, France, 1:05 minutes
Title Design: Gaspar Noé, Tom Kan
Courtesy Fidélité Films, Wild Bunch, BUF

Like sighs from the scythe in a wheat-field psychosis, the opening title sequence for Gaspar Noé's *Enter the Void* is a melting onslaught of typographic design foisted upon the senses. The unrelenting visual overdose hacks pleasurably, as does the tip of a nail finding its destiny. These bright little deaths come as credits with Paz de la Huerta's image encircling your pupils in a fresh-faced state of detachment and LFO's beats driving the nail deeper.
—Alexander Ulloa

Tom Kan on typography
"The choice of typeface came rather naturally. After coming up with a large selection of typefaces in line with the film's 'mood,' we simply chose the ones that best suited the characters and the personalities of those in the team. We had several typefaces per person. It was his [Gaspar's] manner of paying homage and thanking his team. ¶ Several typefaces and designs did not get used because the time reserved for the title sequence was fixed. The sound mix was already done and it was impossible to prolong the sequence. We used only 60 percent of the designs.... ¶ In fact, certain designs pay homage to movie posters or famous typefaces. We appropriated different types, but we never wanted to copy the titles from other films in an obvious manner since I found that to be misleading. For my own credit, I went in many different directions: aged typefaces in metal, Kanji and Japanese calligraphy, techno typography…. In the end, I let Gaspar choose and he went with the biggest, most legible type!"

Catch Me If You Can
2002, US, 2:43 minutes
Production Company (titles): Nexus Productions
Creative Directors: Kuntzel + Deygas
Producers: Chris O'Reilly, Charlotte Bavasso
2-D Animation: Agnes Fauve
Layout and Typography: Olivier Marquézy
Editing: Florent Porte
3-D Supervision: Robin Kobrynski
Visual Effects Supervision: Patrice Mugnier
3-D and Composition: Péregrine McCafferty, Pierre Savel
2-D Composition: Pierre Yves Joseph
Compositing Assistance: Alexandre Scalvino
General Assistance: Ghislaine Marchand
Production Coordinator: Julia Parfitt
Production Assistants: Juliette Stern, Lucy Glyn
Production Accountant: Ian Mansel-Thomas
©2002 Dreamworks LLC. All rights reserved.
Courtesy Paramount Pictures

A gifted young grifter scamps and stamps across the screen, his fugitive flights aided by doctored documents and lying lawyers. The scurrying swindler dares viewers to keep up with his caper, but this race is now a chase with a "top man" on his case. Flowing type, smooth lines, and cool jazz are a playground for this pursuit, snaking and sneaking across the colorful jet-set world of our confidence man's creation, slowly fading to reveal the darkened truth. Kuntzel + Deygas stylistically transpose the handmade design of Saul Bass using decidedly modern means. Accompanied by John Williams' unexpectedly unctuous score, the duo's title sequence for Steven Spielberg's *Catch Me If You Can* is simply outta sight. —Will Perkins

Casino Royale
2006, UK, 3:14 minutes
Director: Daniel Kleinman
Producer: Johnnie Frankel
Production Manager: James Hatcher
Production Assistant: Chris Harrison
First Assistant: Richard Batty
Director of Photography: John Mathieson
Grip: Bob Freeman
Gaffer: Roger Lowe
Production Designer: John Ebden
Stunt Coordinator: Gary Powell
Postproduction Company: Framestore CFC
Postproduction Supervisor: William Bartlett
Music: Chris Cornell, David Arnold
Film Producers: Barbara Broccoli, Michael G. Wilson
Courtesy MGM

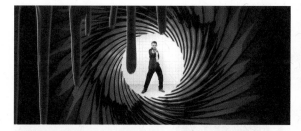

Six Feet Under
2001, US, 1:36 minutes
Created by Digital Kitchen
Courtesy HBO

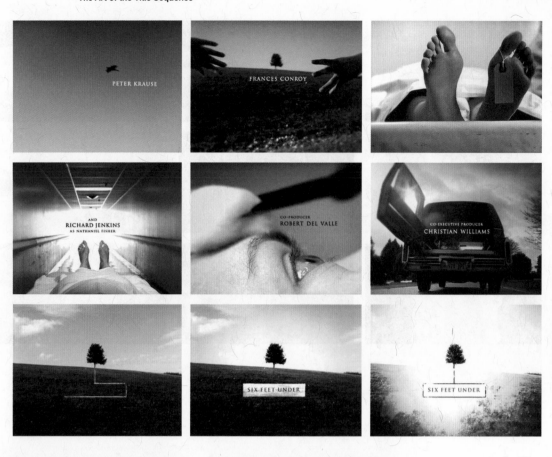

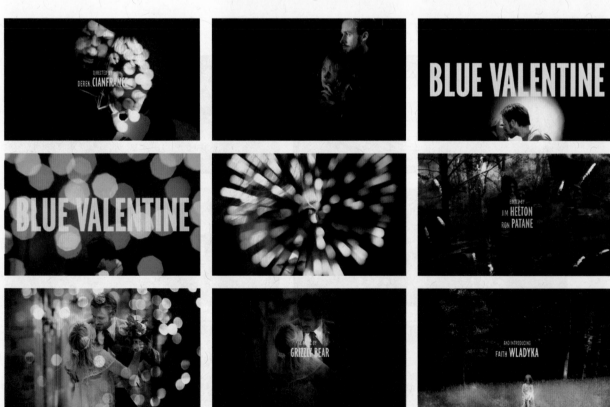

Blue Valentine
2010, US, 2:10 minutes
Title Sequence: Jim Helton
Title Design: Charles Christopher Rubino
Still Photography: Davi Russo
Cinematography: Andrij Parekh
Sound Design: Dan Flosdorf
Music: Grizzly Bear
Courtesy The Weinstein Company

Jim Helton and Charles Christopher Rubino's end credits for Derek Cianfrance's *Blue Valentine* is a last look at what was and what will not be. In a managed duality of the intimate and the expansive, a hypnotic racked bouquet of celestial colors spreads across the night sky with Grizzly Bear's *Alligator* conducting the atmospherics, elevating the experience of the film to something glorious. —Alexander Ulloa

Jim Helton on abstraction
"I was editing *Blue Valentine* alongside Ron Patane and we were just trying to get it done for screenings, so we were very focused on the narrative flow of the film. However, on a late night or two, I made some room for abstraction and delved into Andrij Parekh's beautiful fireworks footage, discovering rhythms in his camerawork and the exploding light. He and Derek shot fireworks somewhere near Scranton, Pennsylvania, on July 4th of 2009.... They threw images out of focus and sometimes even took the lens off. The film ends with a fireworks scene, so it was always going to be fireworks. In the first rough cuts of the film it was just that, an abstract montage of fireworks."

On making something flow
"My first passes on that footage were all silent because I believe that if you can make something flow without music, it will definitely flow with music and then you will actually have two pieces of 'music' playing in harmony together."

Dexter
2006, US, 1:41 minutes
Creative Director: Eric Anderson
Live Action Director: Eric Anderson
Producer: Colin Davis
Designers: Lindsay Daniels, Anthony Vitagliano
Editors: Eric Anderson, Josh Bodnar
Animators: Anthony Vitagliano, Nick Campbell
Compositor: Miah Morehead
Executive Creative Director: Eric Anderson
Executive Producer: Mark Bashore
Music/Sound: Rolfe Kent
Production Company (titles): Digital Kitchen
Courtesy Showtime

A blood valentine to the fucking madness, the opening title sequence for Showtime's *Dexter* is a veritable annunciation of an unholy but likable embodiment of the common rage we can root for. It is a sociopath's ability to focus on the little things. While stabilizing sources suggest *Dexter*'s episodic beginning was carefully designed, it is also enjoyable to view it as slick Grand Guignol, relatable and savage. Here is a killer consumed by the pursuit of an unattainable satiety, all jaw and maw, whetting this morning-time macabre in florid, ratcheting fashion. With a twisted lick of piano wire/dental floss, a favored mosquito going red, and food gone wild, we are able to refine and contextualize the shape, scream, and vision of one Dexter Morgan. The butter of all that blood, shaving to bleed and the tang of hot sauce pyrotechnics, plays toward our tendencies of psychiatrist and sidekick. —Alexander Ulloa

Eric Anderson on the creative process
"I love pitching ideas and feeding off the input I get from clients. I love assembling a team and planting the seed of potential. I love looking through the lens and making shots, love planning the shoot for edit. I love when everything comes together. I love seeing the stuff I shot put to music, and am always energized when all the elements together become something more than the sum of their parts. ¶ I'm not a designer I'm a filmmaker. I think like a filmmaker. It's been my experience that designers can get caught up in self-indulgent details, forgoing larger issues like the piece's story, how it fundamentally relates to the show, how will this prepare a viewer's mind for the show, how will it build excitement, anticipation, its overall impact on an audience. This will be the opening scene for the series, an honor above most. To me these issues are everything."

On the development of the project
"Paul Mattheaus and I got on the phone with the show creators (Clyde Phillips, Sara Colleton, John Goldwyn, and Michael Cuesta) and talked about the character Dexter, his pathology, the overall tone of the show, likes and dislikes, photographers, films, music, composers, Miami, color. They kept using the word 'mundane' over and over. They liked *Six Feet Under* and *Nip/Tuck* for how mundanely both titles dealt with what could have been a visually hyperbolized depiction of each show's subject matter. This made me think of how fascinated I am with crime scene photography—even as a kid I loved looking through my grandfather's *True Detective* magazine collection. Crime scene photographs contextualize mundane things, giving those mundane things overwhelming and sinister importance. Along with this process of photographic-evidence gathering comes an edgy anti-aesthetic, factually lit and mundanely framed rawness. This proved to be a very important point for this piece. ¶ We then started examining normal everyday things that could be seen as horrific. This is when one member of the team, Lindsay Daniels, had the idea of a morning routine. I remember her sheepishly saying, 'How about him getting ready in the morning?' Bang! That's it. I believe the original idea was to have him do these normal things violently, but that soon became the idea of recontextualizing normal everyday things in a sinister way, similar to crime scene photography as I described earlier."

On creating title sequences for television
"When you develop titles for a serial TV show, you're at the mercy of the show creators' knowledge of the subject matter. All I typically know is what I can extract from one conversation, but the creators have an idea of the trajectory of the entire series; they may even know a thing or two about season two or three. So it's smart to defer to their better judgement."

On creating something memorable
"My goal is always to make a splash, stand out. Do something special or meaningful, intriguing, or something that could inspire someone. Do something that you can put all of yourself into. There's nothing worse than selling work that needs to be mediocre to exist, and it's sad to see creative people willing to go there. Something somewhere inspired them to want to make things. The goal is to never forget what that felt like. ¶ I always want to do something identifiable. The phrase 'something we've never seen before' brings out a lot of creative anxiety, creative over-thinking, and should never be taken literally. A lot of young creatives try too hard to convince people that they're creative and end up over-complicating everything. The hardest part is doing something interesting, yet simple. It's incredibly hard to show restraint."

The Incredible Hulk
2008, US, 3:06 minutes
Main Title Design and Production: Prologue Films
Title Designer: Kyle Cooper
Studio: Universal Studios
Courtesy Marvel

Kyle Cooper's opening title sequence for *The Incredible Hulk* depicts Dr. David Banner putting himself in harm's way with a few well-done visual quotes from the original series' opening. The diaphanous daughter, Betty Ross, is bloodied and a hectoring General Ross is loosed. —Alexander Ulloa

Kyle Cooper on having a team
"There's always someone who has to lead the team. For this project, it was me. But people collaborate on different levels. There are animators; there are editors. Sometimes I'll have more than one editor trying different things. For *The Incredible Hulk* there were two editors, at least three animators, and a full crew for the live action shoot. The team at Prologue built props for the shoot and everyone kind of rallied around the project. ¶ For most films or commercials, it seems like there is a team. I know these days you can have a one-man band, where a single designer can do his own boards, his own typography, can shoot his own footage, and even do his own animation. But usually we have to work fast, and having a team allows you to have each person dedicated to one thing. For myself, I'm usually working on a couple of things at once and function more like a director, which is what I really enjoy most."

On picking his favorite elements
"Sergei Eisenstein talks about the 'immutable fragment of actual reality.' It's like breaking reality down into all its pieces and thinking about each frame as a singular composition—and each element within the composition of that frame as a separate entity as well. You can break it down that far. ¶ I try to go through each sequence frame by frame and not have any frames, or any sequences of frames, that I think are poorly color-corrected or composed. On the other hand, even if every frame is beautiful, if the animation isn't choreographed in an interesting way, or if it is not interesting to watch but rather just a series of good-looking frames—then it will not transcend the sum of its parts and become something more. There are so many choices. There is so much stock, and so many elements, and so many stills, and so many key frames. There is so much stuff going on in the sequence, in the office, in my life, I have to ask myself, 'What do I do right now?' And the answer always seems to be, 'Just focus on one little, small thing first.'"

On telling the story within the titles
"For the *Hulk*, the primary goal was to tell the original story in a prologue, rather than spending time on the expository during the film as Ang Lee had done. We approached the problem in various ways. We tried creating a prologue, and having the credit sequence at the end. We tried having some credits mixed with the prologue, and the rest at the end. Ultimately, I proposed integrating the credits fully into an opening that would serve as the main title as well as encapsulating Banner's story. ¶ I know it was a lot to ask. Oftentimes, if a director puts the credits at the end of a film, then he will just have a simple presenter card with the main title at the front. But for *Hulk*, we needed another element—a separate sequence to set up the story. In the past, test screening audiences have sometimes indicated that they were not clear on certain aspects of a film that could have been explained in a prologue. And yet, most of the time integrating or intercutting the credits with a prologue is not considered. It is often assumed that this approach would end up trying to convey too much information—that reading the credits demands a certain amount of time, and that trying to tell a story while this is happening would generate confusion. But I always say, 'Let us try.' And I did that here. So I directed a second shoot with soldiers kicking lab doors down, looking for Bruce Banner, searching for clues, and discovering experiments left behind in old motel rooms long since abandoned. We generated a lot of great footage from the shoot, which ultimately enabled us to tell the story in a concise and engaging way."

Iron Man
2008, US, 1:23 minutes
Main Title Design and Production: Prologue Films
Title Designer: Danny Yount
Studio: Marvel Entertainment
Courtesy Marvel

Dawn of the Dead
2004, US, 2:34 minutes
Main Title Design and Production: Prologue Films
Title Designer: Kyle Cooper
Studio: Universal Pictures
Courtesy Universal Pictures

Whereas George Romero's original film was in part a meta-phor for American consumerism, the title sequence for the updated *Dawn of the Dead* touches upon the idea of Holy War as harbinger of the Apocalypse. It details the consequences for the media when they decide to ask tough questions once the feeding is already upon us. Kyle Cooper's design dovetails what appears to be real war-torn footage with actual human blood as Johnny Cash raises the stakes in a newfound context. Remaining shelters have been compromised and the machine we are trapped in is bleeding to death. —Alexander Ulloa

The Kite Runner
2007, US/China, 2:06 minutes
Main Title Design: MK12
Studio: Paramount Pictures
©2007 Dreamworks LLC and Kite Runner Holdings, LLC. All rights reserved.
Courtesy DreamWorks SKG

A History of Scotland
2009, UK, 29 seconds
Title Design: ISO Design
By kind permission of the BBC

ISO Design's opening title sequence to *A History of Scotland* offers a gathering sense of self and of a scaled Scotland. Using a tilt-shift effect that simulates miniature scale-model photography, a shallow depth of field is created by blurring areas of the composition, either optically or in post. This title technique nicely captures the spirit of the pioneering Picts. —Alexander Ulloa

Damien Smith on the design process
"After early discussions with the producer and director, we kept coming back to one core idea. . . . Scotland's history and its people are defined by its landscape. From the natural barrier the Highlands form to the rugged west coast and islands, down through the central lowlands. This unique landform defined our history. ¶ As with most projects, three or four ideas were kicked around, with the strongest developed into a storyboard. We all liked the idea of historical dates and type tagged or pinned into the landscape and then blowing away in the wind, referencing the elemental nature of Scotland and the passing of time. We then gathered specially shot helicopter footage and added shallow focal planes into the image, which helped to build in a sense of scale and also caused attention to focus in on the type elements."

144

I Am Still Alive # 21

Publication Formal:
Total Recall

£ 1
U$ 2
¥EN 3
ƎURꙨ 4

I Am Still Alive is a parasitical magazine.
Unless otherwise stated, images, texts and the
combination of both are by Åbäke.
First published as a play in the catalogue for *Graphic
Design: Now in Production*, curated by Andrew Blauvelt
and Ellen Lupton, organized by the Walker Art Center
in Minneapolis and the Smithsonian's Cooper-Hewitt
National Design Museum in New York.

*** During their teaching years at the RCA,
Åbäke organised a series of Talks entitled
'Presentation Formal: a Talk which is the
Work, not about it'. Artists, designers and
writers such as Aurélien Froment, Ryan
Gander, Benoit Maire, Ella Gibbs, Amy Plant,
Daniel Eatock or Flavia Müller Medeiros etc.
came and used the medium of the lecture as
raw material.

On Thursday 7 April 2011, they will use the
material of what happened then in the past
to construct a talk of then in the present
and perhaps the future.

**Åbäke, is an artist/design/trattoria/graphic
design/publishing studio based in London.
The list could be longer, as their work
tries to explore diverse fields of creation.

Åbäke**
Presentation Formal:
Total Recall
Thursday 7th April
6:30PM
Research Seminar Room, RCA*
This will be the final
presentation of their series
of lectures***
called 'Presentation Formal:
a Talk which is the Work,
not about it'

They've based their practise on collaborative
projects with artists and designers such as
Martino Gamper, Johanna Billing or Hussein
Chalayan. Their four members**** have been
working under their collective name from
2000, and have since then founded a Music
Label (Kitsuné), a trattoria, a magazine
(Seximachinery) etc. They teach in London
and Europe.

* The Research Seminar Room is located on
the 2nd floor of the Stevens Building, in
the Royal College of Art, Stevens Building,
Kensington Gore, LONDON SW7 2EU

**** Patrick Reichen, Benjamin Suzuki,
Kajsa Lacey & Maki Stahl

This event is free & open to all

PUBLICATION FORMAL:

Presentation Formal: Total Recall was first presented as a lecture at the Royal College of Art (Department 21) as a reaction to the invitation of Sophie Demay, then member of Department 21, a student-led department open to all RCA students, technicians, staff and teachers.

It was then transcribed and published in *The Final Word*. RCA 2011

Characters:

SOPHIE DEMAY,
the host of the evening, with a French accent

ÅBÄKE,
a man or a woman in their mid to late thirties
wearing a Ned's Atomic Dustbin T-shirt

AUDIENCE MEMBER,
a man or a woman in their mid to late twenties

MALE VOICE,
who is heard but does not appear on stage

FEMALE VOICE,
who is heard but does not appear on stage

JÉRÔME RIGAUD,
a.k.a. Electronest

JULIE HILL,
a member of collective St Pierre ʰᵈ Miquelon

ELLA GIBBS,
an artist

AMY PLANT,
an artist

SAMARA SCOTT,
a student

ROBERT SOLLIS,
a member of graphic design studio Europa

On stage, the lecture theatre of an art school.
There are 30-35 Robin Day chairs on stage.
If there are less than 35 members of the audience, they all sit on stage. If there are more, the rest sit in the theatre.

NOTE:
All characters are relaxed, except ÅBÄKE who is constantly drinking from a plastic water bottle, held with both hands and searching approval through eye contact with the more smiling members of the audience on stage.

SOPHIE DEMAY:

[holds a book and pretends to read from it]

Sophie Demay, member of Department 21 at the Royal College of Art, invited Åbäke to give a talk about their lecture series called Presentation Formal: A Talk Which Is the Work, Not About It, which they organised during their teaching years at the RCA. Artists, designers such as Aurélien Froment, Ryan Gander, Sally O'Reilly, Amy Plant, St.-Pierre and Miquelon, Dan Eatock, and Flavia Muller Medeiros came and used the medium of the lecture as raw material. On Thursday April 2011, they used the material of the past to construct the talk which is about to happen. With an audience of 30–35 people, it begins…

[closes the book]

Hello, my name is Sophie and what follows is the lecture as I remember it.

ÅBÄKE:

Thank you for coming, thank you Sophie. Thank you also to all readers who just joined us.

[pause]

I was in the jungle with my mum and the guide pointed at a little bush on the ground. He started explaining and my mum asked: "what did he say?" and I translated what he told us, which was that over the mountain range on some sort of a thousand metre high plateau only accessible by plane, there is a plant which has magical properties. My mum said: "yeah, but what is he showing us now?" So I asked him: "excuse me, so THIS is the plant?" and he said "no but I'm asking you to use the power of your imagination."

[pause]

In the seventies Yvonne Rainer was in a room like this with many people. The phone rang and someone went to answer. "Hello?" "Hello it's Vito," Vito Acconci. "I am now on 52nd Street." The guy tells the audience what Acconci just told him and sits down. Five minutes later, and that's rather long if you have to wait in a room with many strangers, the phone is ringing again. Another person goes to the phone and answers: "Hello, who is this?" "Hello, it's Vito, I'm on 54th Street." Another five minutes, and then the phone rang and someone answers: "Hello it's Vito, I'm on 56th Street." So this goes on for probably half an hour and then Yvonne Rainer yells across the room, "OH, COME ON, TELL HIM TO TAKE A TAXI!"

[pause]

In 1977 there was this mythical concert of the Sex Pistols in Manchester and apparently seventeen people were in the audience but more than two thousand people claimed to have been present. It is mythical because the "kids" in the audience went on to start making music and change the "scenes" later on. Morrissey was there, two guys from Joy Division, Mark E. Smith of the Fall, Tony Wilson who went on to become the head of Factory records, boss of the Hacienda. Somehow the singer of Simply Red was there too. I was not at that concert.

[pause]

I was not in Reading in 1991 either when Nirvana played the festival. The T-shirt I'm wearing today is from that year. It's one of Ned's Atomic Dustbin. If you know this band then you are probably a bit older than the rest of the people here. It was actually an amazing concert but I wouldn't be able to sing any of the songs today. Anyway when I wear this T-shirt and I'm with this friend he always says: "Did you know Mark Leckey (the artist), was in Ned's Atomic Dustbin?" and I don't want to brag but I actually happen to know quite well the history of the band and I've never heard or read that Mark Leckey was part of it. Mark Leckey once won the Turner Prize for works which are based on talks or perhaps ARE talks. The friend I mentioned is artist Ryan Gander who also has worked using the lecture as raw material for one of his artworks.

[pause]

A few weeks ago I went to see Nicolas Roeg give a talk. He is the director of Don't Look Know, The Walkabout and the one with David Bowie who plays an alien?

AUDIENCE MEMBER:

The Man Who Fell to Earth?

ÅBÄKE:

The Man Who Fell to Earth. Thanks. Brilliant films, this was really going to be a treat, I even thought he was dead. Already, it was great that he was alive but imagining him telling us about such fantastically bizarre movies, but the talk was really boring. He was not happy to be there. At times he would tell a joke you felt he had told in another talk. In the end there was not much to say or to ask and then I realised that his films are great because maybe that's what he wants to do and lectures are not really his medium of work. They are just promotional. At this talk, he didn't have a new film to promote. he didn't for a long long time.

[pause]

I did go to college in France, for my BA, and I did my MA here at the RCA in Communication, Art and Design. The big difference between the two was that in Paris we had one talk per month for the whole college of 600 or so students, but while I was there for four years the lecture theatre was being refurbished, which meant that out of four years I think I saw three talks, none of them in any way memorable. When I came here, there were three talks per day, almost, but I really, really liked it. I remember one which was organised by the architecture school and this woman just broke down in front of everybody. What happened was that she couldn't really start. She did stand by the lectern, show a slide and started speaking but stopped. She started over, once, twice, three times and then she got really stressed and everybody was really stressed and you don't know what to do because you are sitting, and you want to help but you can't really help. And after the fifth time she said, "Ok I'm going to have a cigarette." So she had a cigarette for five minutes, so the whole thing was now fifteen minutes into the talk, we all knew that there was not going to be any talk. She sat down next to Nigel Coates, the head of the course on the front row. Basically what we were

looking at was this empty stage with a table, with a blank image, not even that, and just from time to time, smoke being puffed from this cigarette. After half an hour, Nigel Coates said "we cancel," but still we had to go through this for half an hour, and when I say we, it was us, the audience, but also her. I forgot her name but I still feel for her to this day.

[*pause*]

In general the talks were great because you learn so much from what people have done. When we came back to teach here we thought: "Oh Ok, since there are three talks per day and it's a crazy luxury to even have to choose an interesting talk to go to, then we'll try to invite people to come and talk in a different way," I mean in a way which would not be a portfolio of the past works, describing projects: "So this is what we did in 99, in this context, these circumstances and the client didn't pay—always funny, that—and this is what we did in 2001, 2005, 2011, blah blah." All this is interesting but when the work goes through the Powerpoint™ machine, it can be very abrupt because you talk about a project and another, it is embellished and totally decontextualised. Sometimes I wished they could just talk about one thing but thoroughly, rather than feeling we are flicking through an IKEA catalogue or worse, their website.

[*pause*]

Anyway Presentation Formal was … the subtitle is maybe slightly pretentious: "A Talk Which Is the Work, Not About It." Yesterday I tried to count, we invited twenty, twenty-five … twenty plus people. The deal, or the discussion which we had prior to the talk itself was: "we would like to invite you for a talk, it's not a lot of money—at the time it was £70, £35 for a team of two, not much—but we promised that then we would pay a few rounds of beers in the very cheap RCA bar. The talk itself we'd like you to consider as the raw material for a new work."

[*pause*]

I don't know if you are familiar with a performance called "Audience Performer Mirror," from the late seventies by Dan Graham. You see those really quite incredible, mythical black-and-white images of one guy, jeans, beard, longish unkept hair, quite grunge looking, Dan Graham, much younger than today, hands in his pockets, and an audience, but behind him there's a huge mirror, quite close to the audience actually. What happens is he talks about himself, how he feels, and what's in his pocket for, I don't know, twenty minutes, then for twenty more minutes he goes on describing who the people are, that shirt green and black. I want to redo this but today I will just tell you what I've read, seen reported, not even from someone who was in the audience but really, that's pretty much the rawest form of a talk as a performance because it is pretty much about itself only—ok, there is the huge mirror— but where Dan Graham is very clever and maybe generous is that each audience is different and each state of mind he was in was different so the result would be always different—just assuming a lot here and even mythologizing. I don't think he does that anymore but you see photographic documentation of this talk/

performance a lot in books. It's quite radical, very simple, it takes very little, probably a lot of energy, but the setting is all there—ok, except the giant mirror— However I was not there so how can I experience it without its mediation? I was not there.

[*pause*]

I went to see an exhibition at South London gallery where there was exactly the same setting but it was a film, projected onto a wall at actual size, I don't know if you know Ian Lee, he's a fairly known comedian, English comedian. Ian Lee was Dan Graham. It was a re-enactment of this talk and he started by saying he was a little bit sweaty, and again I'm not going to redo this but what happened, because he is a comedian, by the way this piece—by artists Ian Forsyth and Jane Pollard— was called *Mirror, Performer, Fuck Off*. I guess the Fuck Off comes from the stand-up comedy element because Ian Lee was quite rude to people and you could really see that everyone was laughing, but not really, because you knew you were going to be next, and you knew that he was going to say that you were a bit chubby, or you look like a paedophile—he did say that to someone. This felt closer to me I thought because of the time, the filming happened last year and because it was a projection, actual size in colour, which is a bit different from a black-and-white photograph but it was still not close enough. I wished I was there, probably laughing and terrified at the same time.

Anyway this was a long-winded way to explain why we organise the Presentation Formal series: to be there and enjoy it first-hand. I have to describe how some of those talks happened, which still is representation but I will try to make it for you an experience which is the closest to what happened when it happened. So let's go.

Do you have any questions?
No?

Ok, 'cos you don't have to keep the questions for later you know. I want to get back to why it's called Presentation Formal as well. It's Presentation Formal because moderators usually say: "Ok this presentation will be very, very informal" and then already it's very stressful and formal. So we thought that we can just say it is formal, but then it's Presentation Formal and not Formal Presentation because we thought it's a bit like Tate Modern. I sort of understand Tate Britain, but Tate Modern, Modern being an adjective, it could have been Modern Tate, but Modern Tate is a bit weird. Tate Modern is a bit French sounding, sounds a bit French, non? So Presentation Formal instead of Formal Presentation, it does sound a bit strange, like a mistake maybe. At the same time we were titling the series, the head of the course in Design Product was Ron Arad, and I did say Design Product not Product Design. That sounds like a mistake too, and Ron, he's not English so one could think, maybe he's made a mistake, but he sort of claims that because design is more important than Product, Design should precede Product.

[some laughter from the audience]
I'll get to the point. I shouldn't do this chronologically because to be honest I don't remember who came first, or who was last. Do you want to choose, any of them? Choose a card, any card.

AUDIENCE MEMBER:
James Goggin.

Å BÄ K E:
James Goggin, good choice! So James Goggin, for those who don't know, and it will be my interpretation, is a graphic designer. So he did come and had a Powerpoint™ presentation —not Powerpoint™, he had Keynote™—it was the first guy I saw using Keynote, crazy! James was always the first in technology, even at college. What he did talk about was colour. He had just written this article about colour, and the only thing I remember to be honest was this slide of a guy from Australia, using water to create rainbows—that was really nice. At the end he came to me and he said, "Yeah, I really did try to do a talk which was the work, blah blah blah blah blah, but I couldn't help put some of my work in there." And we said, "It's ok!" It's ok because some people we asked to come and talk really didn't care so much about doing something especially for the talk. And I don't mean this in a derogatory or in a revengeful way, it's just that they didn't, it wasn't really their thing. Metahaven, for example, they did a talk, it was interesting but I thought, hey come on, we described the brief. Their work's truly inspiring so it was actually more than fine.
[pause]
Artists without a signature medium are perhaps naturally responsive to the proposal. Aurélien Froment's intervention was such a case. Aurélien came in the afternoon with a big bag and we set up a camera above a big table like this one in the middle of the room [moves table and video camera]. As people were entering, they could sit behind, next to or in front of him. It was a large table and many objects, pieces of paper, puzzle, bits and bobs were more or less organised around an A3 area filmed by the camera. Aurélien then performed something between pantomime, basic animatronic and overhead projection. Some prerecorded soundtracks also joined at some point. I was standing in the back so I could see both the "result" on the wall and the manipulations on the table. It was the film and the making of the film at the same time.
[pause]
This brings me to one person who has worked with Aurélien and I thought was really interested in the idea of using the talk as work, and that's Ryan Gander. I don't know if you are familiar with his work, but he does a lot of different things. However, like many people, I got to know his work through a talk, but not as a talk, it was a transcription in a magazine. There was an image and then quite a long caption, and another image, another long caption, another image, long caption and it was some kind of a strange pub conversation of someone who would say, "Yes I saw this, and that reminds me of that, did you know that Schwarzenegger was in *The Terminator*? Yes, the governor of California. There is a bear on the flag of California, actually flags only usually have one side except one state Oregon, but flags are usually for war, maybe, or marking territories," and it moves on, hopping like this. The examples I just used are not in his talks, they are much better information or anecdotes in his, but that's exactly what his *Loose Associations*—the name of his work— are. He goes from one thing to another. We did ask him, actually quite early on in the series to come and give this talk, and he gave another one, which was actually maybe even better because we didn't know it.

A few years later we thought of inviting him again but then the head of the course said, "Guys, this year we have no money," so we said, "No money, no problem," a phrase curator Matthew Higgs said a lot in the 1990s. It still applies very much today… So we organised Presentation Formal, No Money No Problem or something like that. We tried to come up with ideas of how to continue the presentations without money, which was an entry to define what a talk could be, what it was for, what it offered to either audience or the lecturer. For such a small amount, surely money was secondary. I'll just give you an example. At this point we really wanted Ryan again, but we thought maybe that's ok, instead of Ryan Gander maybe we could have Brian Guander who can do this for free. Brian Guander came, and he gave a talk, which was not the *Loose Associations*, but it was called the *Vague Juxtapositions*. Brian went on and on for an hour, and then we went over to the bar and then one of the students came with us, chatting away with Brian. It's only after one hour that I realised that he thought Brian was Ryan. That's a great thing, because Brian kept in character naturally, and speaking of staying in character, it reminds me of, er, do you know Dan Eatock, Dan Eatock is a, what is he?

AUDIENCE MEMBER:
He's an artist.

Å BÄ K E:
He's an artist. Ok.

AUDIENCE MEMBER:
An artist who used to be a graphic designer.

Å BÄ K E:
An artist who used to be a graphic designer. His girlfriend Flávia Müller Medeiros is an artist. So they have some kind of a parallel work. Different but they spend 24 hours together. And we both know them personally, not one more than the other. One day we asked them, would you like to come to the RCA, the both of you, but each one as the other. It was at the pub, but they don't drink. Anyway they came one as the other. Because their gender is different, it's difficult to think that one is Flávia, and one is Daniel. But at some point, for being in the audience I had completely forgotten that. Where you there? Do you remember something about it?

overleaf, clockwise from top left:
Presentation Formal Manu Luksch and Mukul Patel, Paper Hats and Apparent Extent, David Bennewith, Susumu Mukai and Will Sweeney, Benoît Maire.

AUDIENCE MEMBER:
I remember when Dan, dressed as Flávia, chewed up some chocolate and then spat it back out into her hand.

ÅBÄKE:
Yes I also remember this. Dan is here, Flávia is there. But Dan is Flávia so he is performing or re-performing a performance that Flávia had done a few years before. He chewed it for quite a long time, and then regurgitated it into his own hand. It was almost liquid because in the original performance Flavia had used a Lion Bar and the only available chocolate was a Mars.

AUDIENCE MEMBER:
Did any of the students get them mixed up in the end?

ÅBÄKE:
Not really because this is what happened, I think that their works, which are quite different were made even more different because of the interpretation of the other. Although at some point one said, "But I thought this was a collaboration," and the other said "No, I commissioned you."

AUDIENCE MEMBER:
Is Brian still living as Brian now?

ÅBÄKE:
Sometimes. He's here and he asked me to not reveal his identity.
[everybody looks at each other]

AUDIENCE MEMBER:
Has he always been Brian, or did you look up someone?

ÅBÄKE:
I think it would be more interesting if when you meet him he's still Brian.

AUDIENCE MEMBER:
Yeah… he hasn't got a Brian Guander Facebook or Myspace, has he?

ÅBÄKE:
No, but he's very good at being Brian. Enough for someone to think he was Ryan. Maybe it's all me talking and we need some action, so from one artist to the next: when Nina Beier and Marie Lund came—they used to work together. Well something happened, but they didn't want it to be documented in recording, so what we did ask was if the people from the audience would be ready to give their phone numbers to be published later, for anybody to call them to know what happened. And I found the paper, for today, do we have any reception here?

SOPHIE DEMAY:
I think — Like a phone message? Yeah.

ÅBÄKE:
Can I just give you a few phone numbers and you can call a few people?

AUDIENCE MEMBER:
Do you want me to call them? Oh all right, what shall I say?

ÅBÄKE:
You can ask them what happened during the performance of Nina Beier and Marie Lund.

SOPHIE DEMAY:
Do you have a speaker on your phone?

AUDIENCE MEMBER:
I do, but it's not very good though. I'll call one now. How long ago was it?

ÅBÄKE:
Maybe four years ago.
[laughter from the audience]

AUDIENCE MEMBER:
Four years ago?
[laughter from the audience]

ÅBÄKE:
But we had mobile phones then, you know.

AUDIENCE MEMBER:
What was the artist's names again?

ÅBÄKE:
Well, you can say Nina and Marie, they will probably remember.
[phone rings (dial tone)]

MALE VOICE:
"Hello?"

AUDIENCE MEMBER:
Hi, I was wondering if you could tell me about a presentation by Nina and Marie that you might have seen four years ago?

MALE VOICE:
Er … yeah.
[laughter from the audience]

MALE VOICE:
[laughing] So are you from the Royal College?

AUDIENCE MEMBER:
Yeah, we're actually here right now.

MALE VOICE:
Cool, [laughing] well, that came out of the blue. Weird, let me try and remember what they did …

AUDIENCE MEMBER:
I don't know anything about, it I'm afraid.

MALE VOICE:
Ok, problem is I just got through my door, so you've caught me off guard. I remember Nina and Marie came

over, it was one of the Presentation Formal series, but to be fair, I don't remember exactly what they presented. So who is this again?

AUDIENCE MEMBER:
My name's Raf, I'm actually at a presentation by a guy from åbäke.

MALE VOICE:
Say hello!

ÅBÄKE:
Just tell us what you remember!
[laughter]

MALE VOICE:
I remember they came in and I remember they presented a whispers project, was it something about whispers? Like Chinese whispers? Err … err … You've put me on the spot now … err … to be honest I can't remember, I feel really embarrassed.

ÅBÄKE:
Ah, but don't worry because I don't remember so much myself but I think we are going to try another number.

MALE VOICE:
Well when they came in, they presented a project that they previously did, they reenacted it again, but that's as much as I remember.

ÅBÄKE:
Ok, thanks a lot, we're going to try another number, but thank you very much.

MALE VOICE:
Ok later, bye!
[end of phone call]

ÅBÄKE:
Ok, let's try another one. Someone with a powerful speaker.

SOPHIE DEMAY:
Well maybe you could use my phone, but I would like not to talk.

ÅBÄKE:
Yeah it can be anyone else, that's fine. I think it's really difficult because I do remember each one, but mostly on the formal aspect of what happened. Very, very little on what has been said, which worries me because … ok. Any number, pick any number. He didn't remember the details but he did remember Nina and Marie.

AUDIENCE MEMBER:
What do I ask them? Nina and Marie?
[dials a number] That one's out of service.

ANSWERING MACHINE:
I can't take your call now, but please leave your message after the tone.

AUDIENCE MEMBER:
Hello, yes I'm calling to see if you remember anything about the Nina and Marie presentation sometime around four years ago. If you could just call this number back with some information detailing that event it would be much appreciated. Thank you.

ÅBÄKE:
Ok, no luck then.

AUDIENCE MEMBER:
Well, there's plenty more numbers?

ÅBÄKE:
Yeah, one more, yeah, yeah. Maybe we try one more and then …

AUDIENCE MEMBER:
[dials a number] Hello.

FEMALE VOICE:
Hello.

AUDIENCE MEMBER:
Hello, I just have a really quick question. I would like to know if you have any information about a talk by Nina and Marie at the Royal College of Art four years ago.

FEMALE VOICE:
Oh … I don't think I do. Can you repeat their names?

AUDIENCE MEMBER:
Nina and Marie.

FEMALE VOICE:
Nina and Marie … ah, they gave the shoe talk. They went on the tour.

AUDIENCE MEMBER:
Yeah we are with a guy here who organised the talk, but he said we have to call you to find out what happened, 'cos he doesn't remember.

FEMALE VOICE:
Well, I don't recall the specifics, but I didn't organise it or anything.

AUDIENCE MEMBER:
But you were there? Would you mind just explaining what happened?

FEMALE VOICE:
Yes sure, let's see, that was complicated … would you mind calling back next week? Or is it really urgent?
[laughter from the audience]

AUDIENCE MEMBER:
Ok, well have a good holiday, thank you.

FEMALE VOICE:
Thank you.

AUDIENCE MEMBER:

Ok, bye.

[laughter]

ÅBÄKE:

Well it's a shame actually, but at the same time, that's exactly what they wanted because at some point in our discussion we asked, can we document this? The idea sounded worth recording. And they said, yeah, yeah you can take one photo but it was quite vocal and the photo was inadequate. In an improvised manner at the end of the talk we asked the audience to give us their phone numbers. In retrospect I think it would have been nice to have a film of it but at the same time we are interested in how some events can be forgotten or inversely mythologised.

We can take another example which is much more recent, and we have Jérôme here. I actually invited each speaker to come today and a few did. Jérôme is obviously an eyewitness but of another kind as he was the one speaking. [to Jérôme] when was it, last year? Two years ago? Jérôme, can you come and show us what you did?

JÉRÔME RIGAUD:

Again?

ÅBÄKE:

Yeah.

JÉRÔME RIGAUD:

It's a bit hard now?

[laughter]

I would need a few books.

ÅBÄKE:

Well maybe if you come closer I can help, more as a dialogue, because I know you need those props. It was not in this room, it was downstairs, and then you came with a huge bag? What was in the bag?

JÉRÔME RIGAUD:

In the bag there were a few books that I selected beforehand. Shall I go on and explain what I was doing?

ÅBÄKE:

Mmhmm.

JÉRÔME RIGAUD:

So basically I am, for a few years I've been working on a blog, which is in fact a re-blog. It's now quite common but at that time it was something I was experimenting with and basically the idea is not to write anything, I mean not directly, and work much more like an editor and select bits and pieces of interesting things I come across. And I've been running this thing for four years now on the Internet, and what I did for the talk åbäke asked me to do here was to come with books rather than websites. I don't know, fifteen, twenty books and I spoke about each book and why they were in the bag that I took with me.

ÅBÄKE:

For someone who spent so much time in the digital world of the World Wide Web it was quite surprising. Can you tell us which books?

JÉRÔME RIGAUD:

There were a few books of graphic design, definitely. I think I was quite into this author who wrote about Germany just after the war … "Mon besoin de consolation est impossible à rassasier" … Stig Dagerman. There was a couple of stuff but I can't remember exactly what was the selection. But maybe next week I can do one with the list of current books?

ÅBÄKE:

Yeah. Even the author doesn't remember.

JÉRÔME RIGAUD:

No, I can't. It is a bit of a surprise.

ÅBÄKE:

It is, I realise it is a bit of a set-up, sorry. Thank you Jérôme! There was one which definitely was difficult for people to remember as a collective memory because the audience was completely fragmented. St.-Pierre and Miquelon came to speak but prior to the presentation itself, for one week or more there was a little sheet of A4 paper where you could write down your name and a timeslot, I think it was something like twenty—If anybody knows about this and wants to correct me—I think there were twenty slots, so you could write your name and you were given five minutes. What happened was that you would come to the room, alone, and [speaks to a member of the audience] Julie, do you want to come and sit here? Ok, great. We need two more people who will be Tom and Simon, Julie's two partners. Let's move this. [to the audience] This is Julie Hill from the collective St.-Pierre and Miquelon.

[sound of tables and chairs moving]

ÅBÄKE:

Let's imagine that anything else apart from this table and these three people plus the one member of the audience, let's imagine that we are not here. If you signed up it's just you and three people in this room and what promised to be a talk turns out to be some sort of interview. There are three times more speakers than audience.

JULIE HILL:

Ok, so imagine on this piece of paper there is a Rorschach Test, we asked a series of questions, psychometric testing; tell me what you think is on the paper, and after those we will, without people knowing, we interviewed people for a position to work with us, which all stems back from how we got our name as a collective. Which is we…

ÅBÄKE:

And I'll just cut here. I feel like Rod Serling in the Twilight Zone, you know. What is happening is that Julie here is a bit struggling because I didn't tell her that

something like this would happen today, sorry again but I just intervene: You said something as an introduction to each person, the reason why I know this is because I was in this recess with Kajsa and we had it covered with furniture, hiding in the lecture room. I remember quite well what you said but we couldn't see anything.

JULIE HILL:
Ok, I can't remember what was said now with opening the …

Å B Ä K E :
Can I say it?

JULIE HILL:
Ok, yeah you say it.

Å B Ä K E :
You said, "Hello take a seat. We are St.-Pierre and Miquelon, but last week we went to see a fortune teller."

JULIE HILL:
A psychic.

Å B Ä K E :
A psychic… will you let me say it?
[*laughter*]
We went to see a psychic and she said "But you guys are four," and you said, "No it's only Tom and Simon and I." "No no no no, you are four." So we decided to recruit a fourth member, and this is an interview to see whether you can join us.

JULIE HILL:
It was actually two, the psychic told us we were five, so from the lecture we actually recruited two members and we had very loose working relationships, so when we've had projects where more people can get involved we've kind of gone to them, and they can or can't co-operate sometimes, so we're three but we're flexible, so …

Å B Ä K E :
It was useful?

JULIE HILL:
It was useful yeah, we got some extra mileage out of it, so yeah …

Å B Ä K E :
I really liked it, we could hear behind that wall of furniture that you were not asking the same questions, probably for your own sake as well because otherwise …

JULIE HILL:
To keep it interesting.

Å B Ä K E :
But those questions were in relation to your work.

JULIE HILL:
Some of them, yeah, some were, there were a range, so some were based on projects we'd done and asking people how they would respond to the kind of thing we were doing and the issues we were working with, and other ones were psychometric testing, you know to try and find out what kind of personalities people had.

Å B Ä K E :
Well thank you very much. I'm just taking this opportunity to have people who have firsthand experience of the presentations.

AUDIENCE MEMBER:
Can I ask a question?

Å B Ä K E :
Yeah.

AUDIENCE MEMBER:
Was I at Presentation Formal two years ago with Jürg Lehni, because I was talking to Pedro before, and I was asking him if he's been to any Presentation Formals, and he said he kind of remembered a few, and I tried to remember whether or not I'd been to some, and I was wondering if you could remember me being there?
[Laughter]

Å B Ä K E :
Yeah, but you see, that's also quite loose, the way they are called. I take one extreme example which would be that we would invite someone, "Ok, it's called this because it's part of this series and then you will do something really strange using the material of the talk blah blah" and that person doesn't, we are not going to say that they are not part of the series. But I would say that Jürg didn't really do something which … responded to the canon. Can I even say that? People were obviously free to do anything, we were always so grateful they'd even accept the invitation at all.

AUDIENCE MEMBER:
All I remember is that I think he did, something with a machine that was a blackboard, maybe. Or it might have been a projection, I'm trying to unpick it in my head, all I remember was that I was sat in the downstairs. There was a blackboard on one of the walls. Do you remember?

Å B Ä K E :
Do you mean you are not sure if there was a machine there or if it was a film of it from Powerpoint™? That's interesting. I really believe that some talks can be life changing, but I've never been to one yet.
[*laughter*]
I'm a bit worried that I remember the most anecdotal ones, so for example, Sally O'Reilly came and she is a writer and she … what I remember is the beginning. It's Bergson, Henri and Laughter in Contemporary Art, so that sounds on the one hand funny, and on the other hand quite meaty. The thing is I don't remember what she talked about, what I remember was that at

some point it was all in the dark, and then she had a little puppet of a horse and then she had a torch light, pointing it at a soft toy in the shape of a horse and she was like [*Åbäke makes car noises*] but maybe you have recognised that this was possibly her re-enactment of Anri Sala's film, in which this really skinny horse is by the motorway, and there are cars passing by, it's not funny at all, the film is beautifully sad but then, it was funny. A bit later she went behind the table, or under the table and when she came back she had, she was wearing this naked man's suit. So she stood on the table and then she said with fake chest hair and penis: "Franko B."
[*some laughter*]
It's a bit unnerving because I tell people how amazing these talks were and then when it comes to Sally the only thing I can remember is her wearing this naked man's suit. I always try to say it was about Bergson.
[*pause*]
I'm actually very happy today because someone I invited for this talk is here in the audience. There was a specific moment a few years ago when I saw this person really turn the whole room upside down in one very simple proposition which was extremely generous. It was at the Architectural Association where a few speakers, one after the other, were trying to take into consideration the fact there were people, live people sitting there. But Ella Gibbs, who is here today, just gave the microphone to each person to her neighbour and said: "Big up someone." So the first guy was a bit surprised and struggled a bit before saying the name of his girlfriend, the second one did shout out the name of his nan, and then it just went on incrementally until everybody had thought and said in public the name of someone they were thinking of. Amazing. I will always remember that.
[*pause*]
Something like this is perhaps at the origin of our series. We did invite Ella Gibbs, and Amy Plant, who work both together and not together, but at this point they were doing a few projects together and still do today. Correct me if I'm wrong; Ella and Amy, you came with a camera [*the camera recording the talk makes a noise, indicating the tape is finished*], this sound was just to tell us that it was one hour exactly, so the tape is gone. It's so relevant to what I am going to describe it's magical: Ella and Amy came with a camera and a sixty-minute tape in the morning of the presentation, which was going to be at six-thirty in the evening. They went to every single department, the 20 departments of the RCA, and edited live interviews so this whole day of spending time with different people from the different departments would total sixty minutes, which was then shown in the café's cinema screen. And again, I really remember the form of it or its protocol but I don't really recall so much of the detail of what…

ELLA GIBBS:
What it was about? What it was?

ÅBÄKE:
What it was, I guess that's what it is, you met all those people, but do you remember some of those exchanges?

ELLA GIBBS:
I do. Yeah vaguely, we sort of bombarded ourselves into all these rooms and asked people if they'd be fine being quickly interviewed. I remember going into the glass-blowing place and filming, somebody demonstrated how to blow glass for us, we learned a lot. And I remember people showing us architectural models and talking about various things, yeah, vague little glimmers!

AMY PLANT:
Yeah, everyone was very open and welcoming into their departments and it was quite nerve-racking for us because obviously the first time we saw it was the same time that everyone else saw it.

ÅBÄKE:
But this tape, we still have it, so whoever wants to see it just let us know. And I guess that's where we should go, to the bar now. Unless you have any questions? At the time I thought that was so clever to already take us to where we were going to end up anyway.

SAMARA SCOTT:
I just have a last minute addition, I remember a lecture you did with Martino Gamper and you got us all to put alarms on our phone, and you put them all on the table, and then at the end of the hour they started going off at slightly different times. And it was all the different musical ringtones, and you said that's it. It's finished.

ÅBÄKE:
You know this one is really funny, because it really shows, in different countries it's always different. In some countries, like in Sweden, you get pretty much the same number of phones as the number of people, and then in France, it's going to sound a bit racist—but I'm French myself—in France, we don't really trust each other so we have, I think twenty percent of the phones. Because I don't believe that they don't have phones. So in Sweden eighty percent to ninety percent, France twenty percent. Even though the sound is always quite similar, the intensity is always depending on the quantity of phones. But we do this all the time so I thought not today …

AUDIENCE MEMBER:
I heard of a joke that you might've or might not have told. You might have invented it. I think you might have done this. But I heard it through someone else so I'm not really sure, and I'm not sure if they were talking about you or not. But it was a talk that took place here, that I was not present for, and Noam Toran was giving a talk and he does a lot of his work with Onkar Kular who was my tutor and then Noam was saying, was talking about their work, which they collaborate a lot on, they do a lot of work together, they're attached at the hip sometimes and then something transpired, and he was talking as if Onkar was in the room, and you said something like is Onkar in the room with us now? Can you confirm that?

ÅBÄKE:
Yeah but it was not a joke.

AUDIENCE MEMBER:
It's not? It sounded like a joke.
[Laughter]

ÅBÄKE:
It wasn't a joke. It's just, you know, the way he was constantly saying we, but being alone. That's why … his talk was actually part of the No Money No Problem talks, so we couldn't pay Noam, but what we did was to barter: "We'll do some work for you if you come and do the talk." Later, someone told us, then yeah, YOU paid for it and not the college. I'm not complaining, I'm just saying it was a bit of a flaw in our thinking.

ROBERT SOLLIS:
Can you just explain why you've forgotten to bring my magazines today?

ÅBÄKE:
Yes, to recontextualize where this question came from: I borrowed a few magazines from Rob months ago, and yesterday you sent an e-mail reminding me that it's been months and months and months. I invited Rob to come to this talk. So I took those magazines and I put them in my bag. I put my bag in the entrance so I won't forget it. In preparing this talk I was trying to think whether I should bring images or not, then I remembered one person that we had invited in France to perform, he really did come with nothing. This guy, called Momus, is a singer, and also a performer, so obviously he's got a head start from anybody else, but just before starting, he said, in French: "Je suis venu avec ma bite et mon couteau."
[laughter from francophones]
As a translation, it means "I came with my dick and my knife." Which always means, yeah I came with nothing, empty-handed. I thought that's so fascinating, I always need my laptop, Powerpoint™, props, I would love to do a talk where I come with nothing but memory and something to say. I don't have a knife but …
[laughter]
Anyway, this was on my mind this morning, so I said ok, let's forget about the laptop but then, I also forgot the bag and therefore the magazines. I'll give them to you next week, sorry.

ROBERT SOLLIS:
What was your criteria for inviting people to do a presentation?

ÅBÄKE:
It's a very good question because, we didn't realise why or who up to a certain point. We never had to make a list of people, but now that I look at it retrospectively, I think it was to perpetuate friendship with the Royal College's money. What I mean by this is that all the people that we've invited; they are in one way or another friends. Some are very close friends, and some are new-ish friends. We never invited someone that we only liked the work of. At least we had met them once or twice and enjoyed their company as much as their work. We thought if we can see them more, then we can be even more friends. Not very professional but that's the reason, and this is not even a joke, because it's obviously people we are still in contact with and go to weddings of.

ROBERT SOLLIS:
Can I make an observation? Is it true that…

ÅBÄKE:
That sounds like a question!

ROBERT SOLLIS:
Maybe. All of them are, everyone seems to work independently or in some kind of independent studio, or artist form. Is it deliberate that none of them are big organisations?

ÅBÄKE:
Well I think, it might be a flaw, but actually we don't know anybody who works in ad agencies or trend forecast agencies. I'm not even being ironic here, it would have been interesting. There is one thing that I should emphasize here: this series has never been an attack on the conventional talk. I really like to think of it as being one more talk, in a place which already presents a lot of it … For me the RCA puts a lot of money into getting people to come and talk about their work. It is a policy in a specific form of education. I don't know how we can force ourselves to invite someone who maybe we couldn't be friends with. It sounds a bit black and white but it's just simply, it didn't happen, but maybe soon. I think you're right , we should explore.

ROBERT SOLLIS:
But I didn't say you should.

ÅBÄKE:
Ok, no, I say we should. Having said that it reminds me of a Bill Hicks routine where he says to his audience: "Anybody working in marketing?" "Yeah? Well, kill yourself."

SOPHIE DEMAY:
Ok maybe I have a question to end. The reason we invited you tonight was because we thought it was really good if you were confronted to do this talk. You've asked all your friends slash colleagues. Could the talks happen in another place than here, and if you're interested in continuing the experience, you said you were looking for this amazing talk that never happened. Are you going to continue searching for it?

ÅBÄKE:
Yes.
[Applause. All exit left.]

Name	Phone number	OK to publish
ELIO CACCAVALE	07976953563	✓
Zamir Antonio	0798578456	✓
KRIS HOFMANN	07792965520	✓
Eva Kellenberger	07753328424	✓
Alistair WEBB	07980304674	✓
TED LOVETT	07841 463 364	✓
MARIA JOUDINA	07902032885	✓
OKO GOTO	0790085 7374	✓
Rasha Kahil	07921776299	✓
Antoine Choussat	07 950658097	✓
Lucie Gledhill	07980215443	✓
Georgia Hanjon	07971391048	✓
RiiTTA IKONEN	07763232265	✓
GEORGE WU	07970050552	✓
Clemence Seilles	07837054 831	✓
George Thomas	07904 529 830	✓
Mohammad	07717 283817	✓
Sebastian	078378124A	✓

Past issues:
#1 in *Rebel Magazine* 2, automne hiver 2001–2, insert poster p. 50 (FR)
#2 in *Super, Welcome to Graphic Wonderland*, 2003, ISBN 3-89955-005-6 (CH)
#3 in *Communication What?*, Ma Edizioni, pp 120–7, 2002 (I)
#4 in *IDEA* 297, 2003 pp 99–114 (JP)
#5 in *Sport and Street*, April 2003 (I)
#6 in *Sugo* 0, Ma Edizioni, pp 16–25, 2003 (I)
#7 in *idn:2003:three:volume 10:number 3: flight of fancy ii special insert* (HK)
#8 in *Sugo* 1, Ma Edizioni, pp 112–9, 2004 (I)
#9 in *A Magazine* 1, Flanders Fashion Institute, 2004 ISBN 90-77745-01-7, pp 75–80 (B)
#10 in *Graphic Magazine* 7, Bis, 2005 ISBN 90-6369-092-4, pp 149–56 (UK)
#11 in *IDEA* 309, pp 31–8, Feburary 2005 (JP)
#12 in *Lodown* 45, March 2005 (D)
#13 in *Math 2*, May 2005, www.posikids.org (UK)
#14 in *CREAM*, Autumn Edition 2005 Issue.02, pp 231–47, 2005 (HK)
#15 in *CREAM*, Summer Edition 2006 Issue.05, pp 250–66, 2006 (HK)
#16 in *Spring* X Maison Martin Margiela 6, 2007–2008 edition (J)
#17 in *Apartamento Magazine*, Issue 01, pp 49–64, 2008 (I)
#18 in *CREAM*, Edition 2008 Issue 09 (HK)
#19 in *GRAPHIC* 11, Ideas of Design Exhibition Autumn 2009 ISSN 1975-7905 (KR)
#20 in *TAR mag* Fall issue no. 4, 2011 ISSN 1943-3794 (I)

Up in the Air
2009, US, 2:22 minutes
Main Title Designers: Gareth Smith, Jenny Lee
Aerial Photography: Robert Mehnert, Dylan Goss
Production Company: Shadowplay Studio

Gareth Smith & Jenny Lee's opening title sequence for director Jason Reitman's *Up in the Air* intoxicates us with neatly happenstance compositions of a casual topology from a commuter's perspective with music by Sharon Jones and the Dap Kings that savors common ground. Just below the stratosphere there is our gaze and our patterns. We're big, we're small. —Alexander Ulloa

Gareth Smith on the design process
"We love the collaboration with the director and other creative folks who work on the film. It's such a great vibe working with [the director] and his team because everyone just wants to make a great movie. We also loved being able to work with, and edit, the beautiful aerial photography we had access to."

On keeping the creative energy up
"I think it's important to be able to turn work off, outside of work. It's important to let your mind contemplate things other than the specific creative task you're working on. We love to travel and try to get out of the city as often as possible to clear our heads. Jenny and I never planned on becoming title designers—we kind of just stumbled into this career. Because of that, we don't live and breathe title design. That said, we love the work, and especially enjoy meeting and working with such talented creative people."

On the shorthand he's developed with director Jason Reitman
"A good opening title sequence is particularly important to Jason—it's one of his signatures. He brings us in very early in the process. For both *Juno* and *Up in the Air*, he sent us the screenplay well before he shot each film so we could have some time to work out concepts for the title sequence, and see if there were any ways to take advantage of the physical production. For *Juno*—we came up with the simple transition idea of Juno walking behind some sort of vertical element that we could use to wipe into the animated world. I sent him the storyboard while he was shooting the movie, and he ended up getting that shot for us. And we were able to go up to Vancouver to photograph Ellen Page—taking advantage of the live action production to help make a stronger title sequence. ¶ Working with Jason is a true collaboration. He trusts us to do what we do well, and we respect and like him very much. It feels much more like doing work for a friend than our typical client relationship. He leaves us alone to explore concepts and to develop the design. And when he makes comments and criticism, he's spot on and always takes the sequence in an even better direction. ¶ And just as important—he sticks up for us throughout the post-production process and helps us get what we need to do our jobs well. With *Up in the Air*, we were able to spend a number of hours color-correcting the footage with his colorist, Natasha Leonnet—a luxury that we often don't have as title designers. Because the title sequence is so important to Jason, it's important to everyone else in the post-production process."

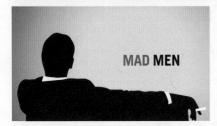

Mad Men
2007, US, 38 seconds
Production Company: Imaginary Forces
Directors: Mark Gardner, Steve Fuller
Executive Producer: Maribeth Phillips
Producer: Cara McKenney
Coordinator: Michele Watkins
Designers: Jeremy Cox, Fabian Tejada, Joey Salim
Animators: Fabian Tejada, Jason Goodman, Jeremy Cox, Jordan Sariego
Editor: Caleb Woods
Client: AMC
Studio: Lionsgate
Production Company: U.R.O.K. Productions
Director: Alan Taylor
Executive Producer: Matthew Weiner
Producer: Scott Hornbacher, Bobby Williams (Lionsgate)
Postproduction Supervisor: Todd London
Editor: Malcolm Jamieson
Editorial Company: Encore Hollywood
Music Composer: RJD2, "A Beautiful Mine"
Courtesy Lionsgate Television

A shadowed figure enters his office, sets down his briefcase, and the room crumbles around him. As he tumbles through a chasm of diamond rings, happy families, and women in panty-hose, the glossy veneer of advertising gives way, revealing the rough humanity of a man lost. RJD2's jazzy "A Beautiful Mine" conducts the viewer through the parallel worlds of the philandering, chain-smoking Madison Avenue boys' club and the idyllic nuclear family, introducing us to some of the themes underpinning the multiple Emmy Award–winning show *Mad Men*. —Lola Landekic

Rubicon
2010, US, 43 seconds
Design and Production: Imaginary Forces
Creative Director: Karin Fong
Designers: Karin Fong, Jeremy Cox, Theodore Daley
Animators: Jeremy Cox, JJ Johnstone, Andy Chung
Editors: Jordon Podos, Caleb Woods, Adam Spreng
Design Assistant: Joey Salim
Design Interns: Daniel Farah, Leo Marthaler
Executive Producer: Anita Olan
Producer: Cara McKenney
Coordinator: Emily Nelson
Music Company: Duotone Audio
Composer: Peter Nashel
Music Editor: Sally Swisher
Client: AMC
Senior VP of Original Programming: Joel Stillerman
VP Original Programming: Jeremy Elice
Manager Scripted Development: Tara Duncan
Rubicon Executive Producers: Henry Bromell, Josh Maurer, Jason Horwitch
Director (Pilot): Allen Coulter
Associate Producer: Leslie Jacobowitz
Courtesy AMC

Juno
2007, US, 2:28 minutes
Main Title Designers: Gareth Smith, Jenny Lee
Main Title Producer: Ari Sachter-Zeltzer
Production Company: Shadowplay Studio
Courtesy Fox Searchlight Pictures

Capitu
2008, Brazil, 1 minute
Creative Directors: Carlos Bêla, Mateus de Paula Santos
Director: Walter Carvalho
Producer: João Tenório
Design: Carlos Bêla
Concept: Carlos Bêla, Roger Marmo, Mateus de Paula Santos
Animator: Carlos Bêla
Assistant Animator: Rachel Moraes
Sound Design: Tim Rescala
Client: Rede Globo
Courtesy Globo

Bored to Death
2009, US, 47 seconds
Director: Tom Barham
Production Company: Curious Pictures
Executive Producer: Mary Knox
Head of Production: John Cline
Producer: Paul Schneider
Animation: Anthony Santoro, Marci Ichimura, Mark Rubo, Mark Pecoraro
Illustrator/Artist: Dean Haspiel
Pre-Visualization: Mark Corotan
Executive Producers: Sarah Condon, Troy Miller, Stephanie Davis, Dave Becky, Jonathan Ames
Producers: Anna Dokoza, Brad Carpenter
Client: HBO/Dakota Films
Courtesy HBO

The titular tome spreads its pages to illustratively set typography; the text embroiders the imagery as shapes and labels. With what sounds like the jingle of loose change, the type scatters and lies as lovely a refuse as turned tree leaves. It is Curious Pictures' title design for HBO's *Bored to Death* by creator/protagonist/writer/executive producer Jonathan Ames. —Alexander Ulloa

Tom Barham on collaboration
"For the most part though, I think collaborations provide the greatest opportunity for personal growth. The challenges are more numerous and involve a greater level of understanding of people and their points of view versus your own personal take on things. The best ventures are usually those that tap into other people's talents as well as your own."

The Number 23
2007, US, 2:40 minutes
Design and Production: Imaginary Forces (IF)
Creative Director: Peter Frankfurt
Art Director: Michelle Dougherty
Producers: Steiner Kierce, Kathy Kelehan
Lead Designer: Juan Monasterio
Designer: Rob Bolick
2-D Animators: Juan Monasterio, Sean Koriakin, Andrew Hoevler, Magnus Hierta
Editor: Danielle White
Flame Artist: Rod Basham
Coordinators: Joe Denk, Heather Dennis
Courtesy New Line Cinema

Imaginary Forces' opening title sequence for the film *The Number 23* features spreading blood splatters and a changing typography that highlights historic events surrounding, what else, the infinite variations on the integer of twenty-three. —Alexander Ulloa

Lemony Snicket's A Series of Unfortunate Events
2004, US/Germany, 6:03 minutes

Creative Director: Brent Watts
Director/Designer: Jamie Caliri
Character Designers: Joe Esquibel, Justin Reynolds
Layout Artists/Lead Animators: Todd Hemker, Benjamin Goldman
Animators: Chris Meyer, Joel Fox
Illustrators: Joe Esquibel, Tom Arron
Typography/Text Layout: Scott Sorenson, Matt Manes
Backgrounds Artists: Celeste Rockwood-Jones, Roger Loveless
Production Coordinator: Mimi Vigh
Production Manager: Renee Cannon
Technical Producer: Benjamin Goldman
Producers: Mike Miller, Gary Levine
Production Company: Axiom Design and MWP/Caliri Productions

Brat Bratu
2008, Slovenia, 1:20 minutes
Producer: Rok Kleč
Creative Director: Žiga Pokorn, Teja Kleč
3-D: Luka Kogovšek, Žiga Pokorn, Blaž Slivnik
Director of Photography: Janez Stucin
Postproduction: Teo Rižnar
Colorist: Teo Rižnar
Production Company: NuFrame
Agency: Armada

Marko Miladinović (Armada) on the process
"The task was to design a visual identity and visuals for the fictional firm B&B that uses a secondhand circus van as transportation. The van was our main character in the production of the opening animation, correspondent jingles, and credits. The visual identity reflects the awkwardness of the main characters. Their world is a mixture of old-fashioned styles, used things and charming bad taste. As they are in the smuggling business, we set the stage as if they are living in cluttered cardboard boxes. ¶ The text of the title song was our main guide. All the props mentioned in the song were used as clutter in this unidentified 3-D world the characters drive through just to get home to turn on the TV and start the show. We used 2-D photos of all the props, built a 3-D city out of cardboard texture and shot the main characters in stop motion. All of that was constructed, designed, and lit in the 3-D program Maya, and at the end composited into the final animation using Shake."

300
2006, US, 2:36 minutes
Design/Animation: yU+co, Hollywood
Creative Director/Art Director: Garson Yu
Art Director/Designer: Yolanda Santosa
Animators: Kamai Hatami, Nate Homan
Studio: Warner Bros.
Courtesy Warner Bros.

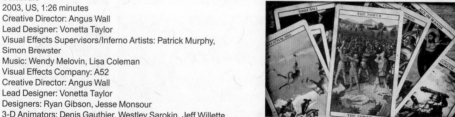

Carnivàle
2003, US, 1:26 minutes
Creative Director: Angus Wall
Lead Designer: Vonetta Taylor
Visual Effects Supervisors/Inferno Artists: Patrick Murphy,
Simon Brewster
Music: Wendy Melovin, Lisa Coleman
Visual Effects Company: A52
Creative Director: Angus Wall
Lead Designer: Vonetta Taylor
Designers: Ryan Gibson, Jesse Monsour
3-D Animators: Denis Gauthier, Westley Sarokin, Jeff Willette
Director of Photography: James Glennon
Original Artwork: Jimmy Yamasaki, 88phases
Final Audio: Richard Davis
Executive Producers: Rick Hassen, Darcy Leslie Parsons
Senior Producer: Scott Boyajan
Colorists: Tim Masick, Company 3; Dennis Cardamone, Ascent
Media; Tim Bono, Bono Film & Video
Research: Absolutely Archives, Nickerson Research
Stock Imagery: Amistad Research Center, Art Resource, Corbis,
Freer Gallery of Art, Mary Evans Picture Library
Stock Footage: CMG Worldwide; FAST Images; Film Archive;
Grinberg Images; John E. Allen (JEA), Inc.; Streamline;
UCLA Film & Television Archives
Production Company: Carnivàle, HBO
Courtesy HBO

What promises did our ancestors fulfill, and what lunacy did they sur-
vive? What historic, phantasmagorical travels did they wheedle through-
out and render? And in a breath, we realize that reasons for exorcists ex-
ist within. German Expressionist American newsreels and tarot currency
push an otherworldly balance that is at once hyper-real and not untrue.
And you get to float through it all, like the pilot of the first zeppelin or the
character in the head of young Bruegel the Elder. —Alexander Ulloa

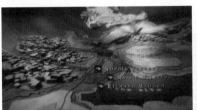

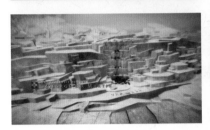

Game of Thrones

2011, US, 1:41 minutes
Production Company: Elastic
Director: Angus Wall

Postproduction
Design Studio: Elastic
Art Director: Rob Feng
Lead Designer: Chris Sanchez
Designers: Henry De Leon, Leanne Dare
Concept Artists: George Fuentes, Rustam Hasanov
Storyboard/Concept Artist: Lance Leblanc
Production Artist: Patrick Raines
Producer: Hameed Shaukat
Executive Producer: Jennifer Sofio Hall

VFX Studio: a52
CG Supervisor: Kirk Shintani
Lead Surfacing/Lighting: Ian Ruhfass
CG Artists: Paulo de Almada, John Tumlin, Christian Sanchez, Erin Clark, Tom Nemeth, Joe Paniagua, Dan Gutierrez
2-D Animation Artists: Tony Kandalaft, Brock Boyts
Compositors: Sarah Blank, Eric Demeusy
Smoke/Colorist: Paul Yacono

Editorial Company: Rock Paper Scissors
Editor: Angus Wall
Assistant Editors: Anton Capaldo-Smith, Austyn Daines
Executive Producers: Carol Lynn Weaver, Linda Carlson
Composer: Ramin Djawadi
Sound Design: Andy Kennedy
Client: HBO
Courtesy Grok! Studios and HBO

A fiery astrolabe orbits high above a world not our own; its massive Cardanic structure sinuously courses around a burning center, vividly recounting an unfamiliar history through a series of heraldic tableaus emblazoned upon it. An intricate map is brought into focus, as if viewed through some colossal looking glass by an unseen custodian. Cities and towns rise from the terrain, their mechanical growth driven by the gears of politics and the cogs of war. ¶ From the spires of King's Landing and the godswood of Winterfell to the frozen heights of the Wall and windy plains across the Narrow Sea, Elastic's thunderous cartographic flight through the Seven Kingdoms offers the uninitiated a sweeping education in all things Game of Thrones.
—Will Perkins

Angus Wall on title sequences

"You have ninety seconds with the title sequence... so why not do something that the show can't do? Title sequences can do a lot of different things, and besides taking you on a journey, this one offers a lot of information about the world you're going to see. It allowed us to really create our own little world. HBO and the creators of the show really let us run with this idea and we wanted to do something distinctive with it. We didn't want to make something that's been done before, like what you've seen in *Harry Potter* or *Lord of the Rings*. Those things are wonderful, but we wanted to do something different."

On the possibility of failure

"In terms of pressure, I think you have to tell yourself that you might fail and you might fail publicly. But you can't be afraid. You can't be afraid to start over, if you have to start over. At the beginning of every job, you're starting over. You're facing failure every time you go out. But you can't live in the place where you're saying, 'I better not try this because I might fail.' Because then you're not going to succeed either."

On the early concepts for the sequence

"In the beginning, it was very simple, nothing animating and everything very flat. One of the things we realized early on was that you couldn't really tilt the camera up very far because it raised the question, what's beyond the map? I kept thinking that if you had all the money and craftsmen in the world, and you could do whatever you wanted, what would you do? In my mind, you'd build the most intricate, beautiful map you could possibly imagine. You'd get the best craftsmen in the world, give them the materials they'd need and give them five years to make this crazy, working, super-detailed miniature."

The Pillars of the Earth

2010, Germany/Canada, 52 seconds
Director/Designer: Michal Socha
Designers: Jakub Socha, Bartłomiej Socha, Mateusz Krygier
Producer: Holly Stone
Executive Producer (main title design): Ron Diamond
Executive Producers: David A. Rosemont, Jonas Bauer, Tim Halkin, Michael Prupas, David W. Zucker, Rola Bauer, Tony Scott, Ridley Scott
Main Titles produced by Acme Filmworks, Inc.
© Tandem Productions GmbH, Pillars Productions (Muse), Inc., Pillars Productions (Ontario), Inc. All rights reserved.
Courtesy Tandem Communications

Het Klokhuis (***The Apple Core***)
2010, the Netherlands, 19 seconds
Director: Johnny Kelly
Executive Producers: Christopher O'Reilly & Charlotte Bavasso
Producer: Luke Youngman
Production Manager: Jo Bierton
Creative Development: Beccy McCray
Client: NPS
Agency: KesselsKramer
Creative Team: Christian Borstlap
Agency Producer: Pieter Leendertse
Model-maker: Jethro Haynes
3-D Printed Model Design: Ben Cowell, Matt Clark
Animators: Matthew Cooper, Tine Kluth
Runner: Xaver Böhm
Compositing: Alasdair Brotherston
Director of Photography: Matthew Day
Filmed at Clapham Road Studios
Music: Harry Bannink
Sound Design: FC Walvisch Amsterdam
Production Company: Nexus
Courtesy Nexus Productions

Quick and affordable 3-D printing technology applied to classic stop-motion animation opens Dutch science program *Het Klokhuis* (*The Apple Core*), which is Holland's oldest youth television show, covering everything from the history of dinosaurs to how an iPhone is made. It is a hybrid of handcrafted frame-by-frame animation and cleanly rendered apples with sprouting science experiments encapsulated like the seeds of an idea about to be discovered. —Alexander Ulloa

Johnny Kelly of Nexus Productions on materials
"The problem at this point was how to do justice to Christian's beautiful logo shape. We hadn't decided yet how the apples would actually be made, and discussed different materials. Something like plasticine wouldn't have the right accuracy. I had used paper before, but it wasn't very good with curvy objects like an apple. My partner Jenny is a product designer and has used 3-D printing quite a bit, and this seemed like a option that could work. This technology, which is still relatively niche, creates a physical object printed up in plastic from a 3-D computer file. It's most commonly used by industrial designers to create prototype models. The film *Coraline* used 3-D printing to create facial expressions, using individual models for each mouth shape, etc. Pixar also used it to create the models for their Zoetrope."

On integrating physical props with typography
"The end titles show what is coming up on the following episode of *Klokhuis*. Christian at KesselsKramer designed some typography for this, and suggested integrating video to show a preview clip. With some episodes, there would be three or four of these listed, other times just one, so we designed the animation sequences to be modular. You can also loop the ticking clockwork for as long or short as necessary. The agency supplied us with some placeholder text so we could show how it works. This Dutch text on the sample animation we made reads: 'Next week on *Klokhuis* … Farts … Submarines … Hip Hop'—so it covers pretty much everything you need in a TV show."

The Kingdom
2007, US/Germany, 3:49 minutes
Creative Directors: Jarik Van Sluijs, Julio Ferrario
Producer: Pamela Green
Assistant Director: Stephan Burle
Storyboards: Stephan Burle
2-D Animator: Stephan Burle
3-D Animators: Gary Hebert, Clint Chang, Greg Reynard
Compositor: Gary Hebert

Editor: Jarik Van Sluijs
Researchers: Daniela Roth, Pamela Green
Production Company (titles): Pic Agency
Courtesy Universal Pictures

Durval Discos
2002, Brazil, 4:34 minutes
Director: Anna Muylaert
Courtesy Africa Filmes

When one watches a fluid Steadicam composition, what takes place is a kind of sustenance. Filmed at Rua Teodoro Sampaio, famous in São Paulo, Brazil, for its concentration of shops selling musical instruments, the opening sequence to Anna Muylaert's film *Durval Discos* is organic in its ease as DP Jacob Solitrenick treats us to the relaxed pathology of the street. At once you figure the arrangement and mute any notion of it, allowing the credits to simply come when they come. —Alexander Ulloa

Anna Muylaert on the concept
"From the first draft of the script I had this idea of showing *Durval Discos'* environment with all the words that we have to read while walking through the city."

On the logistics of shooting the sequence
"We did a few rehearsals and shot. The first take was very good, but we decided to make a second one and that's the one on screen. And that was it. Two shots. The most beautiful thing to me about this shot is that many people on screen are not extras—just people walking on the street (exceptions: the skater, the couples kissing, the guy with the T-shirt in the game house, and our producer Maria Ionescu having coffee in the bar). Everyone else just appeared and didn't look to the camera. Their 'performances' were beautiful, like the woman we follow after the bar. These people came to the camera and disappeared forever."

169

2011
Bubbles, Lines, and String: How Information Visualization Shapes Society
Peter Hall

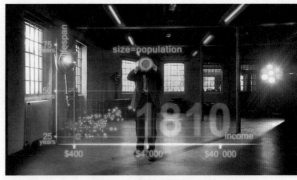

Hans Rosling, Gapminder demonstration from *The Joy of Stats*, 2010 Courtesy Wingspan Productions

Gapminder

Employing Hans Rosling's Trendanalyzer software, Gapminder was founded in Stockholm by Ola Rosling, Anna Rosling Rönnlund, and Hans Rosling in 2005. Released as the online service Gapminder World, Rosling's software uses animated bubbles to show changes over time in the wealth and health of nations. These statistics truly come to life when Rosling provides his own narration, as seen in the 2010 documentary *The Joy of Stats*. —EL

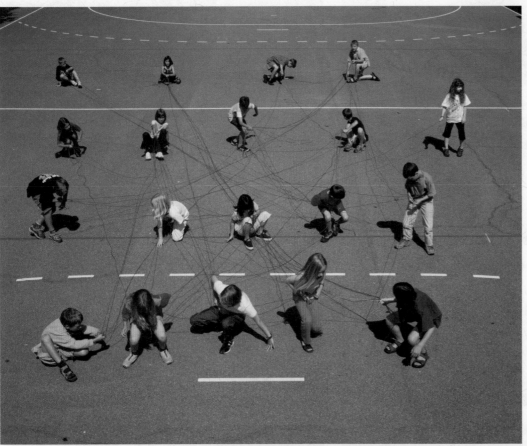

Uta Eisenreich, *Network-Teamwork Sociograms*, Langmatt School, Zürich, 2002 Courtesy the artist

Gapminder Foundation, "Wealth and Health of Nations" presentation using Trendalyzer software Courtesy gapminder.org

Martin Wattenberg and Fernanda Viégas, Chimera, a search tool that finds repetition in texts and represents them as 3-D "skyscrapers" Courtesy Martin Wattenberg

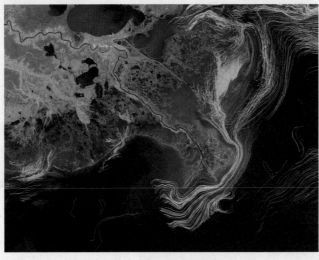

Adam Kuback and Karla Vega, TACC, UT, Austin, in collaboration with Clint Dawson, ICES, UT, Austin; Rick Luettich, UNC Chapel Hill; and Joseph Westerink, University of Notre Dame, *Visualization of the Gulf of Mexico Oil Spill*, 2010 Courtesy Karla Vega

Jacob L. Moreno, *Friendship Choices Among Fourth Graders*, 1934

Sociogram: Friendship Choices Among Fourth Graders

Jacob L. Moreno, a social scientist working in the 1930s, created simple diagrams to visualize relationships within small groups of people. This diagram shows friendships among boys (triangles) and girls (circles) in a group of fourth graders. The diagram reveals how strongly the two groups are separated by gender; only one boy crossed the divide, and not a single girl did. —EL See Linton C. Freeman, "Visualizing Social Networks," 2000

Data visualization has lately become an unlikely form of mass entertainment. When public health professor Hans Rosling first presented his giant, animated graphs of floating bubbles—challenging popular pre-conceptions about global life expectancy and family sizes—he was met with whoops and applause at the 2006 TED (Technology, Entertainment, Design) conference. [1] The video of the presentation has since attracted 2.8 million online viewers, making it the seventh most-watched TED talk in the past five years. [2] "The statistics of the world have not been made properly available," argued Rosling. "Animated graphics can make a difference." [3]

Data provides the means by which science progresses, legislation changes, and society advances; data is the enemy of witch hunts, bigotry, and ignorance (not to mention Creationism). But data is always gathered at a certain time with a certain purpose; and to be useful it must be mined, parsed, and presented. Each step of this process involves decisions about what to omit and what to prioritize. Yet the end result, the visualization, carries an authority, timelessness, and objectivity that belies its origins. Curiously, this fact is neglected in the otherwise rich discourse around data visualization and information design. Johanna Drucker has observed that information designers almost entirely ignore what she considered theoretical problems:

"An empiricist assumption that what you see is what is there underpins their practice. The self-evident character of graphic entities—lines, marks, colors, shapes—is never itself brought into question, however much the parameters on which they are generated or labeled might be criticized. That images themselves might be dialectical, produced as artifacts of exchange and emergence, is an idea foreign to the fields of engineering and information design." [4]

Scientific Practice

To explore why the critical discourse of the arts and humanities is conspicuously lacking around visualization requires that we take a meta-view of the contexts in which it is practiced. Visualization might be separated into three categories of practice. The first, and most dominant, is *scientific*. This, the domain of laboratories, supercomputers, and vast monitor arrays, enjoys the funding of the military industrial complex and a sense of societal importance. According to historian Alfred Crosby, "visualization is one of only two factors responsible for the explosive development of all modern science." [5] Computer scientist

Toby Segaran argues that "almost every field is becoming more reliant on data analysis for advancement." [6] Examples in the scientific category would include visualizations of galaxy formation, predicted weather and oil spill patterns, and simulations of electron behavior. [7] Typically deploying the terms "data" or "information visualization," scientific visualization fashions itself as a tool of discovery improved through scientific method. The implicit assumption is that the tool allows us to explore the data, without bias. Adopting industries are described by one classic textbook in the field as those driven by continuous innovation and repeated discovery: "pharmaceutical drug research, oil-gas exploration, financial analysis and manufacturing quality control." [8]

To engage in the scientific discourse around visualization requires familiarity with—if not higher degrees in—mathematics, statistics, computer science, and cognitive psychology. But even the most cursory glance at the literature reveals a positivist discourse driving questions of visual form, grounded in principles of human cognition. Is the visualization appropriate for the data? How does the visualization fare in terms of usability issues? How does the (universal) human brain respond to visualization x as opposed to visualization y? [9]

Journalistic Practice

The second category is *journalistic*. A response to the information tsunami, and driven by a moral or commercial obligation to inform or entertain, projects in this category strive to make data visible and accessible. Whereas the scientific category is characterized by large datasets and various means of discovering new patterns, the journalistic category seeks to simplify and explain those datasets. As New York Times Graphics director Steve Duenes put it: "It is our job to edit, condense and reduce." [10] Traditionally the domain of information designers whose task is to scrape, shape, and frame existing data, rather than mine and parse new data, this category has lately shifted from static forms to quite advanced interactive web-based formats that allow the public to explore data for themselves. The New York Times Graphics Department provides paradigmatic examples of journalistic information design, as made evident in its fast turnaround of maps and graphics illustrating the hurricanes, tsunamis, oil spills, and wars of the past decade. Freelance journalist and designer David McCandless, meanwhile, develops visualizations that provide a meta-layer of commentary on

other visualizations, such as his "billion dollar o-gram," which seeks to put military expenditure, oil revenue, foreign aid, and charitable donations in context through comparison. His revelation, after mining and visualizing Facebook data, that more couples split up around spring break and Christmas than other times of the year, might be described as journalistic entertainment visualization.

Rosling's Gapminder software for animating global health data began as an educational tool (to make university students use and understand statistics to acquire a "fact-based" world view), but is ultimately a journalistic means to inform and transform public opinion. "Visualization and animation services that unveil the beauty of statistics for wide user groups may induce a paradigm shift from dissemination to access," Rosling has argued. "Data provided in animation format is well suited to tell stories using television and webcasts." [11] Martin Wattenberg's search tool uses simple computation methods to find repetition in texts, which are represented as 3-D "skyscrapers" over the text body. Teaming up with journalist Chase Davis, Wattenberg set Chimera to work to find "clone laws"—legislation prewritten for elected officials by corporations or partisan groups. They found, for instance, that a law passed in Minnesota matched a law passed in Alaska exempting firearms made and sold in-state from federal regulations—"not exactly word for word but many, many passages," noted Wattenberg. [12] Googling the most distinctive passages led to a website promoting the Firearms Freedom Act, a chilling reminder that the laws of this country are not written by legislators but by special interest groups. Discussion of formal issues in this category tends to be dominated by the standards codified by authorities such as Edward Tufte, Donald Norman, and Ben Shneiderman. Examples will be familiar to any designer: Static information graphics should aspire to transparency, objectivity, and an absence of "chartjunk" (Tufte), and interactive visualization should aspire to visual consistency, informative feedback, a sense that the user is in control, and simple error handling (Shneiderman). [13]

Artistic Practice

The third category is *artistic*. Generally misunderstood by the scientific community as cosmetic or frivolous, the art of visualization nevertheless has an important cultural role, reinforced by historical precedent. Artistic visualization, much like thousands of years of art before it, reflects

Sendai
Sendai's city center, about 7 miles inland, remained largely intact after the quake, but there was massive damage along the coast. Much of the airport, which is less than a mile from the water, was also destroyed.

Iwaki area
Whole neighborhoods were in ruin and cars and debris were piled high around Iwaki.

Alan McLean, Kevin Quealy, Matthew Ericson, Archie Tse, and Jason Alvich, "Satellite Photos of Japan, Before and After the Quake and Tsunami," *New York Times*, 2011 Courtesy the *New York Times*

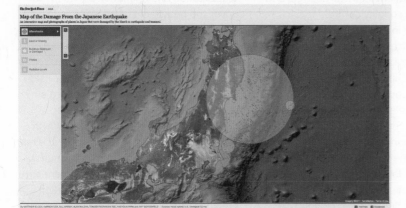

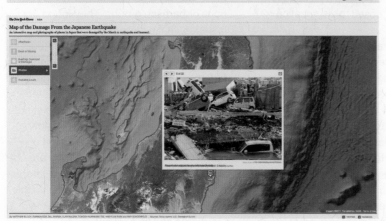

Matthew Bloch, Amanda Cox, Bill Marsh, Alan McLean, Tomoeh Murakami Tse, Haeyoun Park, and Amy Schoenfeld, "Map of the Damage From the Japanese Earthquake," *New York Times*, 2011 Courtesy the *New York Times*

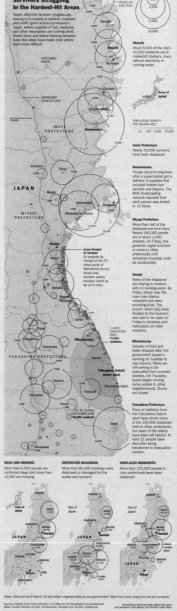

Joe Burgess, Haeyoun Park, Sergio Peçanha, Aya Sakamoto, and Archie Tse, "Japan Finds Contaminated Food Up to 90 Miles From Nuclear Sites," *New York Times*, March 20, 2011 Courtesy the *New York Times*

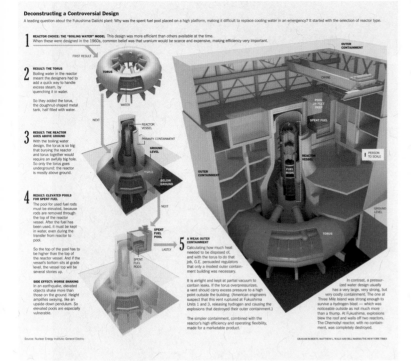

Graham Roberts, Matthew L. Wald, and Bill Marsh, "Deconstructing a Controversial Design," *New York Times*, March 20, 2011
Courtesy the *New York Times*

New York Times Graphics Department

A multi-skilled team makes up the graphics department at the *New York Times*: journalists who understand visualization as well as people trained in statistics, cartography, programming, and 3-D software. According to graphics director Steve Duenes, "We're journalists. We are drawing on the traditions of the *Times* and creating a direction on the web that employs technology to surprise and engage readers while still clarifying and explaining the world around us." While continuing to publish compelling graphics in print, the *New York Times* has led the world of online journalism by using video, animation, sound, and dynamic content. To cover the quake and tsunami that killed tens of thousands of people in Japan and disabled the Fukushima Daiichi nuclear plant in the spring of 2011, the graphics department employed maps, aerial photography, and cutaway views of the plant to help readers understand the crisis. —EL

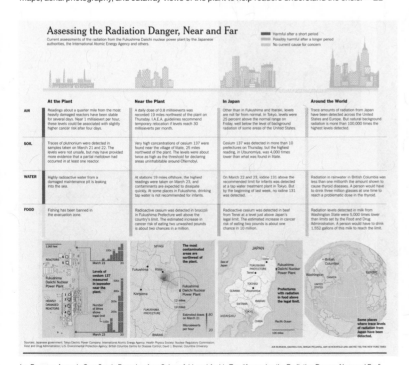

Joe Burgess, Amanda Cox, Sergio Peçanha, Amy Schoenfeld, and Archie Tse, "Assessing the Radiation Danger, Near and Far," *New York Times*, April 3, 2011 Courtesy the *New York Times*

New York Times Graphics Department, "In Japan Reactor Failings, Danger Signs Are Seen for U.S. Plants," *New York Times*, May 18, 2011 Courtesy the *New York Times*

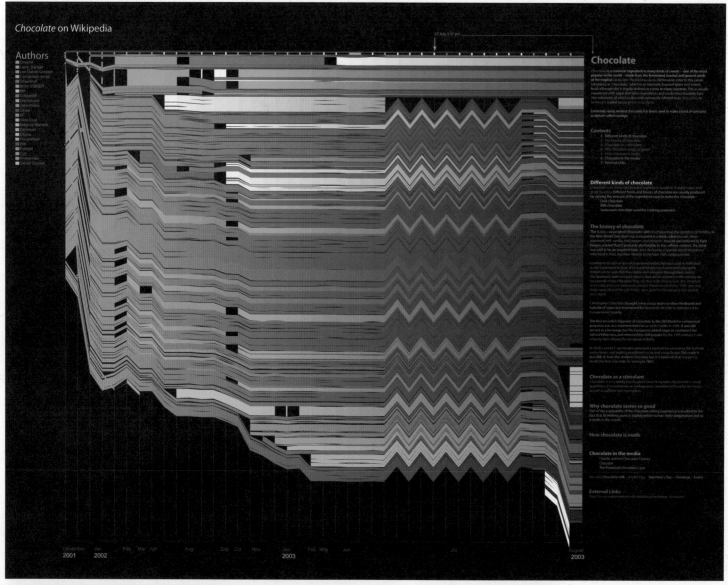

Chocolate on Wikipedia

Martin Wattenberg and Fernanda Viégas, *History Flow*, 2003 Courtesy the artists

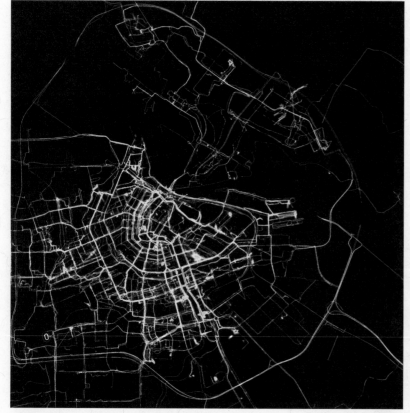

Esther Polak, Jeroen Kee en Waag Society, *AmsterdamREALTIME*, 2002 Courtesy the artists

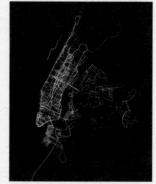

Cooper Smith, visualization of 1,000 runners' routes in Manhattan using Nike Plus, 2011
Courtesy Cooper Smith

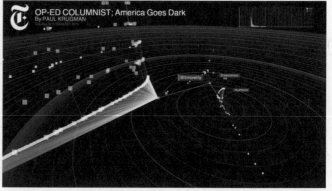

Jer Thorp, *Cascade*, 2011 Courtesy the artist and the New York Times R&D Group

on cultural conditions. Its specific subject is our current preoccupation with data, a development of what critic Benjamin Buchloh called the "aesthetics of administration" that concerned the conceptual artists of the postwar years: "the operating logic of late capitalism and its positivistic instrumentality." [14] Artistic visualization's role is to bring to light and challenge the prevailing assumptions behind the rhetoric, and to offer new, alternative modes of representation. It is the only category of the three in which form, line, and color are not evaluated solely in terms of usability issues.

Absence of Critique

Examples of visualizations from all three categories can be found on popular blogs such as *Information Aesthetics* (infosthetics .com; started by data visualization and architecture professor Andrew Vande Moere in 2004) and *Visual Complexity* (VisualComplexity.com; started by user experience designer Manuel Lima in 2005). Both sites are cheerleaders of the dazzling and richly diverse array of visualizations produced by professionals and amateurs these days, but neither carries the kind of critical discussion called for by Drucker, the "who made it, for whom, and for what purpose—ideology 101." [15] It is difficult not to see the reductivism in many of the visualizations rendering human communication as a thousand dots and veins of wispy color on black backgrounds, as if messy life had finally been conquered, sorted and re-arrayed as exquisite form.

Intricate flowerlike arrangements of frequently used terms in the *New York Times* by Jer Thorp, for example, were the first in a series of projects made by the digital artist for the newspaper's research and development lab. The question "for what purpose?" is initially difficult to answer, since zoomable interfaces of thousands of word constellations don't immediately suggest incisive analysis. Thorp's more recent Cascade project for the *Times*' R&D group, however, which tracks readers' tweets and online sharing habits with colored squares linked by thin gray lines shown through multiple alternative views, reveals a clear agenda in a promotional video. "Perhaps most importantly," asks the voice-over, "how can the *Times* use this information to expand its impact in the conversation, to maintain its position as a news and information leader?" The visualization, arguably, is less a research inquiry into the nature of information sharing than the territorial surveillance of a media battlefield.

Other projects illustrate how the formal languages of experimental artistic visual-

izations are quickly absorbed and put to work for commercial purposes. Student Cooper Smith's recent visualization of Manhattan running routes registered by 1,000 runners using the Nike Plus online synchronization service recalls the earlier, 2002 experimental project by Esther Polak to render a "live" map of Amsterdam by equipping sixty residents with GPS tracer units hooked up to a central server. Where Polak sought to describe the city as it is experienced by its residents, drawing from the anti-rationalist legacy of postwar psychogeography, Smith's well-intentioned aggregation reinforces a collusion of corporate (Nike) and military (GPS) interests: running is no longer just running, but measured, collated, and compared, tagged with personal targets and simulated rewards.

Critical Cartography

The lack of critical discourse around visualization seems all the more glaring given the critical toolkit applied to maps and cartography, which blossomed during the postwar years. An exhibition at the British Library and associated television series on the history of cartography delved into this rich vein of scholarship in 2010. [16] Behind the history of the map is what Jeremy Crampton describes as a "whole series of engagements in politics, propaganda, crime and public health, imperialist boundary-making, community activism, the nation-state, cyberspace and the Internet. That is, mapping has a politics." [17] That thematic maps—the precursors of infoviz—and statistics emerged in the early nineteenth century as "technologies of management" is no coincidence. Political systems, legislation, and the core of our cultural values are all integrated with these technologies. Rather than simply describe a preexisting world, these technologies, in their methods of framing, selecting, and predicting, *make up* a world. [18]

The cartographic scholar J. B. Harley famously noted that the key to decoding a map was to look for its "silences"—maps "exert a social influence through their omissions as much as by the features they depict and emphasize." [19] In the same way, today's network maps and maps of Internet activity reveal their territorial imperatives through what is left out. Maps of the Internet coming from computer research labs in the late 1990s, for example, were frequently shown with a blank backdrop as if to suggest that the network were somehow detached from real space, perhaps adrift in a vast terra incognita of potential security breaches or, alternately, lands yet to be wired. [20] A diagram of

"subject matter experts," produced by management consultant and network analyst Valdis Krebs in 2008, is meant to help us identify the fragile nodes in a company's knowledge domain. It depicts people as colored boxes connected by lines: they are connected if one goes to the other for expertise or advice, and those with many arrows pointing to them are sought out often for assistance. The nodes are colored by their potential to leave/exit the organization. Conspicuously "silent" in the diagram are assumptions about the rate of transfer of knowledge around a network and the working atmosphere. Obviously, a work environment in which people share knowledge freely in pursuit of a shared goal will lessen the impact of a key figure (the "border router") departing the network, compared with an environment in which long-entrenched employees harbor their knowledge as a form of power. The missing information from Krebs' map may ultimately provide the key to the functioning of the network, to the extent that a map of the mood of the network may be more useful. [21]

An alternative *artistic* network map brings such absences to light. Artist Uta Eisenreich's "Teamwork Sociogram," produced with children at Langmatt School in Zürich, takes the form of a series of photographs of the children in the schoolyard, linked to each other by pieces of colored string. Red strings, for example, were linked by the students in response to the question: If you were allowed to invite three classmates to your birthday party, who would they be? The effect of the photographic series is to reveal not the breadth or security of a network, but its fragility; to remind us that the nodes on a network diagram are not uniform squares but people; to hint that, in analyzing a network, it is the node that knows how it is connected. The project references the content of the 1930s social network maps of psychiatrist Jacob Moreno, which sought to identify the structure of groups based on affections rather than roles. [22] But whereas Moreno's and Krebs' diagrams are highly abstracted nodes and lines, Eisenreich's network map is photographic, connoting the ephemeral nature of social ties, and indeed, network maps.

Recent scholarship has demonstrated that our conventions for representing the passage of time are inextricably tangled with a post-eighteenth-century view of time as a sequential line. [23] Temporality is a big problem for the network map; the authority of the line-and-node diagram implicitly suggests that the network depicted is fixed in time. As one group of sociologists has

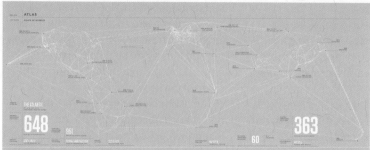

Nicholas Felton, *2010 Feltron Annual Report*, 2011 Courtesy the artist

Ryan Case and Nicholas Felton, Daytum, 2008 Courtesy Daytum

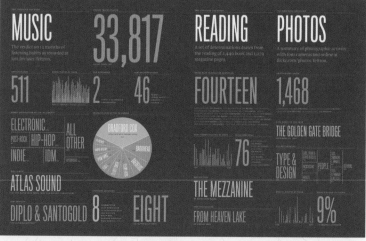

Nicholas Felton, *2008 Feltron Annual Report*, 2009 Courtesy the artist

Archeology of Ourselves

Nicholas Felton began producing annual reports about various activities he had engaged in over the previous year in 2005, which he published under the moniker "Feltron" in the form of a printed annual report. Beginning with such data as the number of songs listened to, miles flown, books read, restaurant visited, types of foods eaten, and so on, he began to form a composite portrait of his life, expressed in various charts and graphs of his design. Felton's project recalls the work of Charles Madge, Tom Harrison, and Humphrey Jennings, who created Mass-Observation in 1930s Britain that used observers to record the everyday behaviors of average citizens. Unlike Madge and Harrison's third-party reportage, Felton typically relies instead on self-recording, reporting, and interpretation of data. In 2008, he developed Daytum with Ryan Case, a website and software application that helps you track your personal data more easily. In 2009, he asked acquaintances to complete surveys about him that formed the 51,445-word data set that begat that year's report. In 2010, he conducted an investigative project not about himself but his father's extensive travels over the course of his life, which Felton reconstructed using passports, photos, calendars, receipts, and correspondence. Through his *Annual Reports*, Felton has expanded Madge and Harrison's concept of an "archeology of ourselves," giving it graphic form and obsessive detail. —AB

Cultural Analytics

Coined by media theorist Lev Manovich in 2007, the concept of cultural analytics can be seen as the consequence of ever-increasing computational power to manipulate enormous amounts of data in real time, the ability of advanced visual interfaces to explore these datasets, and the desire of researchers to explore such resources in new ways. No longer limited to advanced scientific research, such tools and methods can be applied to areas of social and cultural interest forming the arena of digital humanities. As Manovich and his team at the University of California, San Diego, relate: "New super-visualization technologies specifically designed for research purposes allow interactive exploration of massive media collections which may contain tens of thousands of hours of video and millions of still images. Researchers can quickly generate new questions and hypotheses and immediately test them. This means that researchers can quickly explore many research questions within a fraction of the time previously needed to ask just one question. ¶ Computational analysis and visualization of large cultural data sets allow the detailed analysis of gradual historical patterns that may only manifest themselves over tens of thousands of artifacts created over a number of years. Rather than describing the history of any media collection in terms of discrete parts (years, decades, periods, etc.), we can begin to see it as a set of curves, each showing how a particular dimension of form, content, and reception changes over time. In a similar fashion, we can supplement existing data classification with new categories that group together artifacts which share some common characteristics. For instance, rather than only dividing television news programs according to producers, air dates and times, or ratings, we can generate many new programs clusters based on patterns in rhetorical strategies, semantics, and visual form. In another example, we can analyze millions of examples of contemporary graphic design, web design, motion graphics, experience design, and other recently developed cultural fields to create their maps, which would reveal if they have any stylistic and content clusters." —AB See "Cultural Analytics," *Software Studies Initiative* blog, lab.softwarestudies.com, 2011

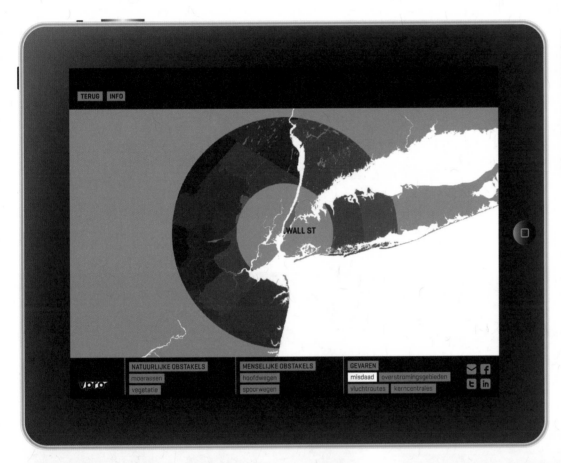

The Flash Crash

May 6, 2010, at 2:42 pm the Dow Jones Industrial Average began to plunge more than 300 points with another 600 point drop in the next five minutes, loosing nearly a 1,000 points. By 3:07 pm, the market had regained most of the loss. It was the second largest point swing—1,010.14 points—and the biggest one-day point decline—998.5 points—on an intraday basis in Dow Jones Industrial Average history. The cause of the crash, according to a Securities and Exchange Commission (SEC) report of the incident, was the ill-timed use of automated trading algorithms from one particular firm. Others have remarked that this trade was merely the trigger of the crash, and that the underlying causes of the use of such superfast transactions and the lack of marketplace safeguards were not addressed. VPRO, the Dutch television company, produced a documentary by Marije Meerman entitled *Money & Speed: Inside the Black Box* to explain what happened that day. The companion TouchDoc app for devices such as the iPad was designed by Catalogtree and merges their information graphics and data visualizations with cinematic storytelling to create a compelling hybrid of the immersive and the analytical. —AB

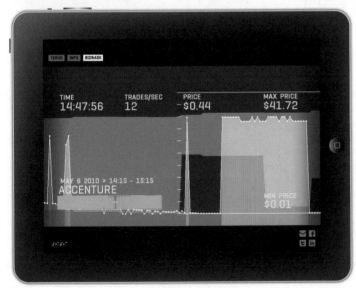

Daniel Gross and Joris Maltha in collaboration with Marije Meerman, Lutz Issler, and Jorn van Dijk, *Money & Speed: Inside the Black Box*, 2011 Courtesy Catalogtree

Video Scribing

Sir Ken Robinson's lecture, "Changing Educational Paradigms," is one of many such talks by leading thinkers that take place at the RSA in London, whose formal name is the Royal Society for the Encouragement of Arts, Manufactures and Commerce. The RSA is an organization dedicated to shaping thinking and action around issues of social progress. It began working with the firm Cognitive Media to transform these lectures into animated videos using whiteboards and markers, and in the process conceived of a new area of media practice called video scribing. As the name suggests, a visual transcription of a talk is created using animated illustrations that follow the actual lecture soundtrack. Video scribing is a combination of hand-drawn illustrations, stop-motion animation, videography, and sound editing. A result of talented artists and technicians, the RSA Animate video treatment has proven to be an extremely popular and engaging form that merges entertainment and education, delight and information. —AB

Cognitive Media, *RSA Animate: Changing Educational Paradigms*, 2010 Courtesy RSA

Justin Manor, John Rothenberg, and Eric Gunther, *Set Top Box*, 2010 Courtesy Sosolimited

Set Top Box

The Boston-based design and technology studio Sosolimited has turned automated reading into an art form. Their project *Set Top Box* filters real-time television programs into dynamic typographic animations, generated on the fly in response to the closed-caption transcript. Custom software combs through the text for emotional and thematic content, transforming the verbal soundtrack into a multilayer audiovisual concoction. According to Sosolimited, "The effect is a floating typographic life form—fed by, performed by, and eternally making sense of, the television." —EL

Justin Manor, John Rothenberg, and Eric Gunther, *Set Top Box*, 2010 Courtesy Sosolimited

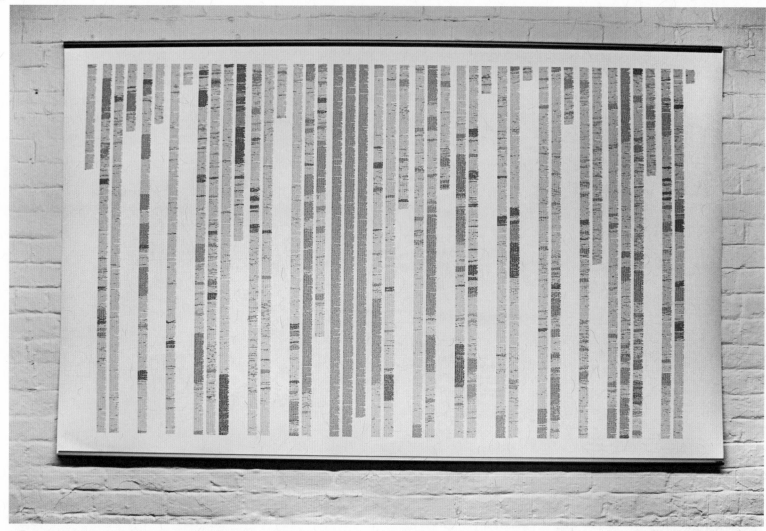

Ben Fry, *On the Origin of Species: The Preservation of Favoured Traces*, 2009 Photo: James Brady Courtesy the artist

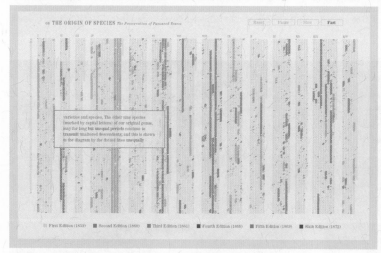

Ben Fry, *On the Origin of Species: The Preservation of Favoured Traces*, 2009 Courtesy the artist

On the Origin of Species: The Preservation of Favoured Traces

We often think of scientific ideas, such as Darwin's theory of evolution, as fixed notions that are accepted as finished. In fact, Darwin's *On the Origin of Species* evolved over the course of several editions he wrote, edited, and updated during his lifetime. The first English edition was approximately 150,000 words and the sixth is a much larger 190,000 words. In the changes are refinements and shifts in ideas—whether increasing the weight of a statement, adding details, or even a change in the idea itself. The second edition, for instance, adds a notable "by the Creator" to the closing paragraph, giving greater attribution to a higher power. In another example, the phrase "survival of the fittest"—usually considered central to the theory and often attributed to Darwin—instead came from British philosopher Herbert Spencer, and didn't appear until the fifth edition of the text. Using the six editions as a guide, we can see the unfolding and clarification of Darwin's ideas as he sought to further develop his theory during his lifetime. This project is made possible by the hard work of Dr. John van Wyhe, et al., who run *The Complete Work of Charles Darwin Online*. The text for each edition was sourced from their careful transcription of Darwin's books, and Dr. van Wyhe generously granted permission to use the text. This piece is a simpler version of a larger effort that looks at the changes between editions, and is intended as the first in a series looking at how the book evolved over time. —Ben Fry, benfry.com/traces/, 2009

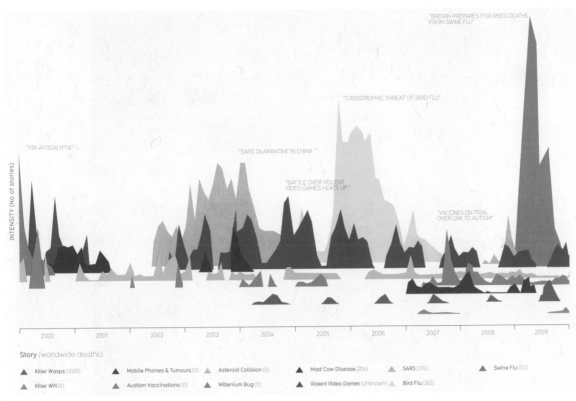

"BRITAIN PREPARES FOR 65000 DEATHS FROM SWINE FLU"

"CATASTROPHIC THREAT" OF BIRD FLU"

"Y2K APOCALYPSE"

"SARS QUARANTINE IN CHINA "

"BATTLE OVER VIOLENT VIDEO GAMES HEATS UP "

"VACCINES ON TRIAL OVER LINK TO AUTISM"

INTENSITY (No of stories)

2000 2001 2002 2003 2004 2005 2006 2007 2008 2009

Story (worldwide deaths)

Killer Wasps (1000) Mobile Phones & Tumours (0) Asteroid Collision (0) Mad Cow Disease (204) SARS (774) Swine Flu(702)

Killer Wifi (0) Austism Vaccinations (0) Millenium Bug (0) Violent Video Games (Unknown) Bird Flu (262)

David McCandless, *Mountains Out of Molehills: A Timeline of Global Media Scare Stories*, 2009 Courtesy the artist

Visual Journalism

In their 2001 textbook *Visual Journalism: A Guide for New Media Professionals*, Christopher Harris and Paul Martin Lester defined visual journalism as a term that "expands the professions of photojournalism, reporting, writing, and graphic design." As the news industry seeks to make the most of new technologies, many colleges and universities have started offering coursework or degrees in visual journalism. Information graphics are an important component of visual journalism, along with video and still photography. The visual journalist doesn't merely visualize a body of data, however, but builds a compelling story around it. —EL

The Billion Dollar-o-Gram

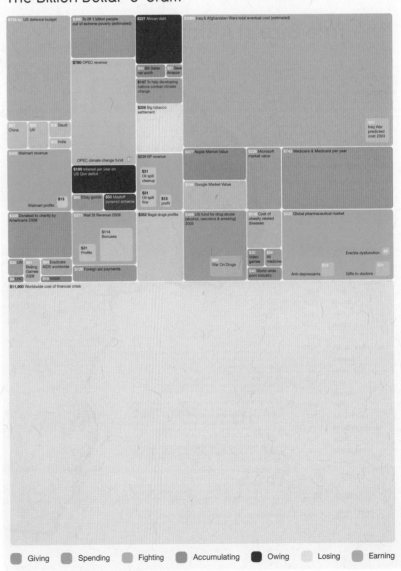

Giving Spending Fighting Accumulating Owing Losing Earning

David McCandless, *Billion Dollar-o-Gram*, 2009 Courtesy the artist

Six Rules of Infographics

1. An infographic is, by definition, a visual display of facts and data. Therefore, no infographic can be produced in the absence of reliable information. **2.** No infographic should include elements that are not based on known facts and available evidence. **3.** No infographic should be presented as being factual when it is fictional or based on unverified assumptions. **4.** No infographic should be published without crediting its source(s) of information. **5.** Information graphics professionals should refuse to produce any visual presentation that includes imaginary components designed to make it more "appealing" or "spectacular." Editors must refrain from asking for graphics that don't stick to available evidence. **6.** Infographics are neither illustrations nor "art." Infographics are visual journalism and must be governed by the same ethical standards that apply to other areas of the profession. —*Neiman Watchdog*, Harvard University, published following the assassination of Osama Bin Laden and the worldwide visual media frenzy it inspired, www.niemanwatchdog.org, 2011

Raleigh Dymaxion Map

Buckminster Fuller produced his *Raleigh Dymaxion Map* in 1954 while in North Carolina and teaching at NC State University. Fuller sought to portray all of the major landmasses of the Earth without dividing them and to lessen the kinds of gross distortions to a continent's relative size and shape—for instance Greenland and Africa—that afflicted other planar maps. Although his goal was to produce an equal area map, Fuller did not know exactly how to achieve this elusive objective and lacked today's sophisticated cartographic software tools. Working with cartographer Shoji Sadao, Fuller mapped the sphere of the Earth onto twenty equilateral triangles. The color of landmasses and the shading of the oceans reflect mean low temperatures. The *Raleigh Dymaxion Map*, while imperfect, is a remarkable achievement that fulfilled the basic premise of Fuller's desire to communicate the fact that "there are many ways to see the world." —AB

U.S. Geological Survey National Center for Earth Resource and Observation Science (EROS), Bolivian Deforestation, August 1, 2000
Courtesy National Center for EROS and NASA Landsat Project Science Office

Picturing Bolivian Deforestation
Once a vast carpet of healthy vegetation and virgin forest, the Amazon rainforest is changing rapidly. This image of Bolivia shows dramatic deforestation in the Amazon Basin. Loggers have cut long paths into the forest, while ranchers have cleared large blocks for their herds. Fanning out from these clear-cut areas are settlements built in radial arrangements of fields and farms. Healthy vegetation appears bright red in this image. This deforestation can be found on Landsat 7 WRS Path 230 Row 72, center: -17.35, -62.18.
—NASA, *Our Earth As Art*, 2005, earthasart.gsfc.nasa.gov/bolivian.html

The **True Size** of **Africa**

A small contribution in the fight against rampant *Immappancy*, by Kai Krause

In addition to the well known social issues of *illiteracy* and *innumeracy*, there also should be such a concept as *"immappancy"*, meaning *insufficient geographical knowledge*.

A survey with random American schoolkids let them guess the population and land area of their country. Not entirely unexpected, but still rather unsettling, the majority chose *"1-2 billion"* and *"largest in the world"*, respectively. Even with Asian and European college students, geographical estimates were often off by factors of *2-3*. This is partly due to the highly distorted nature of the predominantly used mapping projections (such as *Mercator*).

A particularly extreme example is the worldwide misjudgement of the true size of Africa. This single image tries to embody the massive scale, which is larger than the *USA, China, India, Japan* and *all of Europe - combined!*

COUNTRY	AREA x 1000 km²
USA	9.629
China	9.573
India	3.287
Mexico	1.964
Peru	1.285
France	633
Spain	506
Papua New Guinea	462
Sweden	441
Japan	378
Germany	357
Norway	324
Italy	301
New Zealand	270
United Kingdom	243
Nepal	147
Bangladesh	144
Greece	132
TOTAL	**30.102**
AFRICA	**30.221**
Just for Reference: The Surface of the MOON	37.930

Please note:

The graphical layout of this map is meant purely as a *visualization* to illustrate the fact: Africa is *much* larger than *almost everyone* assumes!

Even totally blurred outlines could have been used to make that point, however the table at left is very accurate, citing:
http://en.wikipedia.org/wiki/List_of_countries_and_outlying_territories_by_total_area

Note for instance that the figure in the table for the USA *does* include Alaska and Hawaii, but they *are not even used* in the map, as are a handful of other entries (such as Norway and Sweden).

The reason for this is that the map purposely uses the familiar shapes, as if you are 'moving pieces in Google Maps'. Because the mathematically exact depiction, using equal area scaling, would be *even more* drastic, but would appear highly distorted. I chose to retain the commonly known outlines and proportions to tell the story, even if this conservative size has 'left-over parts'.

The small maps on the right are again the singular message: see some of the countries in direct relation to Africa, a view that is quite unfamiliar and rarely seen.

It is worth looking at *Bucky Fullers* maps or the *Peters* equal area proposals, among many other beautiful attempts to display geographical information. Numerous other side-by-side comparisons have been made, this is by far not the first and hopefully *not the last* such map: someone should find the best fit of all puzzle pieces in a neutral projection.

Until then, please do not take it all *too literal* ('where is Ibiza??') and simply take that one impression with you: Africa.... is immense.

Kai Krause, *The True Size of Africa*, 2010

Top 100 Countries

Area in square kilometers, Percentage of World Total
Sources: Britannica, Wikipedia, Almanac 2010

#	Country	AREA km²	%
1	Russia	17.098.242	11,50
2	Canada	9.984.670	6,70
3	China	9.596.961	6,40
4	United States	9.629.091	6,40
5	Brazil	8.514.877	5,70
6	Australia	7.692.024	5,20
7	India	3.287.263	2,30
8	Argentina	2.780.400	2,00
9	Kazakhstan	2.724.900	1,80
10	Sudan	2.505.813	1,70
11	Algeria	2.381.741	1,60
12	Congo	2.344.858	1,60
13	Greenland	2.166.086	1,50
14	Saudi Arabia	2.149.690	1,40
15	Mexico	1.964.375	1,30
16	Indonesia	1.860.360	1,20
17	Libya	1.759.540	1,20
18	Iran	1.628.750	1,10
19	Mongolia	1.564.100	1,10
20	Peru	1.285.216	0,86
21	Chad	1.284.000	0,86
22	Niger	1.267.000	0,85
23	Angola	1.246.700	0,85
24	Mali	1.240.192	0,83
25	South Africa	1.221.037	0,82
26	Colombia	1.141.748	0,76
27	Ethiopia	1.104.300	0,74
28	Bolivia	1.098.581	0,74
29	Mauritania	1.025.520	0,69
30	Egypt	1.002.000	0,67
31	Tanzania	945.087	0,63
32	Nigeria	923.768	0,63
33	Venezuela	912.050	0,61
34	Namibia	824.116	0,55
35	Mozambique	801.590	0,54
36	Pakistan	796.095	0,53
37	Turkey	783.562	0,53
38	Chile	756.102	0,51
39	Zambia	752.612	0,51
40	Myanmar	676.578	0,46
41	Afghanistan	652.090	0,44
42	Somalia	637.657	0,43
43	France	632.834	0,43
44	C. African Rep	622.984	0,42
45	Ukraine	603.500	0,41
46	Madagascar	587.041	0,39
47	Botswana	582.000	0,39
48	Kenya	580.367	0,39
49	Yemen	527.968	0,35
50	Thailand	513.120	0,34
51	Spain	505.992	0,34
52	Turkmenistan	488.100	0,33
53	Cameroon	475.442	0,32
54	Papua New Guinea	462.840	0,31
55	Uzbekistan	447.400	0,30
56	Morocco	446.550	0,30
57	Sweden	441.370	0,30
58	Iraq	438.317	0,29
59	Paraguay	406.752	0,27
60	Zimbabwe	390.757	0,26
61	Japan	377.930	0,25
62	Germany	357.114	0,24
63	Rep o.t. Congo	342.000	0,23
64	Finland	338.419	0,23
65	Vietnam	331.212	0,22
66	Malaysia	330.803	0,22
67	Norway	323.802	0,22
68	Côte d'Ivoire	322.463	0,22
69	Poland	312.685	0,22
70	Oman	309.500	0,21
71	Italy	301.336	0,20
72	Philippines	300.000	0,20
73	Burkina Faso	274.222	0,18
74	New Zealand	270.467	0,18
75	Gabon	267.668	0,18
76	Western Sahara	266.000	0,18
77	Ecuador	256.369	0,20
78	Guinea	245.857	0,17
79	United Kingdom	242.900	0,16
80	Uganda	241.038	0,16
81	Ghana	238.539	0,16
82	Romania	238.391	0,16
83	Laos	236.800	0,16
84	Guyana	214.969	0,14
85	Belarus	207.600	0,14
86	Kyrgyzstan	199.951	0,13
87	Senegal	196.722	0,13
88	Syria	185.180	0,12
89	Cambodia	181.035	0,12
90	Uruguay	176.215	0,12
91	Suriname	163.820	0,11
92	Tunisia	163.610	0,11
93	Nepal	147.181	0,10
94	Bangladesh	143.998	0,10
95	Tajikistan	143.100	0,10
96	Greece	131.957	0,09
97	Nicaragua	130.373	0,09
98	North Korea	120.538	0,08
99	Malawi	118.484	0,08
100	Eritrea	117.600	0,08
	TOP 100 TOTAL	**132.632.524**	**89,34**

(map labels: NETHERLANDS, BELGIUM, FRANCE, SPAIN, PORTUGAL, GERMANY, ITALY, SWITZERLAND, UNITED STATES, EASTERN EUROPE, INDIA, INDIA PART 2, CHINA, CHINA PART 2, UK, JAPAN)

(small reference maps: United States, Europe, India, Japan, China)

1
Wie oft masturbierst du im Monat? (79% aller Befragten geben an zu masturbieren.)

22%
19%
18%
8%
4%
7%
7%

33
Wo rasierst du dich? (84% aller Befragten rasieren sich regelmäßig, 79% der Männer, 90% der Frauen.)

37%
Intimbereich teils (Männer: 39 %, Frauen: 34 %)

96%
Gesicht
(nur Männer befragt)

59%
Intimbereich ganz (Männer: 50 %, Frauen: 67 %)

93%
Beine
(nur Frauen befragt)

34%
Arme
(nur Frauen befragt)

13
Mit wie vielen Menschen hast du schon geschlafen?

5%	0
10%	1
17%	2 bis 3
14%	4 bis 5
21%	6 bis 10
10%	11 bis 15
6%	16–20
4%	21–30
5%	über 30

22
Hast du schon mal für Sex bezahlt?

1% 17%

2
Wie würdest du deine sexuelle Orientierung beschreiben?

3%
bisexuell

1%
nichts davon

2%
homosexuell, aber mit Heteroerfahrung (Männer: 1%, Frauen: 2%)

7%
heterosexuell, aber mit Homoerfahrung (Männer: 5%, Frauen: 10%)

83%
heterosexuell
(Männer: 87%, Frauen: 78%)

3%
homosexuell
(Männer: 4%, Frauen: 1%)

34
Wie oft im Monat schaust du pornografische Seiten im Internet an? (49% aller Befragten tun dies, 71% der Männer und 26% der Frauen.)

1 bis 3 Mal	4 bis 5 Mal	6 bis 10 Mal	11 bis 20 Mal	21 bis 30 Mal	über 30 Mal
37%	17%	15%	9%	6%	2%
Männer 28%	Männer 17%	Männer 19%	Männer 12%	Männer 7%	Männer 2%
Frauen 63%	Frauen 17%	Frauen 3%	Frauen 3%	Frauen 2%	Frauen 0%

Sarah Illenberger, "The Great Sex Survey," *Neon Magazine*, 2008 Courtesy the artist

Chartjunk

Coined by Edward Tufte in his book *The Visual Display of Quantitative Information* (1983), the term "chartjunk" refers to unnecessary visual elements used in information graphics that distract the viewer from understanding the underlying data being presented. Examples of chartjunk include extraneous images and illustrations, use of ornaments and typography that call too much attention to themselves, superfluous use of color and gradients, competing visual weight of lines and borders, etc. Arguing for a less-is-more approach, Tufte describes the offending phenomena: "The interior decoration of graphics generates a lot of ink that does not tell the viewer anything new. The purpose of decoration varies—to make the graphic appear more scientific and precise, to enliven the display, to give the designer an opportunity to exercise artistic skills. Regardless of its cause, it is all non-data-ink or redundant data-ink, and it is often chartjunk." Tufte's argument seemed directed at the kind of information graphics being used in *USA Today*, introduced just a year earlier and which featured snapshot surveys of various topical subjects rendered with eye-grabbing illustrations accompanying bar charts and graphs. More recently, researchers at the University of Saskatchewan compared the embellished graphics of Nigel Holmes with the same data set expressed in minimalist terms and concluded: "We found that people's accuracy in describing the embellished charts was no worse than for plain charts, and that their recall after a two-to-three-week gap was significantly better. In addition, participants preferred the embellished charts. Although we are cautious about proposing specific design recommendations, it seems clear that there is more to be learned about the effects of different types of visual embellishment in charts. Our results question some of the premises of the minimalist approach to chart design, and raise issues for designers about how charts are designed and used in different publications and different contexts." —AB See Scott Bateman, et al., "Useful Junk? The Effects of Visual Embellishment on Comprehension and Memorability of Charts," 2010

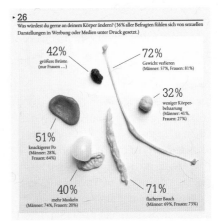

26
Was würdest du gerne an deinem Körper ändern? (36% aller Befragten fühlen sich von sexuellen Darstellungen in Werbung oder Medien unter Druck gesetzt.)

42%
größere Brüste
(nur Frauen …)

72%
Gewicht verlieren
(Männer: 57%, Frauen: 81%)

32%
weniger Körperbehaarung
(Männer: 41%, Frauen: 27%)

51%
knackigerer Po
(Männer: 28%, Frauen: 64%)

40%
mehr Muskeln
(Männer: 74%, Frauen: 20%)

71%
flacherer Bauch
(Männer: 69%, Frauen: 73%)

183

noted: "Most network images do a poor job of representing *change* in networks, and researchers make do by presenting successive snapshots of the network over time.... The problem is fundamental to the media. To effectively display the relational structure of a social network, at least two dimensions are needed to represent proximity, and that leaves no effective space (on a printed page) to represent time." [24]

The problem might seem to be solvable with the help of interactive or animated visualizations that show the ebbs and flows of a network. This is to miss the point, however, that *every* visualization, be it a fixed frame or selected frames from a given period, is a construction of time produced from a particular viewpoint. Drucker and Bethany Nowviskie's explorations with students at the University of Virginia's SpecLab include experiments at representing time as experiential rather than "unidirectional, homogenous, continuous—none of those things are true in humanistic experience." [25] Europe is mapped according to the difficulty of getting from place to place, a train journey is mapped according to perceived time between stations, and days are mapped according to heavy events and levels of anxiety. The goal is to achieve an "affective" mode of representation, and in so doing, "question fundamental assumptions about how we know what we know."

Situated Visualization

In summary, the critical function of artistic visualization is to call into question the claims of transparency, certainty, and objectivity embedded in the Cartesian language of the genre. It is to insist on the *situatedness* of the observer and the phenomenon being observed. Projects as seemingly innocuous as Nicholas Felton's "personal annual reports," named for an imaginary organization named Feltron, work at this level by impeccably parodying the visual and textual language of the corporate annual report—while conveying elements of the modern-day lifestreamer's narcissism. The 2005 Feltron report quantifies in statistical charts everything from kinds of meals eaten, photographs taken per country visit, and the amount of time spent at work and play by its author. [26]

When the situatedness of a visualization is reinforced, it can be scrutinized as a work of rhetoric, a "matter of concern" rather than a "matter of fact." [27] The "scribing" visualizations of UK-based group Cognitive Media do exactly this by eschewing the tenets of Tufte to achieve a subjective visual means of annotating ideas as they emerge in conference presentations

and workshops. Cognitive Media's charming, intriguing marker pen-on-whiteboard drawings, notably of scholars Jeremy Rifkin and Philip Zimbardo, draw attention to a rhetorical aspect of the public presentation that has suffered considerably in the PowerPoint age: that the persuasiveness of a presentation is due not entirely to its logical strength, but also to its emotional appeal and the character of the speaker—in classical terms, not only its logos but its pathos and ethos. [28] If Cognitive Media's informative and visually rich graphics do convey a rich and situated representation of the information as delivered by a particular speaker, then are they not a better paradigm than, say, a flow chart, geometric mind map, rectilinear graph, or table versions of the same information?

Situatedness and contingency are certainly not alien to the language of visualization. Arguably, the sheer fecundity of the field is beginning to shift the ground away from the fixed, objective, atemporal, and totalized visual rhetoric. In visualizing the extensive changes made to Darwin's *Origin of Species* during the course of its publication through six editions, for example, Ben Fry unsettles the idea that scientific notions appear as fixed ideas. [29] In visualizing the changes to specific entries in *Wikipedia*, Wattenberg and Fernanda Viégas zoom in on the disputes and controversies that surround topics that might otherwise seem long since settled. An encyclopedia page becomes a contested territory. [30]

The unaddressed question so far in this discussion is the role of graphic designers in this vast, flourishing field. Clearly designers are at work in all three categories of visualization outlined above, but in increasingly collaborative environments. Traditionally, the designer might produce static graphics, or come in to clean up dynamic visualizations once the hard-core statistical, analytical work and programming were complete. But increasingly, there are designers with programming skills and mathematicians with design skills making inroads into each other's professions. The web-enabled availability of data sources, notably from governments and nongovernmental organizations aspiring to transparency, and the proliferation of free visualization tools and forums—from Many Eyes (visualization platform spawned at IBM) to Gephi (a Paris-based open source consortium)—has brought host of practitioners to the field, designers among them. [31]

Visualization depends increasingly on a cadre of interdisciplinary skills. Fry, codeveloper of the ubiquitous Processing

open source programming environment, recently argued at a conference that the typical process of scientists throwing the parsed, filtered, mined data "over the wall" to the graphic and interaction designers is "a terrible way of doing things." As a designer capable of building dynamic visualizations and participating at the data-mining and parsing stage, Fry finds that "the way the interaction works is going to affect how you do the data-mining portion. You can't really separate these things." [32]

At MIT's Humanities + Digital Visual Interpretations conference in 2010, Wattenberg, a trained mathematician who codeveloped the Many Eyes visualization platform at IBM, argued that the visualization explosion has had a curious effect on visual literacy. It now takes two forms, he argued: reading and creating. Reading is "not in bad shape," he claimed, but knowing whether a line chart, pie chart, or a bar chart is the suitable form for the visualization you are trying to make requires a certain amount of expertise. "One of the things I'm hoping is that people can teach each other, that was one of the hopes for Many Eyes."

Visual literacy, however, is not the only skill required for navigating the deluge of data. The list of facets underemphasized or ignored in the dominant language of visualization is long enough to present a worthy challenge to any research group. The perplexing part is that while the art and critical design world has been riffing off the yawning gaps in the infoviz view of existence, the mainstream practice continues to deploy a visual rhetoric that treats data as pure and judges questions of visual form only in terms of a universalist idea of usability. This seems all the more curious when one considers that the art of typography has long since passed through the perceived crisis that clarity of communication would be lost with the loss of the appearance of objectivity.

For visualization to fully mature requires a better cross-fertilization between the three contexts of visualization practice. The journalistic practice of making data accessible and legible has much to teach the sciences; the forms and critiques of artistic practices can inform, question, and reinvigorate the scientific and journalistic ends of the spectrum; and scientific visualization can provide the journalistic and artistic practices some fundamental lessons in rigor. ⊠

Notes

1. Hans Rosling, "Hans Rosling Shows the Best Stats You've Ever Seen" (presentation at the TED Conference, February 2006), accessed July 8, 2011, http://www.ted.com/talks/hans_rosling_shows_the_

best_stats_you_ve_ever_seen.html.

2. *TED* blog, June 27, 2011, http://blog.ted.com/2011/06/27/the-20-most-watched-tedtalks-so-far/.

3. Hans Rosling, "Hans Rosling's New Insights on Poverty" (presentation at the TED Conference, March 2007), accessed July 13, 2011, http://www.ted.com/talks/hans_rosling_reveals_new_insights_on_poverty.html.

4. Johanna Drucker, *SpecLab: Digital Aesthetics and Projects in Speculative Computing* (Chicago: University of Chicago Press, 2009), 73.

5. Linton Freeman, "Visualizing Social Networks," *Journal of Social Structure* 1 (2000), http://www.cmu.edu/joss/content/articles/volume1/Freeman.html.

6. Toby Segaran and Jeff Hammerbacher, *Beautiful Data: The Stories Behind Elegant Data Solutions* (Sebastopol, CA: O'Reilly Media, 2009), 348.

7. See, for example, feature stories of projects developed at the Texas Advanced Computer Center, University of Texas at Austin, accessed July 15, 2011, http://www.tacc.utexas.edu/news/feature-stories/.

8. Benjamin B. Bederson and Ben Shneiderman, *The Craft of Information Visualization: Readings and Reflections* (Burlington, MA: Elsevier, 2003), xix.

9. See, for example, the work of Jarke Van Wijk, Colin Ware, Ben Shneiderman, and Stuart Card.

10. Gestalten.tv, *All the News That's Fit to Post* (documentary video podcast about the New York Times Graphics Department), accessed July 18, 2011, http://www.gestalten.com/motion/new-york-times and http://infosthetics.com/archives/2010/08/how_the_new_york_times_creates_its_infographics.html#extended.

11. Hans Rosling, "Visual Technology Unveils the Beauty of Statistics and Swaps Policy from Dissemination to Access," *Statistical Journal of the IAOS* 24 (2007): 103–104.

12. Martin Wattenberg, "Numbers, Words and Colors" (presentation at the MIT HyperStudio Humanities + Digital Visual Interpretation conference, Cambridge, MA, May 20, 2010), accessed July 4, 2011, http://flowingdata.com/2010/08/11/martin-wattenberg-talks-data-and-visualization/.

13. Ben Shneiderman, *Designing the User Interface: Strategies for Effective Human-Computer Interaction* (Boston: Addison-Wesley, 2010). See also Shneiderman's "Eight Golden Rules of Interface Design," accessed July 13, 2011, http://faculty.washington.edu/jtenenbg/courses/360/f04/sessions/schneidermanGoldenRules.html.

14. Quoted in Warren Sack, "The Aesthetics of Information Visualization," in *Context Providers: Conditions of Meaning in Media Arts*, ed. Margo Lovejoy, Christiane Paul, and Victoria Vesna (Bristol, UK: Intellect Ltd., 2011). Distributed by University of Chicago Press.

15. Johanna Drucker, "Humanistic Approaches to the Graphical Expression of Interpretation" (presentation at the MIT HyperStudio Humanities + Digital Visual Interpretation conference, Cambridge, MA, May 20, 2010), accessed July 8, 2011, http://mitworld.mit.edu/video/796.

16. Peter Barber and Tom Harper, eds., *Magnificent Maps: Power, Propaganda and Art* (London: British Library, 2010). See also BBC Four, "The Beauty of Maps: Seeing the Art in Cartography" (2010), http://www.bbc.co.uk/bbcfour/beautyofmaps/.

17. Jeremy Crampton, *Mapping: A Critical Introduction to Cartography and GIS* (New York: John Wiley & Son, 2010), 9.

18. Ibid.

19. J. B. Harley, "Maps, Knowledge and Power," in *The New Nature of Maps: Essays in the History of Cartography*, ed. Paul Laxton (Baltimore: John Hopkins University Press, 2001), 67.

20. See, for example, Barrett Lyon, "Opte Project Map of the Internet" (2003), in *Else/Where: Mapping—New Cartographies of Networks and Territories*, ed. Janet Abrams and Peter Hall (Minneapolis: University of Minnesota Design Institute, 2006).

21. Valdis Krebs, "Finding Go-To People and Subject Matter Experts [SME]" (2008), accessed July 11, 2011, http://www.orgnet.com/experts.html.

22. Freeman, "Visualizing Social Networks."

23. Daniel Rosenberg and Anthony Grafton, *Cartographies of Time: A History of the Timeline* (New York: Princeton Architectural Press, 2010).

24. James Moody, Daniel A. McFarland, and Skye Bender-DeMoll, "Dynamic Network Visualization: Methods for Meaning with Longitudinal Network Movies," *American Journal of Sociology* 110 (2005): 1206–1241.

25. Drucker, "Humanistic Approaches to the Graphical Expression of Interpretation."

26. Nicholas Felton, *Feltron Annual Report* (2005), accessed August 22, 2011, http://feltron.com/ar05_01.html.

27. Bruno Latour, "A Cautious Prometheus? A Few Steps Toward a Philosophy of Design (with Special Attention to Peter Sloterdijk)" (presentation at the Networks of Design meeting of the Design History Society, Falmouth, Cornwall, UK, September 3, 2008), http://bruno-latour.fr/articles/article/112-DESIGN-CORNWALL.pdf.

28. Cognitive Media, "RSA Animate—Philip Zimbard: The Secret Powers of Time and Other Things" (June 2, 2010), accessed July 18, 2011, http://www.cognitivemedia.co.uk/wp/?p=272. For a discussion of rhetoric in design, see Richard Buchanan, "Declaration by Design: Rhetoric, Argument, and Demonstration in Design Practice," in *Design Discourse: History, Theory, Criticism*, ed. Victor Margolin (Chicago: University of Chicago Press, 1989), 91–109.

29. Ben Fry, *On the Origin of Species: The Preservation of Favoured Traces* (2009), accessed July 18, 2011, http://benfry.com/traces/.

30. Martin Wattenberg and Fernanda Viégas, *IBM Communication Lab, History Flow* (2003), http://www.bewitched.com/historyflow.html. See also Wattenberg and Viégas, "The Hive Mind Ain't What It Used to Be" (reply to post by Janon Lanier, "Digital Maoism"), http://www.edge.org/discourse/digital_maoism.html#viegas.

31. Gephi Consortium (founded October 2010), accessed August 22, 2011, http://consortium.gephi.org.

32. Ben Fry, "Computational Information Design" (presentation at Adaptive Path UX Week Conference, August 24–27, 2010), http://www.youtube.com/watch?v=z-g-cWDnUdU.

2011
Brand Matrix
Armin Vit and Bryony Gomez-Palacio

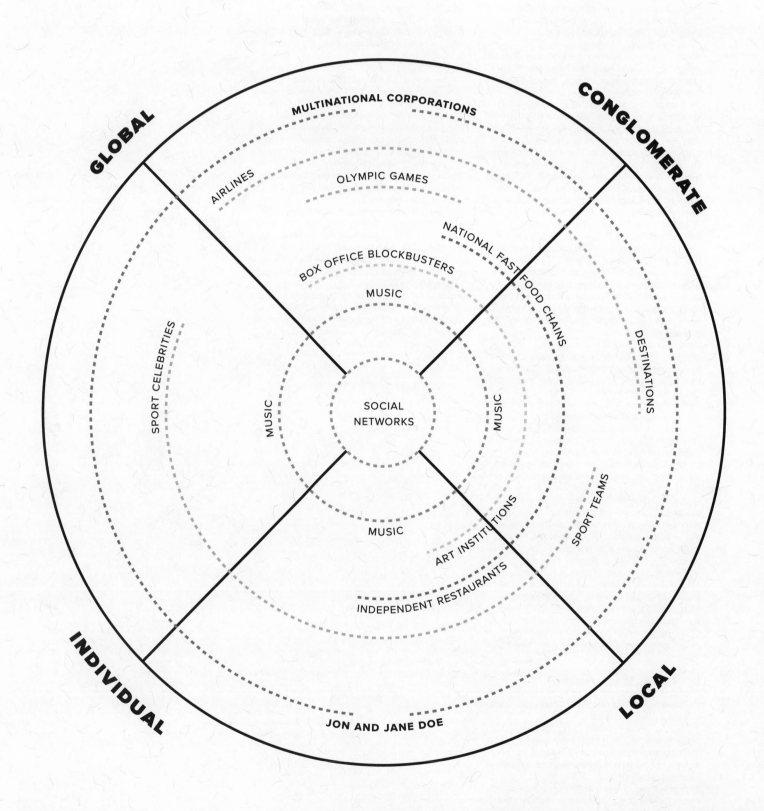

One way to understand a brand is to parse its sphere of influence. This matrix diagrams brands along two axes: one for scope and one for scale. Scope asks where the brand exists geographically: is its impact local or global? Scale asks how many people are involved with the brand: does it engage an individual or a conglomerate? This matrix enables comparison among different brands within the same market or industry. The diagram also demonstrates that branding is not just a tool for international corporations trying to sell things to individuals, but that branding also represents individuals identified with specific locations.

The first ring in the matrix places multinational corporations in direct opposition to you, me, us, Joe and Jane Doe. This relationship is straightforward: Apple sells us computers and iThings, Citibank sells us financial services, Mobil gas, and McDonald's burgers. These companies create, produce, and distribute the things we consume. To make sure we choose their product or service over others, they have established brands that define their best attributes and portray specific personalities. These brands have to be maintained globally by a lot of people and then have to be meaningful to individuals, locally. If you turned the "dial" clockwise on the matrix to be less global and more local, this same relationship could be established between governments that define the parameters under which to live and work, and their citizens, who must accept or at least abide by them. These parameters would even extend to visitors, which is why "destination" branding is such a thriving niche within the brand and identity design industries.

The famous I ♥ NY logo was born as a tool to promote the state of New York; it has now become ingrained in the brand of New York City, expressing the unofficial philosophy, "If you can make it here, you can make it anywhere." Equally ambitious brands have been built around destinations such as the islands of the Bahamas and the nation of Peru. Working within the destination industry are the airlines—many of them operating internationally and having well-defined brands of their own (which is why flying on Virgin Atlantic feels so different from flying on Lufthansa). Airlines bring tourists to and from these destinations, creating a link between the former's role as a global-conglomerate and the latter's as a local-conglomerate. Destinations attract individuals, and individuals must choose a way to get there. Also functioning within this space is a famous individual that exports his or her brand beyond the local boundaries

of the place they would call home. Actors are a good example: Tom Cruise may live in Los Angeles, but his brand (part action hero, part stud, part crazy) is recognizable anywhere in the world.

Or take the "Jumpman" logo. It represents not only one of the best basketball players in the history of the NBA, but also a multimillion-dollar brand for Nike. Michael Jordan's main role was as a player in a local-conglomerate, the Chicago Bulls, but his own individual brand as a player, a celebrity, and as merchandise made him a global-individual—a role few people achieve. Other global-individuals include, say, Barack Obama, "starchitect" Frank Gehry, or an artist like Madonna.

Musicians occupy an interesting place in this matrix, linking all four axes in different ways. A local-individual such as Madonna or the late Michael Jackson has the economic impact of a global-conglomerate, generating millions of dollars across the world through record sales, tours, and merchandise. Yet, despite their bigger-than-life personalities, their impact also strikes local-individuals, the consumers and the fans, the ones that teared up when their favorite artist took the stage. Different artists obviously occupy different spots within this ring, from Metallica, a global act without the mass appeal of Madonna, to a hyper-local band for a specific niche such as the hard-to-categorize Austin, Texas–based Ghostland Observatory. Miley Cyrus, Pearl Jam, Arcade Fire, and others fill in the spaces between those extremes. With their infinitely varied range of influence, musicians exemplify the many ways a brand can manifest itself across this matrix—one that would have looked quite different at the beginning of the decade.

The environment in which brands live is constantly changing. A new development is the rise of the social network—notably Facebook and Twitter. These two services have removed many of the barriers that previously existed between local and global brands, between individuals and conglomerates. Now everyone, everywhere has access: large corporations can see exactly what consumers are saying about them on Twitter, and consumers can choose to "follow" (and duly "un-follow") any brand they like. This is not a revelatory observation, but an explanation of why they sit at the nexus of the matrix. Twitter and Facebook serve to amplify the voices of local-individuals; they even help to form millions of individual brands. From the photographs people choose to share to the selection of their profile images to the friends they let in to the links and stories

they share, individuals are gradually building unique brands. For global-conglomerates, social networks can help humanize and localize their brands, bringing them closer to consumers in a virtual space that is neutral to both parties—everyone has the same default templates to work from.

This is not to say that social networks define conglomerates or individuals, but that they serve as a tool at everyone's disposal for any given motive, in a way that wasn't possible before. ⊠

Christopher Doyle™ Identity Guidelines

To maintain consistency across product lines, collateral materials, promotional items, and overall branded communications, most organizations utilize guideline documents that establish all the elements of the visual identity. Ranging anywhere from two pages to two hundred, these documents leave little to the imagination, specifying everything from the correct color combination for printing the logo to the size at which the logo must be used at an industry-event booth. Sydney-based graphic designer Christopher Doyle thought that his own personal brand could use some consistency, so he appropriated the format and language of guideline documents to create an amusing set of rules for himself that establish the appropriate color palette, correct usage in black and white, clearance space, and more. Wayfinding applications show Doyle pointing in various directions; and even his tone of voice is subject to regulation: "My verbal expression has been equal parts cynicism and positivity. While an overly cynical or critical tone can lead to negative perception, balancing this with humour and positivity provides me with a unique and ownable voice." —Armin Vit and Bryony Gomez-Palacio

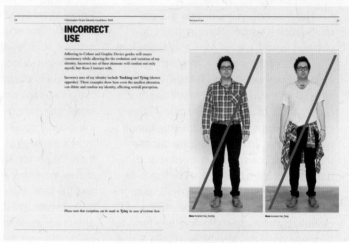

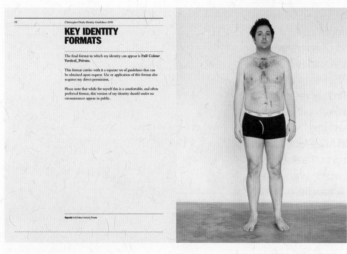

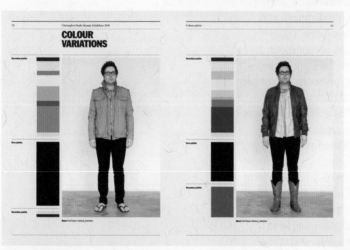

Christopher Doyle, *Personal Identity Guidelines*, 2008 Photo: Ian Haigh Courtesy the artist

Apple Store SoHo, ground floor
status 2003-02-25

Prem Krishnamurthy, *Apple Store Diagram*, 2008 Courtesy the artist

Prem Krishnamurthy inside SoHo Apple, New York, 2008 Courtesy the artist

Apple Store as Design Studio
Think different
1. The Apple Store SoHo, located in the former Prince Street Station post office in New York, packs over fifty top of the line computers, hundreds of peripheral devices (cameras, videocameras, scanners, printers, speakers, MP3 players), music, image, and video editing facilities, a 50-seat theater for multimedia presentations and in-store seminars, a "bar" for chatting about Apple products and getting repair service, and more into its airy 18,000 square feet of showroom. The largest Apple Store so far, the Apple Store SoHo is the perfect playground for the digital shopper. Every piece of technology welcomes experimentation: try before you buy. 2. Production supplants consumption in the Apple Store. Prospective buyers are encouraged to try out the computers in-store until they are fully satisfied. This is not the same as trying on a shirt or even test-driving a car. Given the virtual nature of computer work, "testing" and "working/producing" can be identical: I try out Adobe Photoshop by retouching and printing out a photograph for a client. In contrast to purchasing and using a lawnmower, which requires taking the lawnmower home to the grass, one can design a website while in the Apple Store—akin to bringing the lawn to the store. Working preys on shopping. 3. Internet cafes are a thing of the past. Why pay to surf when the Apple Store invites visitors to "try out" the suite of internet programs available in Mac OSX, all over a broadband connection? Purchasing a several thousand dollar computer for home or office also becomes a questionable decision in light of the opportunities available at the Apple Store. At no cost, one can check email, scan photographs, download MP3s, burn CDs, shoot digital photographs, design websites, and edit videos—all on the highest-end computers available. Using the Apple Store for personal or professional activities, one becomes a benign parasite. Although not explicitly desired by the management of the Apple Store, such activity is not forbidden. After all, the fuller the store is with people working away happily on Apple computers, writing emails and editing music and burning DVDs of movies, the more evidence that everyone is making the switch. 4. Apple Store SoHo, 103 Prince Street, New York, NY Mon – Sat: 10am to 8pm, Sun: 11am to 6pm —Prem Krishnamurthy, "Apple Store as Design Studio," from *Empire: Nozone IX*, 2004, edited by Nicholas Blechman Courtesy Princeton Architectural Press

A fake Apple Store, Kunming, China, 2011 Photos: Jessica Angelson Courtesy BirdAbroad

One Bad Apple?
In July 2011, an American woman living in China and blogging under the name BirdAbroad exposed the existence of what appeared to be fake Apple stores in Kunming. The stores were elaborate replicas of the branded Apple retail experience duplicating the space age visual merchandising, sleek fixtures, employee uniforms, and displaying what appeared to be genuine Apple products. Closer inspection revealed discrepancies in the use of Apple's brand identity and uncharacteristic shoddy construction. As BirdAbroad noted, Apple has limited retail locations in China and none in Kunming. International media outlets, ever conscious of the intellectual property rights dilemma in China, soon picked up the story and several unauthorized Apple stores were closed, although at the time, not this particular location. Apple confirmed the store as a fake. —AB

2011
Brand New Worlds
Andrew Blauvelt

Mark Gardner and Steve Fuller (Imaginary Forces), *Mad Men*, 2007 Courtesy Lionsgate Television

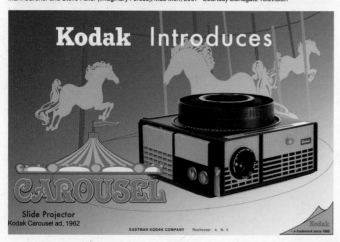

Slide Projector
Kodak Carousel ad, 1962

Kodak Carousel Projector

In 1961, Kodak introduced its Carousel projector, designed with a removable tray holding eighty 35mm color film transparencies, or "slides." Carousel slide shows became a dubious form of party entertainment, as well-meaning hosts lulled their guests into a post-alcoholic stupor with long presentations about family travel. The carousel projector also entered the repertoire of conceptual and photo-based art in the 1960s and '70s, when artists exploited the medium's low cost and portability as well as the public, cinematic experience it afforded. Carousel projectors ceased production in September 2004, forced into obsolescence by digital tools such as PowerPoint, whose interface has kept alive the analog metaphor of the "slide." —EL See Darsie Alexander, *SlideShow: Projected Images in Contemporary Art*, 2005

Wolff Olins, Aol. logo, 2009

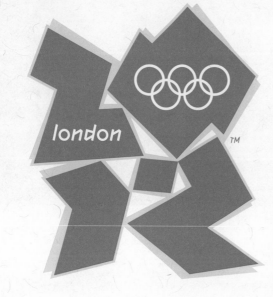

Wolff Olins, 2012 London Olympics logo, 2007

Paul Rand, Enron logo, 1997

The Crooked E

Unveiled in 1997, the logo for the Enron Corporation was among the last works of Paul Rand, who did more than any other American designer to create a serious professional image for graphic design. After Enron collapsed in disgrace in 2002, a group of light-up revolving sculptures of the logo were sold at auction. One of these astonishing relics of corporate kitsch was purchased by Houston ad man Lou Coneglio, who stated, "This was a unique opportunity to own a piece of pop culture during one of the most turbulent times in our city's history. The 'crooked E' became an instant symbol of corporate greed and corruption." Coneglio sold it in 2008—on the cusp of the Great Recession—to a collector from New York City. Every symbol has its price. —EL

"Products are made in the factory, but brands are made in the mind."
—Walter Landor

Don Draper, the lead television character of the acclaimed series *Mad Men,* makes an impressive pitch to two Kodak executives who are searching for a firm to market their new slide projector. Fixated on the machine's most distinguishing feature, they ask if he has found a way to sell the wheel-like mechanism—the oldest of technologies—as something new. "Nostalgia, it's delicate, but potent," Draper tells them, methodically clicking through slides documenting the happier moments of his otherwise troubled domestic life. "It's a twinge in your heart, far more powerful than memory alone. This device isn't a spaceship, it's a time machine. It goes backwards, forwards. It takes us to a place where we ache to go again. It's not called the wheel, it's called a carousel. It lets us travel the way a child travels, around and around, and back home again, to a place where we know we are loved." In typically masterful fashion, Draper schools the postwar business execs in the new ways of connecting consumers to the things they love. Product features and pricing are fine as rational appeals, newness has buzz, but the most direct and lasting route is emotional, an arrow straight to the heart. Welcome to the new world of branding: a place where you don't sell projectors, you sell memories.

In the 1990s, branding subsumed what graphic designers used to call corporate identity. During this time, it was not uncommon to attend a design lecture where the term would be raised only to be accompanied by a Wild West image of a cowboy wrestling a steer to the ground and the requisite (nervous) laughter from the assembled crowd. Although the word has its roots in this etymology, the point was largely missed. True, brands were markers of ownership, used to tell one cow from the other, just as brands in the marketplace must assert their own difference in the cattle call of daily consumption. However, the real impact to design was the devaluation of the mark itself, from a prized talisman to a requisite deliverable. Reduced to playing a bit part, the logo has been eclipsed by a cavalcade of brand expertise and its concepts: brand equity, brand loyalty, brand extensions, brand dilution, brand promise, brand audit, rebranding, brand management, brand experiences, etc. All of this brand activity is fairly self-perpetuating, instigated by brand managers eager to prove their worth to higher-ups with a constant

stream of refresh and renewal campaigns, not to mention the era of mergers and acquisitions and the turnstile CEO, who signals new leadership change the same way Buckingham Palace announces the arrival of the queen—by running it up the flagpole.

The concept of corporate identity, and the logo at the heart of it, sought to embody and reflect the organization—a mirror turned onto the corporate self. Such an approach parallels the evolving logic and expanding status of "corporate personhood," at least as it is understood in the United States. This personification of the corporation—giving it the same basic rights of assembly, movement, privacy, and speech as individual citizens—is in many ways the expansion of the personification of the brands those same companies sell. In contrast to corporate identity, branding is both a projection and reflection of the consumer. Distilled to an essence, even if it looked rather meaningless and abstract, the logo was an embodied marker. Corporate identity was the culmination of the rational, managerial, and bureaucratic functions of businesses that were becoming, in the postwar period, increasingly transnational in their reach. Aspiring to qualities such as efficiency, simplification, and consistency, the lynchpin of corporate identity was the logo or mark. Painstakingly crafted and monolithically imagined, the logo was the quintessential expression of graphic communication, the ultimate reduction of a complex entity to a simple and easily absorbed cipher.

Today, of the many thousands of new logos produced each year, most are design disasters. Why? The reasons are undoubtedly varied, but here are a few that are likely. First, companies today turn to branding consultants, whose principal work is not the creation of a graphic mark but in better-paid and time-consuming adventures such as research, analysis, strategy, and positioning. Because of one-stop shopping, consultancies often create the visuals, too, and employ a range of choices so predictable that one brand guru, who shall remain nameless, refers to these bags of tricks as the "3D Swirlee," a reference to the rendering software effects used to puff up letterforms—replete with reflective surface highlights and shadows, the "look and feel" of Web 2.0. Second, many schools and programs don't teach logo design in the same way or in the same depth anymore. Hours of drawing and focus on issues such as gestalt, flow, and scalability have been replaced by the need to create things like mood boards and to simulate

the research process of consultancies. Third, the application context of marks today is ruled not by the limitations of one or two colors, which forced a kind of simplified rigor, but the glorious and often gaudy rainbow of ubiquitous full-color printing and the luminescent glow of RGB. Fourth, the shelf life of most corporate identities has diminished greatly during each of the past few decades. This constant churn reduces concern for any kind of longevity. Identity, like fashion, is updatable, replaceable, and consequently, disposable.

The criticism of logos, however, is not limited to the design critic anymore. The event-driven nature of the branding exercise means that statements of intent must be drafted by design firms and branding consultants and that the corporate press release must be crafted and circulated. Picking up on this activity is the website *Brand New*, operated by Armin Vit and Bryony Gomez-Palacio, which is a leading forum for presenting and critiquing the brand makeover. Offering an impressive array of before and after comparisons, *Brand New* surveys a large field of activity, from cultural and corporate identity programs, sports teams, and mascots to branded tourism. Here, logo designs and redesigns are treated as a spectator sport, with armchair quarterbacking and color commentary from bloggers and behind-the-scenes reporting on the process and history of the marks by the hosts.

All of this activity, while earnest, seems almost tranquil compared to the rough, open waters of social media. The ability to provide instant feedback, particularly through ubiquitous social networking channels, means that brand redesigns have more potential for greater volatility. Take, for instance, the nearly universal and instant hatred of the proposed London 2012 Olympic Games logo created by Wolff Olins, a leading brand consultancy. Its retro '80s, new wave–style graphic sports the numerals 2012 in a chunky font on contrasting color palettes. Despite its numerical focus, the mark has been seen as anything from a Nazi SS emblem to a Rorschach test image of the cartoon character Lisa Simpson performing fellatio to spelling the words Zion, which precipitated a threatened boycott of the Games by Iran.[1] Faring no better was the recent redesign, recall, and reinstatement by Gap, the legendary clothing retailer, of its twenty-year-old logo. The proposed redesign included the word Gap in the ubiquitous typeface Helvetica overlapping a small, blue gradient square. This uninspired, inoffensive yet somehow offending design

Brand New

Brand New
The popular website *Brand New* is edited by Armin Vit and Bryony Gomez-Palacio. Founded in 2006, the site presents commentary on corporate and brand identities. *Brand New* began as a spin-off of *Speak Up*, one of the earliest and most influential graphic design blogs. While *Speak Up* no longer exists, this vital side conversation has become an important and inclusive voice on the state of contemporary branding. Before/after presentations invite visitors to vote on the concept and execution of new logos for existing brands and to post additional comments. With user-supplied critiques (see below) that range from constructive to inane, these comment threads provide a unique forum on a ubiquitous design genre. —EL

Nickelodeon Redesign: Eric Zim, 2009

Before **After**

I dig it, it manages to modernize the early '90s looking logo while also bringing overall brand consistency. —awesomerobot

The old logo suddenly seems very dated, as if it had needed this for a long time, even though I never thought it did before. —Mog

Where's the kid in these shapes? Where's the drippy goo, the finger paint, the mud on the knees, the frog in the pocket? The redesign looks great, if what you want is something that looks like it's intended for stodgy adults with a desperate need for a colorectal polecectomy. But Nickelodeon is not intended for such adults. So why does the wordmark cater to them? —Warren

Starbucks Redesign: Starbucks Global Creative and Lippincott, 2011

Before **After**

A bold move that worked out brilliantly. I for one love it! —Euan

I may be alone here, but I don't get "simple" from this new logo. It's a fairly complicated mark in comparison to Nike, Apple and Target. Reduction is going to take a sledgehammer to all those little intricate lines in print, and the saving grace of the previous logo was that it still said "Starbucks" when the mermaid became a glob of ink. —Greg Scraper

The siren is a beautiful mark that deserves to emancipate herself. The fact that she is more intricate than most big brand logos is, to me, part of her allure. —Stephan

Comedy Central Redesign: thelab, 2010

Before **After**

Several have argued that it's not "fun" enough, but CC's programming isn't all fun and games. There is a level of sophistication that permeates throughout the network that begs to be treated as a more mature genre. This new systems serves them well. —Evan Stremke

Smart, simple, clever, and exquisitely applied. Love it. —dglassdes

The new mark is too serious, too corporate, and not at all funny. It could have been more fun and whimsical. Instead, it appears that Comedy Central is starting to take itself too seriously. —Ryan

Syfy Redesign: Proud Creative, 2009

Before **After**

So they take all the recognition and character of the old one, and trade it for … a weird up-down-up-down-shaped four-letter nonsense word? Why go through the trouble of teaching their existing audience to recognize the new identity? And will the new logo and name pull in potential viewers, when it barely even hints at the subject matter? —Matt

In space, no one can hear you spell. —Jerry Kuyper

The change in the spelling actually gives them something they can own in a much more obvious way. As for comparison to the old logo, I'd say it's a huge improvement. A stylized Saturn mark is overused and easily forgotten. The new logo may feel a bit blank on the page, but on screen this logo is being used to good effect, and after all, that's the primary form of the logo. —Brian

Bausch+Lomb Redesign: Pentagram (Paula Scher, Partner), 2009

Before **After**

The "+" is starting to grate on my nerves—it seems to have jumped from the professional services world (architecture firms, design firms) into the consumer world. I thought it was overused before—a gimmicky shortcut to say, "Hey, we're forward-thinking and cool." —Deshler

This is a promising step towards a future-oriented eye health company. Bausch+Lomb's new identity is appropriately fresh and medicinal. —Andrew Sabatier

They took from a very superficial retail look and created a more thoughtful, prestigious identity. Nice work. —Bill Dawson (XK9)

TCBY Redesign: Struck/Axiom, 2010

Before **After**

Modern but not timeless, sure to date, got the over print features, and lowercase letterforms. I do like the "y" very much and its flexibility. —Richard Baird

The Y as a cup is a fine analogy I suppose, but the rest of the typography should support the custom Y in my opinion. —Ricky Salsberry

There's a certain point that new and trendy becomes old and tired, and I think (I hope!) this digital, angular look has reached that point. Of course, when it does, many companies will be burned because they got the trendy logo. —Isabelle

Library of Congress Redesign: Chermayeff & Geismar (Sagi Haviv, Partner), 2009

Before

After

The mark is almost perfect. I love the simplicity and dualities of its presentation. You don't see logos like this too much anymore. The flatness and simplicity is a trait of the old school designers but I still love and appreciate it. Also, Trajan is such a horrid typeface, I can appreciate the craft and delicacy of the letters as individuals but when this typeface forms words… it just makes me cringe. —col corcoran

Underwhelming, looks like it's paying homage to the postage stamp. —BlueEyedPeas

Does this look like a book being shredded to anyone else? —Alphon

YMCA Redesign: Siegel+Gale, 2010

Before

After

I really applaud the decision to embrace "the Y" as a mark, as it reinforces how people refer to it in casual conversation. Smart to own that. —Michael

The best part about this logo is the arrow, which to me is communicating forward movement, thinking and progress, which is what the Y is about. I really like the subtlety in how that's integrated into the mark. —Damian Madray

The form of the "Y" is nice, but the placement of the supporting elements looks accidental. First, it looks like it's going to tip over, like the leaning tower of Pisa. If "the" were higher, it would be better balanced. Second, the main motion is left to right, especially with the strong arrow shape, but the upward-moving "YMCA" stifles that movement. Pick one direction and stick with it. —Eric

GLAAD Redesign: Lippincott, 2010

Before

After

While the mark is gorgeous and I love the variations, it feels more electronics/audio to me. I suspect seeing it in use will build the proper association. —Chris Rugen

An improvement. The use of shape, overlap, curve, and color really lends itself to design versatility. The previous signature was falling far short of the mark. —Tyler Border

I'm not sure everyone is going to really "get" the logo upon first viewing (yes they might get the amplification thing but will they get why?) but it sure makes more sense than the dripping paint logo. —Adam K

Pfizer Redesign: Siegel+Gale, 2009

Before

After

I like the update (minus the gradient. I prefer the solid versions) but I really like that there's more consistency in the type. —Erin

I like everything about this redesign except for the gradient. When will the unnecessary gradients and 3D logos stop!? —Slicecom

The old logo suffered from it too, but I'm not crazy about the f-i ligature. It looks too much like an "h" to me (Phzer). Perhaps the ligature line should be thinner? —ChrisM70

Popeyes Redesign: Pentagram (DJ Stout, Partner), 2008

Before

After

This update makes it feel more like a restaurant a la Chili's or Friday's and less fast food. —JonSel

I appreciate the attempt to maintain brand equity, but once you take the cartoonish lettering and set it on a standard baseline, the mechanical sameness of the two 'P's and 'e's becomes glaringly obvious. Couldn't the client afford to draw alternates of the repeated letters? —Jose Nieto

This new look feels more sophisticated and a bit more "down home" than the overly-excited identity they previously used. Kudos on a job well done. It actually makes me want some fried chicken. —Roby Fitzhenry

AOL Redesign: Wolff Olins, 2009

Before

After

I liked AOL because it read just like that—A-O-L. But this new logo feels like it's supposed to be read as a word, like "ay-ol." It's not just a new way of looking at the logo, but a new way of understanding it and reading it altogether. —Catherine

Although there is no doubt that they needed to reinvent themselves with a new brand, I think what they really needed was a modern, simple logo that emphasized AOL as a kinder, gentler overarching content owner (which is really what they have become). With so many sub-properties, what would have been a better approach was a common thread, not a disparate "do what you want" branding solution that leads to visual cacophony. —drewdraws2

I hated it at first, but now I like it. I don't think it would work as well if the wordmark was more complex—it needs to be super simple and chunky, since most of the time we're only seeing part of it and have to complete the rest of it mentally. —Mog

New York Public Library Redesign: Marc Blaustein (New York Public Library in-house design studio), 2009

Before

After

I think it's a great example of an elegant and successful logo redesign. It keeps the original elements, but simply updates and refines them. —David McGillivray

Anything that helps reinforce the New York Public Library as a cultural icon is a noble and worthy endeavor. I only wish they had represented the lower vantage point that most people have when looking at the lions. For instance making the eyes appear less rounded. There's a power to the lion (or knowledge) as an icon that is above your line of sight—something that calls you upward—rather than being eye-to-eye on the same level. —Carlo

I don't like the new lion. It's not the most well drawn and it's a bit too abstract, which makes it feel similar to the MGM lion. The old lion had more of a regal feel and a seal/crestlike quality to it, which is exactly the kind of feeling I want when I see an icon of a lion. —PG

generated enough negative commentary on Twitter to cause the company to take to its Facebook site to proclaim, "We know this logo created a lot of buzz and we're thrilled to see passionate debates unfolding! So much so we're asking you to share your designs. We love our version, but we'd like to see other ideas. Stay tuned for details in the next few days on this crowd sourcing [sic] project." [2] Apparently, the committee formed to create this design wasn't large enough! Or as Alissa Walker put it in her own mock commentary on Gapgate: "This is what dumb dumbs in our marketing department call a pivot." [3] While London stayed calm and carried on as if nothing had happened, the Gap thankfully capitulated to the angry mob and eventually fired the firm that created the mark and the executive in charge of the project (although that was most likely for lackluster sales results).

In the wake of the diminished logo and its replacement by a glut of bloated glyphs, we have a nearly nostalgic view of what could be called "the golden age of logos." These are the classic marks of a bygone era: Jan Tschichold's redesign of Penguin books (1948); William Golden's CBS "eye" (1951); Paul Rand's striped IBM (1956); Lester Beall's International Paper "tree" (1960); Chermayeff & Geismar Associates' Chase Manhattan Bank (1960); Saul Bass' Bell telephone (1969); Nike's "swoosh" (1971); Siegal and Gale's 3M (1978); Saul Bass' AT&T "globe" (1984); Steff Geissbuhler's "eye/ear" for Time Warner (1990); and Landor Associates' FedEx "arrow" (1994). Taking a page from the historic preservationist movement in architecture, we have the first signs of attempting to document the cultural history of these designs.

The Stone Twins, Declan and Garech, were among the first to document and publish their project, *Logo R.I.P.* (2003). This little black book dutifully notes the history and fate of major icons of the twentieth century, while its companion website serves as an electronic repository of condolences. This graveyard of commerce is a fascinating study in the types of changes that can befall a corporate behemoth or one of the titans of logo design. Witness the scandalous collapse of Enron—its logo dubbed the "crooked E" and designed by Paul Rand (1997)—or the sad fate of Rand's UPS "package" logo (1961), replaced by what was derisively dubbed "the golden comb-over," (FutureBrand, 2003). In reaction, designer Scott Stowell penned "The First Report of the (Unofficial) Graphic Design Landmarks Preservation Commission," [4] advocating for the preservation of logos such as Bell, CBS, and UPS, which like great buildings have become an integral part of the landscape and our lives and thus deserve to be maintained, even if freed from their former service. As Rob Giampietro has noted, this proposal taps into our affection for those things that come to form our everyday experience. He writes: "We are the nodes on these companies' networks, so invariably we feel a sense of ownership over their identities. In allowing them to move through us, we have, even temporarily, made their identities our own, witnessing television signals, phone calls, and packages as they spread from one person to the next, all over the globe." [5] Paradoxically, could the desire we feel to preserve these icons be the result of the same love engendered through the mechanisms of branding, which in turn feeds the destruction of these logos in the first place? In a different yet similar vein, designer Ji Lee has been documenting the vestiges of New York's Twin Towers, whose iconic forms on the skyline made them an indispensable component of so many of the city's logos and graphics. In a reversal of fortune in this case, the architecture cannot be preserved, so what remains is its ghostly presence and absence, the memory of what was once there.

In the aftermath of its golden age, corporate identity became, well, corporate: rigid, cold, sterile, and imperious. How to make a proper corporate logo became increasingly formulaic, built on the back of whatever was successful before. Formal solutions could be easily categorized as a taxonomy of visual effects: vertical striping, globes, stars, arrows, ligatures, optical illusions, and so on. On August 1, 1981, at 12:01 am, our understanding of the potential of identity to express its uncorporate side debuted on a few thousand television sets in northern New Jersey. MTV was born. Its identity—a bold, blocklike "M" with the sprayed-painted letters "TV" on top—was created by a trio of graphic designers working as Manhattan Design. Their early sketches for the mark "seemed too normal-looking. Frank [Olinsky] suggested that the logo needed to be less corporate somehow, de-faced or graffitied." [6] Eschewing the typically fixed corporate color palette, the most important effect of this mark was its ever-changing set of patterns, images, and colors that filled the blocky mass of its "M." The age of dynamic identity was born.

Today this feature has migrated to more traditional bastions of corporate culture, as witnessed by the recent redesign of AOL as "Aol." (Wolff Olins, 2009), which offers seemingly endless possibilities of background image choices. Perhaps the most familiar dynamic identity today is that of Google, whose ever-changing logos, called Doodles, are viewed by many millions of users each day. The complexity of these offerings has varied, from the first modified Google logo (a stick figure behind one of the "o"s, an homage to the Burning Man symbol) designed in the late '90s to more complicated interactive offerings, such as the guitar-shaped, playable, and recordable Doodle created to celebrate Les Paul's ninety-sixth birthday (2011).

Today, innovations in the world of identity programs are happening not so much in the corporate world but rather in the cultural arena. Sure, the stakes aren't as high so the ground is more fertile for exploration, and much of the more adventuresome work is for the most visually attuned institutions, but we should remember that the prevailing atmosphere in such places is fundamentally conservative, as in the conservation of objects, reputations, and endowments, and tying to history as much as possible. As James Twitchell notes in his book *Branded Nation*, the museum became a site of intense focus around issues of branding just as the number of museums and like destinations and their audiences grew dramatically, particularly in the museum boom of the late 1990s and early 2000s. It was no longer enough to book the latest blockbuster shows, stock its gift shops with the newest offerings, or create destination restaurants as part of its experience: the museum's projection of its own personality must now follow suit. Twitchell's thesis is simple: where there's a surplus of anything, we find branding. [7] The art world is not immune to the same laws of supply and demand and competition.

The Walker Art Center, where I work, was among the very first museums to enter into this terrain of mutable identities when design director Laurie Haycock Makela commissioned legendary typographer Matthew Carter to create an innovative font called, appropriately, Walker (1994–1995). This font allowed designers to add and subtract serifs and to add underlines and overlines to a bold, uppercase base titling face. Carter's prescient solution was a piece of software, a tool to create design. It worked insofar as the Walker's in-house design studio is staffed by typographically trained designers and produces all of its own materials. Walker Expanded is an identity developed for the institution following its building expansion in 2005. Like its predecessor, it is a piece of software. It

Steff Geissbuhler, TimeWarner logo, 1990

Paul Rand, UPS logo, 1960

Web 2.0: Slippery When Wet

Ever since the introduction of Apple's OSX Aqua interface in 2002, a dizzying array of dimensional effects has entered the collective graphic toolbox: cast or drop shadows; rounded corners and beveled edges; soft, bulbous typefaces; reflective, waterlike surfaces; shiny highlights; gradients; and candy color palettes. These effects have come to signify Web 2.0, the participatory and collaborative culture of user-generated content facilitated by social media—the kind of experience promised with Web 1.0. This slick, glossy aesthetic became so pervasive that it was easier for many websites to adopt the look and feel of Web 2.0 graphics than to incorporate any substantive changes to its interaction and engagement with users. These special effects quickly migrated to the world of branding, prompting blog posts and tutorials on how to makeover your old logo. Like so many styles, this trend is subsiding, something Elliot Jay Stocks argued in his presentation "Destroy the Web 2.0 Look," at the 2007 Future of Web Design conference in New York. —AB

Lester Beall, International Paper logo drawing, 1960

Saul Bass, Bell Telephone logo, 1969

Sol Sender, Obama '08 logo, 2006

Favicon

With the release of Microsoft's Internet Explorer 5 web browser in 1999, users were able to see a graphic icon associated with the website's address or name when it appeared in the address bar or, if the website was bookmarked, in the list of the user's favorites, hence "Favicon." Limited to the diminutive size of 16-by-16 pixels, Favicons must serve as minimalist variants of logos, challenging designers to distill their essence to the lowest common denominator of visual representation. As the examples here show, some logos are instantly recognizable, while others don't fare too well at such small scale.
—Armin Vit and Bryony Gomez-Palacio

Declan Stone and Garech Stone, Logo R.I.P., 2003 Courtesy BIS Publishers

Michael P. Pierce, Favicon Collage, 2004 Courtesy MpP Favicon Gallery

Declan Stone and Garech Stone, Logo R.I.P., 2003 Courtesy BIS Publishers

Lost Logos

Scott Stowell penned the essay, "The First Report of the (Unofficial) Graphic Design Landmarks Preservation Commission," which applies the rationale used in the historic preservation of buildings to the world of visual communication. Stowell asks: "The choices made in creating a piece of graphic design are as much a representation of a particular time as those made in creating architecture. So why don't we care when a logo we've been living with for decades is renovated—or an elegant signage system is defaced by unsympathetic additions?" (Metropolis magazine, May 2004). In 2003, Declan and Garech Stone published the book and website Logo R.I.P. They write: "'Logo R.I.P.' is a commemoration of logos withdrawn from the ocular landscape. Many are considered icons of their time or international design classics, whilst others cost millions only to be replaced within a year or two. These logos disappeared, yet in contrast to the ceremony and pomp that greeted their arrival, they often suffered an ignoble death. Now deemed defunct, they are consigned to the logo graveyard, no longer able to signify." —AB

Manhattan Mini Storage

World Trade Center Preservation Project

Shortly after 9/11, graphic designer Ji Lee began photographing awnings, trucks, fliers, and other commercial artifacts emblazoned with images of the World Trade Center. Thousands of such images can still be found around the city; most are connected with small businesses, which are likely to disappear in the not-so-distant future, taking with them these popular signifiers of a lost local identity. Lee uploads his images to a Flickr photosharing group called the WTC Logo Preservation Project. More than thirty members have contributed content at WTCLogo.com. —EL

Ji Lee, *WTC Logo Preservation Project*, 2001– Courtesy the artist

Andrew Blauvelt

Google Doodles

The home page of Google is famous for its simplicity and scarcity of elements: a dozen or so text links, a search field, two buttons, and the company's logo, all on a white background. It doesn't sound too exciting because it is not. Except when it's a holiday or a special occasion. That's when the Google logo transforms into one of more than three hundred Doodles that convert the corporate serif wordmark into playful, exuberant illustrations and designs that celebrate something as generic as New Year's Day to something as particular as the 119th Anniversary of the First Documented Ice Cream Sundae (April 3, 2011). The first instance of a Google Doodle came in 1998 when cofounders Larry Page and Sergey Brin placed, behind Google's second "o," the icon of the Burning Man festival, which they would both be attending. They wanted to leave a clue to users of their whereabouts in case Google's server crashed. Followed by Halloween, Thanksgiving, and Christmas Doodles in 1999, the Doodles became a staple of Google.com in 2000 when Dennis Hwang—an intern at the time, and now Google's international webmaster—was assigned as the official Doodler, starting with Bastille Day that year and creating more than one hundred fifty designs since. Now, a team of Doodlers produce Google Doodles that appear globally or on select country versions of the search engine. These designers have become increasingly ambitious, creating motion-based and interactive Doodles that make the company's scarce home page worth a visit. —Armin Vit and Bryony Gomez-Palacio

Various artists, Google Doodles, 2000–2011 Courtesy Google

MTV Logo
Created in 1981 by Pat Gorman, Frank Olinsky, and Patti Rogoff of Manhattan Design, the MTV logo became a landmark in the history of graphic identity as well as a cultural symbol of the dawning age of cable television. The designers employed the traditional precomputer technologies of the day: pens, markers, photocopies, and transparencies. For this project they used a can of spray paint as well, using it to create the "TV" letters that overlay the fat, blocky, cartoon-rendered "M." Rather than assign a fixed set of corporate colors to the MTV identity, the designers decreed that just about anything could happen inside its borders. Since then, countless animators and illustrators have embellished this enduring piece of design history. —EL See Frank Olinsky, "MTV Logo Story," frankolinsky.com

Manhattan Design, MTV logo, frames from the first broadcast of MTV, August 1, 1981 MTV logo used with permission by MTV. ©2011 MTV Networks. All rights reserved. MTV, all related titles, characters and logos are trademarks owned by MTV Networks, a division of Viacom International Inc.

BB—TYPE SPECIMEN
B+B=B

Radim Pesko, Boymans typeface, 2003 Courtesy Mevis & Van Deursen

Museum Boijmans Van Beuningen

Armand Mevis and Linda van Deursen have been leading voices in the Dutch graphic design scene since the early 1990s. Their 2001 system for the city of Rotterdam pioneered the idea of a visual identity as a "toolbox of graphic shapes, to be assembled in different configurations for different things." The bright, neon-inspired identity system they created for the Museum Boijmans Van Beuningen takes cues from the museum's history: "We liked the idea that the building had grown over the years, with new buildings added to older buildings, like a growing architectural collection in itself. And we were into the idea of the museum originally being a combination of two different art collections by former collectors. Mr. Boijmans and Mr. van Beuningen. A double collection." The identity expresses these concepts of doubling and growth through its multi-line typeface, custom-made by Radim Pesko. The linear elements of the typeface nest inside each other to create letterforms that vary in weight and complexity, from a slim single-line construction to densely striped variants. The mix of candy-store colors heightens the eclectic, pop culture sensibility. Signs for temporary exhibitions break with the overall identity, as each exhibition acquires its own typographic voice. Emphasizing this disjunction, the signs are printed on panels that lean against the wall, clustering together at the museum's main entry point and then appearing again at the start of each gallery. —EL See Linda van Deursen and Armand Mevis, *Recollected Work*, 2005

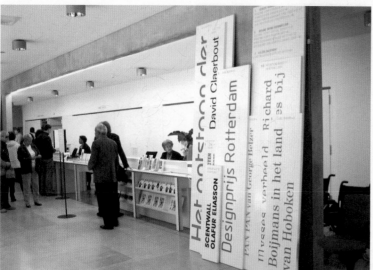

Mevis & Van Deursen, Museum Boijmans Van Beuningen identity system, 2003 Courtesy the artists

SALT EXPLORES CRITICAL AND TIMELY ISSUES IN VISUAL AND MATERIAL CULTURE, AND CULTIVATES INNOVATIVE PROGRAMS FOR RESEARCH AND EXPERIMENTAL THINKING.

Project Projects, SALT identity system, 2011 Courtesy the artists

Timo Gaessner, Kraliçe typeface for SALT identity system, 2011 Courtesy Project Projects

SALT

The graphic identity for SALT, a cultural institution in Istanbul, avoids the idea of a logo altogether. The design team at Project Projects commissioned a custom typeface whose letters S, A, L, and T have a distinctively elliptical form. The typeface, Kraliçe (designed by Timo Gaessner), appears across SALT's communications materials, from signage to catalogues, insinuating its identity everywhere. Project Projects invites designers and typographers to create new alterations to Kraliçe. —EL

17th Biennale of Sydney

Barnbrook Studio's visual identity for the 17th Biennale of Sydney in 2010 employs a mix of elements to create brands and sub-brands for a diverse series of cultural events. The modular design engenders consistency and efficiency, while the cacophony of elements makes each outcome unique. Designed to appear jumbled together, the elements range from Victorian-age medical illustrations and diagrams of crystal structures to abstract assemblies of geometric shapes. The multiple typefaces are original designs released through Jonathan Barnbrook's Virus Fonts. Barnbrook, who has worked in the UK as a designer since the early 1990s, sees letterforms as the visual embodiment of contemporary speech and an essential piece in the "jigsaw" of a design project. Sources for the type range from lettering painted on the side of the plane that bombed Hiroshima to commercial signage from his London neighborhood. With its underlying rhythm and constrained palette of black, red, and white, this flexible identity remains recognizable across a broad range of applications. The system is simple but the results are complex, yielding a cabinet of curiosities that comments on a ragtag civilization surviving in a turbulent age. —EL

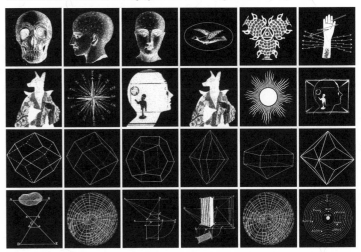

Above and right: Barnbrook Studios, 17th Biennale of Sydney identity system, 2010 Virus typefaces designed by Jonathan Barnbrook and Marcus Leis Allion Courtesy the artists

Mature street trees / 能夠沈思與放鬆 / Having at least 800 square foot to myself / Accoglienti aree pedonali a misura d'uomo con posti a sedere / ไม่ได้ยินเสียงรบกวนจากการจราจรใดๆ ทั้งสิ้น ในขณะที่ฉันกำลังนอนหลับ / Being able to wander the streets, regardless of whether it's

Japanese sake / Savoir dans quelle direction marcher sans lire les panneaux / 친한 친구들 과 스스럼 없이 어울릴 수 있는 것 / Saubere Strassen / I find comfort in just being busy and being in a city where there is always things happening /

平日信步到熟識店家的水果攤, 熟食店, 以及乾洗店 / کوناگونی مردم و تنوع ساختمان های یک شهر است که آنرا گرم و دلنشین می سازد / חלקת דשא לנוה עליה בסוף"ש / أوجه التشابه بين مدينتك أو مدن مختلفة / Traffic lights turning all green at once in sync

Aire acondicionado / ledereen wordt een deel van hun buurt, een deel van de sociale omgeving / ni ayika ogbon ati oye / Knowing I can escape / Ordered chaos / Está sempre movimentada / Sushi lunchbox special / Empty seat on the subway /

Sulki & Min, identity for the first cycle of BMW Guggenheim Lab, 2010–2011 Courtesy the artists

Jonathan Puckey, *SMBA Dictionary*, 2006 Courtesy the artist

BMW GUGGENHEIM LAB

Sulki & Min, BMW Guggenheim Lab identity system, 2011
Courtesy the artists

BMW Guggenheim Lab
This experimental project—part education, part architecture—travels around the world in three instantiations over the course of six years, addressing issues of the contemporary urban environment through public programs and discourse. Sulki & Min were selected to create the overall identity for the project as well as the mark for its first cycle. For the initial series, Sulki & Min's dynamic mark uses the word "lab" as a structural framework, which is then filled with ever-changing content. More specifically, the project website, which was created by the Bureau for Visual Affairs, uses a polling tool with the question: "How would you improve comfort in the city?" The answers appear as color-coded responses within the letterforms. This simple but ingenious solution lays bare the participatory aspect of the project, while playing with the relationship between sentences, words, and letterforms. —AB

Jonathan Puckey on *SMBA Dictionary*

In 2006 the SMBA [Stedelijk Museum Bureau Amsterdam] approached me to design and program their new website. The SMBA is a project space of the Stedelijk Museum and presents contemporary art from an Amsterdam context in their art space on the Rozenstraat. I was interested in using data input into the website as ingredients to distill some kind of new meaning. I created a dictionary system: the SMBA enters words in their personal dictionary, the definitions of these words are defined by the sentences that they appear in. These definitions both define the words and define the way SMBA uses them. Every time one of these words appears in the text, it is linked to the definition page. The colors of the words vary from black (no definitions) to bright green (many definitions). The titles at the top of the page are built up using the words in the SMBA dictionary with the same kind of auto complete function that is used in mobile phones for SMS. Using the custom content management I designed and implemented, the people at the SMBA can easily maintain their website by themselves. —Jonathan Puckey, jonathanpuckey.com

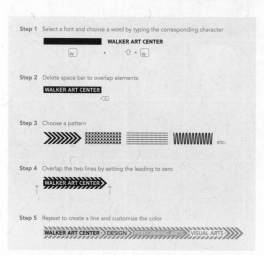

Walker Expanded

While Herzog & de Meuron's architecture was at the heart of the Walker Art Center's expansion in 2005, its institutional identity was also expanded and updated to mark the new era. Building on an existing identity that revolved around a type family, aptly named Walker and designed in 1995 by Matthew Carter, the Walker's design director Andrew Blauvelt and designer Chad Kloepfer created Walker Expanded, a flexible system of vertical stripes using different words, patterns, motifs, and colors that encase the institution's messaging. To aid in the deployment of this complex system, Eric Olson of Process Type Foundry was hired to create a digital font that would contain all the different elements, allowing for both efficiency and consistency across applications. The result is an ever-changing identity system that maintains a common visual language. —Armin Vit and Bryony Gomez-Palacio

Step 1 Select a font and choose a word by typing the corresponding character

Step 2 Delete space bar to overlap elements

Step 3 Choose a pattern

Step 4 Overlap the two lines by setting the leading to zero

Step 5 Repeat to create a line and customize the color

Eric Olson (Process Type Foundry), Walker Expanded utility, 2005

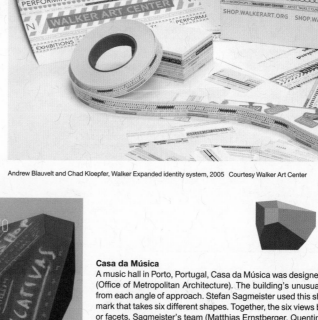

Andrew Blauvelt and Chad Kloepfer, Walker Expanded identity system, 2005 Courtesy Walker Art Center

Clubbing 06
Maio Dom 12:00
patrocínio OPTIMUS
Spektrum
Hans-Joachim Irmler [Faust]
Rework Fujiya & Miyagi Healer Selecta
Go Go Girls entrada livre/sala sugge

SERVIÇO EDUCATIVO

Casa da Música

A music hall in Porto, Portugal, Casa da Música was designed in 2005 by Rem Koolhaas' OMA (Office of Metropolitan Architecture). The building's unusual geometry makes its profile vary from each angle of approach. Stefan Sagmeister used this shifting silhouette to create a brand mark that takes six different shapes. Together, the six views break down into seventeen planes or facets. Sagmeister's team (Matthias Ernstberger, Quentin Walesh, and Ralph Ammer) created a seventeen-point color-picking tool that samples a given image and generates a palette for filling in the facets with color. Images and textures can also be mapped onto the planes of the logo object, yielding a graphic identity with endless potential. While Sagmeister initially sought to avoid directly depicting the architecture, he realized that the building is itself a logo, one that demanded an imaginative and unexpected treatment: "We did try to avoid another rendering of a building by developing a system where this recognizable, unique, modern form transforms itself like a chameleon from application to application, changes from media to media where the physical building itself is the ultimate (very high-res) rendering in a long line of logos." The logo's multiple renditions are intended to reflect the range of music performed inside the house. The logo is like a dice with distinct faces and distinct personalities. —EL

Rem Koolhaas/OMA, Casa da Música building, Porto, Portugal, 2007
Courtesy the artist

Stefan Sagmeister with Màtthias Ernstberger and Quentin Walesh, Casa da Música identity system featuring Logo Generator by Ralph Ammer, 2007 Courtesy the artists

200

Marres

This center for contemporary culture is located in the town of Maastricht, in the southern part of the Netherlands. It explores different ways that art can appear in relation to the broader culture and organizes exhibitions and programs off-site as well as in its own facility. Maureen Mooren designed an identity for Marres that consists of multiple renditions of the center's name. Presented in black and white, most of the logo variants employ drawn or constructed letterforms rather than existing typefaces. Mooren aimed to express the open curatorial program of Marres, countering the notion of a fixed institutional voice. —EL

Maureen Mooren, *Marres In Between: This Is Not A Damien Hirst* poster, 2008

Above and below: Maureen Mooren, Marres identity system, 2007–2011 Courtesy the artist

Design Museum

From 2001 to 2006, Alice Rawsthorn was director of the Design Museum in London. In 2002 she commissioned the London firm GTF (Graphic Thought Facility) to create a new graphic identity reflecting the museum's eclectic definition of design and its growing presence online and in the local community. GTF created a system in which the museum's name sits within a changing tangle of images. Working on-site at the museum, illustrator Kam Tang created dozens of digital line drawings that reflect the diversity of objects in the collection while referring abstractly to broader ideas about pattern, growth, communication, and biomorphic transformation. The drawings that swarm around the principle typography change from one application to another. For the museum's 2006 Designer of the Year exhibition, GTF designed a large-scale mobile featuring drawings applied to sheets of water-jet-cut high-pressure laminate; the complex metal structure was created by Timothy Rose, a mobile artist based in California. In the resulting work, two-dimensional graphics enter a playful 3-D space. —EL

Above and right: GTF, Designer of the Year identity system, 2002
Courtesy the artists and Design Museum, London

operates and loads like a font but instead of individual characters it contains words and customizable patterns that can be merged together on the same line. The tool approach to identity creation can be seen in Stefan Sagmeister's identity for Casa da Música (2007). His software, called Color Picker, isolates, identifies, and creates a color palette based on a selected image, which is used to fill the sides of the logo, its shape derived from a rotating view of the music house's unusually shaped building. Jonathan Puckey, working with an identity created by Mevis & Van Deursen for the Stedelijk Museum Bureau Amsterdam (SMBA), designed the museum's website, which includes a dynamic "dictionary" of terms parsed from staff entries to the site's content management system.

Perhaps the most extreme example of such variable and flexible identities is one for Marres, a contemporary cultural center in Maastricht, the Netherlands. Created by Maureen Mooren, the identity is essentially an uppercase "M" but of seemingly any font, its full name rendered in multiple typefaces. It is an identity built from every other identity. Project Projects' recent identity program for SALT, a contemporary cultural center in Istanbul, offers a custom-designed typeface, Kraliçe (Timo Gaessner, 2011), as its core identity. However, there is no fixed logo configuration; rather, the letterforms "S," "A," "L," and "T" are specially treated like alternate characters in the font and make their appearance in the various messages issued by the institution. In a new twist, this distributed identity program, like the organization itself, becomes the site of a changing program of activity as Project Projects invites a new typographer to reimagine its quattro ensemble of letterforms every four months.

Branding arose to inject a little personality into the abstraction of corporate identity. After all, a logo is just a name, while a brand is an experience. Branding today is a narrative-driven enterprise. A logo was a mark of ownership, while a brand is a story, which is the most compelling form of communication and the most personal. Corporate identity sought to make a name recognizable and memorable, while branding is about bonding consumers to companies with ties so strong that in the words of Saatchi & Saatchi, there is "loyalty beyond reason." [8] To say we live in a branded world is to state the obvious. The concept of branding moved relatively quickly and intensely from the confines of the corporate boardroom to the assembly halls of cities and national governments.

London of the 1990s and the early days of Tony Blair's New Labour government saw the emergence of "Cool Britannia," an attempt to capture the allure of a happening urban scene to rebrand an entire country. Shortly into the new millennium, architect Rem Koolhaas was tasked with imagining a logo for the new European Union flag. His firm's solution of thin vertical stripes representing the colors of each participating country's flag was a novel concept that allowed for infinite expansion (or subtraction). The resulting multicolor design was the seemingly perfect expression of neoliberal inclusive democratic principles ("everyone is equal") under the ubiquitous sign of late-capitalist consumption, the barcode.

One of the more interesting explorations of branding the nation-state was the research project undertaken by Metahaven at the Jan van Eyck Academie, a postgraduate school for art, design, and theory located in Maastricht, the site where the treaty creating the European Union was drafted. Metahaven did not take the EU as its subject but rather the obscure micronation, the Principality of Sealand. Not an island in the traditional sense, it is a World War II–era military fortress just off the coast of England in the North Sea. Occupied since 1967 by British Major Paddy Roy Bates and his family and associates, this elevated concrete platform has asserted its sovereignty ever since, although no sovereign states recognize its existence. Sealand's principle activities have evolved from hosting a data haven (HavenCo, 2000–2008), a safe harbor from the regulation and restriction of information, to current attempts to establish online gambling operations. In this rare instance, a single structure represents an entire country: the map is the territory. Perhaps not surprisingly, the resulting designs replicate the Sealand platform: two verticals and a horizontal on top. With this simplified system and formal gestalt, a wide variety of marks are possible. I prefer an image of two Dixie cups and, appropriately, a paperback copy of Antonio Nigri and Michael Hardt's *Empire*, the now-classic text on the new political order of globalization.

For this exhibition, Metahaven tackles the emerging dominance of social media empire Facebook (and others like it). With more than 750 million users, Facebook would be the third largest country behind only China and India. Appropriately named *Facestate*, this project examines the two sides of this Janus-faced world of centrally owned, privately held information. Social media platforms such as Facebook allow individuals to plug into an

existing system, and in contrast to its failed predecessor, Myspace, offers only a limited ability to customize one's look and feel. As Metahaven notes, Facebook represents a new type of organizational entity, one formed in, by, and through networks and driven by standards, templates, and protocols, not brand promises (Mark "privacy is no longer a 'social norm'" Zuckerberg). [9] More powerful than its logo, Facebook's "like" function permeates the web, and its automated sign-in protocol on other sites makes nearly all such occurrences already a cobranded experience. Social networks are harbingers of the evolution of the value of capital in our society, from the direct product of labor in the days of Karl Marx to the effects of education and knowledge, dubbed cultural capital, and finally to an era of social capital, where affiliations, relations, communities, and networks of mutual recognition operate.

The impulse to identify oneself to others is particularly powerful, a nearly ancient impulse. Among the earliest forms of branding, heraldry began to flourish in Europe in the twelfth century. Concerned with granting, creating, recording, and displaying various coats of arms and badges, heraldry is a graphic language used to identify groups of people such as states, armies, or families. The system of heraldry is described in textual terms as a blazon, a set of instructions or descriptions for the creation of a particular mark. To *emblazon* is to create a mark, which requires some degree of interpretation. Dexter Sinister, which took its name from heraldic terminology for right and left, created a heraldic mark for a proposed experimental art school project as part of Manifesta 6, a biennial of contemporary art. Their blazon reads "(party) per bend sinister." The shield is divided with a line ("(party)") that begins in the upper corner (the viewer's right but since the orientation in heraldry is from the user's position, this would be the left, or "sinister") and bisects the field diagonally ("bend"). [10] The resulting form is independent of any material and thus can be embodied in many different ways. For example, Dexter Sinister has rendered its blazon as a lapel pin or a neon sign.

Given heraldry's roots in the identification of army units since at least the Middle Ages, we should not be surprised to learn that the Pentagon maintains an Institute of Heraldry. Its responsibilities include "the coordination and approval of coats of arms and other insignia for Army organizations." An offshoot of the Heraldic Program Office

HM Fort Roughs, Principality of Sealand, shown after a fire, 2006

Above and left: Metahaven, *Facestate*, 2011

Metahaven, *Uncorporate Identity*, 2010 Photo: Sally Foster Courtesy Lars Müller Publishers

Uncorporate Identity

Few collectives have achieved more notoriety than the Amsterdam-based partnership Metahaven. This "studio for design and research" creates books, articles, exhibitions, lectures, and visual projects that display equal confidence with academic writing and graphic form-making. Metahaven's 2010 book *Uncorporate Identity* (edited by Metahaven and Marina Vishmidt) compiles texts and visual projects critiquing the state of design and the design of states in the postmillennial global economy. Visually, *Uncorporate Identity* demonstrates the reorientation of experimental design since the 1990s. Back in the day, progressive designers sought to interpret content, using typography to amplify and emphasize words and phrases and draw out nuances of meaning. In contrast, Metahaven's work is brutally systematic, using stripes, gradients, geometric shapes, and typographic watermarks that roll like military tanks across pages of scholarly text, laying down a regime of indiscriminate effects adapted from mass media. —EL

PRINCIPALITY OF SEALAND

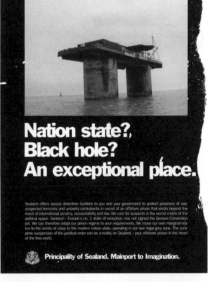

Nation state?, Black hole? An exceptional place.

Sealand offers secure detention facilities to you and your government to protect prisoners of war, suspected terrorists and unlawful combatants in secret of an offshore prison that exists beyond the reach of international scrutiny, accountability and law. We care for suspects in the secret matrix of the political space. Sealand – Europe's no. 1 state of exception, has not signed the Geneva Convention yet. We can therefore adapt our prison regime to your requirements. We move our own marginal status to the centre of crisis to the modern nation state, operating in our own legal grey zone. The complete suspension of the juridical order can be a reality on Sealand – your offshore prison in the heart of the free world.

Principality of Sealand. Mainport to Imagination.

ISBN 978-0-935640-98-4 $40.00

Barcode for *Graphic Design: Now in Production*, 2011

Rem Koolhaas/AMO, proposal for a European Union flag, 2002

QR code for *Walker Art Center Design* blog

Barcode and QR Code

Bar codes use a series of stripes of varying width to turn alphanumeric content into scannable data. The first Universal Product Code (UPC) was applied to a pack of Wrigley chewing gum in 1974. Barcodes have been ubiquitous ever since, linking physical things with digital networks. Barcodes now compete with other technologies, such as radio frequency identification (RFID), used to track the movement of packages, livestock, and even people, and Quick Response (QR) codes, which employ a matrix of squares to convey short pieces of information, such as a phone number or web address, that can be scanned with a mobile phone or other device. While such coding technologies were created primarily to track business transactions, they are now aimed at consumers and have become a powerful marketing mechanism. —EL

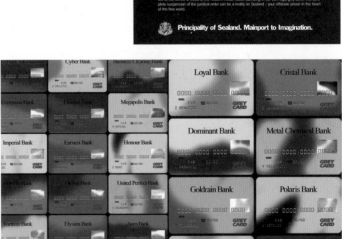

Above: Metahaven, *Sealand Identity Project*, 2003–2004 Courtesy the artists

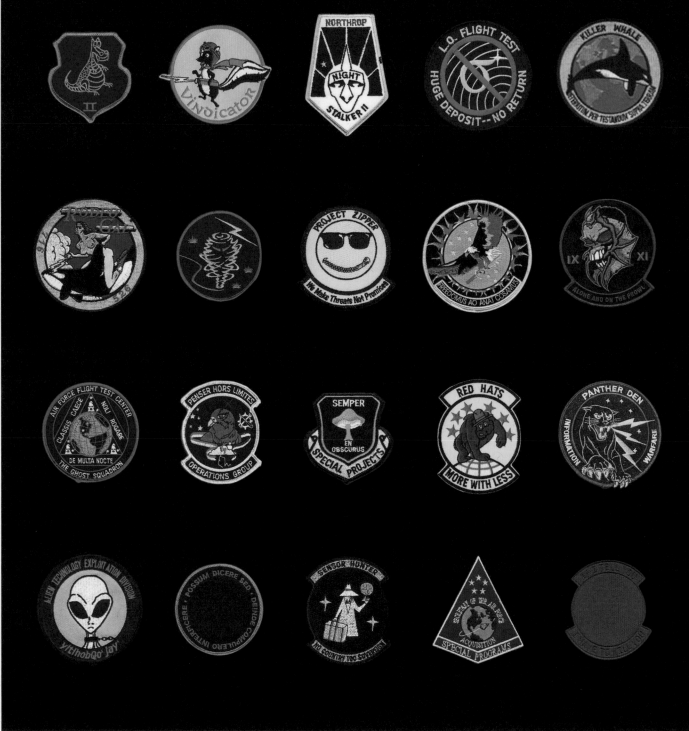

Trevor Paglen, *Symbology Vol. 1*, 2006 Courtesy the artist and Altman Siegel Gallery Collection Mike Wilkins & Sheila Duignan

Symbology: Trevor Paglen

Trevor Paglen is an artist who employs the investigative tools of journalism and social science. To create his 2006 project *Symbology (Volume I)*, Paglen collected embroidered patches from the "black world" of classified military and intelligence units. Although the activities and even the existence of such programs are closely guarded secrets, members of this covert world nonetheless seek to express their group identities. Their underworld patches emulate the established language of the military, where symbols and insignia have long expressed a warrior's rank, achievements, and affiliations. An ominous sense of humor pervades these unofficial insignia, which include anything from a satin-stitched alien head to the warning "Don't ask! NOYFB." Paglen is the author of several books about the culture of national security, including *I Could Tell You But Then You Would Have to Be Destroyed by Me: Emblems from the Pentagon's Black World* (2008). —EL

United States Army Institute of Heraldry

Located at Fort Belvoir, a military installation in Washington, DC, the United States Army Institute of Heraldry provides heraldic services to branches of the armed forces and other governmental entities. The Institute undertakes various activities, such as research, design, development, standardization, presentation, and recording of official symbolic iconography, including flags, medals, badges, insignia, decorations, and seals. Although the US military has been using and issuing insignia and other forms of heraldry since the American Revolution, the roots of official governance can be traced to 1919 when a special office within the Department of War was formed to handle such issues. Public Law 85-263 in 1957 further delineated the authority of the Secretary of the Army to provide heraldic services to the military and other federal entities. —AB

Andrew Blauvelt

(We Would Like to Share)
Some Thoughts on a Possible School Badge

"The oblique stroke appears at first sight to be the signal that the binary opposition between categories (speech/writing or love/hate) won't hold — that neither of the words in opposition to each other is good for the fight. The stroke, like an over-vigilant referee, must keep them apart and yet still oversee the match."
—Steve Rushton

Heraldry is a graphic language evolved from around 1130 AD to identify families, states and other social groups. Specific visual forms yield specific meanings, and these forms may be combined in an intricate syntax of meaning and representation. Any heraldic device is described by both a written description and its corresponding graphic form. The set of a priori written instructions is called a Blazon — to give it form is to Emblazon. ¶ In order to ensure that the pictures drawn from the descriptions are accurate and reasonably alike, Blazons follow a strict set of rules and share a unique vocabulary. Objects, such as animals and shapes, are called Charges; colors are renamed, such as Argent for Silver or Or for Gold; and divisions are described in terms such as Dexter ("right" in Latin) and Sinister ("left"). ¶ A given heraldic form may be drawn in many alternative ways, all considered equivalent, just as the letter "A" may be printed in a variety of fonts. The shape of a badge, for example, is immaterial and different artists may depict the same Blazon in slightly different ways. ¶ The Blazon is a fixed, abstract literary translation of the open, representational graphic symbol (and vice versa.) Using a limited but precise vocabulary, full descriptions of shields range in complexity, from the relatively simple:

> Azure, a bend Or to the relatively complex:
> (Party) per fess, Vert and Gules, a boar's head erased Argent, langued Gules, holding in his mouth the shankbone of a deer proper, in chief: and in base two wings conjoined in lure reversed Argent. Above the shield is placed an Helm befitting his degree with a Mantling Vert doubled Argent, and on a Wreath of the Liveries is set for Crest a hand proper holding a Celtic cross paleways, Or, and in an Escrol over the same the motto "l'Audace".

Today, schools, companies and other institutions may obtain officially recognized forms from heraldic authorities, which have the force of a registered trademark. [1] Heraldry might equally be considered part of a personal or institutional heritage, as well as a manifestation of civic and/or national pride. However, many users of modern heraldic designs do not register with the proper authorities, and some designers do not follow the rules of heraldic design at all. ¶ Bastards. [2] ¶ In proposing a badge for a (possibly) temporary art school, we are interested in following, yet superseding, heraldic conventions. [3] Just as *Manifesta 6* is founded on a new, informed reading of art schools, so its logo can be founded on a new, informed reading of heraldry. Both referring to, and departing from, tradition. ¶ Our Blazon:

> (party) per bend sinister

translated to English means:

> a blank shield with a single diagonal line running from the bottom left edge to the top right hand corner

The badge we would like to wear is two-faced — both founded on, and breaking from, established guidelines. Stripped to its fundamentals, and described in heraldic vocabulary, it is UNCHARGED. It is a schizophrenic frame, a paradox, a forward slash making a temporary alliance between categories, simultaneously generic and/or specific. —Dexter Sinister

Notes

1. In fact, Scotland's chief heraldic authority, Lord Lyon, retains far-reaching powers equal to a high-court judge.
2. It is worth noting that, on reading an early draft of this text, heraldic expert David Phillips commented, "People who use arms without authority are cads, not bastards."
3. Contrary to Josef Albers' notes on Black Mountain College logo from the March 1935 newsletter: "We are not enamored of astrological, zoological, heraldic, or cabalistic fashions. We have hunted neither the phoenix nor the unicorn, we have dug up no helmet and plume, nor have we tacked on learned mottoes. And for 'sapienta' or 'virtus' we are still too young. ¶ Instead, as a symbol of union, we have chosen simply a simple ring. It is an emphasized ring to emphasize coming together. Or, it is one circle within another: color and white, light and shadow, in balance. And that no one may puzzle."

(party) per bend sinister

Dexter Sinister, selections from *We Would Like to Share (Some Thoughts on a Possible School Badge)*, 2006 Courtesy the artists

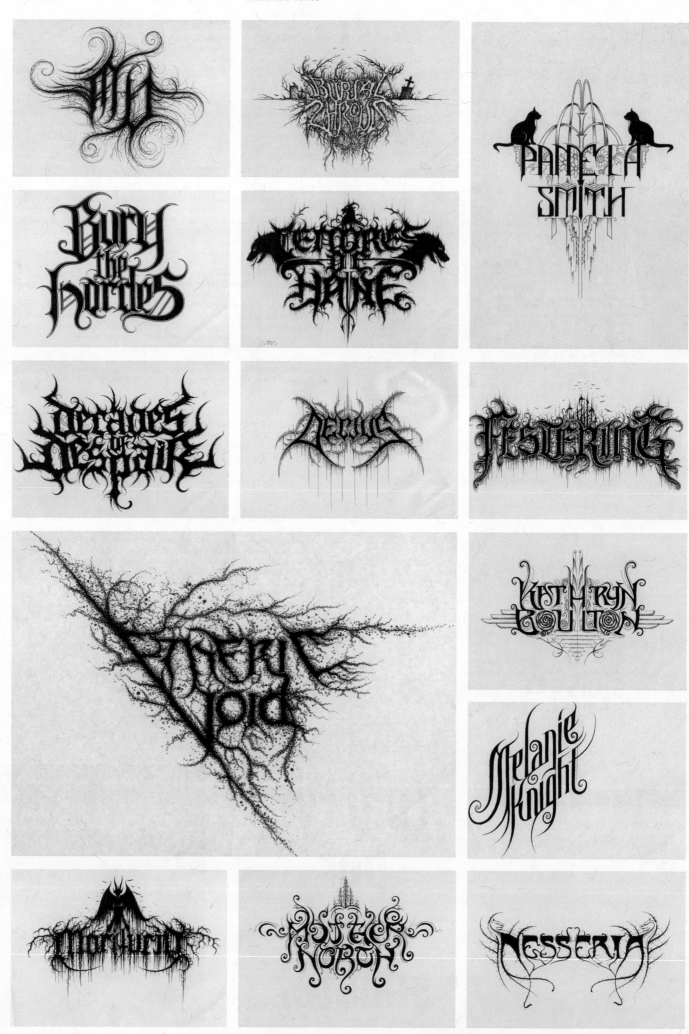

Christophe Szpajdel

Agarthus. Cryptlord. Desecrator. Macabrum. Sadistik Distortion. 6 Black Coffins. Wikkid Gifts. These are only seven of the more than 7,000 black or death metal bands that Christophe Szpajdel has created logos for in the past twenty years. A Belgian currently living in Exeter, Devon, in the UK, Szpajdel works in forestry engineering as well as being a retail assistant at the Cooperative Food Stores and in his free time creates—by hand—intensely intricate, detailed, and energetic logos for the obscure (literally and figuratively) market of death metal. Known as the Lord of Logos, Szpajdel works fast and furiously, just like the music, and in return all he asks for, although he doesn't always get it, is copies of the CDs with his work printed on them. Despite the niche market and apparent visual sameness of death metal aesthetics, Szpajdel has a remarkable range of approaches that are inspired by Art Deco, Art Nouveau, and nature. The 240-page book *Lord of the Logos*, published by Gestalten in 2010, catalogues his impressive output to date.
—Armin Vit and Bryony Gomez-Palacio

206

Christophe Szpajdel, various logotypes, 2009–2011

Left to right, top to bottom (page 206); Abigail Williams Symbol, 2011; Burial Shroud, 2011; Pamela Smith, 2009; BURY THE HORDES, 2010; Cendre de Haine, 2011; Decades of Despair, 2011; Decius, 2011; Etheric Void, 2009; Karthyn Boulton, 2011; Melanie Knight, 2011; MORITURIO, 2011; Mother North, 2011; Nesseria, 2010;
Left to right, top to bottom (page 207); Obsolescence, 2010; Octoculto, 2011; Old Spectre, 2009; Ov Hollowness, 2009; Vultures, 2009; Pyre, 2011; Ruins of the Earth, 2010; Sadistic Passage, 2011; Samantha Byrne, 2011; Self-Inflicted Violence, 2010; Valentine, 2009; The Light Asylum, 2009; To Storm The Fortress, 2009; Vomit Of Torture, 2010; We Are Legion, 2010; HERLAKA ROSE, 2011

created by President Woodrow Wilson in 1919, the institute's purview was expanded in 1957 by Public Law 85-263 to furnish services to essentially all branches of the federal government, covering all manner of objects: flags, streamers, coats of arms, emblems, seals, and badges. Trevor Paglen, an artist, writer, and experimental geographer, has been collecting numerous examples of "black world" military badges. These emblems identify various entities engaged in secret military and covert intelligence operations. Pointing to the inherent paradox of these badges, Paglen asks: "If the symbols and patches contained in this book refer to classified military programs, the existence of which is often a state secret, why do these patches exist in the first place? Why jeopardize the secrecy of these projects by attaching images to them at all—no matter how obscure or indirect those images might be?" [11] By way of explanation, Paglen suggests that esprit de corps plays a key role: "Insignias became a way to show the rest of the world who one was affiliated with—something similar to a sports fan wearing the colors of their home team. To wear insignia is to tell the world that one is part of something much larger than oneself." [12] Indeed, forms of identity are most powerful among those who share it. The code is best or only understood within the community it is intended to serve. The scale and scope of black world insignia is unknowable, although one could easily speculate that it has increased, just as the budgets for such operations have grown since the events of September 11, 2001.

The realm of the subcultural—just like the black world of the government—exists separate from yet part of the larger culture—its codes, styles, and argot serve as markers of distinction from mainstream culture and its social norms. The world of black metal provides one such segment of subcultural identity that has remained largely resistant to the kind of commodification and absorption into the mainstream that befell other movements such as punk and hardcore. Christophe Szpajdel has created more than 7,000 logos for mostly black metal bands since the mid-1990s, although he has been drawing since childhood. The spiky letterforms and intricate visual complexity of these marks are often unreadable to outsiders but nevertheless provide a powerful attraction and resonance within their community. In these instances, illegibility becomes a hallmark trait, an inscrutable communicative act specifically designed to resist outsider interpretation. The black world of the military and the world of black metal music,

besides sharing an affinity for the symbolic absence of light, converged at Gitmo when so-called Satanic strains of such music were played at deafening volumes as an instrument of torture used by interrogators on their pious Muslim captives. [13]

The classic analysis of the concept of subcultures arose from the work of cultural theorist Dick Hebdige, who in his book *Subculture: The Meaning of Style* (1979) focused on the British punk scene of the 1970s. This youth culture movement, the remnants of which can still be found today, provided fertile ground upon which to observe the recontextualization of ordinary objects such as safety pins or the subversion of mainstream signifiers such as a school uniform or the Union Jack. The fluidity and flexibility of meaning that such strategies laid bare provided plenty of evidence of what semiologists refer to as a floating signifier. Glen Cummings and Adam Michaels in their book *X-X-X-X-X-X-X-X-X-X* (2009) explore this iconic letterform of varied meanings across various cultural landscapes, particularly in punk and hardcore music scenes, but also in pornography, the military, and corporate trade names, among many others. As the authors note, the "X" signifies presence ("X marks the spot"), unknown absence ("brand X"), and potency ("XXX rated"). In the naming of new products and services, X reigns supreme: Xerox, Kleenex, Memorex, X-ray, X-Factor, X-Files, X-Box, X-Men, X Games, Timex, Playtex, FedEx, Exxon, Xanax. These fanciful constructions are the lingua franca of the branded world. Their names elide their artificiality, a linguistic vessel or placeholder waiting to be filled with new meanings, associations, promises, and experiences. Cummings and Michaels relate the appeal of the "X" to that of the "O," finding the former more useful in naming circumstances. Undoubtedly, the formal symmetry of each letterform is appealing. While the "X" suggests the intersection or crossing of two things, the "O" connotes continuity and wholeness: no beginning and no end. Like the Kodak Carousel, and branding itself, its action is perpetual. Such is the power of the floating signifier. All that remains is a story to anchor its meaning. ⊠

Notes

1. The saga of the proposed 2012 London Olympic Games mark can be read on the relevant *Wikipedia* page: http://en.wikipedia.org/wiki/2012_Summer_Olympics#Logo.
2. The Gapgate episode is chronicled on the website *Brand New*, http://www.underconsideration.com/brand new/archives/follow-up_gapgate.php.
3. Alissa Walker, "An Exclusive Interview with the New Gap Logo," Fastcodesign.com, October 7, 2010,

http://www.fastcodesign.com/1662453/an-exclusive-interview-with-the-new-gap-logo.
4. Scott Stowell, "The First Report of the (Unofficial) Graphic Design Landmarks Preservation Commission," *Metropolis* magazine (May 2004): 104–107.
5. Rob Giampietro, from his blog *Lined and Unlined*, http://blog.linedandunlined.com/post/404917364/form-giving.
6. Frank Olinsky, "The MTV Logo Story," accessed July 13, 2011, http://www.frankolinsky.com/mtvstory1.html.
7. James B. Twitchell, *Branded Nation: The Marketing of Megachurch, College, Inc., and Museumworld* (New York: Simon & Schuster Paperbacks, 2004).
8. Saatchi & Saatchi promote the neologism "lovemark" to talk about the most profound sense of brand loyalty, http://www.adcentricity.com/services/creative-agency-profiles/saatchi-and-saatchi/.
9. Metahaven, *Uncorporate Identity* (Baden, Switzerland: Lars Müller Publishers, 2010), 8.
10. David Reinfurt discusses the creation of the mark as part of his lecture at the Walker Art Center on March 17, 2009, http://channel.walkerart.org/play/david-reinfurt/.
11. Trevor Paglen, *I Could Tell You But Then You Would Have to Be Destroyed by Me: Emblems from the Pentagon's Black World.* (Brooklyn: Melville House Publishing, 2008), 10.
12. Ibid., 11.
13. Suzanne G. Cusick, "Music as Torture, Music as Weapon," *Cageprisoners* blog, accessed July 13, 2011, http://www.cageprisoners.com/articles.php?id=19404.

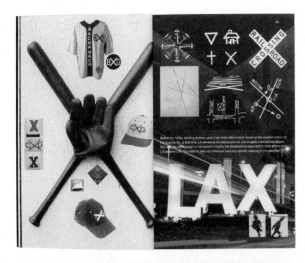

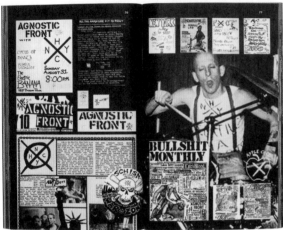

Above and right: Adam Michaels (Project Projects) and Glen Cummings (MTWTF), *X-X-X-X-X-X-X-X-X-X-X*, 2009 Courtesy the artists

Ouroboros

The Ouroboros (or Uroborus) is an ancient symbol depicting a serpent or dragon eating its own tail. It comes from the Greek words *oura* meaning "tail" and *boros* meaning "eating", thus "he who eats the tail". ¶ The Ouroboros often represents self-reflexivity or cyclicality, especially in the sense of something constantly re-creating itself, the eternal return, and other things perceived as cycles that begin anew as soon as they end (the mythical phoenix has a similar symbolism). It can also represent the idea of primordial unity related to something existing in or persisting before any beginning with such force or qualities it cannot be extinguished. The ouroboros has been important in religious and mythological symbolism, but has also been frequently used in alchemical illustrations, where it symbolizes the circular nature of the alchemist's opus. It is also often associated with Gnosticism, and Hermeticism. ¶ Carl Jung interpreted the Ouroboros as having an archetypal significance to the human psyche. The Jungian psychologist Erich Neumann writes of it as a representation of the pre-ego "dawn state", depicting the undifferentiated infancy experience of both mankind and the individual child. —*Wikipedia*

Walker Art Center Design Studio, D-Crit identity system, 2008 Courtesy Emmet Byrne

D-Crit

"X" is the intersection, the crossroads; it marks the spot, like crosshairs or crossed swords. A constantly rotating stable of found images of design—a humble ice cream cone, the exotic Mars Rover, the playful Linux penguin, or the iconic OMA's CCTV tower—will find itself at the center for observation, study, and critique. This very visual identity was for the School of Visual Arts Master of Fine Arts in Design Criticism program, founded by Alice Twemlow and Steven Heller in 2008. The visual identity program was created by the Walker Art Center design studio, which also provided its truncated moniker, or DJ name, D-Crit. —AB

Adam Michaels (Project Projects) and Glen Cummings (MTWTF), installation views of *X-X-X-X-X-X-X-X-X-X-X*, W/—Project Space, New York, 2009 Courtesy the artists

2006
Designing Our
Own Graves
Dmitri Siegel

Joe Scanlan, installation view of *DIY*, Van Abbemuseum, Eindhoven, 2003 Courtesy the artist

Joe Scanlan, *DIY*, 2003 Courtesy the artist

Joe Scanlan, *DIY*, 2003 Courtesy the artist

Joe Scanlan
A while back I was invited to participate in a group show titled *No Man's Land* in Germany and my proposal was to arrive two weeks prior, measure the curator, Julian Heynen, for a coffin, and then build it for him as my contribution to the show. He agreed! Suddenly I was really on the spot, I wanted to do a nice job for him, so I proceeded to sacrifice myself to the execution of the idea. The better the craftsmanship on the coffin, the less visible was my hand in its making. It was a revelatory experience. ¶ Several more coffins ensued, with me getting more and more remote from each one's making, until I got the idea to reverse engineer the one out of IKEA products. I guess this is where the idea of the embedded reaches global proportions, since latent versions of that coffin exist as we speak on the shelves of IKEA stores all over the world. IKEA doesn't know the coffins are there—obviously they don't think they're in the funeral business. But I know the coffins are there, and so do the few thousand people who own *DIY*, the instruction manual for how to shop and make the coffin. —Joe Scanlan, interview with Jeremy Sigler, *Bombsite*, July 2010

Fantasy coffins of the Ga tribe, Ghana Photo ©Karen Miller/Cheekablue

Prosumer
Marshall McLuhan and Barrington Nevitt suggested in their 1972 book *Take Today*, that with electric technology, the consumer would become a producer. In the 1980 book *The Third Wave*, futurologist Alvin Toffler coined the term "prosumer" when he predicted that the role of producers and consumers would begin to blur and merge (even though he described it in his book *Future Shock* from 1970). Toffler envisioned a highly saturated marketplace as mass production of standardized products began to satisfy basic consumer demands. To continue growing profit, businesses would initiate a process of mass customization, that is the mass production of highly customized products. However, to reach a high degree of customization, consumers would have to take part in the production process especially in specifying design requirements. —*Wikipedia*

Buried Art
Since the 1950s, the Ga tribe of coastal Ghana has become famous for their celebratory funeral processions revolving around elaborately hand-carved, wooden "fantasy coffins." Unlike Western caskets, which typically convey a sense of solemn inevitability, fantasy coffins are boisterous and colorful, made in the shape of objects often symbolizing the trade or hobby of the deceased. A shoemaker is buried in a giant shoe, a sewing machine for a seamstress, a pink fish for a fisherman, a 35mm camera for a photographer. Some of these containers even feature the dead one's favorite vice, such as a giant cigarette or a beer bottle. Often costing more than a year's wage, these elaborate sculptures have come to mark a person's social status, and some families choose to send their loved ones off in style—imagine being buried in your favorite luxury brand: a Mercedes-Benz, a single Air Jordan sneaker, a Nokia cell phone. The coffins can take several weeks to create while the deceased patiently waits on ice in the morgue until it is finished, paraded down the street, and then buried, never to be seen again, at least by the living. —EB

A recent coincidence caught my eye while at the bookstore. A new book by Karim Rashid called *Design Your Self* was sitting on the shelf next to a new magazine from Martha Stewart called *Blueprint* that bore a similarly cheerful entreaty on its cover: "Design Your Life!" These two publications join Ellen Lupton's recent *DIY: Design It Yourself* to form a sort of mini-explosion of literature aimed at democratizing the practice of design (never mind that, as Lupton has noted, Rashid's book is actually more about designing his self than yours).

With the popularity of home improvement shows and self-help books, our society is positively awash in do-it-yourself spirit. People don't just eat food anymore, they present it; they don't look at pictures, they take them; they don't buy T-shirts, they sell them. People are doing-it-themselves without end. But to what end? The artist Joe Scanlan touches on the more troubling implications of the DIY explosion in his brilliantly deadpan piece *DIY,* which is essentially instructions for making a perfectly functional coffin out of an IKEA bookcase. Scanlan's piece takes the basic assumption that design is something that anyone can (and should) participate in. But what is behind all this doing-it-ourselves? Does that coffin have your career's name on it?

The design-your-life mindset is part of a wider cultural and economic phenomenon that I call *prosumerism*—simultaneous production and consumption. The confluence of work and leisure is common to a lot of hobbies, from scrapbooking to hot-rodding. But what was once a niche market has exploded in the past decade. Prosumerism is distinctly different from purchasing the tools for a do-it-yourself project. The difference can be seen most clearly in online products such as Flickr and *Wikipedia*. These products embody an emerging form of inverted consumerism in which the consumer provides the parts and the labor. In *The Wealth of Networks*, Yale Law School professor Yochai Benkler calls this inversion "social production" and says it is the first potent manifestation of the much-hyped information economy. [1] Call it what you will, this "non-market activity" is changing not just the way people share information but their definition of what a product is.

This evolving consumer mentality might be called "the templated mind." The templated mind searches for text fields, meta tags, and rankings like the handles on a suitcase. Data entry and customization options are the way prosumers grip this new generation of products. The templated mind hungers for customization and the opportunity to add their input. The templated mind trusts the result of social production more than the crafted messages of designers and copywriters. And this

mentality is changing the design of products. Consider Movable Type, the software behind the blog revolution. This prosumer product has allowed hundreds of thousands of people to publish themselves on the web. For millions of people, their unconscious image of a website has been shaped by the constrained formats allowable by Movable Type templates. They unconsciously orient themselves to links and comments. Any designer working on a web page has to address that unconscious image. And it does not just impact designers in terms of form and style. As the template mentality spreads, consumers approach all products with the expectation of work. They are looking for the blanks, scanning for fields, checking for customization options, choosing their phone wallpaper, rating movies on Netflix, and uploading pictures of album art to Amazon. The template mentality emphasizes work over style or even clarity.

This shift in emphasis has the potential to marginalize designers. Take book covers. The rich tradition of cover design has developed because publishers have believed that a cover could help sell more books. But now people are buying books based on peer reviews, user recommendations, and rankings. Word of mouth has always been a powerful marketing force, but now those mouths have access to sophisticated networks on which their words can spread faster than ever before. Most covers are seen at 72dpi. The future of the medium depends on how it is integrated into the process of social production. The budget that once went to design fees is already being redirected to manipulating search criteria and influencing Google rankings. A good book cover can still help sell books, but it is up against a lot more competition for the marketing dollar.

Prosumerism is also changing the role of graphic design in the music industry. When the music industry made the shift to compact discs in the late 1980s, many designers complained that the smaller format would be the death of album art. Fifteen years later those predictions seem almost quaint. The MP3 format makes compact disc packaging seem like the broad side of a barn. Album art has now shrunk to a 200 x 200 pixel JPEG or has been made irrelevant entirely. Many bands of the last few years—Arctic Monkeys, Vampire Weekend, and Clap Your Hands Say Yeah, to name just a few—have all broken into the popular consciousness via file sharing before or without releasing an actual record with old-fashioned artwork. Gnarls Barkley's irresistible hit "Crazy" made it to the top of the UK pop charts before it was even released, based entirely on MP3 downloads. As playlists and favorites become the currency of the music industry, the album as an organizing principle

may disappear entirely. The public image of a musician or band is no longer defined by an artfully staged photo or eye-popping album art. A file name that fits nicely into the "listening to" field in the Myspace template or a 16 x 16 pixel favicon in the web browser's address bar might be more important.

In *Revolutionary Wealth*, veteran futurists Alvin and Heidi Toffler (*Future Shock*, *The Third Wave*) paint a very optimistic picture of prosumerism. [2] They rightly make the connection between the do-it-yourself ethos and the staggering increases in wealth that have occurred around the world in the past century. They describe a future where people use their extraordinary accumulated wealth to achieve greater and greater autonomy from industrial and corporate production. Benkler also spends a great deal of time celebrating the increased freedom and autonomy that social production provides.

But is the unimpeded spread of this kind of autonomy really possible? Benkler also raises serious concerns about efforts to control networks through private ownership and legislation. *Wikipedia* is not a kit that you buy; you do not own your Flickr account and you never will. When you update a Myspace account, you are building up someone else's asset. The prosumer model extracts the value of your work in real time, so that you are actually consuming your own labor.

And what would the role of the designer become in a truly do-it-yourself economy? Looking at Flickr or YouTube or Myspace, it seems that when people do it themselves, they don't need graphic designers to get it done. The more our economy runs on people doing it themselves, the more people will demand opportunities to do so, and the more graphic designers will have to adapt their methods. What services and expertise do designers have to offer in the prosumer market? Rashid and Lupton have provided one answer (the designer as expert do-it-yourselfer); but unless designers come up with more answers, they may end up designing-it-themselves... and little else. ⊠

Adapted from Dmitri Siegel, "Designing Our Own Graves," *Observatory: Design Observer*, June 27, 2006, http://observatory.designobserver.com/feature/designing-our-own-graves/4307/.

Notes
1. Yochai Benkler, *The Wealth of Networks: How Social Production Transforms Markets and Freedom* (New Haven, CT: Yale University Press, 2006).
2. Alvin and Heidi Toffler, *Revolutionary Wealth* (New York: Alfred A. Knopf, 2006).

2011
School Days
Rob Giampietro

Bradbury Thompson, *The Art of Graphic Design*, 1988 Courtesy Yale University Press

Free Library, curated by Mark Owens and Sara De Bondt for M+R Gallery, London, postcard designed by Mark Owens, 2005 Courtesy the artist

Buckminster Fuller and students demonstrate strength of thirty-one-great-circle dome structure at Black Mountain College, Summer 1949 Courtesy Black Mountain College Project, Masato Nakagawa Papers

Writer Paul Engle teaching Writers' Workshop class at the University of Iowa, circa 1950s Courtesy University Archives, University of Iowa

Off the Wall, Yale MFA Graphic Design Thesis Show, 2010 Photo: Ely Kim and Kate O'Connor

Wild School

At [Paul] Elliman's Wild School of communication design, everyone will be an *auditeur libre*, as the French put it, a "free listener" able to wander at will and determine his or her own educational needs. At the time of writing, the project was more proposal than fully functioning public reality, but sample screens indicated a school structure based on the institutional services of library, refectory, theatre, field trips and studios; these encompass departments of History, Society and Language, each of which will lead to themed workshops. The challenge for Elliman is to transform his proto-school from a list of sometimes eccentric links (a familiar enough Web concept) and recycled teaching briefs by himself and his colleagues into a richly imagined and responsive experience in self-education that lives up to the ideal-istic rhetoric—bulwarked by reference to thinkers such as Michel de Certeau, Gilles Deleuze and Felix Guattari—with which it has been launched. ¶ The point of his electronic school, suggests Elliman, is not that it should replace bricks and mortar, but that it should become a channel for the energy of the students flowing through it. "Everybody has a certain amount of passion," he says, "but might feel it's out of place in some situations. I don't really believe that.... It almost doesn't matter that it's graphic design I'm teaching. There must be equivalents in all academic areas of people who teach through a sense of passion. With the things that you pick up on, it's always the passion and the sense of energy that inspires you." A paradoxical sign that the Wild School is fulfilling its educational aims, Elliman suggests, will be when the students have reduced it to digital rubble and used their passion and spirit to build, layer by layer, a school of their own. —Rick Poynor, "Other Spaces," *Eye* 25, Summer 1997

Scott Ponik, cover design for *Wonder Years: Werkplaats Typografie, 1998–2008*, 2008 Courtesy Werkplaats Typografie

MIT Press Design Department, Donis A. Dondis, *A Primer of Visual Literacy*, 1973 Courtesy MIT Press

Na Kim, *Graphic* magazine cover, Nº 18, Summer 2011, Workshop issue Courtesy Na Kim and propaganda press

"And you may ask yourself, well, how did I get here?" —David Byrne

A few years ago, after being invited to serve as a critic for final reviews at an MFA graphic design program, I found myself riding home with two designers and an architecture critic. Each designer had an MFA from a different program, and the architecture critic was working on a PhD. I have a BA. All of us teach at the graduate level while working actively in the profession. After catching up a bit with one another, our discussion returned to the critique. "Why do the students talk about their personal lives so much in explaining their work?" the architecture critic asked. "What do their biographies have to do with it?" While it is certainly valid to question the place of personal histories in a professional context, to talk about ourselves and our stories, it nevertheless seems a persistent inclination among designers to so. We hardly know we're doing it—look, I've opened here with an anecdote drawn from my own life story.

Perhaps part of this is that there is no one else to write these stories for us. Whether overtly biographical or simply self-referential, design remains even today in the peculiar position of having its history and criticism written largely by and for its own practitioners. Since most of us are involved in making things, we write quite naturally of the hows and whys of making them in a collective effort to evaluate a design's production. But what's gone into our own production? How are designers produced?

There are, of course, many ways, many paths—possibly as many as there are designers. Designers can certainly produce themselves as self-taught designers, often through equal parts passion, necessity, and aesthetic brute force. Or designers can be produced by hands-on training through internships and on-the-job experiences. Or designers might arrive from other disciplines and professions. Here's a cross section drawn from Rob Roy Kelly's account of the early days at Yale in the 1950s: "Most faculty members were well-schooled in art and design history, although several were educated in fields other than art or design. [Alvin] Eisenman, a Dartmouth graduate, studied typography with Paul Nash and had a book design and publishing background. [Lester] Beall had been educated in art history. [Alvin] Lustig did not have a formal education in art or design. [Leo] Lionni was educated as an economist in Italy and was a self-taught graphic designer. [Herbert] Matter studied painting at the

École des Beaux Arts in Geneva and the Academie Moderne in Paris under Léger and Ozenfant. [Bradbury] Thompson was a graduate of Washburn College, a small liberal arts school in Kansas. He had been a cartographer during World War II. Paul Rand, largely self-taught, was influenced by European painters and designers. He attended night classes at Pratt Institute, took some courses at Parsons School of Design, and studied with George Grosz at the Art Students League." [1]

While there may be many routes into a life in design, recent years have found one path in particular on a steady rise: the graduate program. And as more designers return to school for graduate degrees in graphic design than ever before, they fuel a growing list of graduate graphic design programs. Beginning with just a few of these in the 1940s and '50s, including the founding of the first MFA program at Yale in 1951, the National Association of Schools of Art and Design (NASAD) now lists approximately three hundred accredited institutions as its members, the great majority of which offer both graduate and undergraduate degrees in design, and, while the AIGA and other design organizations don't have precise numbers on record, there are published estimates of up to two thousand graduate and undergraduate graphic design programs in the United States alone. By any measure, the design school business is booming.

Consider the example of the School of Visual Arts in New York, which opened its Designer as Author (now Designer as Author & Entrepreneur) MFA program in 1998. Since then, SVA has entered a period of rapid expansion, opening one new graduate program every two years, including programs in Branding, Design Criticism, Design for Social Innovation, Interaction Design, and Products of Design. (I have been fortunate to teach, lecture, or visit in several of these programs.) During the same period of time, designers Karel Martens and Wigger Bierma founded the influential Werkplaats Typografie (1998), Bruce Mau worked with Toronto's George Brown College to create the Institute without Boundaries (2003), and IDEO's David Kelley founded Stanford's d.school (2005). This growth is hardly unique to the field of design. Other creative disciplines have experienced a similarly steady increase in new programs, particularly at the graduate level, along a similar timeline. One of the most significant, in terms of both expansion and cultural impact, has been creative writing, which, starting with a handful of programs in the 1940s, had increased

this number to more than 350 accredited institutions offering both graduate and undergraduate programs by 2004.

The rise and impact of creative writing programs in the postwar period is studied by UCLA English professor Mark McGurl in his thoroughly illuminating book *The Program Era* (2009). McGurl takes my architecture colleague's earlier question about personal histories quite seriously: "[The] category of 'personal experience' has over the course of the twentieth century, and in the postwar period in particular, achieved a functional centrality in the postindustrial economies of the developed world. These economies in turn inhabit what Ulrich Beck, Anthony Giddens, and others have described as a 'reflexive modernity.'" [2]

The reflexively modern society, unlike the conventionally modern society, looks forward to the new *and* backward to its modern past, a modernity whose impact has been total and whose influence reverberates in every sector of culture. Instead of the dismantling and overtly critical strategy employed by postmodernism, the reflexively modern society seeks to examine and correct itself in order to keep placing itself continually back on track. The result is a heightened sense of self-awareness and self-preservation leading all the way back to the individual. McGurl writes that the utility of reflexive modernity as a concept "leaps off the page, suggesting that literary practices might partake in a larger, multivalent social dynamic of self-observation," which includes "the self-monitoring of individuals who understand themselves to be living, not lives simply, but *life stories* of which they are the protagonists."

It is not simply the unexamined life here that is not worth living, but the unnarrated life—and far from a nostalgic examination, that narration is increasingly essential and increasingly likely to occur in real time. Far from narcissistic, McGurl writes, this instinct is decidedly self-preservational and potentially even an unwanted burden, like a kind of punishment: "As Beck puts it, modern people 'are condemned to individualization.' To be subject to reflexive modernity is to feel a 'compulsion for the manufacture, self-design, and self-staging' of a biography, and, indeed, for the obsessive 'reading' of that biography even as it is being written. And in this project there are a host of agencies, including schools, waiting to help."

It would be quite natural to stop here and ask if graduate programs in graphic design and creative writing can really be compared. While the writing program has remained relatively consistent in its

structure and steady in its evolution since its earliest days in the 1920s and '30s at Bread Loaf in Middlebury, Vermont, and at the Iowa Writers' Workshop at the University of Iowa, graphic design programs have changed and adapted to new currents in the profession.

The first schools embraced the Bauhaus' original workshop structure (Josef Albers founded the Yale University School of Art and Mies van der Rohe directed the architecture program and designed the campus at the Illinois Institute of Technology), but the model was soon restructured to include a more programmatic and analytical approach drawn from architectural training. Other schools throughout the '60s and '70s (like CalArts, founded by Walt Disney in 1961) popularized design through the lens of applied art training. When Katherine McCoy was appointed co-chair of the graduate design program at Cranbrook Academy of Art in 1971, she combined an interest in architectural theory with the more language-based techniques drawn from the writings about deconstruction and post-structuralism by Barthes, Derrida, and others. Sheila Levrant de Bretteville's arrival at Yale in 1990 extended these ideas to include postmodern notions of identity and a public-minded social awareness, giving design the broadened sense of a humanistic discipline sited at a major research university. Jan Van Toorn's arrival at the Jan van Eyck Academie in 1991 signaled a similar shift in Europe. The end of the '90s found design education having come full circle, from Dan Fern's studio practice–driven model at the Royal College of Art in London to the Werkplaats Typografie's reintroduction of the workshop model in the Netherlands.

On this level, graphic design and creative writing programs might be considered distant cousins at best. Both are creative pursuits sharing certain structures, like critique and peer review, but many more of these structures remain distinct to each. What McGurl's book offers to a designer reading it closely is not a set of examples to follow in explaining design education but rather a methodology to adapt for investigating it. What if we play the old "designer as author" metaphor in reverse, describing authorship not as an input or mode of creation, but as an output or model of practice: the designer as cultural influencer, identifiable persona, and creator of a distinctly voiced body of work. This, perhaps, is how an author's training and a designer's training are linked.

And this is how the "Program Era," a term that McGurl adapts from literary critic Hugh Kenner's earlier "Pound Era," might resonate with designers today. "The rise and spread of the creative writing program over the course of the postwar period has transformed the conditions under which American literature is produced," McGurl writes, adding: "It has fashioned a world where artists are systematically installed in the university as teachers, and where, having conceived a desire to become that mythical thing, a *writer*, a young person proceeds as a matter of course to request *application materials*. It has in other words converted the Pound Era into the Program Era."

Once dedicated to mastering basic skills of the craft, the school has become, in design's Program Era, tied instead to the production of a professional, the creation of a designer as a whole self, an individual with a self-actualized practice in which student work, not client work, often forms the basis for an introduction and ongoing access to the design sphere. Compare this to Lorraine Wild's description of the graduate school environment at Yale in 1982 that, she writes, functioned like a kind of boot camp where "correct typography" consisted of "using only one font with one weight change." In this context, Wild wonders: "Could you be forgiven, perhaps, for beginning to suspect that what you were being taught was not actually modernism at all, but habit? Or bizarre fraternity rituals? The similarities to frat hazing were alarming; if you did what you were told you would be let 'in.'... If you asked questions, there were no sensible answers and you definitely risked rejection." [3]

Today, students' design work is less learning by rote than practice through self-examination. The resulting work, shared online and through institutions, events, talks, collaborations, extracurricular projects, and other generally pedagogical methods, becomes, in effect, an advertisement for its accompanying self, the designer whose interests and academic path of inquiry shaped it, framed it, and offered it into the context in which it now resides.

"For the modernist artist," McGurl writes, "the reflexive production of the 'modernist artist'—i.e., the job description itself, is a large part of the job." These reflexive professional efforts, he suggests, are not all that "radical" or even "deconstructive," but instead "perfectly routine," part of a system of self-reference that extends past the making of literature and to the making and organizing of all things. McGurl describes this self-constitution of systems using a concept drawn from systems theory called "autopoesis." Designers know these efforts, under slightly different circumstances, as so-called "self-initiated work," which comprises a good portion of what's done as an MFA student. And just as McGurl prepares a list of "signature genres of the Program Era"—which includes the campus novel, the portrait of the artist, the workshop story collection, the ethnic family saga, meta-genre fiction, and meta-slave narratives—we might attempt a designer's list along the same lines, including the thesis book, the process poster, the experimental typeface, the urban map, the data visualization exercise, the group portrait photograph, the image archive, the slide talk, the meta-exhibition, and the project-as-class performance.

This last genre owes a special debt to the recent "pedagogical turn" in art, which suggests that education is itself a form of art, a facilitator of artistic development, and a method for activating art in the public sphere. Among the key projects in this movement is Manifesta 6, which announced the creation of an art school in Nicosia, Cypress, in place of a typically "temporary, drop-on-a-city" exhibition. [4] Artist Anton Vidokle says in the catalogue *Notes for an Art School*: "The Bauhaus, in its brief period of activity, arguably accomplished what any number of Venice Biennials have not (and at a fraction of the cost)—a wide range of artistic practitioners coming together to redefine art, what it can and should be, and most importantly, to produce tangible results. All this in the face of Walter Gropius' famous assertion that 'art cannot be taught.' An art school, it would appear, does not teach art, but sets up the conditions necessary for creative production, and by extension the conditions for collaboration and social engagement." [5]

Vidokle's essay concludes with an "Incomplete Chronology of Experimental Art Schools," beginning with the École national supérieure des beaux-arts (1671) and continuing through the Bauhaus (1919), Black Mountain College (1933), Skowhegan School of Painting & Sculpture (1946), Nova Scotia College of Arts & Design (1966), Whitney ISP Program (1968), Beuys' Free International University (1974), General Idea (1977), the Vera List Center for Art & Politics (1992), Mountain School of Art (2005), and beyond.

While Manifesta 6 did not come to be, it did serve as a catalyst for organizing many groups, including Dexter Sinister, which "proposed to establish a print workshop as part of the [Manifesta] school, which would explore existing modes of art publishing and possibly suggest new ones." In addition to the Bauhaus, Dexter Sinister

Office for Archival Reproduction

The Office for Archival Reproduction (OAR) at Insa Art Space (IAS) is a temporary office responsible for documenting how the IAS Archive is used during the period from 24 May to 2 July 2006. The central activity of OAR is to collect photo-copied pages of the Archive's materials, made by its visitors, staffs, or any other users. The collected copies will be organized into a book afterwards as a record of the IAS Archive's life: without any central planning, it's going to be an almost random archive of the Archive itself. ¶ Although the OAR is physically inhabiting the IAS, it's not part of its official organization: the office has no employees, and its operation is completely reliant on visitors'—your—participation. We encourage you to freely browse the Archive, find materials that interest you, or the ones for any reason you think worth highlighting, then duplicate and contribute the pages to OAR. Your participation will be greatly appreciated by all the nonexistent OAR staffs, as well as the real existent IAS community. —Sulki & Min, www.sulki-min.com, 2006

Sulki & Min, *Office for Archival Reproduction*, installation for *Frame Builders*, Insa Art Space, Seoul, 2006 Courtesy Sulki & Min

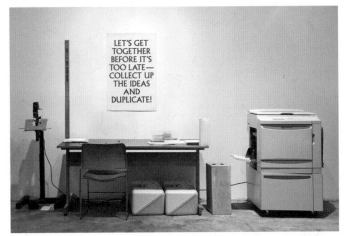

Pop-Up Studio, CalArts graduate seminar on-site workshop and exhibition at Kunsthalle Los Angeles, 2009 Photo: Mark Owens

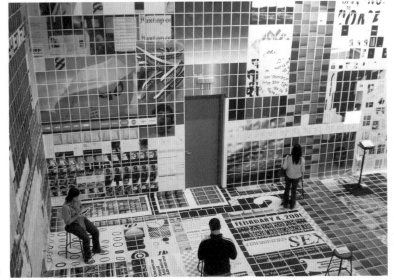

Yale MFA Graphic Design thesis show, 2006 Photo: Ken Meier

Archive

An archive is a repository of documents—texts, images, recordings, etc.—that are preserved because of their historical value and significance. These documents tend to be sources of primary information and are typically unpublished. Unlike a library that contains publications, which exist in multiples, the archive typically contains unique artifacts. If the archive protected the original, the library circulated the multiple. Despite this technical distinction, philosopher Michel Foucault considered the library and the museum and its collections as modern forms of the archive understood as "the will to enclose in one place all times, all epochs, all forms, all tastes, the idea of constituting a place of all times that is itself outside of time and inaccessible to its ravages." The modern conception of an archive is associated with a totality of representation, a collection of everything about something. In 1947, André Malraux began writing about *Le Musée imaginaire*, which constituted the totality of all great artworks, a feat he thought possible because of the widespread circulation of photographic reproductions of art. This vast collection constituted a "museum without walls," which was accessible to many people and cultures across time and space. The Internet as a vast accessible collection of all information is likened to another total archive. Perhaps drawn to the fact that the archive is a collection of multiple voices but without specific authorship and arranged without a particular narrative in mind, it offers a fertile area for artists and designers to explore, undertaking vast cataloguing exercises, assembling repositories of artifacts, and building databases of information. —AB

Pop-Up Studio, CalArts on-site workshop and exhibition at Kunsthalle Los Angeles, 2009 Photo: Mark Owens

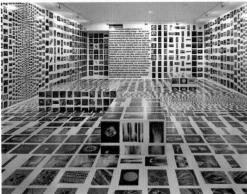

Bruce Mau, installation view of *Massive Change: The Future of Global Design*, Vancouver Art Gallery, 2004, researched and designed by students from Institute without Boundaries Courtesy Bruce Mau Design

Pop-Up Production

Like its retail cousin the pop-up shop, pop-up production refers to the short-term appearance of a particular design activity or event. For instance, a design studio may occupy a vacant storefront offering services to clients, a special workshop may take place not in a classroom but in a public space, or artifacts are conceived, designed, and produced during a short period. CalArts graphic design graduate students organized a weekend-long Pop-Up Studio at Kunsthalle Los Angeles with a course on issues of publication, distribution, and circulation taught by Mark Owens. In 2006, De Daily Whatever began publishing a free and independent newspaper during Dutch Design Week in Eindhoven. The day's edition is produced on the spot, in 2009 for instance at the Van Abbe Museum, with the design and editorial work performed on location. In addition to its own reporting, visitors to the exposition as well as the general public were invited to provide feedback and commentary. —AB

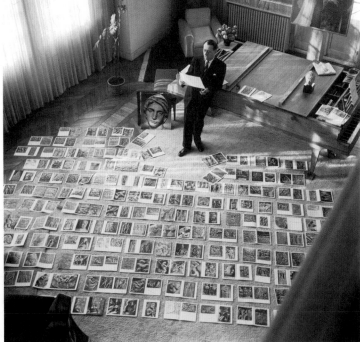

André Malraux selecting photographs for *Le Musée imaginaire*, Paris, circa 1947 ©Maurice Jarnoux/Paris Match/Scoop, 2008

Daniel Eatock, *Trust & Support (group chair balance circle)*, at the workshop We Have at IUAV, Venice, 2008 Courtesy the artist

Neville Brody speaking at It's Nice That conference, *Future Content*, London, 2010 Courtesy It's Nice That

James Goggin and Frank Philippin, *Dear Lulu* workshop with students at the Hochschule Darmstadt, Germany, 2008

Åbäke workshop with students at Fachbereich Kommuni-kationsdesign Mathildenhöhe, Darmstadt, Germany, 2008 Photo: Patrick Gasselsdorfer

AtRandom #1: Harmen Liemburg, Look at the Highway Stars—Roadside Silhouettes and Such, organized by Jon Sueda and Sean Donahue, Center for the Arts, Eagle Rock, Los Angeles, California, August 20th, 2006 Courtesy Jon Sueda

Michael Marriott lecturing with *Viktor*, by Jürg Lehni and Alex Rich, as part of the exhibition *A Recent History of Writing and Drawing*, Institute of Contemporary Arts, London, 2008 Courtesy the artists

Luna Maurer and Jonathan Puckey, video still from *Graphic Design in the White Cube* poster-making workshop, 22nd International Biennial of Graphic Design Brno, 2006 Courtesy Luna Maurer

looked to Toyota's "just-in-time" production process as a model for its workshop. The spirit of this pragmatic academic/commercial workshop fit well with Manifesta's hybridized exhibition/academy format. Dexter Sinister, which designed *Notes*, also contributed the school's iconic blazon, a slashed shield that Steve Rushton likens to a typographic slash marking the tenuous boundary between terms such as love/hate, speech/writing, and perhaps, art/school.

As art's "pedagogical turn" seeks to dissolve or at least refashion this last boundary, so too does McGurl undertake an effort to frame writing as a distributed, multifocal, and highly structured creative effort. With this, he completes the second of two substantive transformations of standard-issue Program Era criticisms. The first, as we have seen, is to dismiss the idea that program work is narcissistically *self-involved* and instead suggest that it is enlightenedly *reflexive*. McGurl's second transformation is to dismiss the idea that program work is "generic," "assembly-line," and basically *unoriginal*, and instead suggest that it is deeply *systematic*. [6]

But how can a creative discipline be systematically taught? The question is pervasive. Earlier, we saw Vidokle nod to Bauhaus founder Walter Gropius' assertion that "art cannot be taught." McGurl quotes the Iowa Writers' Workshop's official history in the same vein: "Though we agree in part with the popular insistence that writing cannot be taught," it states, "we continue to look for the most promising talent in the country, in our conviction that writing cannot be taught but talent can be developed." It's a careful balancing act of populism and elitism, allowing for the popular notion of individual genius on one hand while underscoring Iowa's legacy and prestige on the other. Neither Gropius nor Iowa doubts the possibility of the creative individual, but both seem at best anxious about and at worst dismissive of a creative system. Creativity, especially in the last century, has been characterized as something that breaks from the pack; how, then, can it be broken down, spread out, and passed on?

To the extent that there are systems in place to teach writing and other forms of creativity, they are not the same systems that are in place throughout the rest of the university. At Iowa, for example, one participant recalls that her teachers "commented on what they liked or didn't like about a particular story, offered isolated bits of advice about technique, but most of us got through two years of instruction without any formal discussions of theory or craft." The description might apply to many design classes as well. And while there was much debate, especially in the early 1990s among a new generation of design educators, about the potential for adapting theoretical systems in the teaching of design, "slowly," notes Andrew Blauvelt in his essay "Toward a Critical Autonomy," "the debates subsided." [7]

"Graduate schools," Blauvelt continues, "whether celebrated or scorned, were once seen as the source of 'the problem'" of design's reduction "to its commodity form—simply a choice of vehicles for delivering a message: ad, billboard, book, brochure, typeface, website, and so on. Implicit in this reductive understanding is the denial of graphic design as a social practice and with it the possibility of disciplinary autonomy." Here a new question has emerged: not "can it be taught" but "to what end"?

Lorraine Wild asks a similar question, writing in 2004 that "for a time, some of the design schools were more responsible for creating a space where a little more perspective and independence about the practice and the 'profession' could occur than anywhere else. The formal investigations produced by students and teachers were produced against this context, which utilized, and was enabled by, a reading of critical theory, and had large targets." But soon, she writes, these forms "were so alluring (and so specific to a younger audience) that, like every other formal expression of a cultural idea in our consumer-based society, they entered the life cycle of visual style; that is, they were marketed." [8] In Blauvelt's formulation, the project of teaching design is tied to the project of teasing design apart from other disciplines; in Wild's formulation, the project of teaching design is tied to the potential of the school's position as a space outside the commercial aims that design typically must serve.

But school was changing too. As McGurl notes, the increasing commodification of everyday goods (including those design objects that Blauvelt and Wild describe) required the marketing of "the experience of being marketed to" as a reflexive thing unto itself. After a brief nod to Joseph Pine and James Gilmore's late '90s business classic *The Experience Economy*, [9] McGurl quotes landscape architecture scholar Dean MacCannell's book *The Tourist* [10] from a decade earlier to help illuminate this shift in our cultural understanding of school. MacCannell, he writes, surveyed this new landscape of experiences and compared it to a "generalized tourism" in which "the value of things such as programs, trips, courses, reports, articles, shows, conferences, parades, opinions, events, sights, spectacles, scenes, and situations of modernity is not determined by the amount of labor required for their production. Their value is tied to the quality and quantity of the *experience* they promise."

What may have first looked like a shift away from the idea of including theory in the classroom was instead a shift toward the classroom as a lived experience in which people, places, and real-world projects come together in a pragmatic whole—an idea that was advanced by Werkplaats Typografie with its arrival in the late '90s. In its prospectus, founders Martens and Bierma describe the idea of "Workshop as Meeting Place": "For typographic designers who are just starting to practice—in this case, the participants of the Typography Workshop—it is vitally important that they become familiar with the standpoints and considerations of other typographic designers. The best way to do this is literally to enter into a conversation with them. Moreover, it is important that participants are offered the opportunity to *present* themselves to future colleagues." [11]

The prospectus goes on to describe the idea of carrying out real-world assignments alongside individual research as participants inhabit a fully-equipped studio where other participants, advisers, and outside experts are all available to discuss and develop creative work.

And though its prospectus doesn't exactly describe a classic master/apprentice system, the Werkplaats' outside experts do seem to function in a similar way. McGurl notes a similar dynamic in the creative writing classroom, where the relationship between student and teacher is more of a creative "apprenticeship," and knowledge is delivered informally via practice rather than systematically via syllabus. Perhaps, like the teaching of writing, the teaching of design at the graduate level has this kind of informal system at its root.

McGurl extends this idea further still, past the classroom and into the writing itself: "Creative writing issues an invitation to student-consumers to develop an intensely personal relation to literary value, one that for the most part bypasses the accumulation of traditional cultural capital (that is, a relatively rarefied knowledge of great authors and their works) in favor of a more immediate identification with the charisma of authorship.... Part of the value of the modern literary text, quite apart from the 'relatability' of its characters, is the act of *authorship* that it records, offering read-

217

ers a mediated experience of expressive selfhood as such."

Rather than separate the teaching of writing from the autopoetic act, the experience economy bundles them together. "Is such a thing [as systematic creativity] possible?" McGurl finally asks. "Or is it, rather, perfectly normal?" Isn't declaring a passion for a creative pursuit and making time for it in our busy lives, selecting to be in a group of similarly passionate people led by a mentor who has been successful at that effort, improving our work through discussion and debate, and developing a sense of ourselves and our role in the wider field of cultural production—isn't that a system? Isn't it one that allows us to grow and be more creative? Isn't it one that asks us to teach and learn, lead and follow, remain who we are and be changed by our surroundings? Don't our deepest lived experiences change us? And isn't school one of them?

Setting aside the anxieties that naturally surround discussions of systematic creativity in this way is just one of McGurl's many useful insights into the world of creative training and how we might reflect differently about it—to reevaluate (and here I'll crib a favorite author) What We Talk About When We Talk About Education. The key question is not, as McGurl so lucidly observes, "Programs: pro or con?" Instead, he suggests, we need studies that seriously examine the influence of these programs on literary production and interpretation in the postwar period. What, he asks, are the social factors that gave rise to these programs? How, in their sheer magnitude, have these programs reorganized creative production in our time? And how might we seek a new and more nuanced awareness of the creative products they produce?

Perhaps around the bright sun of design we have, during the last few years of our own Program Era, added more planets, more moons and comets, more elliptical orbits, more complexity, and more interconnectedness to our disciplinary universe as it expands ever outward. This idea ran through part of a RISD MFA syllabus that I wrote several years ago called "Graphic Design & Critical Thinking," which, if I can indulge in a second autobiographical moment, I will quote here: "Designers are asked to have a tremendous number of technical and analytical skills at our disposal to communicate information that is unfamiliar to us. Borrowing from Alice Twemlow's book What Is Graphic Design For?, [12] a few of the forms that designers regularly use include: typefaces, motion graphics, music and sounds, games,

signage and wayfinding systems, posters, magazines and periodicals, books, information graphics, interactive systems, identity systems, advertising, writing, software programs, and more. All of these forms require very different skills, different critical tools for understanding them, and different expectations from audiences in terms of which forms suit certain kinds of content best."

Rather than seeing design as a single paradigm practiced in a uniform way by canonical figures, this "universal" model of design—McGurl would note the similarity to "university"—sees a multiple, shifting set of polarities with highly influential individuals and institutions acting as centers of gravity. The task for emerging designers is to first enter an orbit and then, if they wish, increase their gravitational pull over time. A wider variety of schools and programs naturally help to foster this exercise in self-definition. As more types of people described as "designers" arrive, however, skill sets can grow more distinct and distant from one another.

One of the effects of this broadening has been that design has, in recent years, become noticeably less like a trade and more like a humanistic discipline than ever before. As part of this shift, designer and professor Gunnar Swanson authored a call in 1994 to reconsider "Graphic Design as a Liberal Art." [13] He writes, "We must begin to believe our own rhetoric and see design as an integrative field that bridges many subjects that deal with communication, expression, interaction, and cognition. Design should be about meaning and how meaning can be created. Design should be about the relationship of form and communication. It is one of the fields where science and literature meet. It can shine a light on hidden corners of sociology and history. Design's position as conduit for and shaper of popular values can be a path between anthropology and political science. Art and education can both benefit through the perspective of a field that is about expression and the mass dissemination of information. Designers, design educators, and design students are in a more important and interesting field than we seem to recognize."

In Swanson's formulation, design as a discipline acts as a kind of guide between disciplines, adopting and adapting specific theoretical concerns of each and passing them through the lenses of form, communication, and distribution. To this process Blauvelt adds the important quality of reflexivity: "Graphic design must be seen as a discipline capable of generating meaning

out of its own intrinsic resources without reliance on commissions, functions, or specific materials or means. Such actions should demonstrate self-awareness and reflexivity; a capacity to manipulate the system of graphic design." [14]

If humanistic disciplines bridge the analytic, critical, and speculative impulses in understanding ourselves and our world, then design is increasingly engaged in all three of these impulses. It always has been analytic, attempting to understand and solve problems in both the commercial and cultural spheres. But, with the support of academic institutions such as schools and museums, design has explored a critical role as well. "Critical design" is a term associated with a growing set of designers, including the RCA's Anthony Dunne and Fiona Raby. (Dunne is the head of the Design Interactions Department; Raby is on the faculty as well.) "Speculative design," another alternative practice model and cousin to critical design, has sprung up with methods allowing designers to unpack new scenarios of technology, citizenship, communication, and power. Metahaven, which teaches, lectures, and publishes widely, is frequently cited as a touchstone for speculative design and practice.

The subdiscipline of "design research" has been launched as well. In his preface to one of the first collections on the topic, UCLA's Peter Lunenfeld begins by stipulating that "the territory is vast" but cites Rem Koolhaas as one possible model for design practice in three ways: "first, to understand the context of any building project he might wish to undertake; second, to develop the building's program itself; and third, in a reflexive way, as a selling tool for the research and the building themselves." [15] Research, in this model, is not only an analytic method, but also its own cultural product.

And there's "design thinking," a kind of reenvisioning of problem-solving itself, less didactic and more open-ended, less specifically about problems and solutions and more of a method for observation and analysis, particularly within larger corporations and institutions. Its name is a curious mash-up of forming things and formulating ideas, which are both separated ("designing" and "thinking") and intertwined ("design thinking"). It may, in the minds of many, be more easily associated with a set of advocates than a set of concepts, as Helen Walters wrote in early 2011 for Fast Company: "I joined [BusinessWeek] back in 2006, which was a time when design thinking was really beginning to

IFS, Ltd., 2010 Company Portrait (left to right: Harry Gassel, Benjamin Critton, Brendan Griffiths, Mylinh Trieu Nguyen, and Zak Klauck) Photo: Yorgos Prinos

IFS, Ltd., installation view of *The Book Trust*, with furniture by ro/lu, NY Art Book Fair at MoMA PS1, New York, 2010 Courtesy Mylinh Trieu Nguyen

Will Holder, *Common Knowledge*, from the exhibition *On Purpose: Design Concepts* at the Arnolfini, Bristol, UK, 2008

Library shelves at Werkplaats Typografie, Arnhem, the Netherlands, 2011 Courtesy Werkplaats Typografie

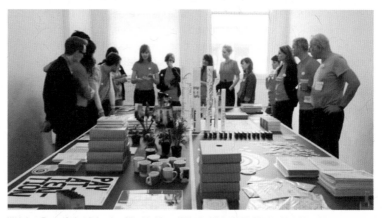

Werkplaats Typografie, installation view of *Feed the Library*, NY Art Book Fair at MoMA PS1, New York, 2011
Courtesy Werkplaats Typografie

Stuart Bailey, Angie Keefer, and David Reinfurt, *The Serving Library*, 2011
Courtesy the artists

Library

A collection of useful material—books, publications, recordings, or other resources—for common use organized by a community, institution, or individual. The public libraries we think of today, where access was permitted beyond those who owned the materials and which were collectively organized, began in nineteenth-century England and quickly spread to the United States and other countries. Philosopher Michel Foucault described the library as "indefinitely accumulating time," a kind of perpetual archive and, likening it to the museum, declares it "never stops building up and topping its own summit." The open access character of such libraries, long thought to be a cornerstone of democratic principles, provides a useful metaphor for many contemporary designers. In 2001, Christoph Keller initiated *Kiosk: Modes of Multiplication*, an itinerant exhibition of more than 7,000 examples of contemporary independent publishing that has traveled the world to numerous venues, accumulating additional materials at each stop. In 2008, Will Holder created *Common Knowledge*, a lending library of his personal books, as part of the exhibition *On Purpose*. Using an online database to document his holdings, visitors could browse and borrow the titles on offer from among Holder's sixteen shelves. More recently the trope of the library has moved from collecting and sharing to explore modes of exchange. For instance, Mylinh Trieu Nguyen and fellow graduate students at Yale created an installation at the NY Art Book Fair at PS1 in 2010 that offered visitors an opportunity to purchase futures in their enterprise through an exchange of books—their "library" assembled through trade. At the same event, students at the Werkplaats Typografie conducted their project, *Feed the Library*, which invited visitors to give a book on an art or design topic that might enhance their school's collection. In exchange, they could select an item on display, which ranged from Dutch pastries to plants to works created by the students. The concept of the circulating library and the archive are joined in *The Serving Library*, a new project by Stuart Bailey, David Reinfurt, and Angie Keefer. A "collectively built archive," *The Serving Library* publishes new material in the form of a free, downloadable series of PDF bulletins that will be printed, bound, and distributed twice per year. As they note: "Publishing and archiving have always been either end of a continuous loop, but now on an electronic network like the Internet, the two activities are both simultaneous and indistinguishable." —AB

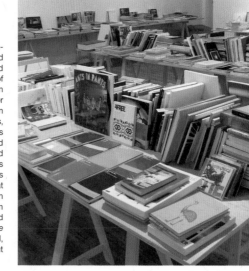

Installation view of *Kiosk (XIX): Modes of Multiplication*, curated by Christoph Keller, Artists' Space, New York, 2007 Photo: Alice Twemlow

219

take hold as a concept. My old boss, Bruce Nussbaum, emerged as its eloquent champion while the likes of Roger Martin from Rotman, IDEO's Tim Brown, my new boss Larry Keeley and even the odd executive (A. G. Lafley of Procter & Gamble comes to mind) were widely quoted espousing its virtues." [16]

Other than Walters and Nussbaum, who are journalists, each of these figures is associated with a postgraduate educational institution: Martin became Dean at Rotman School of Business in 1998 (before that Lafley was his client at Monitor, a consulting group), Brown at Stanford's d.school, and Keeley at Chicago's ITT (Illinois Institute of Technology). Walters' article continues: "Still, in the years that have followed, something of a problem emerged.... When we stopped and looked, it seemed like executives had issues rolling out design thinking more widely throughout the firm. And much of this stemmed from the fact that there was no consensus on a definition of design thinking, let alone agreement as to who's responsible for it, who actually executes it, or how it might be implemented at scale."

With its collection of faculty-advocates, its self-evolving set of methods, its position as a primarily theoretical rather than practical structure, and, above all, its assertion that—unlike the more action-oriented, collective "doers" of business cultures past—this process is defined by a more contemplative, individual "thinker," "design thinking" is in every way more the kind of movement that emerges from a school than the kind that emerges from a typical boardroom.

And it is the kind of movement that's funded like a school as well, complete with the grants, fellowships, prizes, and an expanding base of institutional support. As programs grow, many designers may also rely on teaching to support their practices, and many grad students may look to teaching as a way to remain engaged in the more reflexive practice of design that they currently study. "Like most writers these days, I support myself by preaching what I practice," jokes John Barth in his 1966 novel *Giles Goat-Boy* [17] (which appears near Chip Kidd's *The Cheese Monkeys: A Novel in Two Semesters* from 2001 on *Wikipedia*'s illuminating list of "the school and university in literature"). [18]

But before we settle too comfortably into this system of increased support, there are those who take a more cautionary tone. As historian and theorist Thierry de Duve notes in the book *Art Schools (Propositions for the 21st Century)*: "Art schools have

not always existed, and nothing says that they must always exist. Their proliferation is perhaps a trompe l'oeil, masking the fact that the transmission of art today from artist to artist is very far from occurring directly in schools." [19]

In de Duve's version of events, the growth of art schools is not a steady trend but an illusory and temporary event. This is the "school experience" as gold rush, like a kind of speculative bubble about to burst—with dozens of ad-hoc schools, for-profit trade academies, and educational ventures jockeying for a piece of the student loan industry pie. There is now more education-related debt than credit card debt in the United States.

And there may be over-education, too. While there has never been a more important goal than universal access to a college education, the US Bureau of Labor Statistics nonetheless reports that 17 million Americans with college degrees do jobs that do not require them. In the sciences, the number of PhDs given has grown by nearly 40 percent during every year since 1998, reaching 34,000 doctorates in 2008. In her essay "The PhD Problem," science writer Kate Shaw cautions that "the workforce cannot absorb all these highly trained graduates," most of whom "are fully funded through research assistantships, teaching opportunities, and fellowships. With so many graduates these days taking jobs they are overqualified for, some educators and economists believe this money is simply being wasted." [20] These developments suggest that education may need to adopt a more streamlined attitude in the years to come.

During an interview in *Eye* magazine from 1997, Paul Elliman noted, "It almost doesn't matter that it's graphic design I'm teaching. There must be equivalents in all academic areas of people who teach through a sense of passion.... The World Wide Web—an environment where, for better or worse, connection is everything—suggests, among other things, new possibilities for design and its education."

He continues, "This space allows both practice and reflexivity. For the 'school,' both as extension to the old model and in the transition to a new one, the Internet will offer a more continuous dialogue with practicing designers, and with other specialized areas, in ways that could counter some of the problems and complexities found in the institutional teaching of design." [21]

To tweak Gropius' assertion once more, the question here is not "can it be taught" but rather "can it be taught in school"? Because just as art is a frame for a certain

kind of aesthetic practice, school is a frame for a certain kind of pedagogical practice. And just as there are types of aesthetics that are not called art or are coming to be known as art, so too are there types of pedagogy that are not called school or are coming to be known as school.

Vidokle notes in his essay that his research into the Manifesta 6 school project unearthed "an amazing range of schools in the past 100 years" that suggest an ever-changing field. "Art education is not in stasis," he writes. "It is being constantly rethought, restructured, and reinvented." De Duve calls the extracurricular teaching and learning of artistic practice "transmission" and suggests, along with its deprofessionalization, that it be made available to everyone, not just art students. As Raymond Williams' *Keywords* project teaches us time and again, what we call things now may be different from what we call them in the future. [22]

But whatever we call design school next, our design schools now have undoubtedly produced the design culture we share today, and perhaps this is exactly the point. As more designers go to school, go back to school, and return again to teach in school; as there are more postgrad "lifelong learning" environments such as conferences and meet-ups; as there is more discussion and debate online, in after-work lectures, and at weekend book fairs and degree shows; as designers seek to make themselves better, learn more, and define a life in design as an unfolding lived experience—as all this happens, then the culture of design becomes increasingly more like the culture of school. As we look back on this period in the years to come, these may be design's school days indeed. ⊠

Notes
1. Rob Roy Kelly, "The Early Years of Graphic Design at Yale University," *Design Issues* 17, no. 3 (2001).
2. Mark McGurl, *The Program Era: Postwar Fiction and the Rise of Creative Writing* (Cambridge, MA: Harvard University Press, 2009).
3. Lorraine Wild, "Castles Made of Sand," in *Looking Closer 5: Critical Writings on Graphic Design*, ed. Michael Beirut, William Drenttel, and Steven Heller (New York: Allworth Press, 2007).
4. Emily King, "Wouldn't it be nice ...," Interview with Dexter Sinister, October 25, 2007, accessed May 30, 2011, http://www.dextersinister.org/index.html?id=123.
5. Anton Vidokle, "Exhibition as School in a Divided City," in *Notes for an Art School* (Nicosia, Italy: Manifesta 6 School Books, 2006).
6. Steve Rushton, "Sinister/Bastard," in *Notes for an Art School* (Nicosia, Italy: Manifesta 6 School Books, 2006).
7. Andrew Blauvelt, "Towards a Critical Autonomy," in *Looking Closer 5: Critical Writings on Graphic Design*, (New York: Allworth Press, 2007).
8. Lorraine Wild, "Castles Made of Sand."
9. Joseph Pine and James H. Gilmore, *The Experience Economy: Work Is Theater & Every Business a Stage* (Cambridge, MA: Harvard Business Press, 1999).
10. Dean MacCannell, *The Tourist: A New Theory of*

the Leisure Class (Berkeley: University of California Press, 1999).

11. Karel Martens and Wigger Bierma, "WT Prospectus," in *In Alphabetical Order: File Under: Graphic Design, Schools, or Werkplaats Typografie*, ed. Stuart Bailey (Rotterdam: NAi Publishers, 2003).

12. Alice Twemlow, *What Is Graphic Design For?* (East Sussex, England: Rotovision, 2006).

13. Gunnar Swanson, "Graphic Design as a Liberal Art," in *The Education of a Graphic Designer*, ed. Steven Heller (New York: Allworth Press, 2005).

14. Andrew Blauvelt, "Towards a Critical Autonomy."

15. Peter Lunenfeld, Preface to *Design Research: Methods and Perspectives*, ed. Brenda Laurel and Peter Lunenfeld (Cambridge, MA: MIT Press, 2003).

16. Helen Walters, "Design Thinking Isn't a Miracle Cure, but Here's How It Helps," *Co.Design*, March 24, 2011, accessed May 23, 2011, http://www.fastcode sign.com/1663480/helen-walters-design-thinking-buzzwords.

17. John Barth, *Giles Goat-Boy or, the Revised New Syllabus* (New York: Doubleday, 1966).

18. *Wikipedia*, "School and University in Literature," accessed May 23, 2011, http://en.wikipedia.org/wiki/School_and_university_in_literature.

19. Thierry de Duve, "An Ethics: Putting Aesthetic Transmission in Its Proper Place in the Art World," in *Art School (Propositions for the 21st Century)*, ed. Steven Henry Madoff (Cambridge, MA: MIT Press, 2009).

20. Kate Shaw, "The PhD problem: are we giving out too many degrees?" *Ars Technica*, April 25, 2011, accessed May 23, 2011, http://arstechnica.com/science/news/2011/04/the-phd-problem-what-do-you-do-with-too-many-doctorates.ars.

21. Rick Poynor, "Profile: Paul Elliman," *Eye* 25 (1997).

22. Raymond Williams, *Keywords: A Vocabulary of Culture and Society* (Oxford: Oxford University Press, 1985).

2x4 25, 46, 50, 69
3st 62
8vo 131
17th Biennale of Sydney 199
032c 84, 85
180 Amsterdam 125
300 166
2001: A Space Odyssey 23
@RadicalMedia 27

A2-TYPE 129
Åbäke 10, 55, 145–160
Academie Moderne 213
Acconci Studio 49
Adler, Deborah 32, 34
Adobe DPS (Digital Publishing Suite) 90
Adorno, Theodor 12
Aesthetic Apparatus 92, 96
affichism 108
Africa Filmes 169
Afro 77
AIGA 62, 213
AIGA Journal 33
Albers, Josef 214
Albinson, Ian 10, 137–144
Alexander, Darsie 190
algorithm 107
Alvich, Jason 172
A Magazine 55
Ambasz, Emilio 18
Amelia's Magazine 84, 87
Anderson, Charles S. 32, 33, 36, 37
Anderson, Chris 29
Anderson, Eric 141
Anorak 80, 81
Antoine et Manuel 113, 119
Antonelli, Paola 118
Aol. 190, 193, 194
Apartamento 80, 81
Apeloig, Philippe 113, 116
Apple 22, 31, 33, 68, 74, 88, 187, 189, 195
archive 215
Arendt, Hannah 12
Armada 165
Arment, Marco 68
Arruda, Ryan 103
Art of the Title 10
Art Students League 213
AtRandom #1 216
AT&T 194
Augusto, Yomar 125
Augustyniak, Mathias 62, 97
Austen, Jane 67
Axiom Design 165
Ayers, Jeff 30

Bags of Joy 103
Bailey, Stuart 12, 20, 21, 28, 55, 57, 67, 69, 219
Baldaev, Danzig 72
Balušíková, Johanna 131
Banner, Bruce 142
Bantjes, Marian 47, 113, 120
Barber, Ken 112
barcode 202, 203
Barendse, Jeroen 107
Barham, Tom 164
Barnbrook, Jonathan 59, 199
Barnes, Ben 103
Barney, Matthew 66
Bartels, Luke 39
Barthes, Roland 58, 67, 214
Barth, John 220
Bass, Saul 139, 194, 195
Bateman, Scott 183
Bates, Paddy Roy 202
Bauhaus 13, 33, 132, 214, 217
Bausch+Lomb 194
Beall, Lester 194, 195, 213
Beatles, The 28, 29, 43, 104
Beckham, Tom 87
Beck, Ulrich 213
Bedford Press 54
Bêla, Carlos 163
Bellafante, Ginia 67
Bell Telephone 194, 195
Bendall, Scott 87
Benguiat, Ed 112, 114
Benjamin, Walter 12, 13, 33, 34, 108
Benkler, Yochai 211
Benner, Laurent 55
Bennewith, David 62
Benson, Eric 103
Berkson, William 129
Bernadette Corporation 60
Best Made Company 34, 35
Bevington, William 19
Bierma, Wigger 213, 217
Bik Van der Pol 70
Bil'ak, Peter 11, 97, 126, 127, 130–134
Bilet, Maxime 64
Bill, Max 99
Biotypography 118
BirdAbroad 189
BIS Publishers 195
Bitfonts 133
Black Mountain College 212, 214
Blanka/Print-Process 99

Blaustein, Marc 193
Blauvelt, Andrew 6, 10, 11, 22–31, 92–111, 190–209, 217, 218
Blechman, Nicholas 189
BLESS 54, 55
Bloch, Matthew 172
Bloomberg Businessweek 84, 85
Blue Valentine 135, 140
Blurb 56
BMW Guggenheim Lab 199
Bocchino, A. J., 45, 48
Bochner, Mel 133
Bodoni, Giambattista 130, 134
Bojkowski, Michael 89
Bolick, Rob 164
Bonillas, Iñaki 58
Books on Demand 56
Book Trust, The 219
Boom, Irma 66, 69
Borcshe, Mirko 83
Bored to Death 164
Born, Julia 63, 128
Bourke, Marissa 86
Bourriaud, Nicolas 28
Boyle, Megan 60
BP 26, 27
Braddock, Kevin 83
Brand Eins 78, 80
Brand New 10, 191, 192
Brand, Stewart 22, 23
Brat Bratu 165
Bratell, Evelina 64
Bravi, Enrico 130, 132
Bread Loaf 214
Breaking Bad 136
Brin, Sergey 197
Brody, Neville 59, 133, 216
Brook, Tony 71
Broton, Guillermo 103
Brown, Tim 220
Bruce Mau Design 63
Bruggeman, Frank 89
Bruni, Dimitri 54, 62, 125
Brunner, Laurenz 55, 54, 63, 114, 128
Bruun, Asgur 87
Buchanan-Smith, Peter 34, 35
Bucher, Stefan G. 14
Buchloh, Benjamin 175
BUF 138
Buivenga, Jos 114, 127
Burdick, Anne 70
Burgess, Carl 54
Burgess, Joe 173
Burian, Veronika 129
Burnham, Clint 43
Burrichter, Felix 81
Burrill, Anthony 12, 92, 98
Burrin, Joseph 89
BusinessWeek 218, 220
Byrne, David 213
Byrne, Emmet 11, 209, 210, 224

Cage, John 19, 133
CalArts (California Institute of Arts) 214
Caliri, Jamie 165
Canham, Jeff 39
Capitu 163
Carlos 77, 79
Carl's Cars 80, 82
Carnivàle 136, 166
Carpenter, Ron 128
Carson, Anne 61, 67
Carson, David 131, 132
Carter, Matthew 124, 194, 200
Casa da Música 200
Case, Ryan 24, 176
Casino Royale 135, 139
Catalogtree 107
Catch Me If You Can 136, 139
CBS 194
chartjunk 171, 183
Chase, Abi 125
Chavez, Esteban 103
Chermayeff & Geismar 193, 194
Chimera 170
Chronicle Books 14
Churchward, Joseph 62
Cianfrance, Derek 140
City Magazine Luxembourg 79
Clark, Christopher 114, 115
Clark, Phillip 103
Clemens, Mark 64
Clowes, Daniel 9
Cockerham, Rob 68
Cognitive Media 178, 184
Colaluca, Jessica 103
Colophon Conference 76
Commercial Artisan 62
Commodore Amiga 19
Contempora 33
Cooper-Hewitt, National Design Museum 6, 8, 9
Cooper, Kyle 135, 136, 142, 143

Cooper, Muriel 12, 54, 55, 67
copyleft 30
Coraline 168
Corral, Rodrigo 65
Coudal Partners 32, 40
Cox, Amanda 172, 173
Cox, Jeremy 162
Craig, James 22, 24
Cranbrook Academy of Art 122, 123, 214
Creative Commons 74
Creative Printmakers Group 12
Crisp, Denise Gonzales 19
Crosby, Alfred 171
Crouwel, Wim 16, 17, 18 108
crowdsourcing 26, 27, 28, 67
CSA Images 32, 33, 36–37
cultural analytics 177
Cummings, Glen 208
Cuppens, Brecht 132
Curious Pictures 164
cyan 46

Dadich, Scott 85, 90
Daniels, Lindsay 141
Dare, Leanne 167
Darwin, Charles 180, 184
Davis, Chase 171
Dawn of the Dead 143
Dawson, Clint 170
Daytum 24, 176
D-Crit 209
Dean, Jeremy 103
DeArmond, Stephanie 123
De Bondt, Sara 58, 212
de Bretteville, Sheila Levrant 214
de Certeau, Michel 212
de Duve, Thierry 220
de Groot, Sam 29
De Leon, Henry 167
Deleuze, Gilles 212
Derrida, Jacques 214
Design Museum 201
Design Observer 59, 62, 126, 211
Design Quarterly 6
design thinking 16, 33, 218, 220
DesignWriting 70
desktop publishing 9, 12, 13, 19, 20, 23, 67, 93
Dewar, Nick 103
Dexter 99, 141
Dexter Sinister 55, 57, 69, 202, 205, 214, 217
d'Hanis, Luc 41
Digital Kitchen 140, 141
digital reader 68, 74
Diprose, Andrew 82
di Sciullo, Pierre 132
Dixon, Chris 85
Dixon, Keetra Dean 123
DIY 21, 26, 28, 33, 34, 74, 89, 91
Donahue, Sean 216
Dondis, Donis A. 212
Dot Dot Dot 28, 69
Dougherty, Michelle 135, 164
Douglas, Noel 103
Doyle, Christopher 188
Draper, Don 191
Draplin, Aaron 32, 40
Drenttel, William 29
Dressen, Markus 58
Droog 41
Drucker, Johanna 171, 175, 184
Drudge Report 68
Drueding, Alice 103
d.school (Stanford) 213, 220
Duenes, Steve 171
Duggan, Brendan 82
Dumas, Ryan 103
Dumont, Stephanie 82
Dunne, Anthony 218
Durval Discos 169

Eames, Charles 32, 33, 44, 55, 56
Eames, Ray 32, 33, 55
Earls, Elliott 122
E.A.T. (Experiment And Typography) 131
Eatock, Daniel 42, 104, 216
École des Beaux-Arts 214, 224
Edwards, Gareth 135, 137
Eggers, Dave 67, 72
Eisenman, Alvin 213
Eisenreich, Uta 170, 175
Eisenstein, Sergei 142
Elastic 167
electronic paper 68
Elle UK 68, 84, 86
Elliman, Paul 38, 73, 103, 212, 220
Emigre 19, 21, 33, 34, 113
Enron 190, 194
Entente, The 128
Enter the Void 135, 138
e-pub 74
Ericson, Matthew 172

Ernstberger, Matthias 200
Ernst, Joseph 76, 79
EROS (U.S. Geological Survey National Center for Earth Resource and Observation Science) 182
Esopus 84, 87
Etling, Will 103
Etsy 26, 29, 74
Everything Studio 103
Ewing, Larry 30
Exergian, Albert 99
Experimental Jetset 26, 28, 43, 108–109
Eye 59, 124, 212, 220
Ezer, Oded 113, 118

Fabrica 63
Facebook 56, 93, 113, 171, 187, 194
Facestate 202, 203
Fairey, Shepard 102, 103
Fallot, Mathilde 103
Fantastic Man 80, 83
favicon 189
Feed the Library 219
Fella, Ed 22, 23, 94–95
Felton, Nicholas 24, 176, 184
Feltron 176, 184
Feng, Rob 167
Fern, Dan 214
Ferrario, Julio 168
fetal photography 22
Fidélité Films 138
Field Notes 32, 40
Fincher, David 136
Fiore, Quentin 60, 113
Fire & Knives 80, 81
Flatstock 96
Flickr 26, 56, 211
Flipboard 68
Foer, Jonathan Safran 61, 67, 73
FontLab 125
Ford Motor Company 57
Forman, Stacey 108
Forss, Sarah 14
Forsman & Bodenfors 64
Foucault, Michel 60, 67, 215, 219
Four Corners Books 28, 73
Fozouni, Farhad 118
Fracareta, Dylan 81
Franke, Uli 12
Frankfurt, Peter 135, 164
FR David 69
Free Library 212
Freeman, Linton C. 170
Freeman, Sean 115
French Paper 36, 224
Frere-Jones, Tobias 114, 129
Friedman, Mildred 6
Fry, Ben 24, 57, 180, 184
FUEL Publications 60, 72
Fuller, Buckminster 182, 212
Fuller, Steve 135
Furie, Matt 72
FUSE 133
FutureBrand 194
Future Content 216

Gaessner, Timo 198, 202
Galilei, Galileo 131
Game of Thrones 167
Gap 10, 191
Gapminder 170, 171
Gardner, Mark 135
Gehry, Frank 187
Geissbuhler, Steff 194, 195
George Brown College 63, 213
Gephi 184
Gerber, Anna 61
Gerritzen, Meike 41
Gigposter.com 96
Gilmore, James 217
GIMP 30
Glaser, Byron 33
Glass, Polly 97
GNU 30, 31
Godard, Jean-Luc 28
Golden, William 194
Gomez-Palacio, Bryony 10, 27 186–187, 191, 192, 195, 197, 200, 206
Google 23, 26, 29, 67, 68, 74, 76, 194, 197, 211
Gore, Al 68
Gorman, Pat 197
Gotham 9
Grahame-Smith, Seth 67
Graphic 102
Graphic Design in the White Cube 216
Graphis 33
Gray, Adam 103
Green Patriot Posters 102
Greenpeace 16, 26
Gregory, Amelia 87
Greiman, April 6, 8
Greybull Press 69
Griffiths, Brendan 219

groenland.berlin.basel 56
Gropius, Walter 214, 217, 220
Gross, Daniel 177
Grosz, George 213
Grumm, Lina 58
GTF (Graphic Thought Facility) 38, 201
Guattari, Felix 212
Guitiérrez, Diego 103
Gunther, Eric 178

Haag, Fabio 128
Hadid, Zaha 84
Haller, Monica 69
Hall, Peter 11, 170–185
Hamilton Wood Type & Printing Museum 124
Hammer, Melle 131
Happiness 12, 98
Hara, Kenya 62, 71
Hardt, Michael 17, 30
Hardy, Jason 103
Hares, Jonathan 55
Harley, J. B. 175
Harper's Bazaar 84, 86
Harris, Christopher 181
Harrison, Christopher 87
Harrison, Tom 176
Haspiel, Dean 164
Hasting, Julia 66
Haviv, Sagi 193
Hebdige, Dick 208
Heller, Steven 11, 13, 32–53, 61, 209
Helton, Jim 135, 140
Heltzel, Jessica Karle 112
Helvetica (the film) 71
heraldry 202, 204, 205
Herdeg, Walter 33
Hervy, Étienne 97
Herzog & de Meuron 200
Het Klokhuis (The Apple Core) 135, 168
Higashi, Sandra 33
History of Scotland, A 135, 144
Hitchcock, Alfred 15, 136
Hochschule Darmstadt 216
Hoefler & Frere-Jones 114, 129
Hoefler, Jonathan 114, 129
Hofer, Urs 56
Hoff, James 28
Hoffman, Armin 99
Holder, Will 12, 55, 67, 69, 70, 219
Hollein, Hans 22
Holmes, Nigel 183
Holtzman, Joseph 87
Honn, Tracy 124
Horman, Harold 112
House Industries 33, 112
House M.D. 136
How We Built Britain 135, 137
Hubbard, Elbert 33
Hudek, Antony 58
Huot-Marchand, Thomas 130, 131
Hustwit, Gary 71
Huyghe, Pierre 105
Hwang, Dennis 197
Hyland, Angus 65

I Am Still Alive 55, 77, 145–160
IASPIS 97
iA Writer 68, 74
IBM 184, 194
IDEA 55
IDEO 213, 220
IFS, Ltd. 219
IKEA 64, 210, 211
Illenberger, Sarah 183
Imaginary Forces 135, 136, 162, 164
immaterial labor 17, 28, 30
Independent Group 92
Indian Type Foundry 126
i newspaper 76
Information Architects 68
Instapaper 68
Institute for Social Research 12
Institute without Boundaries 63, 213, 215
International Biennial of Graphic Design Brno 97, 216
International Paper 195
International Poster and Graphic Design Festival, Chaumont 38, 97, 108
Inventory Books 60, 72
Iowa Writers' Workshop 214, 217
iPad 68, 74, 88, 90, 177
Iron Man 136, 142
Is Not Magazine 76, 77
ISO Design 135, 144
Issacs, Ken 28
Issler, Lutz 177
It's Nice That 88, 89, 123, 216
ITT (Illinois Institute of Technology) 214, 220
Iverson, Britt 61

Jackson, Michael 187
Jackson, Warren 79, 83
Jacques 80, 83
Jan van Eyck Academie 16, 202
Javal, Louis Émile 130, 131
Jenkins, Chester 103
Jenkins, Tracy 103
Jennings, Humphrey 176
Jeroen Kee en Waag Society 174
JMR 103
Jobs, Steve 23
Jocham, Hubert 113, 126
Johnny Cash Project, The 26
Johnston, Edward 114
John Wiley & Sons 65
Joliat, Julie 63
Jones, Gareth 73
Jongerius, Hella 66
Joy of Stats, The 170
Jung, Carl 209
Juno 135, 161, 163
just-in-time production 57, 67, 217

Kalman, Maira 61
Kan, Tom 135, 138
Karen 82, 88
Kare, Susan 22
Kasino A4 77, 79
Katzeff, Miriam 28
Keefer, Angie 57, 219
Keeley, Larry 220
Keller, Christoph 70, 219
Keller, JK 123
Kelley, David 213
Kelly, Johnny 135, 168
Kelly, Rob Roy 213
Kemerling, Justin 103
Kenner, Hugh 214
Keough, Sarah 81
Kickstarter 67
Kidd, Chip 65, 220
Kim, Na 212
Kindle 68, 74
Kingdom, The 168
Kinko's 93, 100
Kiosk (XIX) 219
Kiss Kiss Bang Bang 136
Kite Runner, The 143
Kleč, Teja 165
Kleiner, Carl 64
Kleinman, Daniel 135
Klein, Yves 97, 133
Kloepfer, Chad 200
Klosterman, Chuck 65
KnollTextiles 50
Koblin, Aaron 26
Koch, Rafael 56
Kodak Carousel 190, 191
Koedinger, Mike 76
König, Anne 58
Koolhaas, Rem 60, 200, 202, 203, 218
Koser, Mikkel Crone 130, 132
Kostadinova, Kristina 103
Kraliçe 198, 202
Krause, Kai 182
Kraus, Karl 70
Krebs, Dimitri 54
Krebs, Manuel 62
Krebs, Valdis 175
Krishnamurthy, Prem 189
Kroloff, Reed 122
Kruger, Guido 79
Kuback, Adam 170
Kubel, Henrik 114, 129
Kubrick, Stanley 23, 136
Ku, Eric 123
Kuntzel + Deygas 139
Kyes, Zak 97

Lacy, Gene and Jackie 62
Lachaert, Sofie 41
Laeufer, Andreas 87
Lafley, A. G. 220
Lalova, Ben 89
La Más Bella 76
Landekic, Lola 162
Landor, Walter 191
Larsen, Reif 61, 67
Lars Müller Publishers 60, 62, 71, 203
Lavin, Maud 22
Lazzarato, Maurizio 30
Leder, Jonathan 83
Lee, Jenny 135, 161, 163
Lee, Ji 194, 196
Lehni, Bram 73
Lehni, Jürg 12, 24, 25, 125, 216
Lehni, Urs 14, 29, 55, 56
Leis Allion, Marcus 199
Leming, Tal 112
Lemony Snicket's A Series of Unfortunate Events 165
Lentjes, Ewan 18
Leonnet, Natasha 161
Leslie, Jeremy 10, 76–91, 87
Lester, Paul Martin 181
Le, Steve 103
letterpress 93, 124
Letterror 133
LetterSetter 112

Letter to Jane 88, 91
Lewis, Clyde 36
LeWitt, Sol 132, 133
Library of Congress 193
Licko, Zuzana 19, 33, 113, 114, 125
Liemburg, Harmen 216
Lima, Manuel 175
Linefeed/LineRead 88, 89
Lineto 125, 128
Lin, Tao 60
Linux 30
Lionni, Leo 15, 213
Lippincott 192
Lippy, Tod 87
Little White Lies 80, 82
Lodown 55
long tail 28, 29, 59
Longworth, Rob 82
Losowsky, Andrew 76
Lowe, Rob 81
Luettich, Rick 170
Lulu 56, 57
Lunenfeld, Peter 218
Lupton, Ellen 6, 10, 12–13, 33, 34, 55, 58–75, 112–129, 211
LUST 92, 106
Lustig, Alvin 213
Lüthi, Hans 73

Maag, Bruno 128
MacCannell, Dean 217
Macintosh computer 6, 22, 33, 67, 128, 189
MacNeil, Ronald L. 54
Madge, Charles 176
Mad Men 135, 136, 162, 191
MagCloud 88, 89
magCulture 88
Maharam Digital Projects 45–48
Mailler, Séverine 71
Majoor, Martin 114, 127
Makela, Laurie Haycock 194
Malraux, André 215
Maltha, Joris 177
Manders, Mark 73
Manhattan Design 194, 197
Manifesta 6 202, 214, 217, 220
Manor, Justin 178
Manovich, Lev 177
Many Eyes 184
Manzine 80, 83
Marmalade 84, 86
Marres 201, 202
Marriott, Michael 216
Marsh, Bill 172, 173
Martens, Karel 45, 213, 217
Martin, Roger 220
Marx, Karl 202
Marx, Stefan 14
Massive Change 63
Matter, Herbert 213
Mattheaus, Paul 141
Mau, Bruce 60, 63, 213, 215
Maurer, Luna 117, 216
McBride, Adam 103
McCandless, David 171, 181
McCoy, Katherine 214
McCullogh, Malcolm 24
McDonald's 187
McFetridge, Geoff 52, 82, 103
McGinnis, Ralph 81
McGurl, Mark 213–220
McLean, Alan 172
McLuhan, Marshall 58, 60, 72, 112, 113, 114, 210
McMullen, Brian 72
M&Co 32
McSweeney's 67, 72
McWilliams, Chandler 107
Meatpaper 80, 81
Mechanical Turk 28
Meerman, Marije 177
Meindertsma, Christien 63
Meiré, Mike 78, 85
Melcher Media 68
Mellier, Fanette 58, 97, 108
Merz 33, 55
Meseguer, Laura 114, 126
Metahaven 24, 30, 31, 55, 71, 202, 203, 218
Mevis & Van Deursen 69, 97, 198, 202
MGMT Design 68
MICA (Maryland Institute College of Art) 34
Michaels, Adam 72, 208
Mickel, Jeremy 114, 124
Mijksenaar, Paul 17
Miladinović, Marko 165
Milk, Chris 26
Miller, Abbott 51, 127
Milne, Ross 114, 127
Mined 84, 87
MIT (Massachusetts Institute of Technology) 12, 55, 67, 143, 184, 212
MK12 143
M/M (Paris) 55, 62, 97, 105, 121
Modern Library 54
Modra, Penny 76
Moere, Andrew Vande 175

Moholy-Nagy, Laszlo 13, 56
Mohr, Peter 114, 129
Monasterio, Juan 164
Money & Speed: Inside the Black Box 177
Monika 77, 78
Monitor 220
Monocle 77, 79
mono.kultur 84, 85
Mooren, Maureen 201, 202
Moore, Tim 91
Moran, Jim and Bill 124
Moreno, Jacob L. 170, 175
Morgan, John 73
Morisawa Type Foundry 126
Morris, Edward 102
Morris, William 33, 55, 56, 67
Movable Type 211
M-real 84, 87
Mrozowski, Nick 76
MTV 194, 197
Muir, Hamish 131
Müller-Brockmann, Josef 19, 93, 99
Müller-Brockmann, Shizuko 93
Müller, Lars 71
Munari, Bruno 14, 15
Murciego, Pepe 76
Museum Boijmans Van Beuningen 198
Musil, Robert 69
Muumuu House 60
Muylaert, Anna 169
MWP/Caliri Productions 165
Myhrvold, Nathan 64
Myspace 56, 202, 211

Naked woman covered in glitter, and words 77, 79
NASA 182
Nash, Paul 213
National Association of Schools of Art and Design (NASAD) 213
Neal, Chris Sials 103
Negri, Toni 17, 30
Neiman Watchdog 181
Nest 84, 87
Neumann, Erich 209
Nevitt, Barrington 210
New Directions 61
New Line Cinema 164
Newspaper Club 88, 91
news reader 68, 74
New York 84, 85
New York Public Library 193
New York Times Graphics Department 171, 172–173, 175
New York Times R&D Group 174
Nexus Productions 168
Nguyen, Mylinh Trieu 219
Nice Magazine 76
Nickelodeon 192
Nielsen, Jacob 74
Nietzsche, Friedrich 43
Nijs, Annette 17, 18
Nike 187, 194
Nilsson, Lennart 22
Nip/Tuck 136
NODE Berlin Oslo 85
Noé, Gaspar 135, 138
Non-Format 113, 121
NORM 54, 55, 62, 125
Norman, Donald 171
Nowviskie, Bethany 184
NuFrame 165
Number 23, The 135, 164
Nussbaum, Bruce 220
NY Art Book Fair 26, 30, 219

Obama, Barack 26, 27, 67, 187, 195
Objectified 71
Occasional Papers 58, 59
Office for Archival Reproduction (OAR) 215
O.K. Parking 77, 78
O.K. Periodicals 77, 78
Olinsky, Frank 194, 197, 208
Olmedillas, Cathy 81
Olson, Eric 114, 125, 200
Olympic Games (London 2012) 10, 190, 191
OMA 200
One Frame of Fame 26, 27
One Page Magazine 76
On Purpose: Design Concepts 219
Ortiz, Diego 76
Oskay, Windell H. 68
Ouroboros 209
Our Type 129
Owens, Mark 212, 215

Page, Ellen 161
Page, Larry 197
Paglen, Trevor 204, 208
Palma, Paolo 130, 132
Parker, Philip M. 28
Park, Haeyoun 172
Park, Nick 30

Parreno, Philippe 105
Parsons School of Design 213
Pascal, Didier 89
Patane, Ron 140
Paul, Les 194
Paulus, Edo 117
Pearson, David 65
Peçanha, Sergio 173
Penguin 61, 65, 194
Pentagram 51, 65, 66, 127, 192, 193
Perec, Georges 132
Perkins, Will 139, 167
Perlow, Lauren 103
Perry, Mike 44, 103
Pesko, Radim 114, 128, 198, 224
Petchesky, Rosalind 22
Pfizer 193
Phaidon 60, 63, 66
Philippin, Frank 216
Photo-Lettering, Inc. (PLINC) 112
Pic Agency 168
Pienaar, Peet 78
Pierron, Keo 103
Pine, Joseph 217
Pin-Up 80, 81
Piracy Project 67
Pisano, Falke 70
Pistoletto, Michelangelo 12
Pobolewski, John 62
Pokorn, Žiga 165
Polak, Esther 174, 175
Pollock, Xander 103
Ponik, Scott 212
Popeyes 193
Pop Ink 32, 36–37
Pop-Up Studio 215
Port 80, 83
Postrel, Virginia 24
PostScript 9, 132
Pottok 52, 53
PowerPoint 184
Poynor, Rick 59, 212
Prada 25, 69
Pratt Institute, 213
Primary Information 28
Princeton Architectural Press 34, 72, 189
Pritchard, Merion 86
Processing 9, 132
Process Type Foundry 125, 200
Procter & Gamble 220
Project Projects 57, 72, 198, 202
Prologue Films 135, 142, 143
prosumer 11, 210, 211
Public Design Expo, Seoul 92
Puckey, Jonathan 24, 26, 68, 117, 199, 202, 216
Pugliese, Erin 103
Purtill Family Business 69
Pushpin Graphic 33
Push Pin Studios 33
Push Pop Press 68
Put A Egg On It 80, 81

QR code 106, 203
Quantange 132
QuarkXPress 9, 84
Quealy, Kevin 172
Quick Brown, The 68

Raby, Fiona 218
Radatz, Ben 10, 135–136
Raeder, Manuel 54, 55
Rajpurohit, Satya 126
Rand, Ann 14
Random House 22, 65
Rand, Paul 14, 15, 56, 190, 194, 195, 213
Rashid, Karim 211
Rauschenberg, Robert 130, 133
Rawle, Graham 61
Rawsthorn, Alice 201
Ray Gun 9
RCA (Royal College of Art) 218
Readability 68
read-later app 68, 74
Reas, Casey 24, 107
Recent History of Writing and Drawing, A 216
Reichenstein, Oliver 68, 74
Reinfurt, David 55, 57, 67, 69, 219
Reitman, Jason 161
relational design 54, 55, 56
Re-Magazine 77, 78
Renner, Paul 114
Revolutionary Struggle 130
Rezac, Matthew 7, 69
RFID 203
Rich, Alex 25, 216
Ride Journal, The 80, 82
Rifkin, Jeremy 184
RISD (Rhode Island School of

Design) 218
RISOGraph 28, 54, 55, 73
Roberts, Graham 173
Robinson, Sir Ken 1786
Rock, Michael 10, 14–15
Rogoff, Patti 197
Rollo Press 14, 28, 54, 55, 73
Roma Publications 29, 58, 59, 73
Romero, George 143
Rondthaler, Edward 112
Rose, Timothy 201
Rosling, John 170, 171
Rothenberg, John 178
Rotman School of Business 220
Rowle, Graham 61
Royal College of Art 214
Royal Institute of British Architects 38
Roycroft Press 33
RSA (Royal Society for the Encouragement of Arts, Manufactures and Commerce) 178
Rubbish 80, 82
Rubicon 136, 162
Rubino, Charles Christopher 135, 140
Rushton, Steve 205, 217
Russell, Bertrand 35
Ryan, Rob 84

Saatchi & Saatchi 202
Sack, Aurèle 114, 128
Sadao, Shoji 182
Sagmeister, Stefan 41, 200, 202
Sahre, Paul 65
Salim, Joey 162
SALT 198, 202
Sanchez, Chris 167
Sandberg, Willem 18
Santosa, Yolanda 166
Santos, Jon 103
Savannah College of Art 34
Scaglione, José 129
Scanlan, Joe 210, 211
Schaefer, Brandon 103
Scher, Paula 192
Schiøt, Hjalmar August 130
Schoenfeld, Amy 172, 173
School of Visual Arts (SVA) 34, 209, 213
Schuller, Gerlinde 71
Schuurman, Michiel 100–101
Schwartz, Christian 112
Schwartz, Johannes 63
Schwitters, Kurt 33, 131, 132
Sciullo, Pierre di 132
Scorsone, Joe 103
screen reader 68, 74
Scriptographer 24, 25, 117
Se7en 136
SEA Design 128
Sea Shepherd 16
Sebald, W. G. 67, 69
Segaran, Toby 171
self-publishing 21, 56, 74
self-reflexive page 73
Sepp 80, 83
Serving Library, The 69, 219
Shadowplay Studio 161, 163
Shapco Printing 224
Shaughnessy, Adrian 71
Shaw, Kate 220
Shneiderman, Ben 171
Sholly, James and Jon 62
Shteyngart, Gary 67
Shull, Avriel 62
Siegel, Dmitri 11, 59, 102, 210–211
Sigler, Jeremy 210
silkscreen 12, 26, 44, 93, 96, 98, 104
Silver Buckle Press 124
Simon & Schuster 65
Simplex Grafik 55
Sintétik 103
Six Feet Under 136, 140
Skidmore Sahratian, Inc. 22
Skolos, Nancy 103
Sleazenation 84
Sloat, Andrew 103
SMBA (Stedelijk Museum Bureau Amsterdam) 24, 199
Smith, Cooper 174, 175
Smith, Damien 103
Smith, Gareth 135, 161, 163
Smith, Marlena Buczek 103
Smith, Ryan Matthew 64
Smith, Sinclair 103
Smithson, Alison and Peter 92
Smits, Lisette 70
sociogram 170, 175
Sockwell, Felix 103
Solitrenick, Jacob 169
Sontag, Susan 93, 94, 108
Sosa, Omar 81
Sosolimited 178
Spector Books 58, 59
speculative design 218
Spence-Trace, Sasha 86

Spencer-Powell, Richard 79
Spielberg, Steven 139
Spin 71
Stack 81
Stallman, Richard 31
Starbucks 195
Sterne, Laurence 73
Stern, Meredith 103
Stocks, Elliot Jay 195
Stoker, Bram 73
Stone, Declan and Garech 194, 195
Stout, DJ 193
Stowell, Scott 194, 195
St. Pierre & Miquelon 28
Stranger, The 60
Struck/Axiom 192
Stryjewski, Sara 103
Sueda, Jon 216
Sulki & Min 199, 215
'Sup 80, 82
super family 127
Supermarket 26
Suter, Batia 73
Svenja, Buro 83
Swanson, Gunnar 218
Swara, Kuchar 83
Syfy 192
Szpajdel, Christophe 206–207, 208

T-26 33
Tacer, Frédéric 103
Talarico, Lita 34
Tamm, Triin 73
Tankard, Jeremy 127
Taylor, Vonetta 166
TCBY 192
TED (Technology, Entertainment, Design) 171
Tejada, Fabian 162
Terret, Ben 91
Text Pencil 24, 117
Thackeray, William Makepeace 73
The Believer 61
The Incredible Hulk 135, 136
thelab 192
Things Our Friends Have Written on the Internet 88
Thomas, Scott 27, 67
Thompson, Bradbury 212
Thorp, Jer 174, 175
Threadless 26
Thumb 103
Thurlow, JP 86
Time Warner 194, 195
TNO 17
Toffler, Alvin 210, 211
Toffler, Heidi 211
Toivonen, Pekka 79
Torvalds, Linus 30
Total Design 16
TouchDoc 177
Toyota 57, 67, 217
Traum, Thomas 54
TPUTH, The 68
Tscherning, Marius Hans Erik 130
Tschichold, Jan 56, 128, 132, 194
Tse, Archie 172, 173
Tse, Tomoeh Murakami 172
Tuan, Cynthia 56
Tufte, Edward 171, 183, 184
Turley, Richard 85
Tux 30
Twemlow, Alice 209
Twitchell, James 194
Twitter 56, 93, 113, 187, 194
Type Kit 114
Type Together 114, 129
Typotheque 125, 127, 130

UCLA (University of California, Los Angeles) 213, 218
Ulloa, Alexander 137, 138, 140, 141, 142, 143, 161, 164, 166, 169
Underware 114, 126
Unimark International 16
Union 224
Unit Editions 16, 60, 71
United States Army Institute of Heraldry 204
University of California, San Diego 177
University of Toronto Press 112
University of Virginia's SpecLab 184
Unusual Suspects 62
Up in the Air 135, 161
UPS 194, 195
Urbanized 71
U.R.O.K. Productions 162
USA Today 183

Valicenti, Rick 62
van Bennekom, Jop 55, 78, 80, 83
van Blokland, Erik 112, 133
Van Dam, Stephan 33
van der Hoeren, Ernst 89

VanderLans, Rudy 19, 113
van der Rohe, Mies 201
van der Velden, Daniel 10, 16, 16–18
van Deursen, Linda 198
van Dijk, Jorn 177
Van Lanen, Jim 124
van Rossum, Just 133
Van Sluijs, Jarik 168
van Wyhe, John 180
Vasiliev, Sergei 72
Vega, Karla 170
Velonis, Anthony 12
Verlag Niggli AG 19
Victore, James 39, 103
video scribing 178
Vidokle, Anton 214, 217
Viégas, Fernanda 170, 174, 184
Vier5 103
Viktor 24, 25, 216
Village 103, 124
Villegas, Jon-Paul 103
Vishmidt, Marina 203
Visible Language Workshop (VLW) 12, 55, 67
Visual Editions 61
visual journalism 181
visual writing 61
Vitagliano, Anthony 141
Vit, Armin 10, 27, 186–187, 191, 192, 195, 197, 200, 206

Wachowiak, Dirk 126
Wälchli, Tan 55
Wald, Matthew L. 173
Walesh, Quentin 200
Walker, Alissa 194
Walker Art Center 6, 8, 9, 105, 194, 200
Walker Expanded 200
Walker, T. B. 224
Wall, Angus 166, 167
*Wallpaper** 17, 84, 86
Walters, Helen 218
Ward, Craig 115
Warde, Beatrice 15, 18
Warhol, Andy 28
Warner Bros. 166
Washburn College 213
Watson, Steve 81
Wattenberg, Martin 170, 171, 174, 184
Watts, Brent 165
WebTypographyfortheLonely.com 114, 115
Weeds 99
Wendt, Bianca 82
Wenzel, Jan 58
Werkplaats Typografie 18, 30, 212, 213, 214, 217, 219
Werner Design Werks, Inc. 14
Werner, Sharon 14
Westerink, Joseph 170
White Night Before A Manifesto 30, 31
Whole Earth Catalog, The 11, 22, 23
Wikipedia 8, 11, 12, 30, 61, 67, 130, 184, 209, 210, 211, 220
Wilde, Oscar 73
Wilderness Downtown, The 26
Wild, Lorraine 19–21, 66, 69, 70, 214, 217
Wild School 212
Wiley, Matt 83
Willberg, Hans Peter 56
Willems, Roger 29, 58, 73
Williams, John 139
Williams, Raymond 220
Willoughby, Paul 82
Windlin, Cornel 55
Wired 84, 85, 90
Wizansky, Sasha 81
Wolff Olins 190, 191, 193, 194
Worthington, Michael 131
Wouters, Roel 26, 117
Wozencroft, Jon 133
WPA Federal Art Project 12
Wrap 87
WTC Logo Preservation Project 196
Wurman, Richard Saul 33

Yale University School of Art 212, 213, 214, 215
YMCA 193
Young, Chris 64
Yount, Danny 142
YouTube 29, 56, 211
yU+co 166
Yu, Garson 166

Záruba, Alan 131
Zauft, Richard 124
Zimbardo, Philip 184
Zim, Eric 192
Zinio 90
Zolo 33
Zone Books 60
Zuckerberg, Mark 202

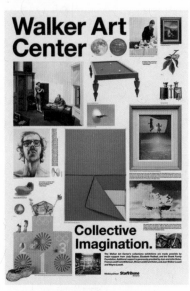

Walker Art Center Collective Imagination campaign, 2009

Early book mockup for this catalogue featuring a trimmed down 2011 Insights poster as the dust jacket

Helvetia Vulgaris

This book is set in Union, a typeface by Radim Pesko: "Union derives from the two most commonly used typefaces on PC and Mac platforms: Arial and Helvetica. Essentially, Union is a synthesis of these typefaces; its contours have been adjusted to retain the flexibility characteristic of both fonts. Union is intended for situations where Helvetica seems too sophisticated and Arial too vulgar, or vice versa." —EB

Credits

Curators: Ian Albinson, Andrew Blauvelt, Jeremy Leslie, Ellen Lupton, and Armin Vit and Bryony Gomez-Palacio

Curatorial Assistance: Camille Washington

Catalogue Concept: Andrew Blauvelt and Emmet Byrne

Catalogue Design Direction: Emmet Byrne

Catalogue Designer: Michael Aberman

Exhibition Design and Graphics: Andrew Blauvelt, Dylan Cole, and Matthew Rezac (Walker Art Center); and Project Projects (Cooper-Hewitt, National Design Museum)

Catalogue Editors: Andrew Blauvelt, Pamela Johnson, Ellen Lupton, and Kathleen McLean

Indexing: Ellen Lupton and Pamela Johnson

Contributing Writers: Åbäke, Ian Albinson, Peter Bil'ak, Andrew Blauvelt (AB), Emmet Byrne (EB), Rob Giampietro, James Goggin, Peter Hall, Steven Heller, Jessica Karle Heltzel, Jeremy Leslie, Ellen Lupton (EL), Ben Radatz, Michael Rock, Dmitri Siegel, Alexander Ulloa, Daniel van der Velden, Armin Vit and Bryony Gomez-Palacio, and Lorraine Wild

Picture Researchers: Andrew Blauvelt, Emmet Byrne, Dylan Cole, Amanda Kesner, Jackie Killian, Ellen Lupton, and Camille Washington

Photographer: Cameron Wittig

Title Image Stills: Ian Albinson

Image Preparation and Correction: Greg Beckel

Image Preparation Assistance: Michael Aberman, Anton Pearson, and Brian Walbergh

Publication Project Managers: Andrew Blauvelt, Emmet Byrne, and Dylan Cole

Wiki Developer: Eric Price

Printer: Shapco Printing, Inc. (Avery Group)

Paper Manufacturer: French Paper Company

Publisher: Walker Art Center

Distributor: D.A.P., Distributed Art Publishers / artbook.com

Walker Insights lecture series poster, 2011 · Moon · Sun

The galleries in T. B. Walker's home, circa 1904

Bits and Pieces

The design of this book is the culmination of a text-image strategy first employed in a campaign created to promote an exhibition on the Walker Art Center's painting collection (2009). Inspired by museum founder T. B. Walker's own salon-style hangings in his nineteenth-century mansion and our painting storage facility, this display style allows for a dense presentation of material and unexpected juxtapositions. Although dominated by its strong visual approach, the design also integrates textual material throughout its composition. In 2010, this layout strategy was used in a poster to celebrate the Walker's twenty-five-year collaboration with the AIGA on the Insights design lecture series. For this catalogue, the strategy was elaborated and extended. Previously utilized in the design of a single poster or billboard, the layout approach was used to create more than one hundred pages of this 224-page publication. Small texts that we call bits are incorporated throughout the catalogue and represent a combination of original writing, aggregated authorship, and excerpted quotations. In this way, the design weaves together the voices of curators, "crowds," and artists with images of works found in the show and beyond, including the supplemental and the tangential. This premodern style of arrangement, which attempts to impose an order and sensibility on an often incoherent assemblage of objects, speaks to our condition of information overload in an increasingly fragmented search-based culture. —AB

Radim Pesko Union typeface specimen Courtesy the artist

Earth's core

Branch

Night School students with Joe Avery of Shapco at final press check for *Graphic Design: Now in Production*, 2011

Rabble-Rousers

A salon-style hanging refers to an installation of artworks—typically photographs and paintings—hung close together on the wall from floor to ceiling. Its roots lie in the Paris salons first held in 1674 as a way of presenting the work of recent graduates of the École des Beaux-Arts, the royally sanctioned art school. The density of the hanging accommodated as many works as possible—large pieces placed high and smaller works below, with some tipped for better viewing. In 1737, the salon was opened to the public. Before that time, the judgment and discernment of art was the function of an institutional system of royal patronage. This democratizing development encouraged not only the mingling of different social classes who now shared the same event, but also propagated new opinions—beyond those of the court—about the art on display. Using the popular form of pamphleteering, ordinary people could write, print, and distribute their own criticism about the works on display and those who sanctioned it. Not surprisingly, the elite would often view these remarks as those of the uneducated and unenlightened masses—the noise of the crowd or rabble. Of course, the term "rabble" could have been applied to both the amassed crowds and the assembled jumble of works on view. The opening up of art to the democratizing impulses of the time would not only irrevocably alter the cultural relationship between the elite and the masses, but also presaged the social and political revolutions of the late eighteenth century. —AB See Thomas Crow, *Painters and Public Life in Eighteenth-Century Paris*, 1987

Work Safely sign at French Paper Mill

French Paper Mill, 2011 Photo: Emmet Byrne

French Paper Company

This book is printed on French Paper's Dur-o-tone Newsprint Extra White 50# text. Established in 1871 and located in the small town of Niles, Michigan, French Paper is a sixth-generation, family-owned American company. Known for its distinct, designer-friendly paper lines, French also makes small-run custom sheets that incorporate additives into its pulp like shredded dollar bills, grass clippings, and even insect parts. French uses no petroleum in the manufacturing of its papers, and instead generates its own clean, renewable energy by way of hydroelectric generators installed on-site. To prove that the water going out of the French Paper mill was cleaner than the water coming in from the St. Joe river, starting in 1944 Chairman "Big Ed" French would drink a cup of mill waste water each day from a crusty tin cup. "Big Ed" is now 173 years old and glows in the dark. He credits his longevity and radiant good health to the "nutrients" in the mill water. French was also an early pioneer of recycled, 100 percent postconsumer, and other environmentally friendly sheets. For this catalogue, we requested that French cut the paper along the short edge of the grain (opposite the usual direction) in order to allow the pages to have more bend, giving us the desired flop effect. —EB

Shapco Printing

This catalogue was produced by Shapco Printing, Inc.—one of the Walker's printing partners—using inks that cure immediately when exposed to ultraviolet light. This process allows the ink to sit on the surface of the paper, rather than soak in, resulting in better quality reproductions and eliminating the VOCs (volatile organic compounds) typically emitted during printing, which makes the process more environmentally friendly. Shapco was founded in 1976 by three brothers (two accountants and a lawyer), who gave up their day jobs to form a printing company focused on quality and craftsmanship. Today, Shapco specializes in high-quality books, catalogues, and magazines, particularly for the cultural sector. Shapco produced this smythe-sewn catalogue in sixteen-page signatures with thirty press checks, eighty-four hours of print production, two-hundred and thirty pounds of ink, and over sixty hours of binding. Based in downtown Minneapolis' warehouse district on the site of a former linoleum tile company, Shapco now sits comfortably in the shadow of the new Minnesota Twins stadium and offers free game-day parking to all of its customers, a perk that we frequently use. —EB